THE LITTLE CLAVIER

WINTER PATHS—*refuge* . . .

(i)

Inverted sled
at winter camp: after
storm, two fieldmice
call it home.

(ii)

Among the alder
with hanging catkins,
a nest
that was left behind.

(iii)

Where is the Dipper's
house? Behind the waterfall,
the rock,
or the stream?

(iv)

The hut was locked
all winter long:—
a sure sign of
mean-spirited times.

(xvii)

See the primrose
nested on south-facing rock—
the patience
of deep snow.

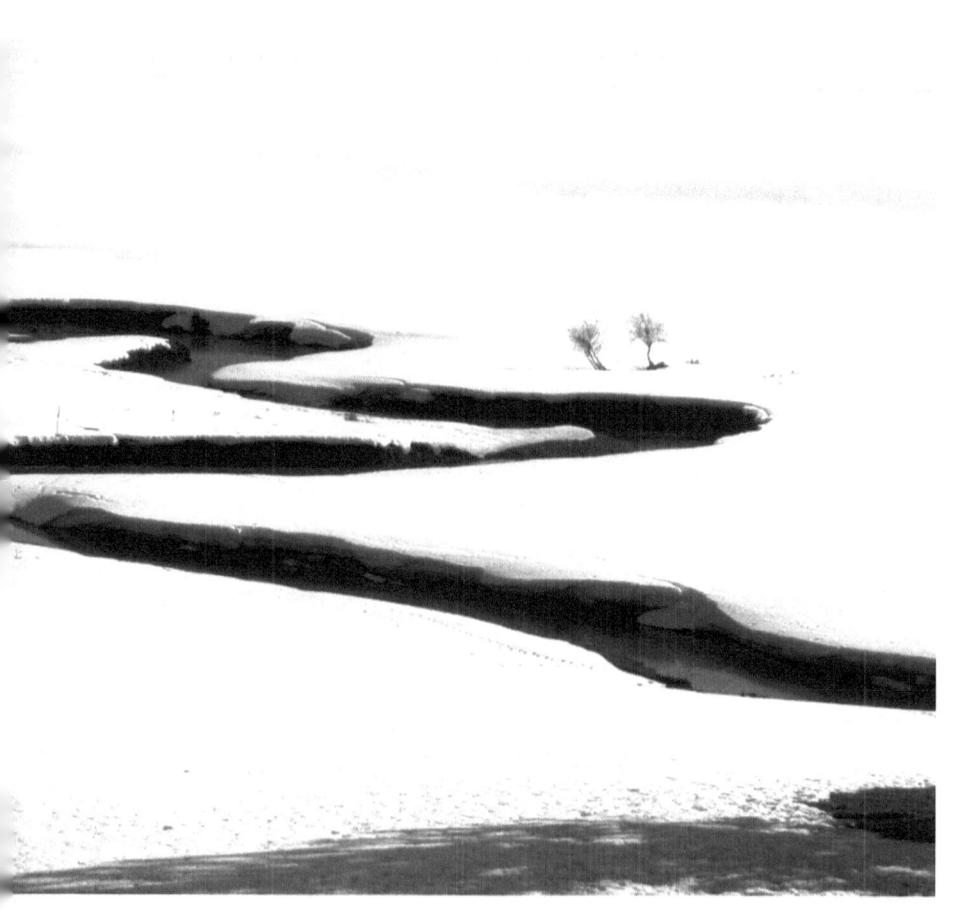

(xiii)

The white death
of snow comes fast.
He went to the barn
and never came back.

(xiv)

The way of snow shows:
Never trust the
man who is
absolutely sure.

(xv)

Today's traverse
may be tomorrow's trap.
How hard, this art
of waiting.

(xvi)

After storm, new snow.
All the old paths are gone.
Time to begin,
once more.

(ix)

The snowmachine's tracks
cut ruts in the snow;
its sound, smell,
carry miles.

(x)

The silence of snow
is deep. If we listen,
we, too,
become silent.

(xi)

Overcast again,
new snow tomorrow.
Good day for lichens
and buds.

(xii)

If snow comes and
goes in winter, then,
you're not in the
right place for snow.

(v)

Cars hate snow: *Stuck. Skid.*
Flip. Swerve. Won't start. Crash.
Oh my god, I'll
be late.

(vi)

Snow means slow,
quiet, peaceful.
Cars mean fast, heavy—
get out of the way.

(vii)

When two movements
bite or fight each other,
this is called—
contradiction.

(viii)

The fieldmouse tracks
go, *"hop, hop."*
Straight line of tail
never leaves the snow.

WINTER PATHS—*deep snow . . .*

(i)

The blank page
of freshly fallen snow.
Where shall our first new path
begin?

(ii)

How deep snow heals.
The old wreck
of a car is gone.
Almost gone, the cross.

(iii)

In one single night,
the rudeness of machines
and straight lines—
is erased.

(iv)

Children and snow
go together: *Try. Make.*
Break. Play. Angel. Snowman.
Wings!

WINTER PATHS—
two sets of seventeen 17-step poems

WINTER PATHS . . .

More than five feet of snow
has healed the deeply scared
landscape.

Even the houses seem more
at peace with the Earth.

But these winter paths . . .

winding, sensuous,
unhurried rhythms,

a drifting of the
timeless music of
long, cold—

 white nights.

(Winter of 1987, Urnerland, the Alps)

And as the snow rises and hardens and consolidates, first one foot, then two and then five and six and more, there is a new found freedom about the land. Asphalt vanishes, concrete disappears, and even large boulders and small spruce trees are completely buried. So, after the storms clear, nature presents us with a new blank page upon which to play the diverse figures of our own music. But this play, the winter paths in the snow we create, moving from hut to barn to house, tells a remarkable tale. Perhaps it's the beautifully balanced, graceful curves. Or the steady, unhurried rhythms, movements which have left a trace, like melodies of a wooden flute lingering in the evening air. A very human trace at that. Perhaps that is it. Not an alien landscape shaped largely by aggressive entities like cars, but wholly by us, and by us alone. That is the great beauty of winter paths.

WINTER PATHS—*The Alps*

In the mountains above 1,600 meters or so, just below treeline in the north of the Alps, winter comes and remains for a good half of the year. And once the snow falls, it stays. This is because the air at that altitude is lighter and colder, and because the sun retreats behind the higher peaks to the south. For those of us who have not had the opportunity to experience such a high-country landscape first-hand, I can easily imagine that this sounds terribly forbidding. But in fact, the very opposite is the case. I've frequently heard older German climbers say that the higher up a peak they go, the closer they feel to God. Well, if we were to say that God is truth, or God is beauty, I would certainly agree. Part of this is because we sense a return to natural simplicity; instead of a meadow of a thousand blooms, we now have vast expanses of the purest white. But there is also the great blanketing effect which comes with deep snow. Imagine all the noise of the world—without a doubt wherever you read this will have the not-so-distant roar of traffic in the background—as a pile of the foulest filth, but now being progressively covered and muted with layer upon layer of soft, fluffy snow, snow the color of freshly washed cotton, the color of mother's milk. Come about the beginning of January, all that remains is silence. And yes, if we were to say that God is silence, I would certainly agree again.

So, with each passing storm of winter, the snow pack grows deeper and deeper, and thoughts of religion as cathedrals, and religion as belief in some kind of savior, become like the clamor of cities— nothing but faint, distant memories. What is sacred but that which I walk upon?

WINTER LINES

The lines of winter poems

lie tightly together

like buds tucked close

against a leafless twig,

stopping short of snow

and cold:—

seeds of crystals,

of new ideas,

listening

for the chance,

just the chance,

of an echo

in the surrounding silence

of mist and snow.

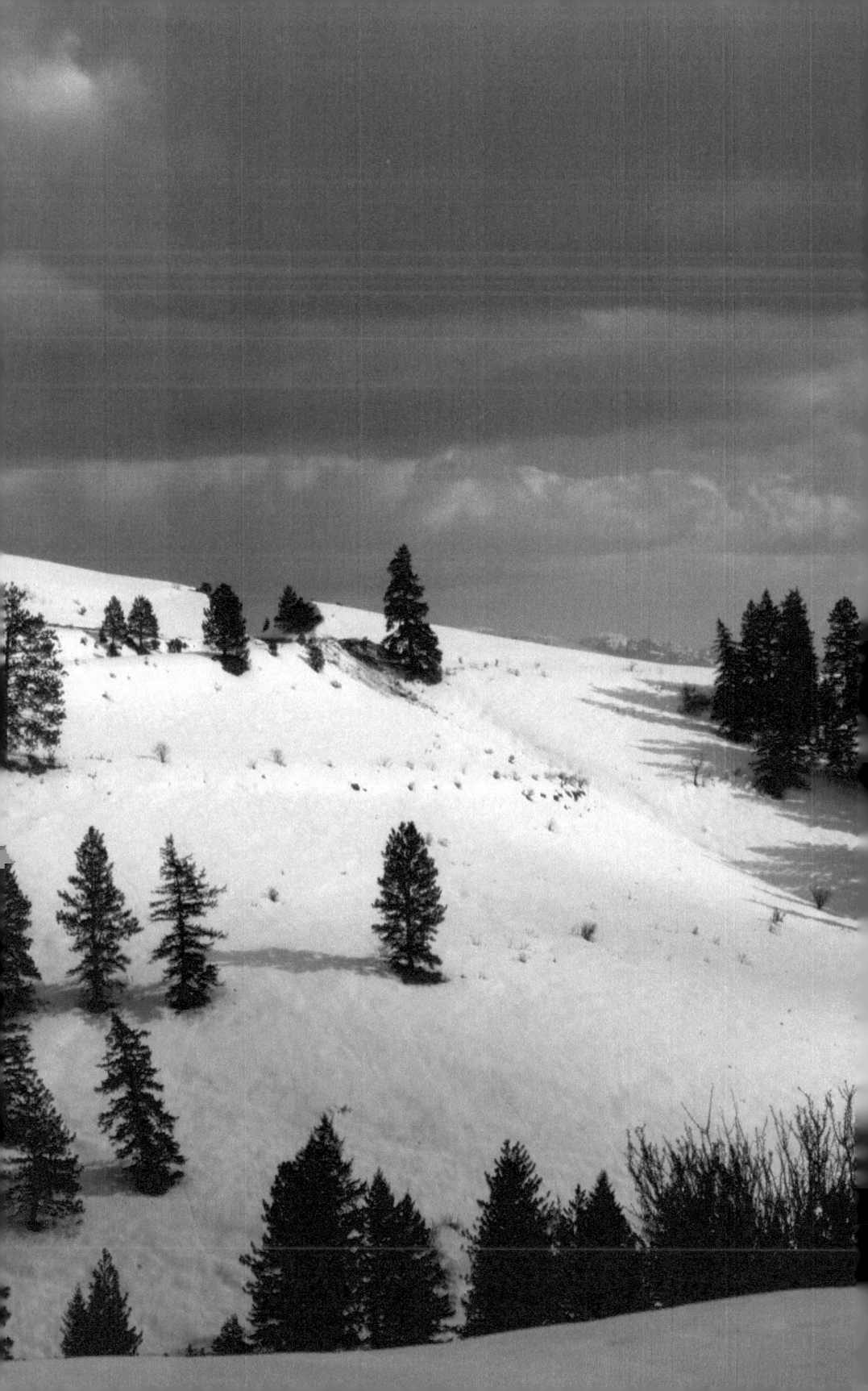

The Little Clavier: Part XX

Dialogue is like a journey we make together on foot through unknown terrain. Where we do not move as one, we simply stop and start over again.

It is the movement of the journey itself that is primary, and not any particular destination or goal.

* * *

Every well-made path was once only a possibility. Because it is well-made, daily use only makes it more beautiful.

* * *

Taking Back the Night? Just as the ear longs for the nothing of silence, so the eye longs for emptiness of darkness. The long northern winter nights are the natural spiritual home of both.

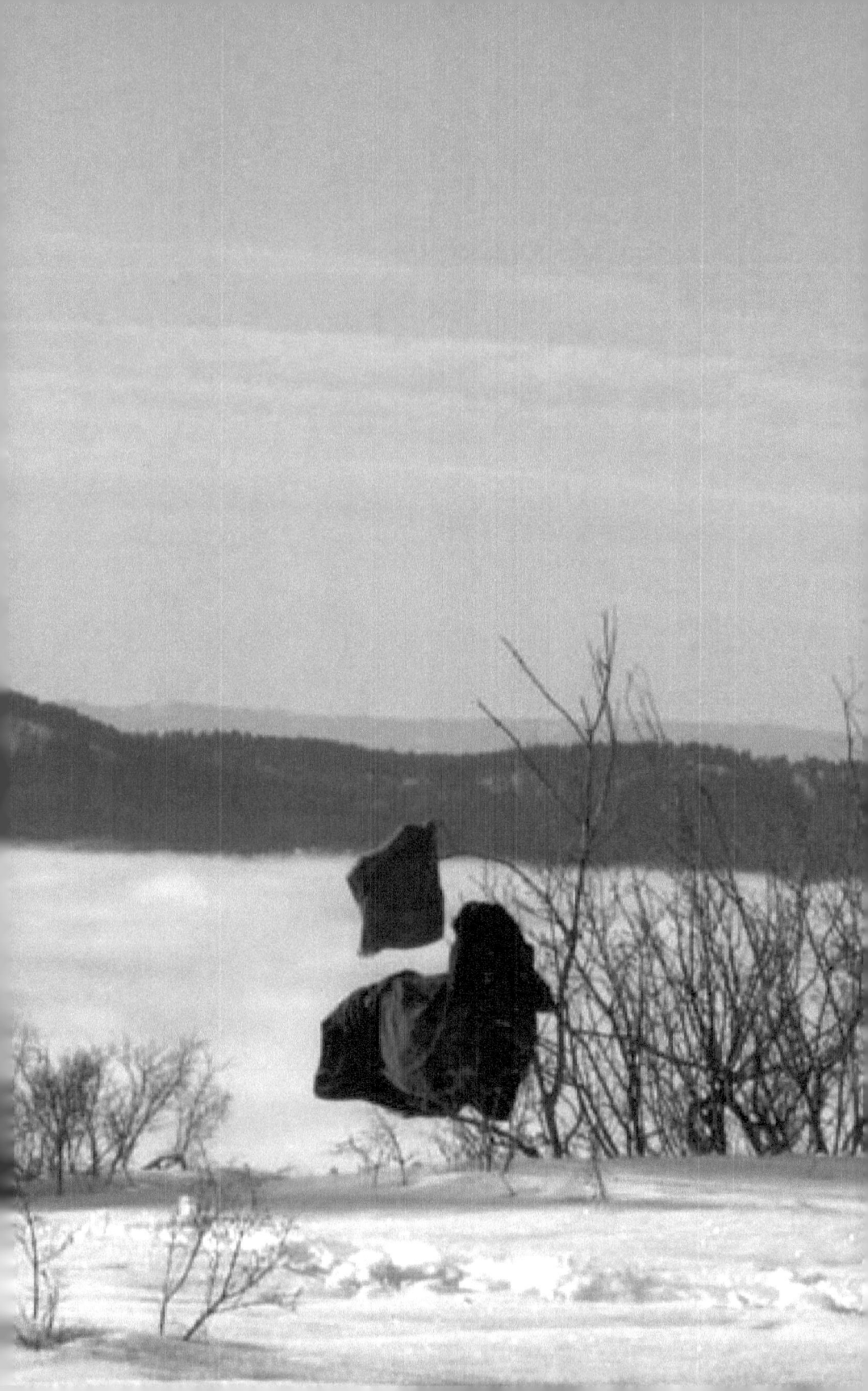

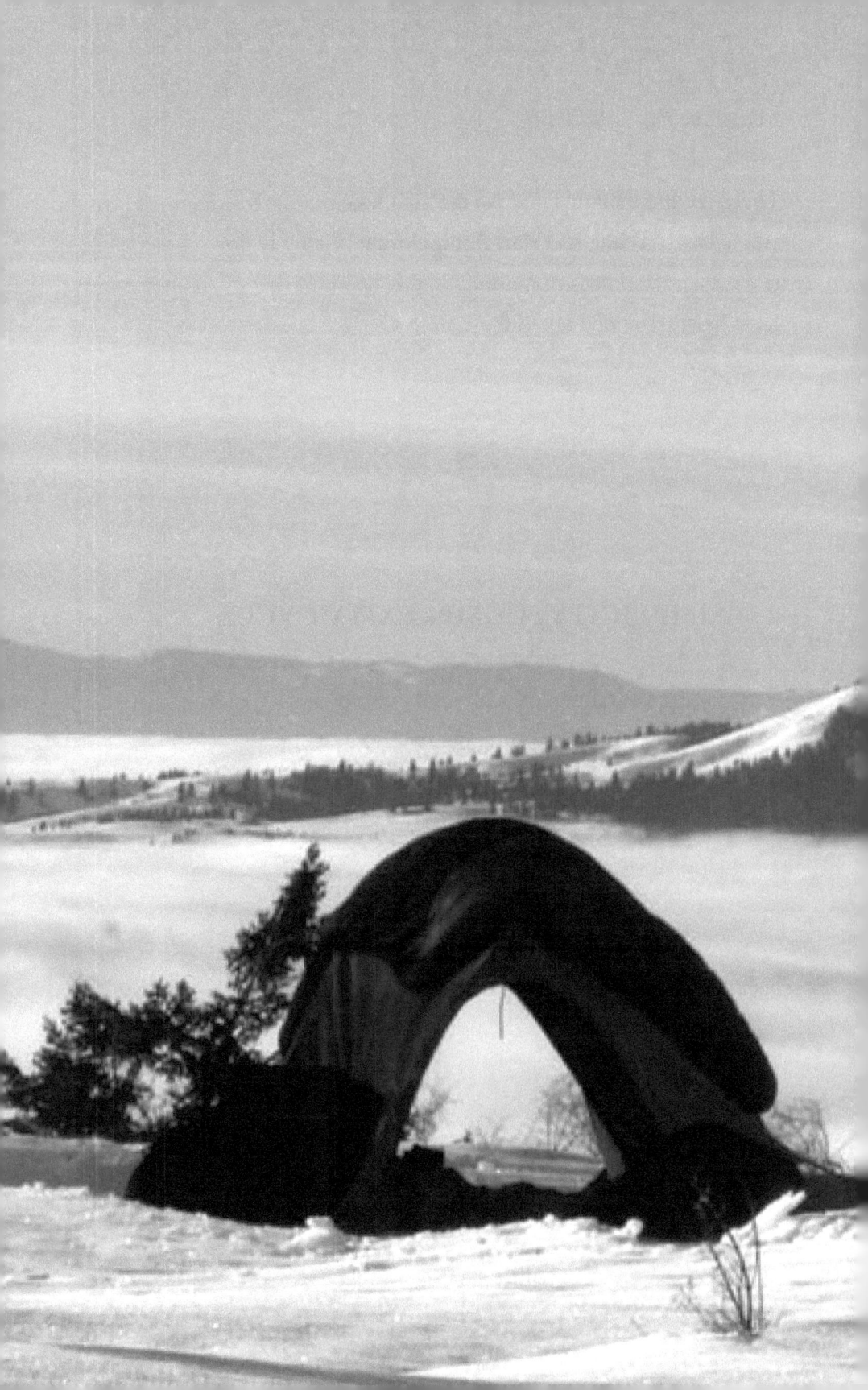

free of the fear of falling?"

These are the thoughts that fill me, as I take out my headlamp, adjust its single bright beam, and start finding my way slowly down a steep talus slope as the darkness of night descends upon me, happy to once more have been reminded about these things.

SIMPLICITY / COMPLEXITY CYCLE

Where the climax of complexity comes we
can never know for sure, but natural movement
always begins and ends with simplicity.

Draw a circle which is not
surrounded by emptiness;
Speak a word which does not
emerge from and return
to nothing at all.

WEST WIND AT POP CREEK PASS—
a prose poem

Each time I cross a pass, I suddenly remember something I always seem to be forgetting, forgetting about the energy of insight, about how similar for me the two experiences are.

This moment of crossing over, the epiphany that fills us as a new valley and a new horizon appear before us and instantly rush in. This is the energy, it seems to me, of sudden awareness, of suddenly discovering a new way of seeing. Where does it come from? What is its source? It doesn't seem personal to me, a mere mechanical product of my own memory. No. Insight seems to be coming to us from someplace different, from someplace truly intelligent or divine, an 'inbreathing of the gods,' as the ancients used to say. To me, the energy of insight is just there, ever-present, like the clear sound of fast-flowing mountain water moving around me everywhere.

A steady west wind roars through the ridge crest firs and pines, blowing the last few thoughts of the past decisively away, and bringing the sound of what seems to be a distant ocean near. O view of the known world . . . I turn to look a last time at the valley whence I've come. Just before I step across into this new world, the flashing white outline of a nutcracker's wings catches the last light of day as it shoots straight up, sheering the strong winds like surf, and vanishing almost as quickly out of my field of sight. And all this as if to say, *"Ah, you poor people people. Will you ever learn to fly, learn to fly free of the fetters of fear,*

DEEP WATER

In an adverse cultural climate, with its perennial waste, and war, and utterly mindless violence against the Earth, mimic the alpine plants:—grow close to the ground, keep a tight cushion of friends clustered around you, wear a coat of densely woolly white hairs, and especially, send roots through every crack and crevice down to deep, reliable water.

MIRACLE

The miracle of intelligence is that it
does not require miracles.

CENTER OF LEARNING

That which cannot be touched by force—*Love, Intelligence, Compassion*—forms together the basic triangle at the center of all learning. Because they cannot be achieved by force, they are best approached negatively, by taking away the blocks that are in the way.

The task is clear: perfectly tuned octaves, fourths and fifths you leave alone; what you go after are the broken strings.

FOR THE YOUNG—*a few necessities*
of the artistic life

An abundance of wonder.
An absence of fear.

The fierce doubt of spiritual freedom.
A love of self, a love of other, a love of Earth.

The calm of clear. cold night air just after a winter storm.
The quiet patience of a stonepine.

The excellence which comes with determination, diligence
and devotion in all matters of craft and technique.

Like a mountain spring, a natural ebb and flow of giving and receiving, indifferent if others do, or do not, choose to drink, while asking nothing in return.

And finally, an intense passion for awakening—one at a time,
and all at once—all the above qualities in the young,
or just younger than you.

like the ecstatic counterpoint of ravens

after all the hunters have gone home,

like a bell on a misty hill ringing out into

the darkness from all its sides,

like the sound of gently falling snow beneath

the dome of angel stars that gives us both refuge

in this most uncharted wildness of all.

I'M TOO POOR IN THIS WORLD, AND YET NOT POOR ENOUGH . . . *after Rilke*

I'm too poor in this world, and yet not poor enough

just to stand before you like a Buddha,

or naked, like a new-born babe;

I'm too clever in this world, and yet not clever enough,

just to vanish before your eyes

like a single leaf, or blade of new spring grass.

I want my world to be shaped by meaning, by sense,

and not by greed, or envy, or corporate gold.

I'm sick of war, of waste, of conflict,

of presidents who lie, and governments

who slaughter in my name and call it peace.

I want to walk with those who speak

a wholly different language;

with those who ask questions, real questions,

and who listen with a certain selfless fierceness

regardless of where the answers lead.

I would like to sing.

And I want my song to resonate with your whole being

and not just some narrow backwater of your soul.

I would like to pray. I would like to pray

that my song might come alive with energy,

like the sound of rushing water,

it takes pure, living water to sustain the life of a village.

And yet, that this was a land where nothing

was sacred anymore.

Nothing about it. Not even water.

And this in a land where rain is rare, and drought common.

In the past, when there was still a place for horses

next to the south doors of the little wooden church,

under the deep-rooted, broad-leaf trees—

the silver maples, black walnuts, the elms—

seedlings brought all the way from the richer,

greener fields found east of the Ohio country,

and when neatly-dressed women of all ages

still had a faint scent of freshly cut hay in their hair,

he reminded himself that people *came in* with the church,

and that people *went out* with the church.

Now they just seem to go out.

He had his work cut out for him.

That much he knew.

That much he knew for sure.

BAPTISM

The preacher was new in town.
He had his work cut out for him,
that much he knew.
In a land where rain is rare, and drought common,
it is hard to break the sacrament of
living, holy water,
but here it has been done with a vengeance
and forgotten about generations ago.
Here, at the village center, stands no well,
no fountain offering the wayfarer the gift
of the waters of this and this place only, where
a young man would come first to drink after
returning from war, or an exhausted
midwife would go to wash her hands
with the returning first light of day.
In its place now—this even a child can prophecy—
will be a filthy parking lot for cars and trucks, and a phone
that takes your money, but doesn't work.
The preacher was new in town.
He had his work cut out for him.
More than just a surfeit of funerals.
He knew, although he couldn't quite say it in words,
that it takes a village to raise a child, and that in turn

One by one, without a sound,

those gathered together stand and begin

to walk out the massive doors facing West.

So the smaller infinitude inside the cathedral

gives way into the larger eternity of the evening sky,

—an evening resting motionless it seems

in the great cycle of seasons, neither the end of winter

nor the beginning of spring—

and into the gentle, forgiving hands

that seem to hold them both.

HYMN

One by one,

in the stony silence of the nearly dark cathedral

the choir boys proceed from the domed apse

pass the altar to the high, massive doors

opening to the West.

The procession does not so much move

as float, the young feet whispering

in a measured hush that's been rehearsed and mastered

and passed on over many, many centuries.

One by one,

the boys blow out their candles

in a single and perfect rhythmic puff.

And so, one by one,

what began as a circle of light becomes a serpent unfolding

into a gently curved straight line which grows shorter

and shorter, contracting into but a single point

which seems to hold all that has ever been

and ever shall be of time.

As the last candle is blown out,

a darkness falls heavily upon the floor

just as a collective sigh rises,

an out-breathing of some commonly held grief,

a sadness which cannot be expressed when we are alone.

The President was only at the third hole.

He read the note. *Destroyed.*

He drove a shot straight down the fairway.

He learned to love the game while a student in Florida.

It made him feel, he couldn't quite say, feel good inside.

Terror without sound.

Death at a distance.

Terror without sound.

"The bastard," he thought. They got 'em.

It made him feel good inside.

DEATH AT A DISTANCE

The missile slammed into the glass as if outside of time.
They got 'em.
Cheers went out of the filthy windowless cubicle,
littered with tea cups and annime comic books,
like a dam of frustration burst by a deluge of sudden joy.
the young man was shaking and calling out ecstatically.
They got 'em.
The operator knew this was his moment.
He took a marker and scratched out the name.
A second drone gave details.
A McDonalds in Detroit: A party for his seven-year old twins.
He would always consult the oracle
before an operation: in the middle of the night,
it said *Ch'ien*. "Modesty," he thought?
Terror without sound. "Modesty?"
The restaurant was entirely destroyed.
He was trying hard to make out the new models of cars.
Some were on fire.
There were people screaming, running chaotically in all directions.
Terror without sound.
Other operators were entering the filthy, windowless cubicle.
Laughing. Asking about the red convertible with the top down.
One knew all the names, even how to pronounce them.
Ch'ien, he thought.
He handed the note to an officer.
They got 'em. *Destroyed.*

(iii)

Culture is the engine of social uplift. Example leads, and generates the energy, the inspiration, the ideal. It demands the best of the most creative part of our being. When the demagogue, the populist, the capitalist drag high culture in the dirt, they seek to control and profit by feeding the brutish brain with what it craves: free license to release not the highest, but the very worst of our being. And they have historically always answered critics with the same disingenuous reply: *"But this is what the people want!"* Once excellence and learning are attacked as elitist, one can be sure that the lowest instincts in us all are once again rising to power.

THE WATER IN US . . .

How the water in us wishes to lie flat in deep repose at night,
like the water of a clear mountain lake high in a hidden valley.

And how the water in us wishes to hold and reflect, like a lake's quiet surface, all the stars and planets and galaxies of the cloudless night sky.

The water in us: *Here. Now. Timeless.* The water in us: but a mere fraction of the whole, yet resonant with a Universe evidently without beginning, and without end.

THREE MINIATURES ON WAR &
THE CHANGE OF MEANING

(i)

War is not an end in itself. Neither is war a *means* to an end, War is simply the ultimate *dead-end,* a path not to peace, but to more of the roar of the perpetual motion machine fueled only by more of itself, that is—more war.

(ii)

We shape the world and the world shapes us.

See the fact: To kill is seen as manly. It has been a key part of our entire natural history. To provide protection; to provide food. The problem now, is that things have changed. Yet the instinct of the brutish brain remains. Killing, it should be clear, no longer provides protection, no longer is even strictly necessary for food. See the fact: To kill is still seen as manly, yet the stone thrown now has a potential death-force amplified over a million million fold. Now, it may be argued, the manly thing, *nay,* I say the necessary thing, is to put down the stone.

VETERAN

See that guy over there,
under the bridge?
He was Commander-and-Chief.
They took away his stars.
The other guys don't like him much.
He gave the orders.
They dropped the bombs.
In Hell-on-Earth, they stand
around and share the same fire.
He's at the bottom of their ladder of honor.
The bottom. Hell has its rules, as Virgil knew.
The other guys tell him their stories.
He still doesn't listen.
They recite by heart on cloudy nights
the speeches of the commanders of Troy
as they breached the ramparts guarding the Greek ships,
that real men have a duty
to fight with the men they command;
They sing verses from *Mutter Courage;*
And repeat again and again Vonnegut's
healing reverse of the fire-bombing of Dresden,
planes flying backwards, weapons deconstructed,
laid to rest in the womb of the Earth.
He still doesn't listen.
He never did.
He gave the orders.
They dropped the bombs.

WAR DEAD—*a prose poem*

—for Dickovicky,
Vietnam Vet, lover of poetry, and friend
on many of the happy backroads of my Berkeley days

Imagine two flocks of white doves released like colorful balloons at a ceremony's end. The doves take off up into the bright morning air, but then remain by some tragic mistake tethered to the ground. Repeatedly, the birds fly up towards the blue skies, but then fall back just as quickly to the earth in a sudden tug of violence. Most of the people present, perhaps because of their own grief, because of their own great personal loss, seem somehow unaware of this suffering of the doves. Just so, at the end of this wall, remain two questions which the heart releases, and which flail helplessly about in need of some resolution, some serious, believable, answer: Where are the other names, the names we cannot pronounce, the names that would have increased at least five-fold the wall's already tremendous, horrible, terrible length? And will this be the last such wall, the last such war, or shall we repeat again, and then again, the same wholly unnecessary, brutal, mistake of making more of such wars, and of such walls?

At the end of the wall remain two questions, questions a child might ask that the heart releases, and which flail about in need of some resolution, some serious, believable, answer.

The Little Clavier: Part XIX

How complicated the ways
we wander once Truth is lost;

how unnecessary the wars,
how without meaning—
the waste.

$5.00

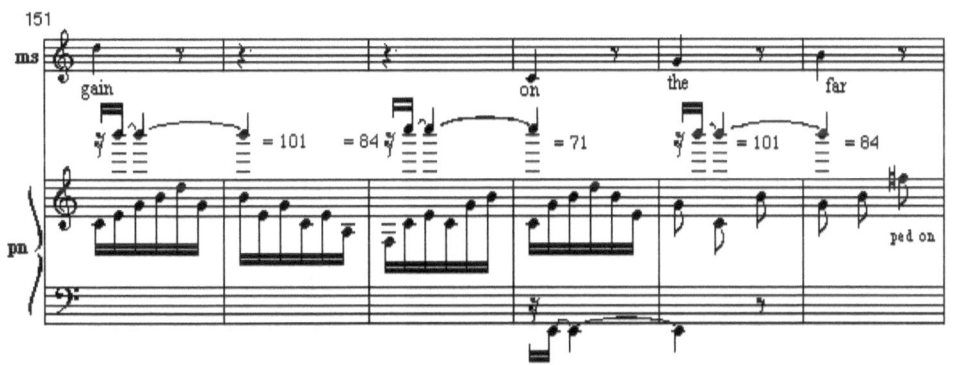
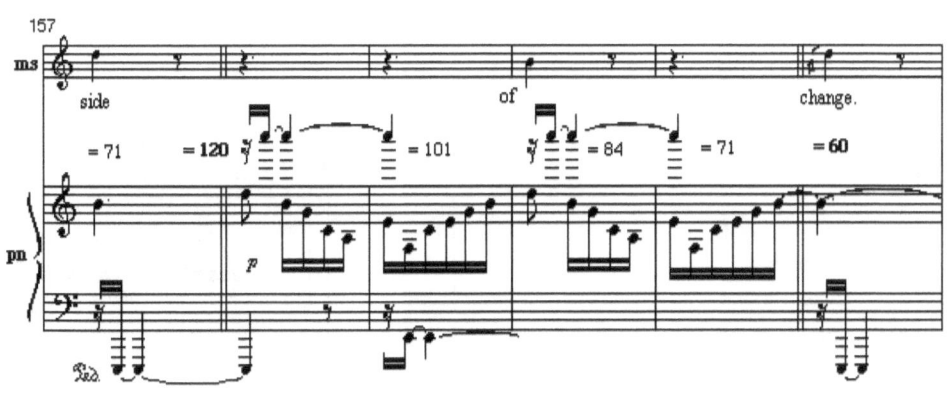
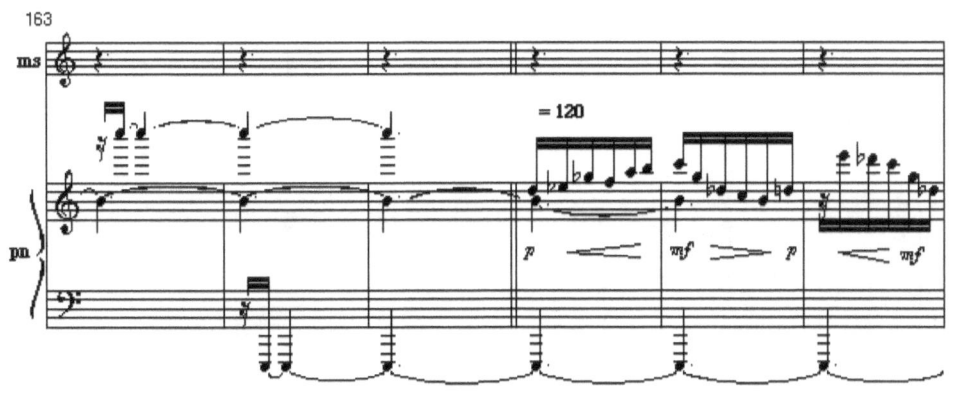

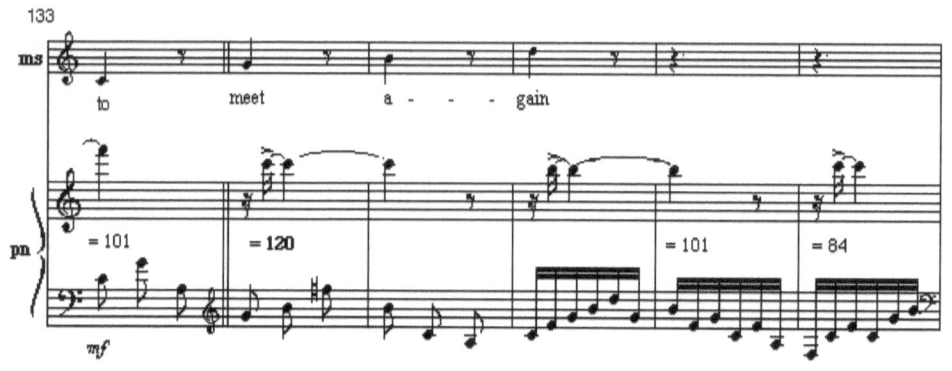
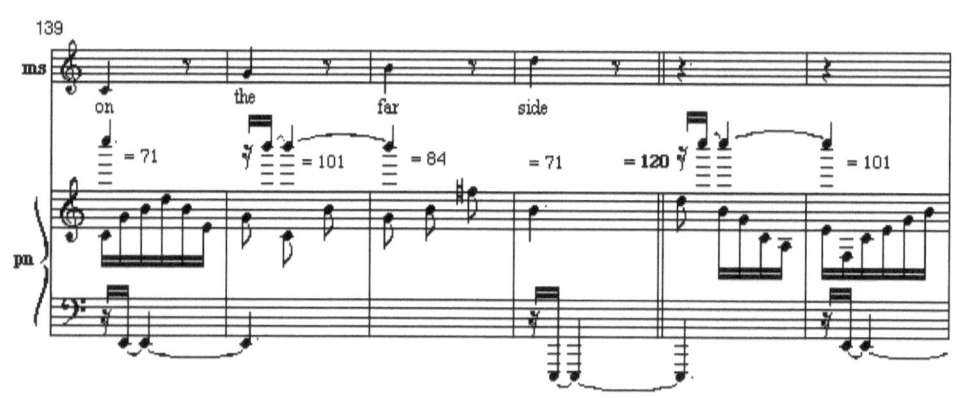
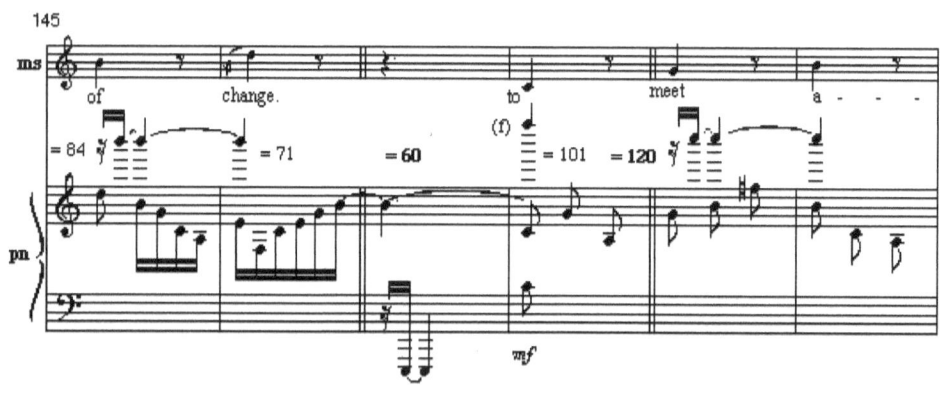

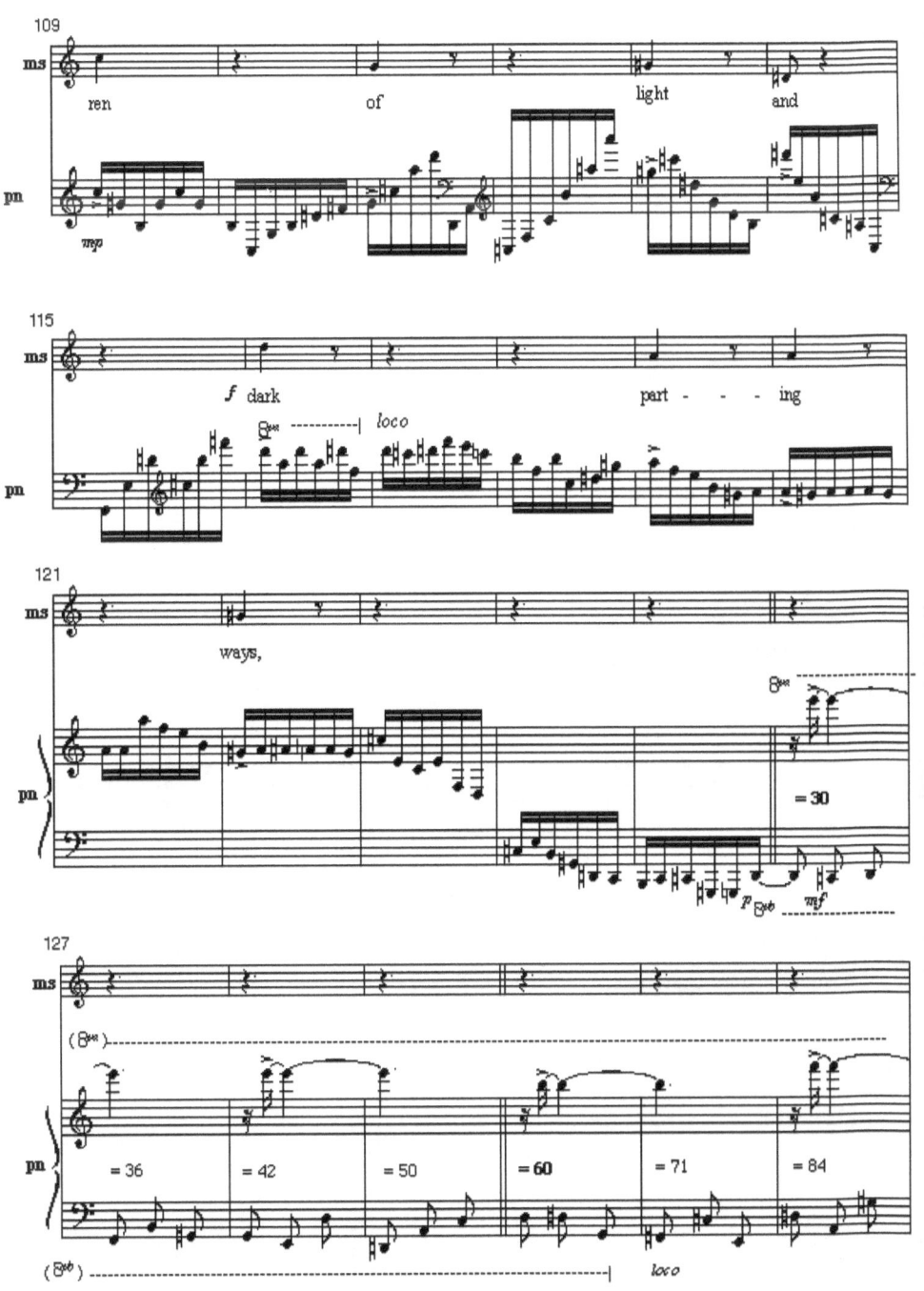

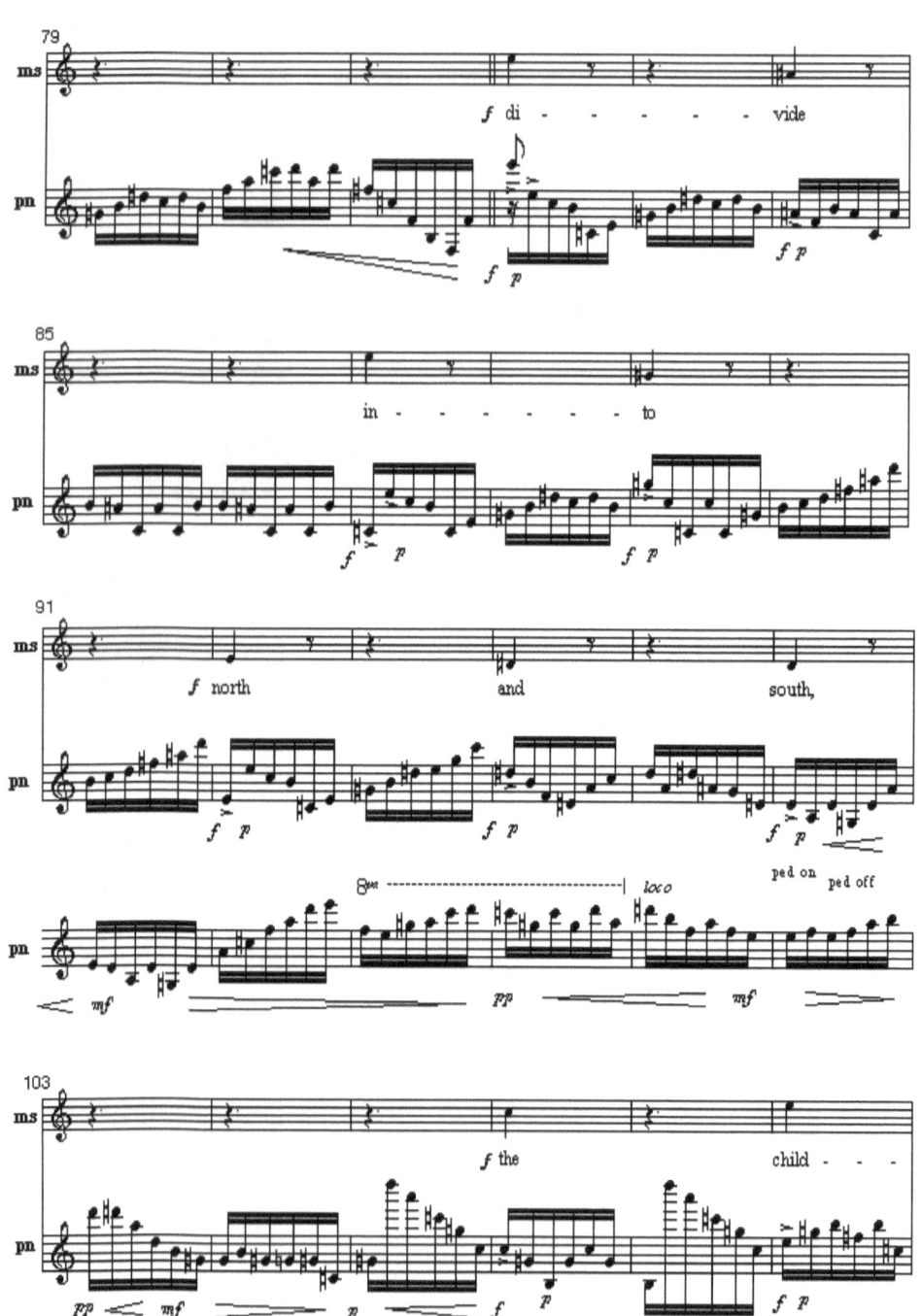

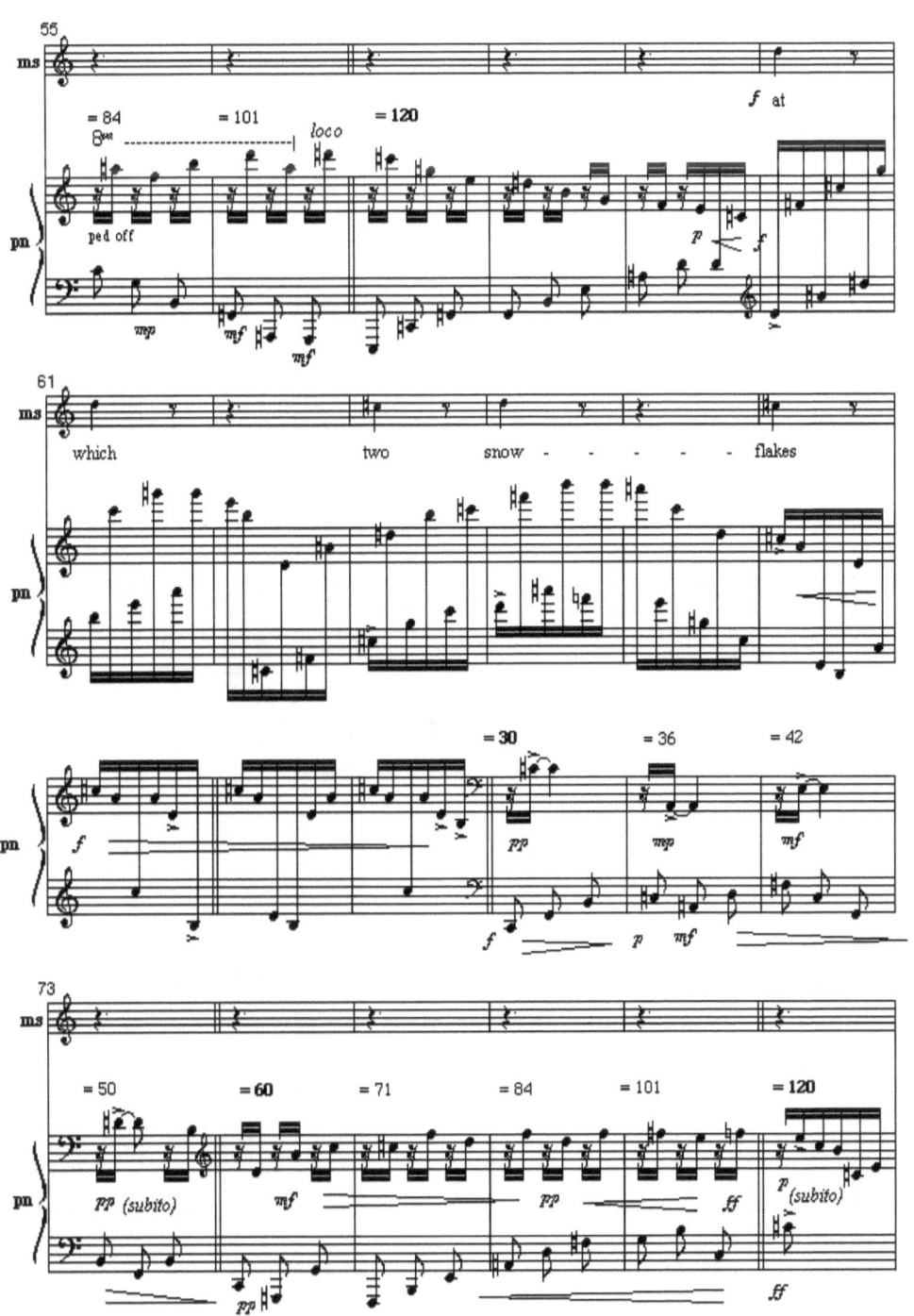

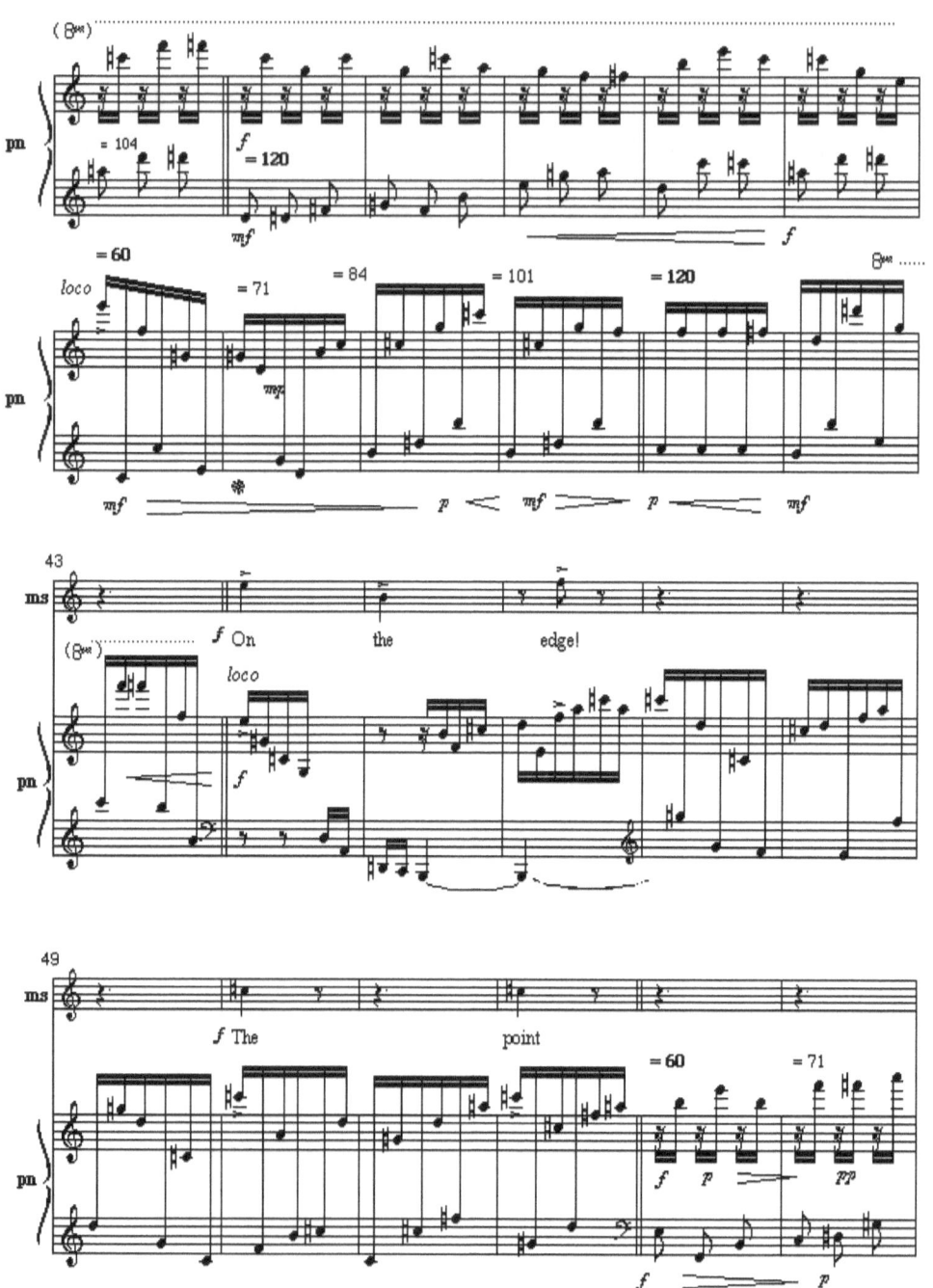

X: *On the edge!*

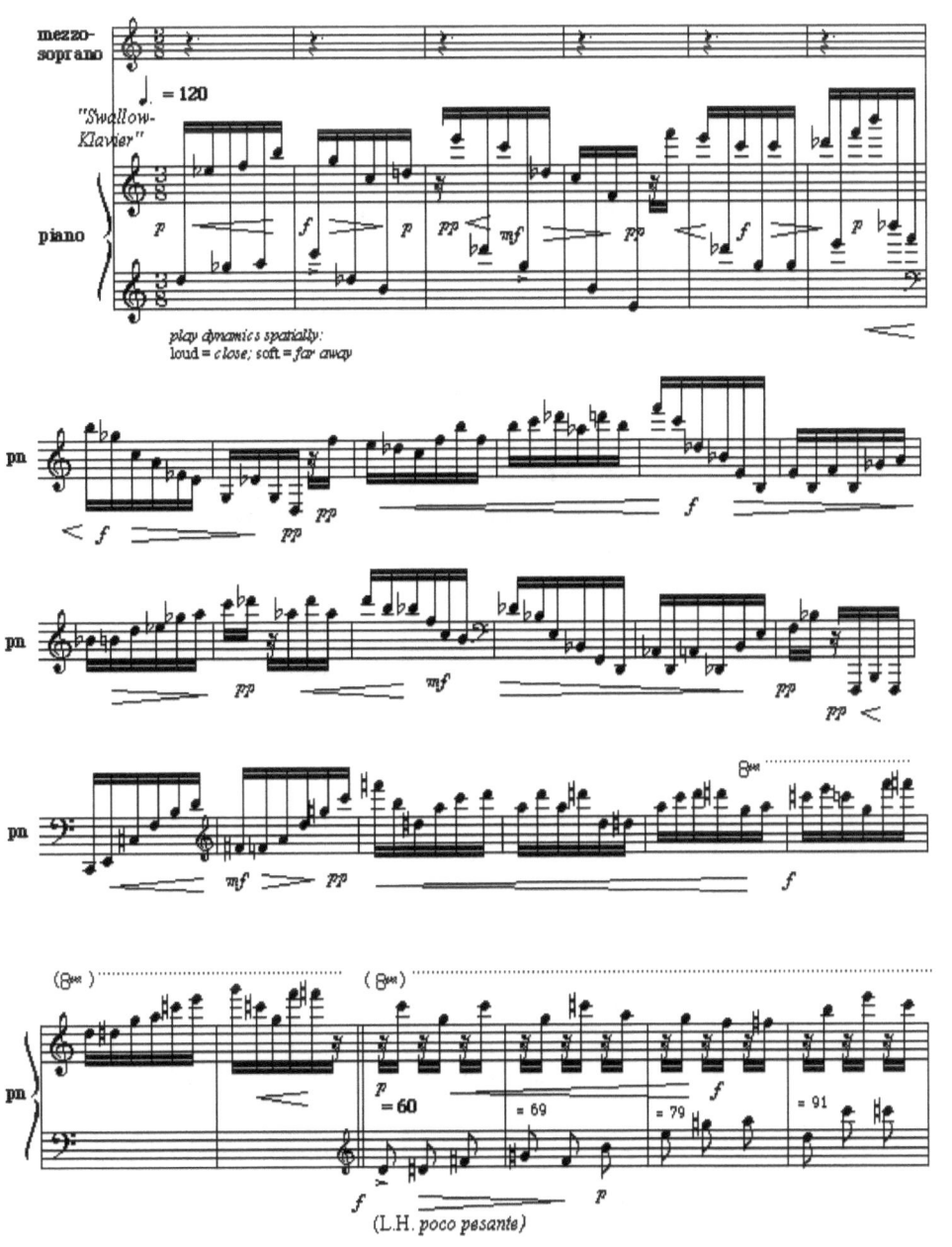

(xiii)

Coming down, a rain
drop runs the south edge of a ridge,
the grain of a slope offering

countless ways

of becoming a
stream, of flowing then returning.

(xiv)

The further down, the
more limited things become: a
self-spun traceless thread feels its way

to well-worn

paths, to jeep-trails, to
the hard concrete used every day.

(xv)

A day rises on
smoke and ash, eyes searching for whirl-
pool galaxies, sounds of water

and rock. Thoughts

turn, wither and dry,
feeding night-fires no one sees.

(x)

On the edge! The point
at which two snowflakes divide in-
to north and south, the children of

light and dark

parting ways, to meet
again on the far side of change.

(xi)

Sight! So utterly
limited, incapable of
focusing on two eyes at once,

of looking

out on the whole of
north and south, grasping it as one.

(xii)

Returning! Would it
be possible at all without
the distant green of the forest,

without the

steady rise and fall
of wind and rocks, of trees and snow.

(vii)

Through windflowers filled
with a harp's gentle praise, stepping
out onto scree and misty snow.

Total white...

the s o u n d of metal-
on-ice the only moving thing.

(viii)

A pathless passage
through the daytime boreal night,
through downhill winds which give no rest.

A darkness

so complete that ech-
oes crack and rocks fa l l forever.

(ix)

Moving on rhythm,
not time, neither up nor down but
boots and breath, the idea of south

pressing down

bursts as the body
stops and the earth lets go at last.

(iv)

Walking light, heading
south over a high mountain pass,
a pack heavy with simple things.

The rise and

fall of trees and snow,
a cycle spinning new each turn.

(v)

The high sheltered space
of a spruce forest dissolves in-
to low knotty shrubs, tangled with

the light of

a thousand moons -- the
patience which lives i n s i d e thin air.

(vi)

The north-facing slopes
of the arduous life, where snow goes
to hide from the spring plants, who, after

long months of

snowy inwardness,
are ablaze with pinks and wild blues.

(i)

Night-fire watch turns
to sleep, the soft glow of thoughts rolled
out on beds of feather and rock.

The arms of

whirling stars reach down,
a day rises on smoke and ash.

(ii)

The afternoon river's
roar now the gentle murmur of
dawn, a chorus of dreaming fish

sings of schools

of birch leaves soaring
straight out of the she-goat's milky eyes.

(iii)

Waking in wonder,
the darkness of the valley floor
stares breathless at the peak's rosy

blush, the face

of a mother play-
ing mad and a child feigning sleep.

RIDGE CROSSING—
a set of fifteen
37-step poems
in five *sets of* three

 Sometimes, a poem wanders about the world
 in search of its proper place
 and hour.

 To learn it lovingly by heart is
 to walk with it;

 To offer it freely to another
 is perhaps to bring
 it home.

[The *Ridge Crossing* poem cycle forms the basis of a composition for Mezzo soprano and piano. (q.v. score for *"Swallow Clavier"* **movement X** below)]

ON THE SOUND OF WHITE-WATER RUSHING—
an appreciation

Just as the smell of freshly cut hay or just turned garden soil seems to contain all other smells, so also the high sparkling sound of rushing water seems to hold all other sounds.

The sound of the wooden flute, the violin and oboe is there. And the trumpet and the human voice. Or the deep sound of skin drums, and strings of tiny metal bells. All are held, it seems to me, in this mysterious rushing sound of flowing mountain water.

Perhaps that is why we sleep so peacefully in the sonic embrace of an alpine stream. No other sound has such deep roots in our own natural history's story. Indeed, how could this be otherwise? For where there is clear flowing water, *there* there is security of the very most basic kind.

The sound is whispering, as it were, a soothing reminder to someplace deep in our common unconscious, that like love itself, where there is water, life flourishes.

TWO PATHS

> *"It is no longer the choice between violence*
> *and non-violence in this world;*
> *it's non-violence or non-existence."*
> from Dr. Martin Luther King, Jr.'s last major address,
> April 3rd, 1968, *"I Have Been to the Mountain Top."*

One of the most persistent illusions of human consciousness is that it is possible to come to peace by way of war. It is the tacit assumption of this thought that conflict is inescapable—an idea that is largely hidden under the surface of awareness, yet actively shapes our perception and actions—that itself leads us to incessantly prepare for war. Yet, preparing for war is not like preparing for fire, or for a hurricane. In contrast to the prudent readying for the inevitability of natural disaster, preparing for war has become itself a primary cause of war.

There are evidently only but two alternative paths: One follows the drumbeat of leaders so lost that they are marching us straight off the precipice of non-existence; The other path is the still largely untried, and unknown path of peace.

Nowhere do these two paths cross; Nowhere do they meet.

The great and historic challenge before us, both individually and collectively, is the demonstration of the necessity of this truth.

will be the protest on the home front by citizens—especially those who do not benefit from the spoils of empire or who feel that it is morally unjust—demanding more open and less corrupt representative governance. At the same time, liberation struggles in the physically far away but in terms of modern information technologies right in your living room resource colonies will resist, as they always have, all suppression and exploitation.

So, regardless of which face is put on for public display, Democratic Empire must necessarily collapse because of its contradictory nature. It did in the Greece of Athens. It did in the Rome of Julius Caesar. It nearly did in the Great Britain of Winston Churchill. And now, in the North America of Mr. Obama?

Contradictions, as any naturalist knows, are non-renewable.

Contradictions, because they are in essence conflicting movements of energy fighting against one another—can only be kept alive by massive artificial inputs of energy from outside the system. And these in turn can only be obtained by equally massive amounts of waste and use of force. Not a pretty picture, not a pretty face, indeed.

THE TWO FACES OF EMPIRE

> *Oderint dum metuant*
> Seneca

Sometimes, Empire puts on a happy, cheerful face as it takes what it wants from you, all the while promising you peace and protection, and giving you a solid silver medal stamped with a President's image.

Other times, Empire puts on a more straight forward, mean and ugly face which projects military power and a willingness to use it. Like the Romans said, and the epigram above has it, *"Let them hate, as long as they fear."*

For those peoples who are suppressed and exploited, which face, say, an American president puts on makes very little difference. Democrats, for example, seem to prefer the cheerful face, whereas Republicans evidently tend towards the mean and ugly. The real question, however, is not the face which is used, which after all is merely a projection. The real question is rather how much longer the violence of Empire can continue to wear the cloak of Democracy. For this is a hybrid, contradictory form of government if ever there were one, a form of government which should for reasons of clarity be called exactly what it is: *Democratic Empire.* Democratic Empire is contradictory because, on the one hand, it is based on the hard-won constitutional principles of equality, freedom and civil rights, while on the other it requires massive forms of exploitation and economic slavery beyond its visible boundaries to sustain itself. Democratic Empire will therefore necessarily be threatened with collapse on two fronts simultaneously. There

Douglas-fir, Subalpine Fir and Englemann Spruce, and the little rain and searing summer heat endured by Juniper and Sage.

One must have an ear for the origin of words to hear consciously the adjectives, 'massive' or 'ponderous' in the Ponderosa's name. And one must have more than a keen sense of forest history to imagine the prodigious giants lost to bandsaws and trains. Trains? Yes, in Northeastern Oregon, whole tracks were built for the sole purpose of carrying the trees away. In the North Wallowas, already by 1926, few of the grand old ponderosas were left, and the tracks constructed for their wholesale plunder from Minam to Enterprise are now but a footnote for Sunday tourists. And as with all natural destruction, who is left with first-hand, direct experience to speak to the children about the grandeur that has been lost? Field biologists will tell you that it is now difficult to find suitable stands of old-growth ponderosa—reduced in a mere three of four generations to but 3% of their former area—simply for study and comparison purposes

I frequently remind myself, speaking with Chinese poet, *"If one wants to know the ponderosa, go to the ponderosa."* And sacred ground it is. No better place to camp. No better place to build a home. And no better place to discover a new creative spirit which takes as its epithet not 'man the destroyer,' but 'man the creator,' the generator of new habitats for the whole web of the symphony of life.

ON THE PROTECTION OF TREES

"What a friend we have in a tree."
Wangari Maathai

Unlike the European Alps, in which the environmental factors of high altitude, cold and snow limit the growth of coniferous trees and forests, in the East-side mountains of the American Northwest an additional factor plays a key role at lower elevations—namely, drought. For the large and graceful and beautiful trees that are native there, the lack of reliable yearly amounts of precipitation is just as severely a limiting factor as the deep snowpack that lingers well into the summer months.

Accordingly, I've come to see the great forests of fir, spruce and pine not so much as static masses of green, but rather as a kind of dynamic, living movement. The movement is suspended, like a question on a string, between these two limiting extremes of altitude and drought. With different amounts of snowfall and rain, or higher or lower mean temperatures, the forest will respond by moving up, or down, the mountain; and by expanding or contracting into or away from the dry plains and arid canyonlands.

In the middle of this movement, it seems to me, stands the great Ponderosa Pine. It is the yellow-green ribbon of the arboretum's rainbow spectrum in the Oregon forestlands; it is the middle C of the forest's frequency scale, the strong, stable triangle between geometry's circle and square. Where the ponderosa forms large stands, it takes the happy middle ground between the colder, more moist preferred habitats of

instantly, for it is essentially how the young mind innately engages the world.

So, in a way, the twin guideposts of Yoga and AT serve to strengthen, nurture and protect gifts which, by their very nature, are already implicitly there, waiting as it were just under the surface, and ready to be developed and fully awakened.

THE THREE MISTAKES OF EDUCATION

The first mistake in education is to separate learning from
the body of the Earth;

The second mistake in education is to separate learning from
the body of the student;

The third and most serious mistake in education is to separate learning from the nature of the mind which learns.

To learn is to learn the numbers, the flowers, to sing and dance, and most importantly, to learn—by life-long observation—the nature and the formative workings of the mind itself as it learns to learn.

ON THE TWIN GUIDEPOSTS OF *YOGA* & *THE ALEXANDER TECHNIQUE*

A mistake is a mistake repeated.

In this sketch, I'd like to suggest that the twin guideposts of all learning and education are *Yoga* and *The Alexander Technique*. Yoga is in this view much more than simply doing daily exercises or stretches, but is also the life-long practice of learning to work and move and do things, important things like learning itself, *without force*. And The Alexander Technique (AT) forms the complementary life-long practice of learning to work and move and do things *without unnecessary tension*.

So we have movement *without force,* and we have movement without *unnecessary tension.*

Together as one, the twin guideposts of Yoga and AT form a kind of path, a path of awareness. What we become aware of is essentially waste, the waste of intelligence, and the waste of physical energy when unnecessary force and tension are used to accomplish ends or goals, in whatever form, at whatever level.

The twin guideposts of Yoga and AT also point us clearly in the direction of an implied constellation of ethical and aesthetic criteria. To do things—whether writing at a table, working at a computer keyboard, or learning the flute or violin—without unnecessary force and tension *is always good;* it is also always beautiful. Children, I think, sense this

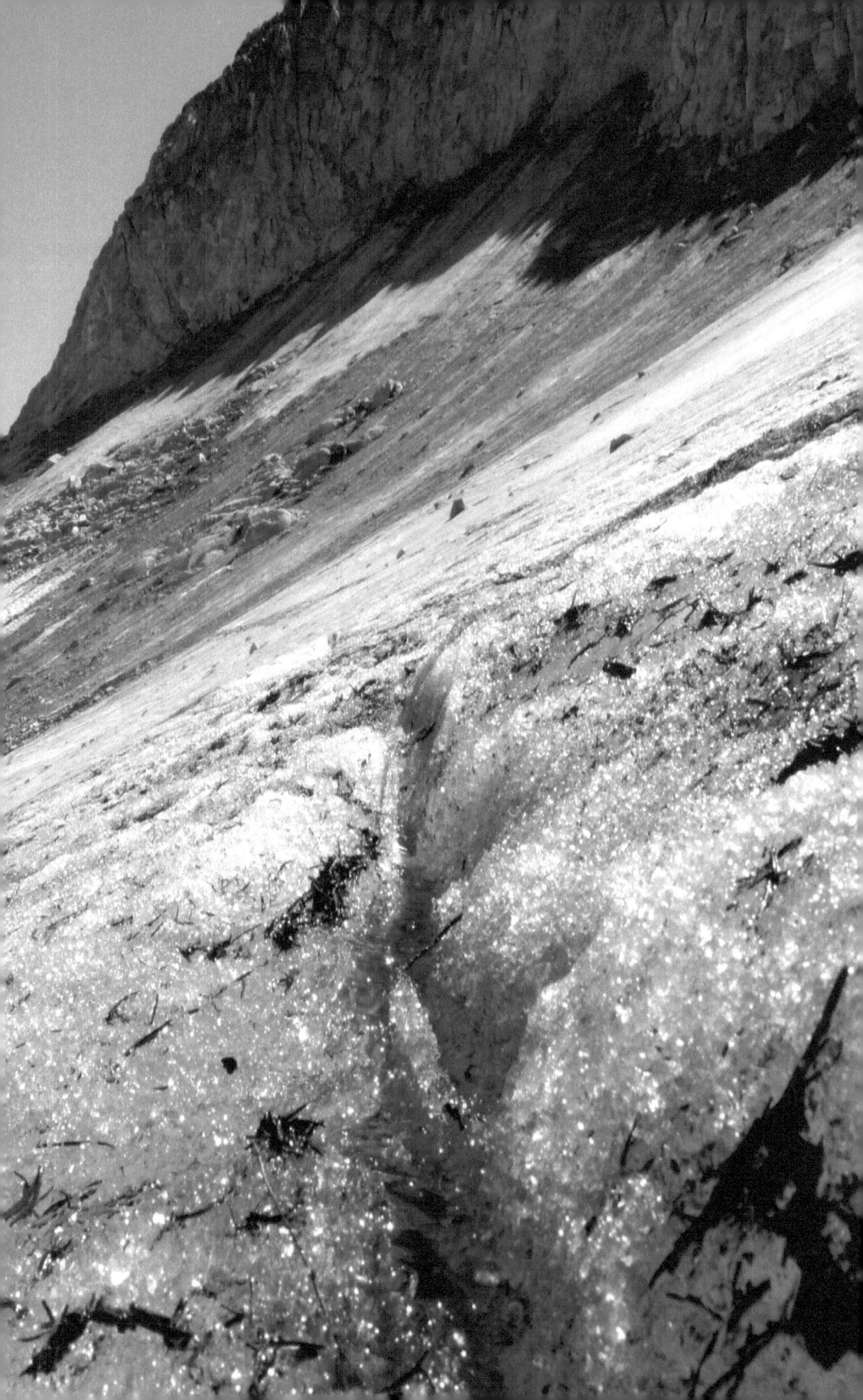

filth of the world. All because of an idea, a new way of seeing, that happens to be true.

* According to Charles Moore, the discoverer of The Great Pacific Garbage Patch, "Plastics, like diamonds, are forever." On average, each person on the planet throws away 50 kilos of plastic a year; And amazingly, about half a trillion [sic] plastic bags are produced each year.]

OUT OF TUNE

As the harmony between Nature and Culture, between Law and Convention, collapses into contradiction, there will be a parallel loss of the sensitivity of perception required to see the corruption. The result is a devil's loop of mutually reinforcing devolution and degeneration. This is dangerous because, once the downward spiral begins, it becomes increasingly difficult just to see it, let alone stop it. Witness in the present era the loss of excellence in matters of musical culture. Here we see clearly that the inability to sing or play in tune goes hand in hand with the preference for louder and louder, and less and less subtle, sounds. Perhaps it could be said that the penultimate phase of degeneration is when we sing out of tune and no longer hear it. The last, is when we no longer care.

THE REAL THING

Real passion, real inspiration, cannot be imitated.
That is why we imitate them.

[Photo: Benson Icefield, Eagle Cap Wilderness, black condensates from particulate pollution. These greatly accelerates melting of glacier ice worldwide.]

There is logical beauty in this because we have before us a clear reflection of where we have gone wrong. Pollution is telling us in its own way where mistakes in design need to be corrected. And as part of the natural system ourselves, this is indeed what we would do—that is, correct our mistakes—as long as there is nothing blocking us from doing so.

This is easy to test for yourself. Consider this: it is a fact that plastic shopping bags are wrecking havoc with the water cycles of the world. For example, the area that has become known as *The Great Pacific Garbage Patch,* a vast surface whirlpool of plastic-based trash between the west coast of the United States and Hawaii and now covering an area the size of Texas, is full of these ubiquitous white items of convenience. Ugly, yes. Harmful, doubtless, I think all would agree. I would also argue that it is *unethical,* unethical in the most direct, straightforward way because the facts show clearly a failure to take into account the harmful wider-context consequences of our actions. This is especially so because white shopping bags are in no way necessities; they are merely a habit of convenience and could easily be replaced. Here, it would also be reasonable to suggest that, like all activities that are by consensus found to be harmful to the common good, the bags should naturally be prohibited, as is already the case in many places from China to San Francisco.

The sport of philosophers is to watch meaning change. Just as rooftops without gardens or banks of solar panels are beginning to look like a great opportunity lost, and vehicles which still have exhaust pipes are morphing into ill-designed instruments of mindless waste, artifacts like white plastic bags have for many already shifted in meaning from the once stalwart icon of clean consumer convenience to the needless foul

POLLUTION, WHOLENESS & THE PLASTIC BAG *

—for Thorny & Dorothy, my friends at the Eagle Valley Hitchin' Post

In a way, it is possible to say that the pollution of the Earth, especially at the extraordinary and massive scale at which it is now taking place, is only possible because of a radical fragmentation of our thought and perception.

It's interesting that pollution is not an end in itself. In other words, pollution is not something we do deliberately, but is rather almost entirely a result of the unwanted side-effects of everyday actions and habits. Because pollution is not an end in itself, or goal, it is therefore very easy to, as the apt figure of speech has it, "put out of mind." In other words, we focus with laser-like precision on some goal, like making a computer, or powering a car, while ignoring the pollution factor or the ratio of kilograms of toxic waste which results from each kilo of product produced. Again, my contention is that this denial of such highly relevant facts is only possible with an equally highly fragmented manner of perception.

From the philosophical point of view, what's interesting about pollution, is that it does not simply go away because we for whatever reason avoid thinking about it. In fact, this is precisely why pollution is so revealing: it is because of the very wholeness of the natural systems of the Earth that pollution—like it or not—comes round as a kind of highly unflattering mirror of our own fragmentary styles of thinking.

The Little Clavier: Part XVIII

A free economy is a strictly limited one.

Even the busiest of thoroughfares still retains
a thin white line, protecting the rights of those
of us who prefer to walk.

<p align="center">* * *</p>

Change is the second most difficult thing,
understanding—the first.

(iii)

Mirrors made of sound,
piano-forte of the mind,
sets of celestial strings that

resonate

with life's sympathy.
O sound of the soul, eternal.

MIRRORS OF LIGHT & SOUND—

three 37-step sounds

(i)

High walls of contrast,
flat surface of an alpine lake, giving
back wind and clouds, bright moon and faint

planets and

stars. Mind of Earth, eye
that rejects none, and accepts all.

(ii)

Flat, even surface
of neutrality, water reflects,
receives, both a god's self-love,

and the thoughts

of humble fishes
caught in the swirl of a moth's wings.

ON THE NECESSARY WISDOM OF ELDERS

Sudden change even a child can see. It is the slow, hard to perceive changes that require the experienced eye and acquired wisdom of the elder.

A wise eye may see that a certain bird species fails to return in spring; it may see when a new species of weed pulls into town and sets up shop; or when a small stream or creek runs dry in August, whereas a decade ago it still delivered reliable water for crops until the fresh new rains of fall.

The scientist studies, gets paid, and walks away. But the wisdom of the elder by its very nature stays put, and like a tree with deep roots, is more likely to stand its ground and protect the land of which it is a part.

One of the first lessons of the young should be the need to safeguard this wisdom of elders, for that is what in turn safeguards their own future, and their children's future. Likewise, one of the tasks of the older generation is not to get stuck in the tight jeans purchased from the cute teenager at the big-city mall. It must learn again to move proudly with, like the dignified ridge-top stonepine that has seen perhaps a thousand winters or more, the slower, deeper, and much more resonant drum beat of wisdom and great age.

ON THE MASCULINE ENERGY OF CONTROL

> *Once the balance of masculine and feminine principles is lost, mere competition between the genders will replace complementarity.*

There's something about the decidedly masculine energy of control that loves the crisp, clear, straight lines of a laser's or bullet's trajectory. Think of it:—*straight* walls, *straight* pipes, *straight* roads, *straight* dams.

Pity the time when we no longer cry out that life is not only a matter of the shortest, most efficient route between points *a* and *b,* but that there is more, and that life is from another perspective—the eternally feminine—essentially round.

Pity the time *when time itself* is seen not just an arrow flying fast and furious to its goal, but also a mysterious, rhythmic pulse of wheels turning within wheels which comes round with the miracle of each new birth.

Pity the time when we acquiesce in our silence and become at once both imitator and victim of this powerful, but oh-so-one-sided straight-line universe of men in love with the illusion of mechanical control.

when the fundamental is for example for whatever reason absent, re-generate a new ground tone. Within the classical music tradition, this re-generation principle was used in the Baroque era, especially in the Italy of Stradavari and Vivaldi to great effect. And then nearly two centuries later once again by the French-American composer Edgar Varèse, but now to create totally unique, vibrantly alive, sound complexes.

My conjecture, again here very briefly, is that this hologarchic principle of mutual co-generation of part and whole, may be very much more common in the natural world than we at present realize.

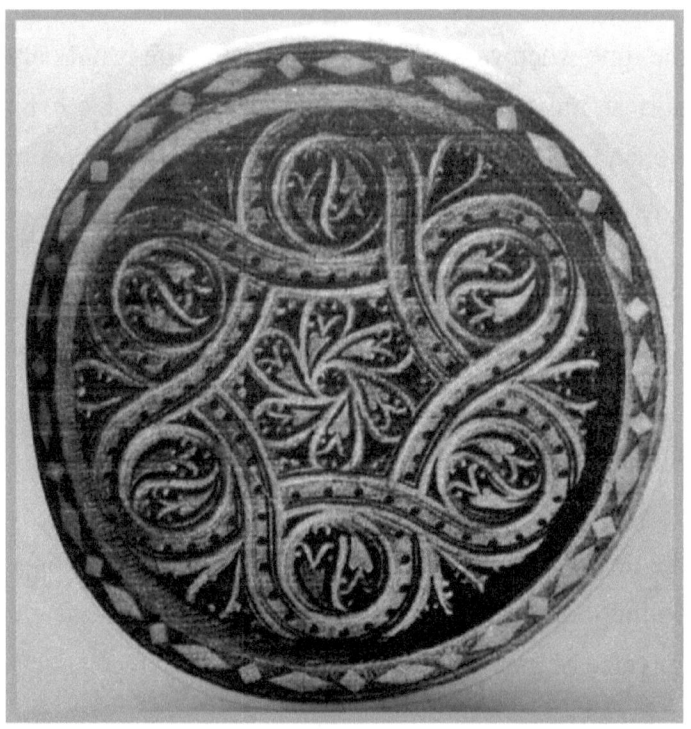

[Image: A hand-carved lute filigree, *Antonio Stradavari* 1644 - 1737]

ON HOLOGARCHY—*the order of the whole*

Hologarchy is the mutual or co-generation of whole and parts. With hologarchy, both whole and parts share in a kind of co-relative equal importance in the distribution of generative intelligence.

This is, of course, in marked contrast to the idea of *hierarchy*, or how we normally conceive of organizational structure as an ascending ladder of importance or rank. Higher is more; lower is less. Higher or lower of x, of whatever—power, control, information, money, or all of these.

Hierarchy we see as a kind of directional flow of order and importance from the top to the bottom, as in classic military or corporate structure. Or as a somewhat weaker and less common alternative, there is also the more "grass roots" interpretation of the flow of order in hierarchy, from *the bottom up*.

In contrast, what is unique about what I'm calling hologarchy is the generative flow of order both *from the bottom up*, and *the top down*, at the same time. The model or paradigm I always like to keep in mind—that is, actually hear—is that of acoustic harmonic sound. Briefly, with a harmonic series, the ground tone or fundamental generates the higher harmonics or overtones, while at the same time these harmonics or overtones come round by means of difference tones to re-enforce, or,

THIS MORNING

This morning
I awoke in total darkness
sleeping on five feet of snow.

Ah, hot coffee made
of crystals of ice!

Before first light, the sound
of a woodpecker drumming on larch.

Right place, right time.
The 1st of March!

We've made it through
another winter.

TECHNIQUE

Everything will be practiced,
Everything will be learned,
One mistake, one discovery,
at a time.

SNOW MACHINE

Ridingwildchainsawsoverpristinenewsnow,
highpitchedgrindofthemindoftheangryyoungman,
theinyourfaceethicsofthewhocares?
ifmyfunisyourlossgetandthehelloutoftheway!

SNOW DEVILS

Spirit of the mountains,
turning round and around.
Wind North by Northwest . . .
Put the cameras away!

WINTER STORM

After every storm
comes the day of clearing.
Hope is the motionless flame
which burns quietly bright
as the winds
rage.

DECIBELS

The Chainsaw said to the Jackhammer, *"Who's making all the noise around here? The Electric Bass or the Drums?*

Tolerance for noise? They say, a frog in a pot of water, if you turn up the heat slowly enough, will let itself be boiled.

SIMPLICITY

In *Politics*, the most radical idea is *simplicity*;

In *Art*, the most difficult idea is *simplicity*;

In *Science*, the most necessary idea is *simplicity*;

In *Religion*, the most mysterious, arduous, complex idea—is *simplicity*.

OPERA BUFFA

The Frog said to the Toad, *"They're boiling us again in Washington."* *"Ya,"* answered the Toad. *"They say a politician will let himself be burned alive if you keep throwing enough cash into his re-election fire!"*

MACHINE INTELLIGENCE

The Crow asked the Squirrel, *"Can Computers think?"* And the Squirrel said—

"Just as airplanes can fly!"

AGAINST *STURM & DRANG*

Beat-up inside teutonic kettle drums,
the much-will-have-more of self-expression
lays waste to the wilderness of the Ear,
banging away at the bars of crazy codas that
find no way to inflict the final blow.

Repeat. Repeat. Repeat. The orchestra of a
thousand marches across past battlefields
still hazy with the smoke of holy cannon roar.

Yet see:—a truce has been called:
Waves of water write signs upon the white sand.
The Song Thrushes have arrived again from the south,
and at any moment may speak
to the stars of the clear northern skies.

MEMORY IS SPATIAL

We shape the world and the world shapes us.

Arrange the objects you use every day in a clear spatial array and you'll never have to think of where to find them. The hand simply moves to the left, or to the right, and picks up your book and writing pen, without giving it a second thought. Indeed, this is perhaps one of the more important meanings of "second nature." The objects and tools and artifacts we work with become easily and naturally extensions of ourselves. This should be a guiding principle of digital design: finding things should never be *self-consciously visual,* but rather *unconsciously spatial.* We shouldn't have to think about the tools that help us think.

IN PRAISE OF ZIPPERS

Be honest. Hand-on-heart: How many zippers do you own? I would guess, that if you're anything like me, they are many, very many. I tried counting mine the other day, but gave up. And then, there's the problem of how a zipper works. I mean, really works. I would guess that, again if you're anything like me, you don't have a clue. To be honest, I don't even know how a zipper breaks. But when it does, I can tell you, *that much* I know for sure. Zip open, zip shut. Big zippers, long zippers, tiny and short. Inside protected from outside, but without all the bother of lock and key. Zippers are private, always close to your flesh, your body. Zippers hide a secret, at least that's my theory. That we know that we don't know how they work. The secret lets us act for all the world as if we did.

TREE OF WISDOM

We shape the world and the world shapes us.

If Religion and Metaphysics are to mean anything, they should help us age and grow older not merely as an ever-larger and more burdensome collection of broken physical parts, but rather with the slowly increasing wisdom of a tree, a tree which has seen and holds the complexity of the centuries with its ever-clearer, ever-more mature and beautiful, spiritual form.

WATERCOURSE WAY

We shape the world and the world shapes us.

Balance in Art follows the natural movements of water and weather. Fast mountain streams give way to the slow, supple curves of lowland rivers, and the broad expanses of the sea. Dark, cold rains are followed by bright skies and the happy warmth of the sun.

Balance is never either/or, but rather the course which runs between extremes. The culture which has lost direct contact with these movements of the symphony of life will also necessarily lose its sense of balance and measure in its Art.

·

RUNAWAY DECEPTIONS ...

A runaway deception is a false, or negative, idea which is put into a *positive feedback loop,* much like a microphone feeding back on itself and wildly amplifying its own sound.

Runaway deceptions as ideas tend to be self-reinforcing. Once you have the idea that, for instance, all Arabs are terrorists, just the earthy, guttural sound of their language, which few in the West feel any sympathy for, let alone speak fluently or understand, is enough to trigger fear and hate and violence. And when we approach the world with such fear and hate and violence, the world will most likely answer us in kind, thereby wrapping round itself and giving still more energy to the deception.

In this way, runaway deceptions also tend to be self-destructive. In their extreme, fundamentalist form, the survival of the false idea of the deception itself—that it should prevail—may very well become more important than one's own survival.

Runaway deception, indeed.

SCIENCE. ART. RELIGION.

Science begins with the willingness to drop a theory when it is contradicted by fact.

Art begins with the willingness to tear down a museum or concert hall and put up a new one when they no longer fit what we see as meaningful or beautiful.

Religion begins when we are willing to drop rigid belief and claims to absolute authority because we have seen that these are the very source of the barriers that divide us.

Attempting to unite Science, Art and Religion in their present state of disarray, however, would be certain folly. It would most surely result in questionable hybrids, like a Mozart Mass pumped up with drums and bass guitar, or a pseudo-science constructed consciously as a smokescreen for the fundamentalist conditioning of the young.

And yet the fragmentation of Science, Art and Religion corrupts the high-country springs of our collective creativity. Better to take down the arbitrary blocks and dams that are the root cause of their present division—*one at a time* and *all at once*—and let them flow together in what for us now are wholly unknown ways .

DOUBLE BIND

Our troubled relationship with the Earth?
God wrote the music.
The *Devil* conducts.
And don't forget:
Everyone must play in the Symphony of Life.
The contract says, *"forever."*
So we push our buttons, hit our drums,
and stroke our strings,
all at his command.
Remember: Everyone must play.
The contract says, *"forever."*
He reminds us, *"Poor child. There's no*
way in Hell you could live without the results."
And we believe him.

to take possession of our souls. They do this by conditioning our likes and dislikes. Consider that by the time the average student arrives at a North American university, he or she will have seen a solid 12,000 hours of commercial television. Extraordinary, by any standard.

These new instruments of control thereby gain great influence over how we vote, how we spend our money, and how and what we believe is true and important. And this they have done with amazing success.

If you think this exaggeration, imagine this tableau: put a young person from China, India, Japan, Australia, North or South America, or Europe on a forest path anywhere in the world. Remarkably, they will in a nearly identical way look wholly out-of-place. Their movements will all seem to emerge from one simple, common, programmed language. These movements say, *"Hey, dude! I speak MTV! Get out of the way."* A revolt of youth? Quite doubtful. Personally, I wish it were. But that would require I think at the very outset the inspired austerity of *doing without,* of throwing away the keys to the car, tearing up every logo in sight, swearing off trash food forever, and smashing your CD's and lining up for execution in the backyard your TV. Perhaps the most endangered species of the Western world has become the free spirit, the young or old person—age makes no difference here—who can think, see and act with intellectual integrity and independence.

I say to you, to outfit oneself in style for the coming peaceful, inward revolution, one need not buy a single thing. Now imagine that!

Remarkably, in this sense, complicatedness in Nature does not exist, because it wastes energy, and therefore contradicts Nature's economy of the watercourse way.

(4) Just as water flows around all obstacles, intelligence naturally moves to resolve all unnecessary difficulties. Poor design imposes arbitrary blocks or limits to the freedom of this flow.

TWO MINIATURES ON RELATIONSHIP

(1) Some people make us smart; others, make us dumb. Some people make us happy; others, make us sad. If dialogue and compassion form two sides of the triangle of friendship, then *encouragement*, or the mutual generation of the creative energy that makes real change and discovery possible, might be the third. This is how the world becomes a better place, two people at a time.

(2) Have you ever thought about why the world of Nature no longer informs or shapes our manner of movement or dress? Or why, in a more general way, contemporary culture no longer seems shaped or informed by a fertile interaction of human creativity and place? Is this not in part because of a kind of not physical, but rather *spiritual*, colonization? In the past, the colonization of the mind practiced by organized imperial religions wanted us to believe *this* or *that* primarily as a means of spiritual dominion and control (The actual details of content are in my view irrelevant.). Now, the instruments of commerce, corporations, governments, and, yes, once again—religion—all wish in similar ways

happen. It just did. Think of it. Noise, like other forms of pollution, is entirely a by-product, a side-effect. And yet it has become a dominant factor of much of urban and even rural life. What kind of philosophy of design is that?

FOUR MINIATURES ON FORM

(1) A melody, or a phrase in a poem, is not built up of parts like a wall is built up of bricks. Fold into fold, the parts reflect and refer to the whole, while the whole in turn gives structure and order to the parts. It is the quality of the movement of the whole that is primary. Vitally important is that this movement can only partially be seen or studied on the printed score or page.

(2) Form—whether that of a musical composition, or a poem, a ribbon of water, or of a flower—emerges out of movement; it is the outward envelope of the rhythmic pulse of change.

(3) *Complicatedness* is difficulty which serves no purpose and is therefore without reason or meaning; it is difficulty which is unnecessary. Nothing else defeats the mind more quickly than having to deal, on a day-to-day basis, with unnecessary difficulty which goes unresolved. In any traditionally hierarchical social structure, whether it be a school, an army, a symphonic orchestra, or large corporation, this is the single most important factor which frustrates the intelligence or creativity of the individual.

TWO MINIATURES ON PLANTS & NOISE

(1) To love the plants is to know them. To know the plants is to make them your friend. To make the plants your friend is to surround yourself with teachers as old and wise as the Earth itself.

(2) Just as no one wanted to cloud the skies with the smoky haze of accumulated car exhaust, or wanted streams to run muddy with plastic bags and human waste, no one wanted the world to become a noisy place. But noisy it is, all the same.

And, now that noise has become a part of practically every landscape—even the most isolated and highest mountain ranges have jets roaring above them—how shall we ever know what the deeper, more subtle effects of noise on the human psyche really are? Or on Nature as a whole? For the question has in a way become: where are the untouched control groups to be found? And where are we to find even a single researcher who has not been to some extent profoundly conditioned—even while still in the womb—by a sea of surrounding noise?

My guess is that noise works on the mind something like a slowly contracting air-tight room. As the noise levels increase, the walls of the room close in and the pressure builds. Finally, one finds one's face pushed up against the wall, until one can no longer hear oneself talk, or even think. An *ur*-scream of almost unbearable angst would almost certainly be the result.

Remarkably, no one designed this environment, or intended this to

THREE MINIATURES ON SEEING

(1) The greatest instrument of change is the new idea. It brings together both for the individual and the collective our hitherto scattered, diffuse and confused creative energies into one unified movement.

The new idea does not show us the details of *how*, but rather the necessity of *why*. And that makes all the difference.

(2) The interval between two tones, the shadow cast by a tree, the flashing sparkles of waves on a stream or leaves on a tree, all are not static "things," but rather movements of relationship.

Perception is always a problem of relationship.

(3) One advantage of eyes that grow weaker with age is that one sees less and less of the disturbing detail reflected in the unforgiving mirrors of physical decline. But then there's also the possibility that the mind's *inner* eye, if it learns to see more deeply into the nature of seeing itself, with such insight grows younger, brighter, and ever-more resilient with each passing day.

ments of clouds and weather. Watch how that, if you go on to write yourself, with time, much more space will begin to enter in the rhythms of your prose. And if you compose, you may soon discover for yourself the most basic of all movements in music— the back and forth of sound and silence. Listening. It's perhaps the most beautiful and primary of the arts.

(7) If we do not love what we teach, order and discipline, which naturally come from *within,* must be imposed from *without.* The result is learning spaces which are all too similar to industrial farms, with their animals chained in barns and behind fences, monocultures in tight, neat rows, harvests that fatten but do not nourish, and a soil which hungers for proper respect and care.

(8) The essence of natural learning is sympathetic love resonance. Here, a strong inward movement of intelligence awakens a similar movement in the child. When you know a path by heart and yet still discover it anew every time you walk it, the child will follow your footsteps perfectly without giving it a single thought. When you love the path you walk, the first step holds all subsequent steps, just as the first sound of a poem or a symphony holds implicitly the whole story it is about the tell. A child senses this instantly. The integrity, the craft, the truth of it. The story is passed on; the seed has been planted. And, most wonderfully— afterwards, the first thing a child wants to do is share or teach what he or she has learned to a friend. This is why the master / apprentice relationship ought to be seen as something primary and sacred, and as the central learning space of choice in all creative traditions.

EIGHT MINIATURES ON LEARNING

(1) *Schools?* A place where the gift of wonder becomes the fear of failure and exams.

(2) *Questions* open the door into the unknown, *tests* shut it.

(3) In all learning, the first thing we need to do is create a space free of fear.

(4) *Awards? Competitions?* Why do we not see that the sweet offered as a reward is the other side of the same stick of punishment? Real learning transcends the mere conditioning of pleasure and pain, and ascends to the demonstration of mastery in performance.

(5) The discipline which is imposed from *without* quickly becomes the hurt carried *within*.

(6) Reading for hours at a time narrows the mind to the stuffy confines of a room without windows. Listening, in contrast, whether *in-* or *out-of-doors,* is much more alive; it allows the eyes to roam freely about, no longer straining in a small, constricted field of vision. Listening allows for great space. And a polyphony of simultaneous, complementary movements. Don't take my word for it. Try it. Experiment. Take what your reading and record it in your own voice, or let a computer speak it for you. Then go out side to some, quiet place and listen. Watch how easily you can follow the flow of what is being said and still observe the flowers, the birds, the wind in the trees, the move-

(iii)

Behind the light that every flashlight gives is a dark story. We want to know nothing about it. It is a story of suffering, of children forced to work in the mines of Africa and South America. It is the story of Cadmium. Of Zinc, Of Lead. All leaching unchecked as we speak at our leisure, you and I, into the great and vast surface waters of the living Earth, and into the mother's milk of the still unborn. The story says: *You there,* brother; *You there,* sister. What a sad way to discover that the world is round!

(iv)

Some things we can evidently know only by demonstration. Visual inspection will not reveal to us which batteries are 'alive,' and which batteries are 'dead.' Just as mere cursory auditory inspection will not reveal to us which performer of a Bach solo sonata brings the music truly to life. They may play exactly the same notes, in the same order, in the same approximate measure and tempo. Yet, when magically the inner energy or spirit of the music comes alive, begins to breathe like a natural singing voice, we too begin to move or resonate with it sympathetically. Like Aristotle said of the gift of metaphor in poetry, this is perhaps the one thing in music that cannot be taught. But how do you know when this very subtle inner something is there? Be simple. When the 'lights' come on!

[Photo opposite: *Aster ray florets,* skyview (seen from underneath, the ground up). Asters as a family show us Nature working with the *simple* and the *complex* in a marvelous way: simple single flowers arranged in a wonderfully complex double spiral array, very similar to the geometry of the pinecone we looked at above (q.v. 216)]

(ii)

Imagine that we decide on a whim that we shall from this day forward collect all the dead batteries of the world and dump them at one convenient central location, say, for instance, *your* house. (You do use batteries, don't you?) I don't mean the big car-battery kind; Just the small ones, like the ones used in flashlights. Think of it. Before the end of the day, there would be a veritable Matterhorn in your front yard, a toxic mountain of the used-up and unwanted.

As the pile grows, however, you might cleverly initiate an action via the world-wide web. You decide, and encourage others to follow your lead, that instead of sending the dead batteries to your house, we'll all join in together and send them to *his* house, *the White House.* This would not only be saying *Yes We Can* both to Civil Disobedience in the spirit of Amos Bronson Alcott and Henry David Thoreau, but also to an utterly—when it comes to doing anything fundamental about eliminating not just waste, but the very idea of waste itself— *deadbeat* Washington.

Keep the packages coming! From around the Nation. No! From around the world. Now that would be change!

[Note: In a time of systemic political paranoia, it may be worth mentioning that the above miniature is meant *as satire.*]

A MEDITATION ON BATTERIES—*a quartet*

(i)

Consider this: Does an empty battery weigh less than a battery fully charged? Or is there a difference in weight between the living human body, and the body's weight at death? Or consider that if we break apart a triangle of sticks, or smash a computer, and then weigh the resulting pile of parts, *before* seems to equal *after* in each case. But what is lost then, if 'it' is evidently weightless? A pattern? A working together, or harmony of parts?

A child might ask, *"Where does the triangle go?"* Does it at the moment of break-up just cease to exist, like after switching off the lights, colors cease to exist in a darkened room? Or is it more like a handful of brightly colored sand thrown at random on the skin of a large bass drum turned on its side, brought into resonant movement by a singing voice, or trumpet, or trombone? After all, instantly, there is here pattern. Instantly, new figures of extraordinary complexity emerge with each new change of pitch. (If you actually see this first-hand, you'll never forget it.) But once the sound stops, the structure quickly loses its integrity. You can weigh the sand, before and after, but again it will show no difference. So again, to our current way of seeing and measuring and thinking, *before equals after.* That is, except for a loss of resonance. A loss of resonance? A mere weightless nothing? Or just perhaps, very much closer to, *everything.*

TOO MANY VARIABLES

We shape the world and the world shapes us.

To master the complex, keep things simple.
To keep things simple, keep the number of variables
to but a single dial.

Turned all the way down, the dial produces the sleep
of rigid dogma; turned all the way up, it produces
the runaway confusion of random noise.

Better to keep things focused on the
clear limits of the middle way.

ON THE NECESSITY OF ROADLESS AREAS (II)

It is true: once a road is built, it frequently becomes easier and easier to get to places that are less and less worth going to. If it can be said that roads have a tendency to bring out the worst in people—the noisy grind of greed and self-centered haste—then perhaps paths bring out the best, a kind of waste-not-want-not of a rugged, but increasingly rare spirit of self-reliance. One, a sharp-edged knife that rips apart the fabric of forest and meadow; the other, a single thread which in the walking weaves itself seamlessly back into the natural world. Clearly, we obviously need good, well-designed roads. But even more we need the wisdom of natural limits which tells us when not to build them.

THERE'S A CERTAIN SOUND THE WIND MAKES—*a prose poem*

There's a certain sound the wind makes in the tall pines of steep slopes, where mountains wear winds like strings of braided crystals. I sit on a rock to rest a while, motionless center of the world about me, and am amazed to hear the low, resonant train of sound cut a wide yet distinct swath down, around, and back up the late summer mountain. This is a sound that begins not with silence, but with the icy periphery of human time when we slowly began to walk on two feet. From this moment on, the wind, who has always been something of a stern and demanding elder, has been reminding us in a persistent voice: *"You, upright one."* it calls. *"It is time. It is time. You have lost your fur and now go naked in the world. It is time to find safe shelter from the sure and certain coming of winter's snow and deep cold of darkness. It is time. It is time."* So we listen, and are reminded—once again.

of collapse. Contradiction—or how the all-important limits of Nature and the artifacts of Culture 'speak or fight against one another'—has two key features: First, it points to weaknesses in our way of thinking, or philosophy of design, which are at the same time happily always new opportunities for discovery; And second, contradictions are always non-sustainable. That is, opposing movements grind against each other until the wheels of the system at some point simply fall off. This means that, regardless of how we think about them, where there is contradiction there will be collapse. It is up to us—and this is the problem's ethical dimension I think—to use the best of our science to untie the knots, so to speak, in an intelligent and measured way, or else be swept away in a highly unpleasant flood of mostly unforeseen negative consequences.

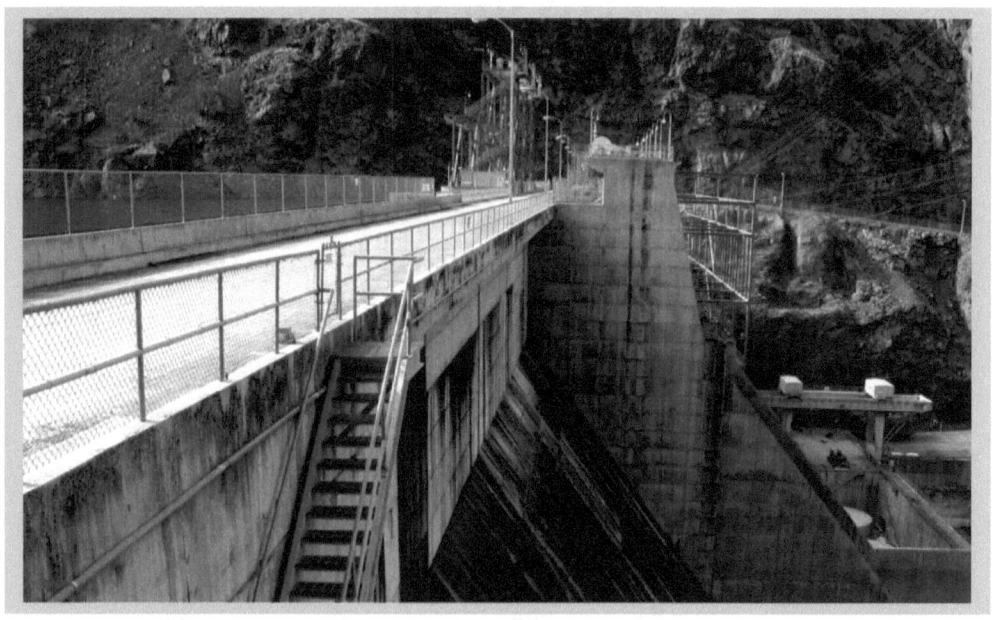

[Photo: *Hells Canyon Dam,* on the Snake River. Completed 1967, 100 m. high, with 391 MW capacity. Like the other two dams of the Hells Canyon Project, it lacks passage for migrating salmon, blocking movement to Shosone Falls.]

If water managers say, for example, that they need for a town of 5,000 two million liters of water a day, and the basin provides only one million, well, the "needs" will just have to change. Full stop. Second, it is meaning that shapes this all-important perception of natural limit, just as meaning in turn is shaped by a culture's primary formative images or metaphors. If we think of water as money, for example, then it is clearly a waste of capital to let water just flow out to sea without making it work for us. So, just like money, we put water in "banks," by building reservoirs and dams. And, just as with money, we act as if there is no natural limit: more is always better. The crucial flaw, I would argue, in this water-is-money style of thinking—its essential contradiction—is that there's no compound interest when it comes to water, nothing like the money-begetting-more-money of for example a 5% loan that hedges against doubling its cash in a mere 16 years, and that essentially out of thin air! Water behind a dam, it is true, does build up for a time, but its quality rapidly degenerates, and the knotting up of the natural flow invariably sets off a cascade of contradictions throughout the wider water-based web of life. The water silts up; water temperatures rise as vital oxygen levels decrease; the thermal weight of such large bodies of static water may set-off a micro-climate forcing, raising ambient temperatures enough to melt snowpack on the higher peaks before that snowmelt is needed, or cause more precipitation to fall as rain instead of snow; agricultural pollution is no longer periodically flushed out of the system; the complex nested rhythms and dynamic balances of the ebb and flood of the water-year are broken; the macro flows of essential nutrients from mountain forest to the sea and back again are destroyed. These are just a few of the facts, not in my view as it is euphemistically put, "concern," but rather

the great Columbia watershed in which I'm now focusing much of my attention—the South Wallowas—the salmon *also* stopped running that same year: 1958. Those are facts.

But in a far more subtle and tragic way, some vast, essentially unknowable, natural movement has been lost; it has stopped turning, as it were, as if a heavy wrench were thrown into the delicate spokes of a finely tuned wheel.

So the movement of the cycle *fragments*, breaks up into essentially out-of-phase, partial, disharmonious, smaller half-cycles. The result is that the entire life-community that depends on this rhythmic flow of a watershed as a whole begins to suffer—one species at a time—begins to pull back, decline, dry up, and, finally, vanish. "Vanish" is not, I believe, an exaggeration here. In both areas mentioned above—the central Alps and the South Wallowas—there are at present no real recovery plans for salmon, which means that they are effectively being erased from consciousness.

How has this happened? Well, I would say because of highly confused meaning.

The basic question is, *"What is a river?"* Is it something like a vein or artery of the living Earth? Or is a river more like a water pipe or sewer, with precise, measureable properties? These questions of meaning and perspective are more basic than the facts of objective needs, like water for irrigation, power generation or human consumption, as important as these might be. Why? First, because natural limit always trumps need.

ON THE FRAGMENTATION OF NATURAL WATER CYCLES

*The spring gives freely of its water,
but only in freedom can we drink.*

Let me begin by saying that I don't really know first hand what a truly large-scale natural water cycle is like, because I have never lived for a sustained period of time in a culture wholly nested within one. At the same time, I *do* know and have extensive experience with what a natural water cycle *is not*. And let it be said from the outset, that I do not like what I see, both in the parts of the European Alps that I know well, and those areas of the Northwest that I am presently exploring.

I do not like this recurrent pattern of the radical fragmentation of natural water cycles: *break* the flow; *dam* the river; *fill* the reservoir; *divert* vast quantities of water for frequently questionable, wasteful ends. Perhaps most importantly, I simply do not like the folly of attempting to control what is not really understood. The rich and chaotic complexity of the natural water cycle has been treated as if it were as neat and orderly and precise as a Swiss train. And now, only some fifty years after the great boom time of mega-dams, everywhere the negative side-effects of the extraordinary hubris of this philosophy of control are building up before our eyes like piles of unpaid bills.

The facts are unequivocal. In the *Reuss / Rhein* watershed of the Alps, where I've worked for many years intensively, the salmon stopped running in 1958; And now, by some very strange twist of fate, the part of

The Little Clavier: Part XVII

In limit, there is freedom; in freedom,
there is limit.

Even the wildest of rivers creates itself
the boundaries of the bed that order
its flow.

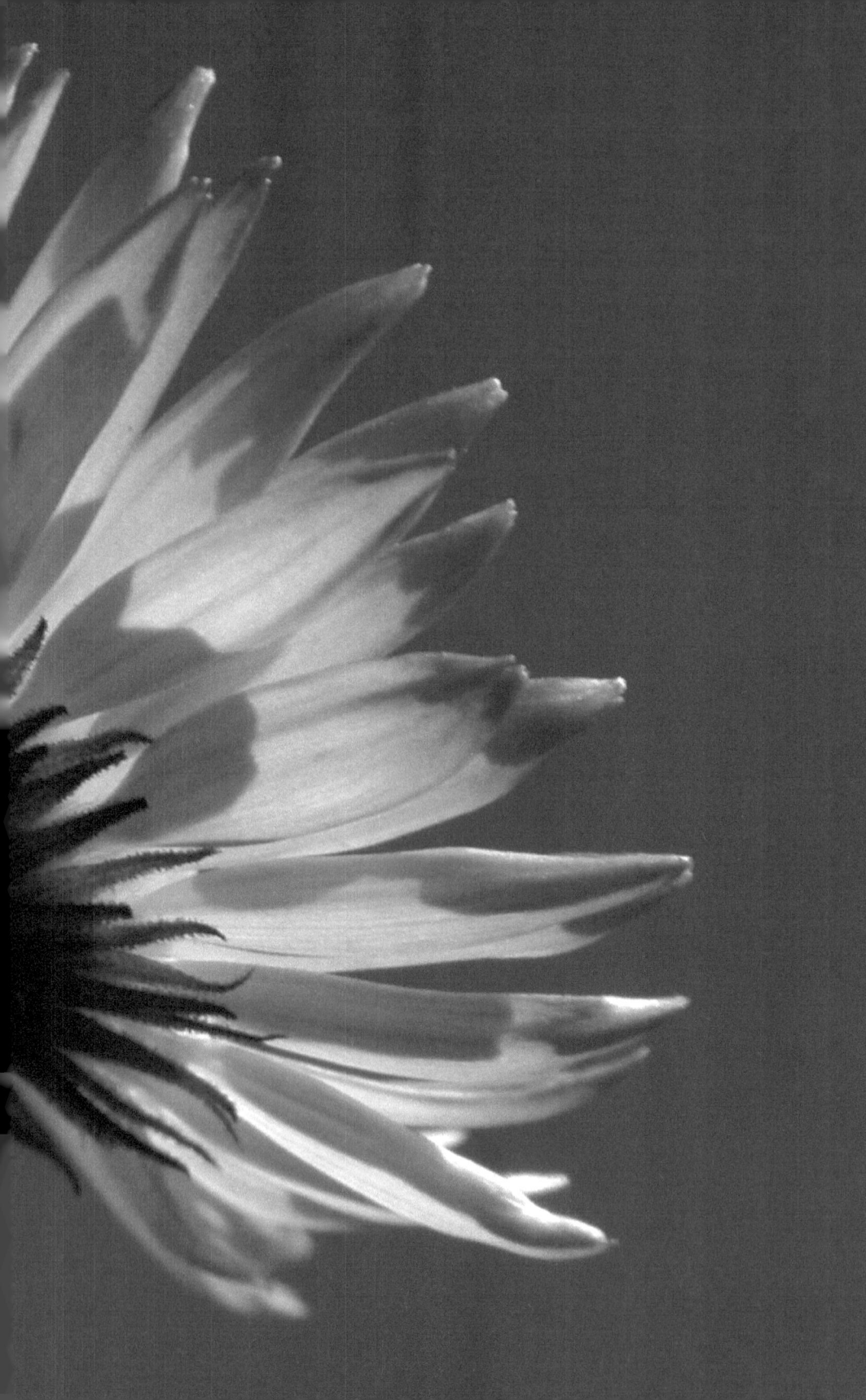

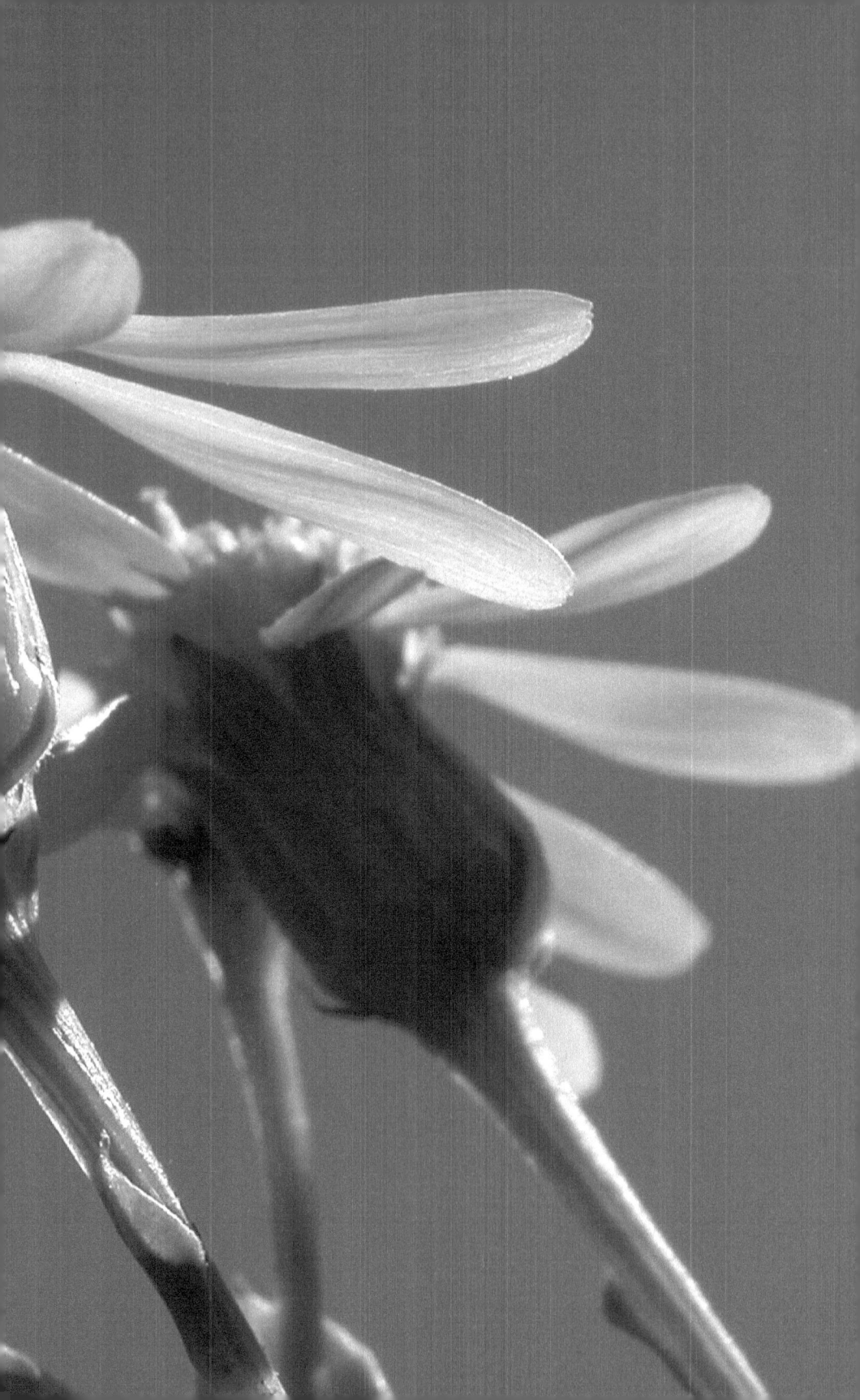

"*How much/ an/*

tap, *he,*
rap, rap,
 /hour?/

(satascataraback), Ooooo pain/ stiff/

 sorry, rift

(tapazapawapawap),

she's ss, ooo, o, o, ta-lenttttt t t t, t, t, tt—
oo, mmm, rrr, r h y - t h m, oh , u m, s o r - r y,

"Print it out!"

*mm*m,

(tensionintheneckandwrists)

Tap, twist, tap, twist - e r,
he said/

y o u?
d o ?

"Do it!" Ooo₀₀₀₀.....

Twist, tap, rap, trip, err, or,

tear,
t e a r,
s c a r e,

terro/
Tap, tap, tap, tap, t a p, t a p- e,

(/es b o r e d)

she s e e s, s e a s, *he,* w a v e s,

 r a v e s, s a v e s,

*p*ush, save, shift,
rhy-thm, yes
mmmm_m,

 taptap, tap

What would *he* have t/

 mistake,
 e r r o r,
 k e y,

Type, Tap, Drift, Shift, Sif-t

 l e t - t e r s
 n o t - h e r s

TapTap!!

 What?

t e a r s,
f e a r s,
t e a r s.
y e a r s,

tap,tap, type, ripe, hype, r, rr,

AT THE KEYBOARD

R h y t h m, *mm_{m,}*
that sound, one hears it whole,
but the fingers trip and stutter
slightly,
mm_{m,}
we back up...
tap,tap, **tap,** tap, tap,
like the quick little flights and chirps of
birds, each word, each sound, makes
its own special flutter of movement,

thinking with 10 fingers, they say,
a woman can easily do this dance
and talk to a hundred men at once.

(What would *he* have to say?)
R h y t h m, an ancient sounding word,

no, no, no, b a c k u p, correct th/
mmmm,
tap, tap,
tap, tap, **tap,** tap, t a p,
tap, tap,

 t a p

BASIC BALLOT

BASIC BALLOT
(mark one only +)

() left

() right

(+) no viable alternative

vote *yes* for *no!*

FOUR EASY STEPS...

...TO A RADICALLY NEW POPULAR MUSIC

(1) don't play 4/4;

(2) don't say "love;"

(3) don't say "baby;"

(4) pull out the plug.

who for whatever reason are motivated and knowledgeable enough to have figured out the code. Who would suspect that the **DOE**, or the **D**epartment **O**f **E**nergy, imitating the same sound we write and make for a peaceful female deer, is the governmental agency responsible for the development and safe care-taking of the above-mentioned nuclear weaponry? Of course, if you run **ICBM** through a spelling checker it will probably tell you to change it to **IBM**. Indeed, computer scientists and programmers, following the military-style interconnected building-block systems approach, have introduced acronyms and abbreviations into the everyday language in a very big way. Again, a bit of history reveals something of the interesting relationship. Who would ever guess that **ARPANET** or **A**dvanced **R**esearch **P**rojects **A**gency **NET**work (now **DARPA**), originally intended for the development of military technology, would become the precursor of the hugely popular Internet and World-wide Web. (**DARPA** financed much of the infrastructure development for the Internet, including versions of **UNIX** (an important operating system) and **TCP/IP** *(Protocol Suite Transmission Control Protocol* over *Internet Protocol)?* By now, to make an impression in a hard-wired, high-tech world, one must learn to effortlessly crack cryptic acronym-speak or live with the fear of an embarrassing flame from someone more perspicacious or, as one says nowadays, savvy, than you.

(read as if in one breath)

ACRONYMSPEAK

: an everyday rhetorical practice of introducing new words—each of which forms its own unique visual icon and sound—which come to represent new concepts, organizations or technical procedures; Best used with care, sparingly, like one might orchestrate *musique concrete* sounds into a symphony of sonorous acoustic strings. If we remember that the evidently intentionally humorous wake-up sound in a vintage acronym like **WAC** stands for **W**omen's **A**rmy **C**orps, and that the term **RADAR** was cleverly pieced together from "**ra**dio **d**etecting **a**nd **r**anging," we see, that, because of this recent history of their usage in English, acronyms frequently have a military-like or governmental ring to them. Indeed, the military seems to like acronyms as a convenient way of putting a clean, surgical, scientific-sounding front cover on the technology of death. To say, for example, that a country has 20 **ICBM**s (an abbreviation for **I**nter**C**ontinental **B**allistic **M**issiles, each outfitted with megaton payloads) pointed at enemy territory, with another 12,000 or so such warheads stockpiled somewhere, is deliberately deceptive use of language. It is as if the **ICBM** acronym were designed to be dealt out like chips in a table game which plays with big numbers and high stakes, while in reality, just one or two such weapons would be enough to kill 10 or 20 million human beings. Politicians are fond of using acronyms and abbreviations for similar reasons. Just one or two encoded first-letter icons per 8 1/2 by 11 page will give any report an aura of thorough preparation and expertise. That is, to those

effectively has the **O**ld profound mistakes of the past

thoroughly **N**eutralized, and, well: the urgency

of all th**I**s should by now be obvious — it is after all rather boring — in that

he world which seeks security in **N**-weapons — (¿contradiction?) — might soon

need more than just more **D**econtamination & **D**ecommissioning.

(read as if in one breath)

[Image:: *DANGER! d & d!* This is being written ± 150 k as the crow flies downwind of the so-called *Hanford Superfund Site.* On the Columbia River, it is one of the largest areas of nuclear contamination anywhere in the world, and while still use, produced the plutonium for 60,000 weapons [sic], leaving 203,000 m3 waste still to be cleaned up. *Plutonium,* named for the god of hell, is the most deadly substance known to man, with but *1,000,000,000* of a gram — a nanogram — thought to be enough to cause cancer. [source: Dr. Helen Caldicott iyltp.org #72], and remaining dangerous for 250,000 years. *d & d,* indeed! source of data on Hanford: *Wikipedia*]

one am**O**ng countless millions of other members of creatura

wish we would have **N**ot produced in the first place,

&,

given the fact that i myself, too, **D**o need, as you, perhaps, too,

and many others, also, do need mor**E** than a modicum

of purifi**C**ation and cleansing,

why on earth does the w**O**rld not put its foot down and simply insist that

we stop thinking up ever-more new deadly **M**aterials

which **I**'m sure, too, nobody

really wants or need**S**,

at lea**S**t

until **I**t (

d & d

unen**D**angered

sp**E**cies of

deadly substances la**C**e

w**O**mb of earth,

con**N**ecting

wi**T**h nothing other than more of themselves,

l**A**unching

Multiple waves of

indeterm**I**nate effects,

reso**N**ating

in w**A**ys so appallingly contorted in their

insoluble complica**T**edness,

that **I**, as

A QUINTET OF
NEON GRAFFITI

Written in a rare,
inert gaseous element,
obtained by a fractional
distillation of much
suffering.

Colorless,
but glows reddish orange
in an electric discharge.
displayed on
walls...
soon to be taken
down.

"Vague and insignificant forms of speech, and abuse of language have so long passed for mysteries of science; and hard and misapplied words, with little or no meaning, have, by prescription, such a right to be mistaken for deep learning and height of speculation, that it will not be easy to persuade either those who speak or those who hear them, that they are but the covers of ignorance, and hindrance of true knowledge."

from An Essay Concerning Human Understanding (1690)
John Locke (1632—1704)
.

The Little Clavier: Part XVI

Form emerges out of movement; it is the outward envelope of the rhythmic pulse of life.

The river creates itself the boundaries of the bed that order and give structure to its flow.

almost say the poems have to be actually heard to be understood.

If you would like to see (and hear) a much longer cycle of 15 little 37-step poems, go to the score excerpt below from *Ridge Crossing: X—On the Edge!* *(poem cycle:* page 300; *score page* 306) Here, the poems are collected together in five sets of three and, as a whole, make a kind of ritual walk from valley floor over a difficult, dark, north-facing, mountain ridge and then continue on down the other south-facing side of a new, unknown valley. Instead of the title, Ridge Crossing, this longer cycle might just as easily have been called North / South. This is actually the kind of cross-country mountaineering I have practiced in the European Alps and now in the American Northwest and Wallowas for many years, and how many of the photographs in the THE LITTLE CLAVIER and picture-poems.com collection generally were made. Basically, one moves from valley to valley, frequently without knowing for sure if there is a route to the other side, or indeed, what to expect once one is there. If the poems at first seem a bit austere in aspect, I suppose that has something to do with the granite-like ruggedness of the country out of which they have emerged. I can only hope that they start to, as the saying goes, 'sound right' after a time.

rhythmic succession. The flow from poem to poem creates a wonderfully dynamic interplay of *similarity* and *difference* — similar in form, but different in actual content. This is, of course, no different than how we experience form generally in the natural world. There, we encounter, for example, the same basic spiral structure in the arrangement of seeds in a pine cone, or on the disk on a sunflower, or the threads of water in a whirlpool in a fast-flowing stream.

But in addition to going back to traditional forms like sonnets or, for example, *haiku* with their 17 steps, I'd also like to work with something new. This is because I'm very much looking for an organic fit between, on the one hand, the outward form, and, on the other, the inner movement of meaning in a composition. And well, I would also argue that new meaning in a way must have new form in order to properly manifest.

One last thought for those readers interested in the relationship between music and poetry: If one were to write the poems down *as I say them* in musical notation, they would all have exactly 37 notes, but the durations, meters, accents, dynamics, and other articulations would look — and sound — strikingly different. In contrast, when written down in standard English script as above, the result is in a subtle and fascinating way quite misleading. This is because they do indeed look almost identical, just like a series of sonnets would, but, remarkably, the mode of notation does not display any of the just mentioned important differences. In other words, this is much like having to perform Bach from a simple sequence of pitches with no indicated rhythm, which would be almost impossible. So, in a way — just like music — you could

* A TRIO OF MINIATURES

I like to think of the form of a poem as a pattern which emerges out of movement, much like the shape of a wave emerges out of the formative flow of a stream. We hear the flow of spoken words, and without trying to think about how the poem is written down or formally structured, we sense a certain rhythmic pulse, a certain fluctuation of density and texture. This is how I conceive of the poem's music, again not so much as notation or what we see written on the page, but rather as a kind of natural movement to be experienced.

With *First / Last,* I'm exploring the possibility of a new species of poetic miniature which is related to what in traditional rhetoric is called syllabic verse. This is when we count the steps—or syllables—that a sequence of words makes in a phrase and arrange them in some kind of outward, more or less pre-determined structure. The result is a kind of dance which is made with language instead of the feet. After a lot of trial and error and experimenting with this idea, I eventually came up with a little 37-step form that was both *short enough* to be heard as a single breath, yet at the same time *long enough* to create its own space, perhaps even with both a kind of storyline and center.

One of the beautiful things about a a relatively short form like this is that it can be repeated, thereby creating a sequence of variations. I've always been struck by the extraordinary richness of, for example, the Shakespeare sonnets—all 140 steps each—when hearing, say, just three or four of them in slow,

(iii)

Walking out into
the growing darkness, events of
the day dropping like leaves after

the first freeze

of fall. Windless days
not returning, each night the last.

(0)
— — — — —
— — — — — — —
— — — — — — —

— — —

— — — — —
— — — — — — —

('t Rechte Wegje, De Veluwe, 1987, The Netherlands)

FIRST / LAST *—*three 37-step poems*

—for Helen Metzelaar, *my dear lowland expatriate friend of many years, who mischievously interrupted a forest retreat of mine unexpectedly the day this trio of little poems was composed*

(i)

Each day the first, new

shapes grow out of the disappearing

darkness, the color of damp leaves

and pine. Trees

standing firm, giving

back our movement, your voice, first light.

(ii)

This patience of trees,

an unmoveable trust of the earth

upon which they stand, nets weav-

ing themselves

into the light, the

dark, growing in a l l directions.

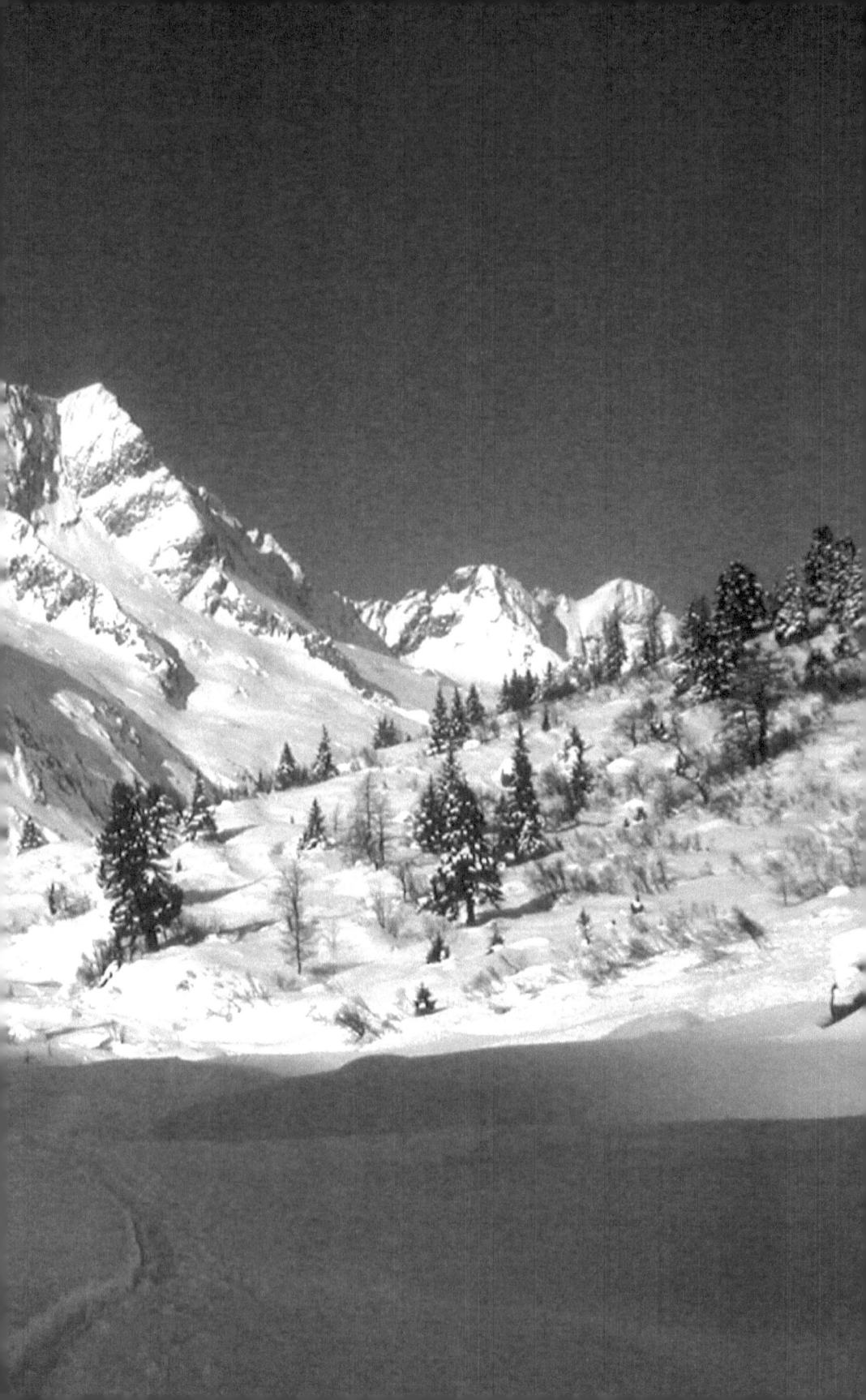

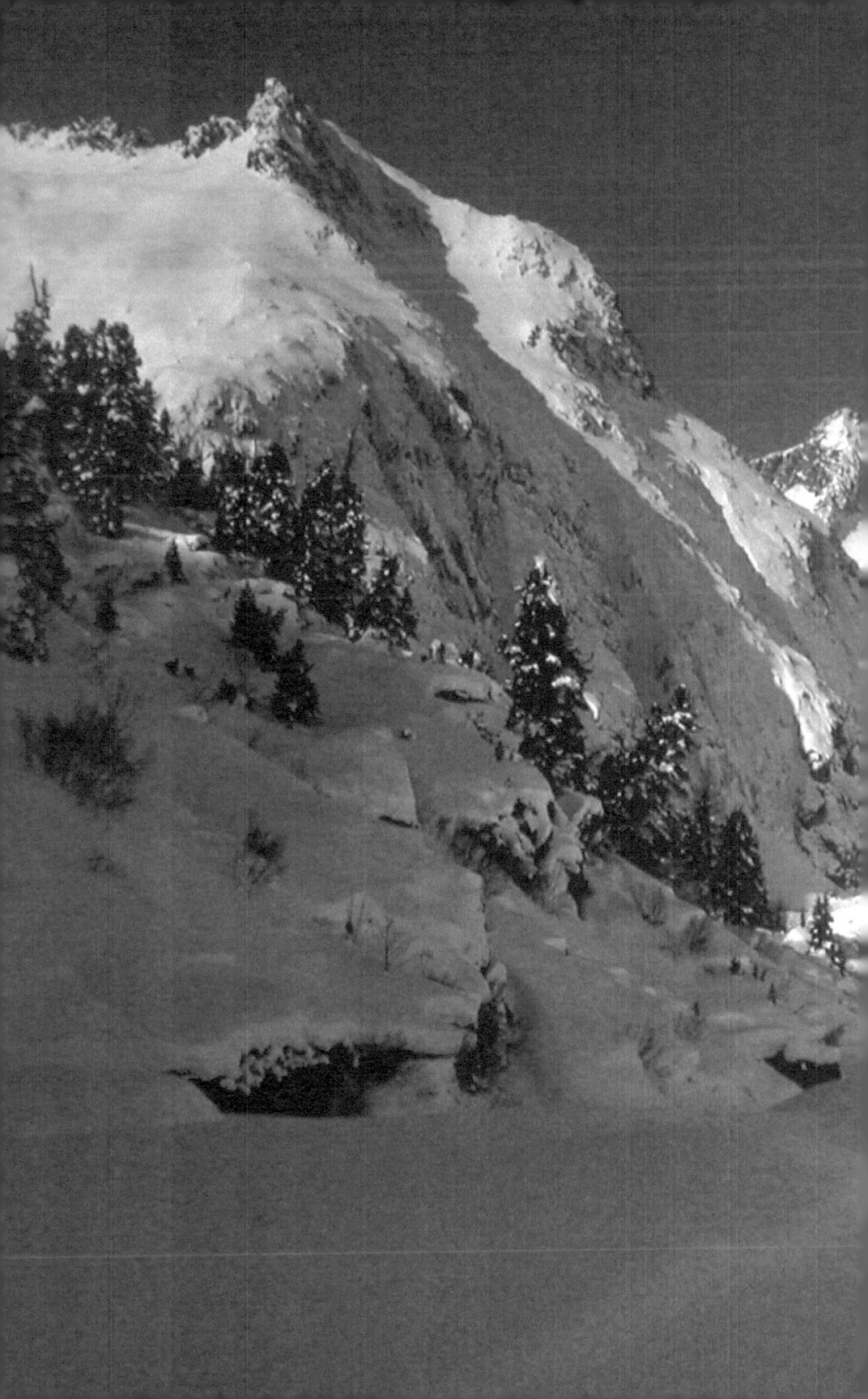

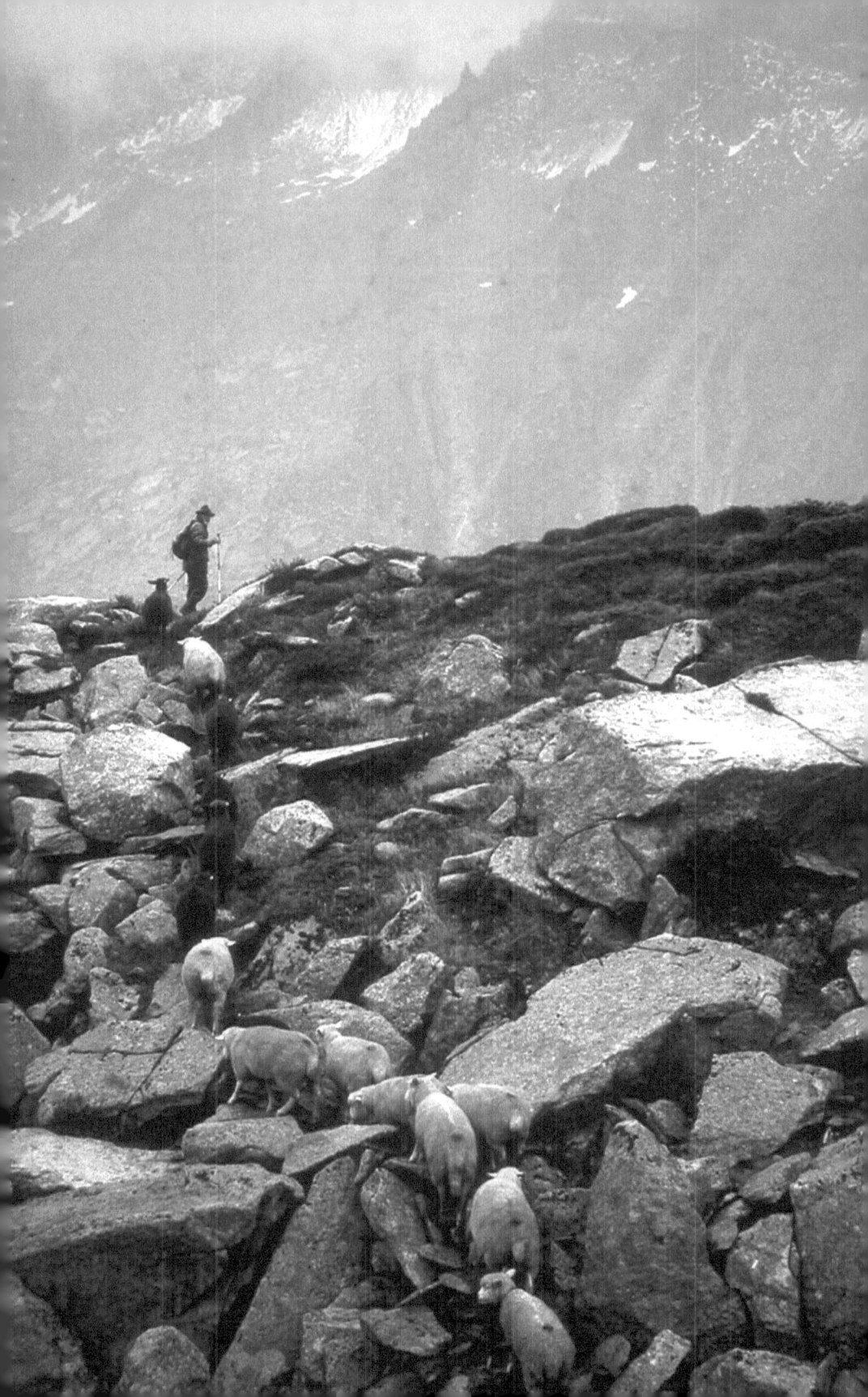

SITTING

Always close to the flow
of fountains, the old sit in the forenoon
sun and are sometimes seen
holding little bouquets
of wild flowers.

Secretly, they collect the plants themselves, but
grasp them and look at them as if they were
the gift of a child. (The light, the color,
the warmth.)

They listen to the sound of the flowing water, and
rehearse stories we know they will never
quite tell us.

They smile their way, but don't like to talk much
until it's almost dark.

Without asking, they know where the
young men are going, and the young men know
where the old have been, and
have been, again and again,
and again.

this plant, the name of which seems
to elude him, he now sees for the
very first time.

(On the European Continent, one must venture up into the land
far above the trees, above 2000 meters or so, to enter a realm
which to this day is still almost entirely pristine and natural.
Here we find a place free of the confusion
of false competition between largely
indigenous species—so characteristic of the lowlands—
caused evidently by Climate Change and the, in historical terms,
recent misuse of the land.)

KNOWING

Summer mountain, magic meadow,
the mysterious weave of flowers
and grasses, and weeds—

the hard question of what is native
to this place, and what is not.

But does the botanist in me always have
to point his finger inwardly, tapping off

complete indices of the species of fields
and pastures like some might look for

> all the *A's* or *B-flats* in
> a symphony,
> neatly sorted, counted, placed
> in a row?

If you ask him to sing the note
of a particular plant, always,
his pitch must be perfect.

But he'll probably never confess to you,
although he'd like to, that, the more
he seems to know, the more difficult it is to
admit freely like a child to others, that,

"What is this plant?"

for him, more of a possible mistake than
a real query, a question which can fill even
an expert with fear...

"What is this plant?" A child may stop looking at
flowers forever as soon as we ask,—test, for
but a single—

 common name.

COMMON NAMES

Morning work finished, time
to rest for a while.

There are two things that will
take away a farmer's appetite
at breakfast:

One is the news in the paper
that the politicians, regardless
of the color of their party, are talking
again about cutting not hay but subsidies;

The other is the sound, even if properly
pronounced, of botanical Latin...

 Pratensae vulagrus, yes,

the name of the proverbial meadow species;
it always stands not for a plant of some kind,
but for the school he did not attend and has
been taught to think he should have.

So he sinks into his morning coffee
as culture's *Cultivar neglectus.*

The proposition,

He ponders this, the right time, cutting time.

He knows the common names of a handful of grasses.
Those are the ones he watches change and ripen like a clock.
This one, the Cock's foot, never used to be this high,
sticking out like a gas station sign along a highway.

"That's the fertilizer they've been using."

He taps the head of the Fox's tail, a trace of yellow dust.
"Snuff," his father used to call it. Smells good.

"Not hard to cut with a scythe."

CUTTING TIME

Straightening the hose, the old farmer
gives the wooden tub a kick. The water
splashes around chaotically, only gradually
smoothing itself out into a smooth mirror-like
surface. He ponders his reflection.

The movements of moon and sun, wind and
weather, ought not shake the land with random,
violent extremes. This he thinks to himself.
When he was a boy, it never froze in summer.

Meadows ripen all to their own mysterious rhythm.
Some, lower down, are ready early, while
the higher ones, the steepest, are to be cut last
or not at all.

The right time to cut. He doesn't talk much
with the neighbors any more. Not that he
wouldn't. In the distant past they all worked
together.

When the time was right and the weather looked
like it would hold, they moved. Now, the worst thing
is to wake up late and somebody already has
a third of a flat meadow on the ground.

Looking out into the distance, this is the moment
at the threshold of a new day when the heart
of every farmer forgets its scriptures and speaks
directly to the quiet land.

The ritual of hay making coming round each year,
somehow, this was meant to be, that much they
know. *"You can't bring a mower up here. Far too steep."*
That's what they like to joke about. The old ways.

Three men working, one above the other—by the
time the morning sun touches the grass they'll stop
competing, find their rhythm, put the whetstones
in the little creek that boarders a neighbor's land and
unpack the coffee.

 Down moves the scythe in its broad arc, steeply,
 repeatedly down, the sweet, smooth, swishing sound
 of sharp blades, neat piles of wet grass, one above the other,
 moving rhythmically, step by step, down the mountain.

 Down goes the blade, steeply down—to make
 a wild garden paradise of the earth is hard work,
 some would say, good work.

That much the three men know, without saying
a single thing.

MAKING HAY

—for Konrad and Christof

Early morning. The sun is still far behind
the high ridge to the East. From the snowfields
and forests above, countless braided streams
flow down the mountain,

converging on all sides in a single ribbon
of life, flowing down, without pause, always
flowing down. The birds are silent,
their songs of spring seem very distant
now, almost not of this place.

Like morning mist on quiet water, at this
hour, sound in the summer valley hovers close to
the ground. Only visitors from afar, if they were
here, might be the ones heard to speak too loudly.

Three men, walking slowly, steeply up
along a narrow path grown hardly visible,
the subtle weave of meadow grasses and
flowers leans down towards the earth,
heavy with morning moisture.

There is little talking. The quiet time
of the night before never seems long enough.
Higher up, at a ledge, they stop and sit for awhile;

EVERY VALLEY REMEMBERS

Two neighbors working,
tapping out the blade,

the complementary rhythms of
2's and 3's.

Distance and a summer breeze
do strange things to sound,

 the sharp tang of heavy hammer
 on anvil planted on heavy rock,

 the delicate edge moves slowly
 round the tapping of the blade,
 a new moon moving from East
 to West.

Higher up the mountain, silver
consonants ricochet off nameless
steep granite walls...

Wide awake, noon rest finished,
these sounds—were not made today.

 (Urnerland, Fire Festival Time,
 getting the scythes ready, making hay)

THE FARMING LIFE—
six longer narrative poems from the Alps

> A farmer's life
> is measured by
> the pitchfork fulls,
> of hay,
> of manure,
> of the mountain of work
> each day
> left undone.

THREE MINIATURES ON SOUND

(1) The 2nd-hand artificial sounds of electronic recordings and instruments corrupt the ear just as assuredly as the oil-refinery colors of suburban lawns and hybrid flowerbeds corrupt the eye. Edges must be made sharper, colors made ever-louder and more saturated, and forms made ever-more confined to tight rows marching to the square boxes of a 4/4 beat. Start with the facts of corruption. Children now take a new instrument out of the case for the first time, already eager for recording contracts, instructed by teachers who tune their guitars by machine, teachers who are unable to hear a true 4th by ear, who cannot sense the difference between a living tempo and a computer's dead and dry click track. May the Muses have mercy upon us.

(2) Odds are, that twenty years from now, when you ask a current user of earbuds & iPods about the music they used to listen to back then, they'll say, *"What did you say?"*

(3) Once walking the land has become a nearly extinct species of movement, the atrophy and then loss of a deeply rooted sense of rhythm will inevitably soon follow. Poets will compose lines that miss all the beats, lines without cadence, that never pause to rest, and that have forgotten all about the heart beat and necessary breath of silence.

FOUR MINIATURES ON ART

(1) In all Art, the primary criteria of what is good, right and beautiful are not to be found just in philosophy and aesthetics, but rather in a life devoted to the diligent observation of Nature. Once artists no longer live by the seasons, the four directions, no longer know the winds, birds and flowers, their work will eventually come to refer only to itself, or, at best, merely to other art. Such work denies itself the guiding, nurturing, and sustaining resonance with the symphony of natural sounds and forms that surrounds us.

(2) The silent joy of making things instantly vanishes if unforced, unselfconscious anonymity is lost. The deer in the meadow are always uneasy about someone surreptitiously looking on from a distance.

(3) The only thing we can know for sure about creativity is perhaps *what it is not,* or what blocks it. *Fear, greed, jealousy:*—as easy to spot as weeds in the summer garden. But the source of the seed? One looks up to the heavens and is brought down to earth, clear blue skies in all directions.

(4) The most creative of all acts is that of bringing people together in new, unknown ways. It is also the most difficult. What could be more necessary than this?

and collectively. Just as the wild proposal of the poet-politician that we must go to the Moon not because it is easy, but because it is difficult, crystallized and brought together an entire generation of creativity, we need now to see that the dual imperatives of the new millennium are *ending waste and war. Waste,* because it in one word summarizes where the *conventions of Culture* are out of step with the *laws of Nature.* Eliminate waste, and you solve the problems of pollution, renewable energy, corrupt agricultural practices and climate change all at once. *And War,* because of its destructive insanity—and *it is* insanity because the entire Earth is now at stake—of contemporary weapons technology stands before us as the central fact of our time:—that it is no longer a question of violence or non-violence, as Dr. King suggested also about forty years ago, but rather of non-violence or non-existence. Seen from this larger perspective, it becomes clear perhaps that War and Waste are essentially two sides of but one problem.

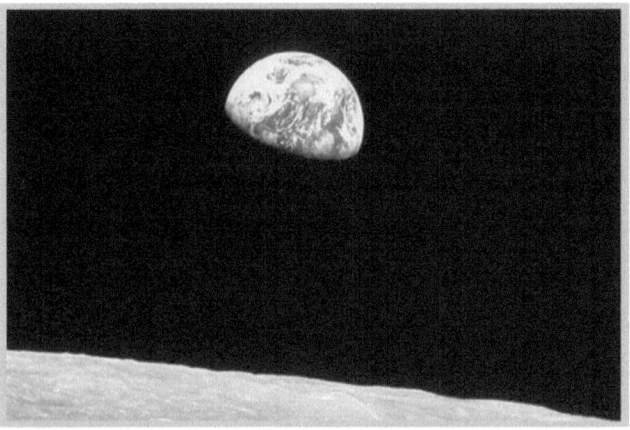

For who would not say that, from the perspective of the Moon, waste is indeed humanity's *total war on Nature,* and that, in turn, war is not humanity's total waste of its own spiritual essence and promise?

ETHICAL IMPERATIVES—*a meditation on Earthrise*

The first imperative of ethics, it seems to me, is that ethics itself should not be thought of as belonging primarily to what is now considered religion, but rather as a primary dimension of *all* human activity. 'Primary' means that it is the *first* aspect to be considered in all action and decision making, and *not the last.*

All action resonates in space and time. Sometimes only a second or two, sometimes for centuries; Sometimes only a few centimeters out from my own body. sometimes perhaps to infinity.

Outwardly, this is *ethical consequence;* inwardly, it is *ethical conscience.*

The key feature of this complementary inner and outer movement of consequence and conscience is the breadth of the circle of awareness and responsibility. The great leap of consciousness brought home in the historic *Apollo 8 Earthrise* photograph made by astronaut William Anders in 1968—perhaps the most important image of our time—is that it shows to the mind of compassion with granite-like clarity that the necessary breadth of this circle of awareness and responsibility begins and ends with the whole of the living Earth, and not with the largely arbitrary, conflicting fragments like current nations states.

Necessity is a thing of great philosophic beauty. This is so because necessity awakens, and in a most powerful way brings together, the very best of our intellectual and spiritual energies, both individually

cult. But also, I think, revealing. That is why I call the set of three *The Liberty* or *Liberation Triangle.* By just doing *one* of the three, we step outside of the dominant stream of everyday behavior. This is rather like venturing up to clearer, higher ground and looking down on the whole of a culture's activity in certain areas and directions. From the new perspective, suddenly we see pattern, we see motivations, and we see consequences and inter-relationships. And, we are surprised because the new vantage point makes these seem so obvious.

The Triangle can also be reversed. Interestingly, if we introduce just one of its three sides into a culture which hitherto has remained unexposed, we might conjecture that the integrity of that culture will quickly fall apart. This, it seems to me, suggests that the petrochemical cult of cars, the mesmerizing propaganda blitz of TV, together with the highly habit-forming nature of industrial agriculture's junk food, make for a kind of powerful mutually reinforcing illusion. A kind of perceptual prison, you might say.

Hence, the idea of liberation, of freeing oneself, by doing nothing more than *not* doing three key thing: *don't drive; don't watch TV; don't eat junk food.*

Simple indeed!

THE LIBERATION TRIANGLE—*a meditation on cultural change*

I've always felt that the simplest and most powerful of all possible tests is the test of doing without. It is simple because there is nothing new to buy, no new set of skills one must master, no lessons to attend. We simply stop doing something that we're used to doing. And it is powerful because we quickly become aware of how habit shapes perception. After all, it is possible that what we once thought was absolutely necessary and essential may turn out to be largely arbitrary, and, in a deeply insidious and unconscious way, destructive.

So, here are three key *do's* of present Western culture I've turned into a trio of *don'ts:*

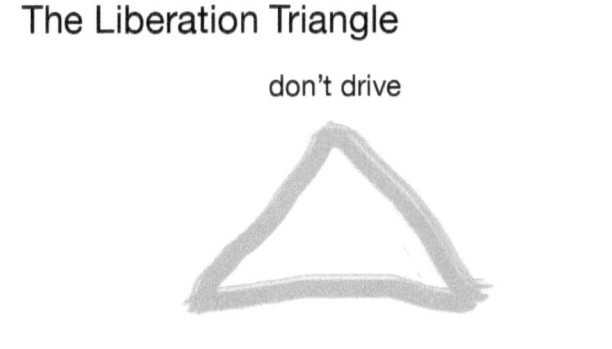

There are other sets of three, of course. Perhaps some readers might come up with better collections themselves. It must be said that they are simple only in principle. To actually live them would be diffi-

The Little Clavier: Part XV

Time folds into Space like a thread
wound round into a skein;

The *one-at-a-time* folds into and becomes
the *all-at-once,* and the myriad differences
become co-present.

Listen to the notes of Melody wind round
themselves to become Harmony as the
piano's sustaining pedal is pushed down.

That's the sound of *Time* becoming *Space!*

(iii)

Boom days of easy
plunder now a thing of the past,
Speed's run flat dead knowing that the

direction

was wrong. *Cut down. Dig*
up. Put barbed-wire around the rest.

MAN OF ONE CUP—*three 37-step poems*

(i)

Empty, round, metal
cup I use every day, how I've
grown fond of the feel in my hand,

center with

gifts from near and far . . .
Hot tea steeped in cold spring water.

(ii)

Square grid without a
center, towns built with quick money,
with gold, whiskey, easy women.

Your home was

always someplace else.
O Silver Maple, so far West.

UNDERSTANDING THE SHAPE OF CHANGE—

12 primary concepts for the description and generation of movement in Music, Poetry *and* Dance

(1) difference

(2) complementarity

(3) qualitative temporal-spatial ground

(4) density

(5) directionality

(6) constant / variable

(7) regular / irregular

(8) continuous / discrete

(9) homogeneous / heterogeneous

(10) spatio-temporal hierarchy

(11) simple/complex

(12) the universal somatic constant

LET ME REMIND MYSELF HERE:

Do not mistake—*density* for *intensity*, *randomness* for the *unexpected*, *complicatedness* for *complexity*, *sentimentality* for *simplicity*, *intellectual virtuosity* for *subtlety*, *length* for *depth*, or merely *a loud voice* for *vitality*.

THE TWELVE PRIMARY CONFUSIONS

(1) The relationship and significance of human beings with regard to the whole of creation. Are we merely an accident of evolution, or is our being, while clearly a product of evolutionary processes, also somehow an instrument which in a unique way holds and reflects the whole?; (2) The nature of the living center of each individual, or what we call 'the self,' and the relationship of this center to the whole of life, and what might be thought of as the spiritual realm; (3) The relationship of individual consciousness to the consciousness that evidently pervades the whole of Nature; (4) The natural similarities and differences, large and small, between the genders, and the necessity of gender complementarity; (5) The necessary unity of Art, Science and Religion; (6) The necessary unities of learning and love, of freedom and limit, and of security and wholeness; (7) The source and significance of intelligence and creativity; (8) The difference between mechanical and creative change or evolution, or a merely mechanical tradition and a creative one; (9) The difference between true complexity and that which is merely unnecessarily difficult or complicated; (10) The nature and meaning of natural cycles of birth and death; (11) The nature of energy as it manifests in the movements of life, and its relationship to all of the above confusions; (12) The source of the form of but a single poem or flower.

Striking, these orders
of the mind,
of thought
made
manifest, a danc-
ing chorus held in

the hand or a hand holding us?
What's the difference? A neutral,
eternal instru-
ment? Quite doubt-
ful. More
like
a light in the dark having for-
gotten that it's just

a light and
not the sun.

Of course, what could we display at
all with-
out measure, without
a bed to hold the stream, a smooth
surface for the cream-
like shades of the moon is the key,
the key to these dark
spaces behind the

brilliance of Mozart's
smile, an un-
known place where the birds go in winter,
flying through
endless skies,
sure wings, silent breath.

PIANOFORTE—*a fractured mirror poem*
—for Edgar Varese . . .

 Pythagoras's harp
 now lies mute
 on its
 side,
 covered with the wood
 of a black forest.

 Three teutonic legs stand firmly.
 What a difference! This step by
 step movement from soft
 to loud and
 back a-
 gain,
 abrupt shifts now accompanied
 by the subtle fruits

 of mechanical
 invention.

 Recalcitrant leaps of five scaled
 down by
 the overwhelming
 power of ten, hands walking the
 threads of an ancient
 loom strung tightly with the rough cords
 of a black and white
 weave. Whether strings or

 snares, an astounding
 tool, pure space!
 For time sits lightly on a four-
 legged stool
 of inter-
 national design.

WASTE OF TALENT

We shape the world and the world shapes us.

See the empty glamour of the contemporary music virtuoso. Technical sophistication perhaps, but without the joy and passion which come naturally with the journey of discovery into the wilds of the unknown. How many more complete Beethoven cycles do we need? Such a waste of talent, such great poverty of spirit, of meaning. Like love for sale, the movements may look exactly the same, but everybody
knows your heart isn't in it.

THE POET'S LYRE

>Between the peg of Nature,
>And the pin of Culture,
>I span my string.

ON MUSIC AS COMMODITY

Once we have divided the world into the separate conceptual frames of *living subject* and *lifeless object,* it is but a single easy step from lifeless object to resource, and from resource to commodity.

This habit of the mechanical brain of mapping life onto the lifeless has conditioned historically how we see and act towards rivers, towards forests, and soil and the land generally. So it should come as no surprise that we now follow the same pattern or habit of thought when it comes to Culture as well.

Consider music. Music in high-tech Western culture is no longer something that we *make* or *play*; Music has been reduced to a mere object or commodity we must *have* or *buy*. Music has become life-style. What does the Pope, or the President have on their iPod? Good god, smash the damn thing! And to think that just two hundred years ago, Thomas Jefferson is said to have practiced violin for two hours a day. Or it was perhaps a French translator's lively fiddle playing that got Lewis and Clark and the great Corps of Discovery safely across a vast, wild continent and back.

So what have we lost in the wake of our technical sophistication? I would say it is the life, or the spirit of the sound. The sound of real plucked and bowed strings. The sound of a real trumpet across a quiet forest lake. The sound of the living, talking drum. That's what we've lost.

THE DIFFERENCE OF BUT HALF A STEP

Bright sun on grayish-white granite,

a major key ascending,

rising beyond the high snowy peaks and distant stars.

A cloud passes by with misty rain

and suddenly all changes to shades of

dark reddish brown volcanic ash and wet rock,

a minor key descending without end,

falling with roots to the middle of the Earth.

The happy and the melancholy,

two sides of one movement . . .

How could I ever choose?

O mystery of creation,

why do we no longer ponder this difference

of but half a step,

no longer play this lyre of solace and peace,

forever tuned and tempered, not to one,

but to both?

INAUGURATION

A timeless day, just above the clouds,

new snow from horizon to horizon.

It says to me: *Cars do not exist.*

Money does not exist.

America does not exist.

The first man and woman

look through our eyes down upon

what seems like mile-thick glacier ice,

filling whole valleys with their motionless white water,

sweeping away all that has been.

So the world celebrates the first day

of its new beginning, without fanfare,

without the confusions of false promise.

The trees bear witness.

The air bears witness.

The rivers bear witness.

O suffering of the world. What have I done today to end it?

It says to me: *Nations are not great.*

Armies are not great.

Flags are not great.

See the bridgemaker, speaker of many tongues,

the planter of trees and freer of rivers . . .

O clear signs of a birdless sky.

1.20.2009
Stonepine Overlook,
Eagle Cap Wilderness

HOPE IS . . .

Hope is the patch of blue sky high above on the mountain before me as it begins without a trace of wind ever so gently to snow;

Hope is the first fish that returns in the fall from the sea, knowing that others—against all odds—may soon follow;

Hope is the young cellist who already knows all her Bach by heart;

Hope is the loud, raucous sound of nutcrackers stashing pine seeds for winter, or the tiny buds of a grouse-berry already prepared for the coming spring;

Hope is the sound of the British choir boy's voice echoing off the great stained-glass windows to the west, singing vespers, at Chartres;

Hope is the labyrinth we all must walk as the silence of nighttime descends upon the land like a benediction, and we suddenly realize that we too must continue our journey alone, after these few, and lucky, and rare, and all-too-brief moments of warmth, and sharing, along the way.

END OF MOUNTAIN SUMMER

The fall winds have again descended upon me,

and summer has departed like a beloved

headed South

in the middle of the night,

the door left open,

and leaving not even a short note behind.

I wake up in a cold sweat

thinking to myself, *"Shall*

I follow her? Where on earth could

I find her? Tending her flocks of sheep on the pampas?"

No, I'm staying put.

I'd have to search every Tango

joint in Rio. She'll come back when she's ready.

I'm already digging in.

Time to shorten up my long-winded Mediterranean lines

into something more like Spartan, tough-minded,

laconic couplets.

What was it Dienices said at Thermopylae

when told the Persians would rain down a cloud

of arrows so thick it would block out the sun?

"Good then. We'll fight in the shade."

TOWN

A place to park the truck.

100 steps to the Post Office,

40 to the Café,

20 to the Bar.

A place of reduced speed,

where we drive slow enough to see if a neighbor

has a new girlfriend, or wave politely to local elders,

but fast enough not to think or worry about,

all the broken windows,

or why children no longer play in the streets,

or even the high price

of bad land.

PHOTOGRAPHY AS MANDALA

A ritual circle which brings the far away, the very small, the ignored or half forgotten, into the magical middle realm of the contemplative compassionate eye.

A circle which not just mirrors the Beautiful, but reflects also the Strange and Ugly through the clear, yet necessarily imperfect and always slightly blurred lens of partial truth.

LAST MAN ON EARTH

First rule: don't let the fire go out.

Prime possessions: Swiss army knife and that stainless steel pot over there.

Most important pastime: sending smoke signals on windless days to potential last women.

Key skill: using your ice-axe as you always have:—*digging for roots.*

THE DIFFERENCE BETWEEN THEM

Along a trail through a high

cottonwood meadow,

horsemint and *death camas*

grow side by side,

the one healing herb,

the other poison root.

Such is the strangeness of the way things are.

Sure sign of "evil" as a dark

force of nature, out

to do me in?

Quite doubtful . . .

More the ever-present possibility,

as we cross paths with the good,

and the bad,

of not knowing the difference

between them.

POPLAR OF FORGIVENESS

—for Midge

A Cottonwood tree offers me shade. Moving from ridge
to valley, I stop at a rock to rest a while.

It's the sound, the sound of the wind moving in the leaves,
a sound wholly absent in the higher more austere altitudes,
that washes away like the water of a Lourdes
all the hurts and pains of the past.

How we long to go back, go back and set straight
all our mistakes of the past, to say
that it wasn't like that, or that
we didn't intend things to turn out
the way that they did.

But the sound carries these thoughts
away to somewhere else I know not where.
I open my eyes. A leaf, already yellow, falls.
A blackcap chickadee flutters quickly by.
 —I must live a better life.

PATH OF DIALOGUE

Stow away your conclusions and opinions in the bag of unnecessary gear you leave at home. The path of dialogue begins with *real* questions, with *real* problems. And with a few simple words which get us started in the right direction: *"I don't know; Let's find out!"*

PATH OF CONFLICT

I refuse to have enemies.
I have only potential students,
first and foremost,
myself.

PEACE MAKER

Be the destroyer of arbitrary borders,
the creator of paths, of patterns, of bridges,
that connect all peoples.

MATTER & SPIRIT

Where does matter stop, and spirit begin?

This is evidently a question which not only cannot be answered properly at present, but which will continue to confuse the mind as long as it is posed in this manner.

This is because the question of where does matter stop and spirit begin assumes separation in space. If one thinks in terms of sound, however, separation in space is not a part of the problem.

Spirit, or intelligence, might be thought of as a very subtle form of resonance.

This might be a kind of resonance body which envelopes the whole of the less subtle and more dense physical body, the one nested within the other.

There is no separation in space in this view, only a movement of resonance from gross and physically manifest—and therefore measurable—to the more subtle and less physically manifest, and therefore still beyond the instruments and conceptual framework of present empirical science.

MEDITATION—*a way of looking*

Meditation may very well be the natural state of the mind. Rather than simply an art or skill to be learned or achieved, one might instead come to meditation by taking away all the blocks that are in the way.

Meditation then, instead of *adding something new,* might essentially be much more a movement of negation, *of taking away.*

From this point of view, meditation might be something like a great watershed of the mind in need of restoration: remove all the sources of disturbance and pollution, the blocks and dams, and we might once again drink freely from the flowing waters, and see something of the mystery of the bottom of the pool.

ON THE MEANING OF NATURAL LIMITS

Powerful expression in the Arts is channeled
by invisible, yet equally powerful, natural limits.

The mystery of limit is that we never see it, and
yet it guides and shapes every step of Creativity's
dance.

Who has not marvelled at the clear sound of
rushing mountain water? And yet the rocks
that bind together the movement remain silently
in the background, ever-more polished,
ever-more serene.

WILDERNESS IN NORTH AMERICA

A goddess chained to a rock

with on all her sides

the greedy grind of petrochemical lust

racing to road's end—

ready to take the wild bitch for a ride.

Who is to say? . . . Out of the ice . . .

Perhaps that is all we are. Just patterns of waves, and mostly water..

POOL OF MIND—*a meditation*

The mind is like a pool of water

that reflects many mountains.

Rarely, if ever, do we

see the mountains directly.

Better to keep the water pure,

protected, whole.

POOL OF LIFE—*a meditation*

The bite of a trout breaks the surface of the water's morning calm . . .

Small fish are protected by their lightning-fast speed; Large, by their greater weight and water-wise ways. But neither is safe from the folly of the farmer's banker as he in his unquenchable thirst taps off the last drops of the pool's water.

O round pool of an alpine tarn, waves resonating, ringing out into the distance. Who is to say where they stop? See the subtle society of their merging, their complex composite forms.

Some cultures just rush right by, so full of fear are they that the banker will lock his doors before they can make a final run on their cash. Others, give the reading of such waves their complete and utmost attention, protecting the quiet waters upon which they are composed from interferences undue.

As the autumn morning shades into afternoon, a lone golden eagle turns wide, soaring gyres above the pond, first sun-wise, then widershens. I lay back on the soft heather tundra and remember images from the Alps, the past. *"Sempre solo, tutti cresti!"* says the proud Italian mountain farmer. Not far away, a man came out of the time-warp of glacier ice, *Ötzi,* more than four thousand years old, with boots—see the miracle!—made of four different kinds of leather and a layer of matted straw for warmth.

LAND ABOVE THE TREES

Paradise only lasts a day.
Let Time stretch out to eternity.
Let Space open up to the stars.

The new ice you found at the spring this morning is already gone.
See that Lily over there: it only lasts an hour.

Write that love letter you've been waiting for, for a thousand years.
Figure out those equations that Einstein knew he had wrong.

The sound of the rushing water mixes with the late summer wind.
As it always has; as it always has.

Your next life can begin another day.

QUIET WATER

Sitting. Waiting.
The quiet sound of morning water
fed by meager snowfields.

A plane flies up the steeply-walled valley,
the sound of its motor wrapping round itself,
beating, fighting against its own echo—then
tapering off in a low, harmonious hum.

So civilizations come and go,
each in their own time, each in their own way,
yet the sound of their final silence is always the same.

A chickadee goes *tja tja tja tja*
flittering from fir to fir, same lively little bird
of the fiddle-top spruce in the Alps.

The quiet water flows with flashes,
sparkles, faint stars of morning light,
fed by meager snowfields.
Sitting. Waiting.

 The final silence is always the same.

PILGRIM'S PATH

There are many stones on the pilgrim's path.

Under each one lies another piece of yourself.

You trip, you stumble, you fall.

Sometimes, you turn the stones over

and find faded pictures of lost loves,

long lists of things you should have done, or could have said.

But *here*, *now*, at this crossing, which way to go . . .?

Down that jeep-track over there to the city below,

or follow this ridgeline up into the pathless country

of lord-knows-where?

Which way to go, which way to go . . .?

The sound of rushing water rises into the cool morning air.

It's time to go now,

Time to go.

PILGRIM

—for Evelyn Fisher

Armies have sergeants.
Monks have masters.
Pilgrims must go it alone.

Somebody give me a name for the energy
of breaking camp, and heading out—
into the unknown.

The Little Clavier: Part XIV

Aphorisms?

The place where Logic follows
the markings on the Poetry's flower
to embrace in the sweet nectar
of new meaning.

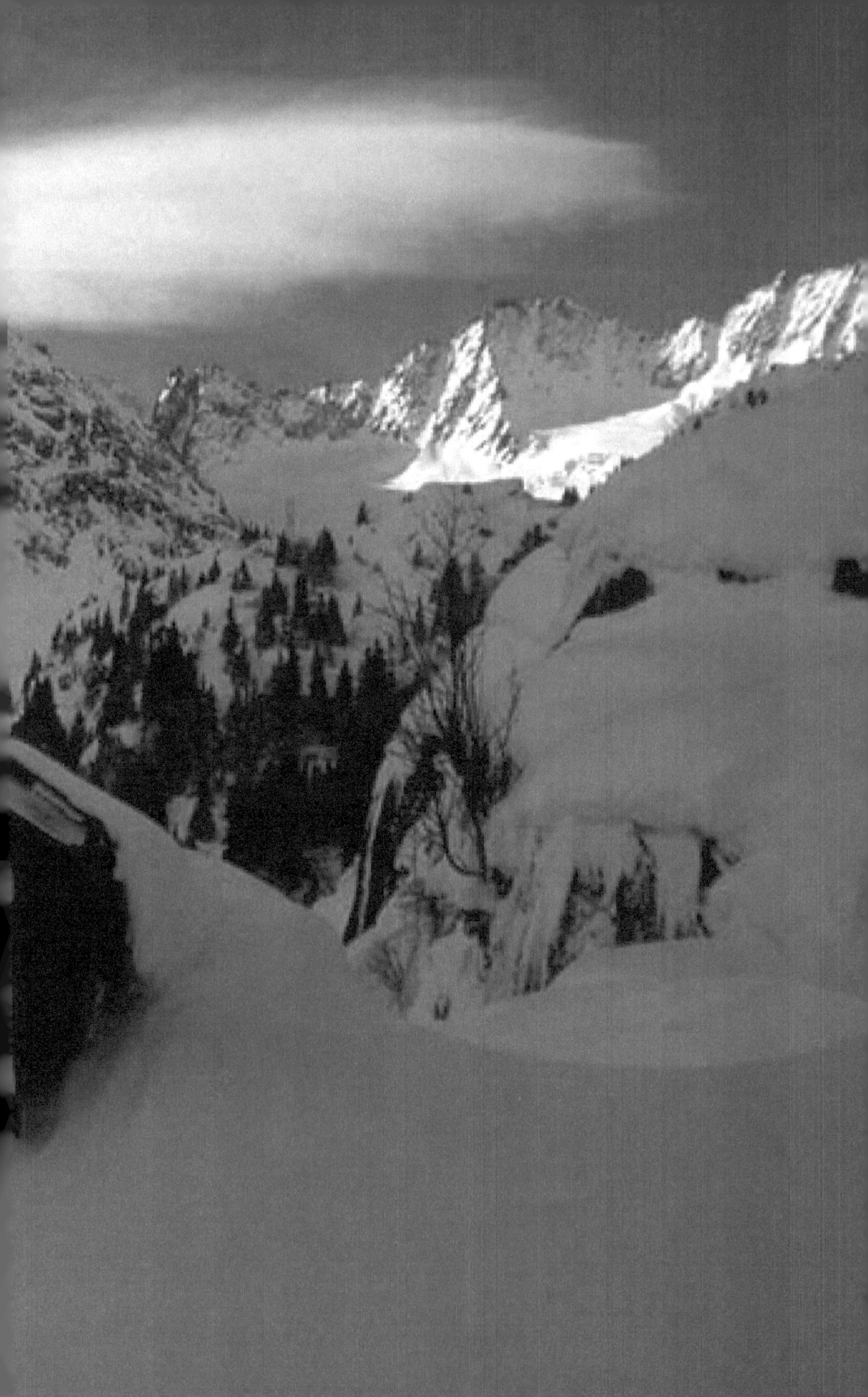

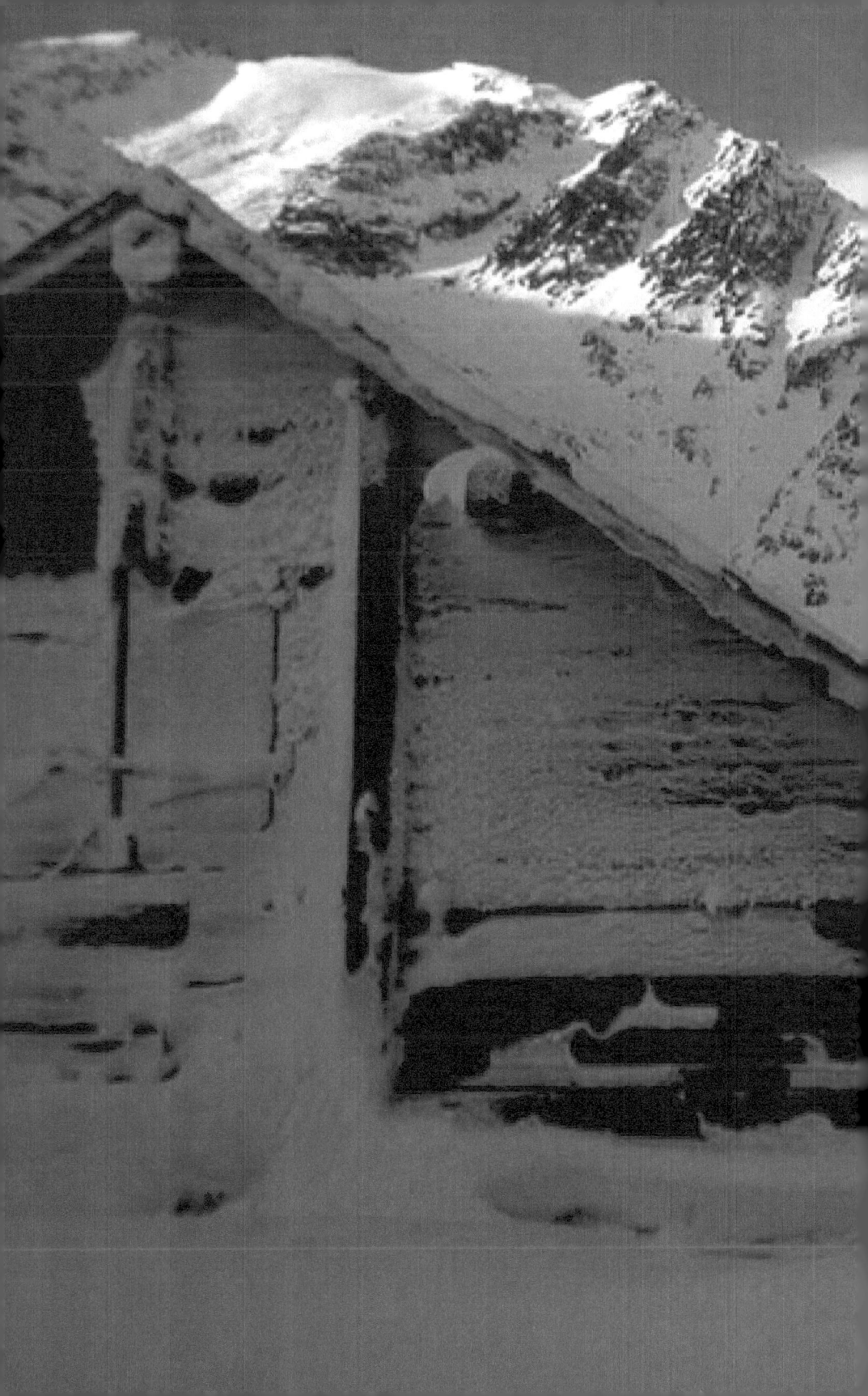

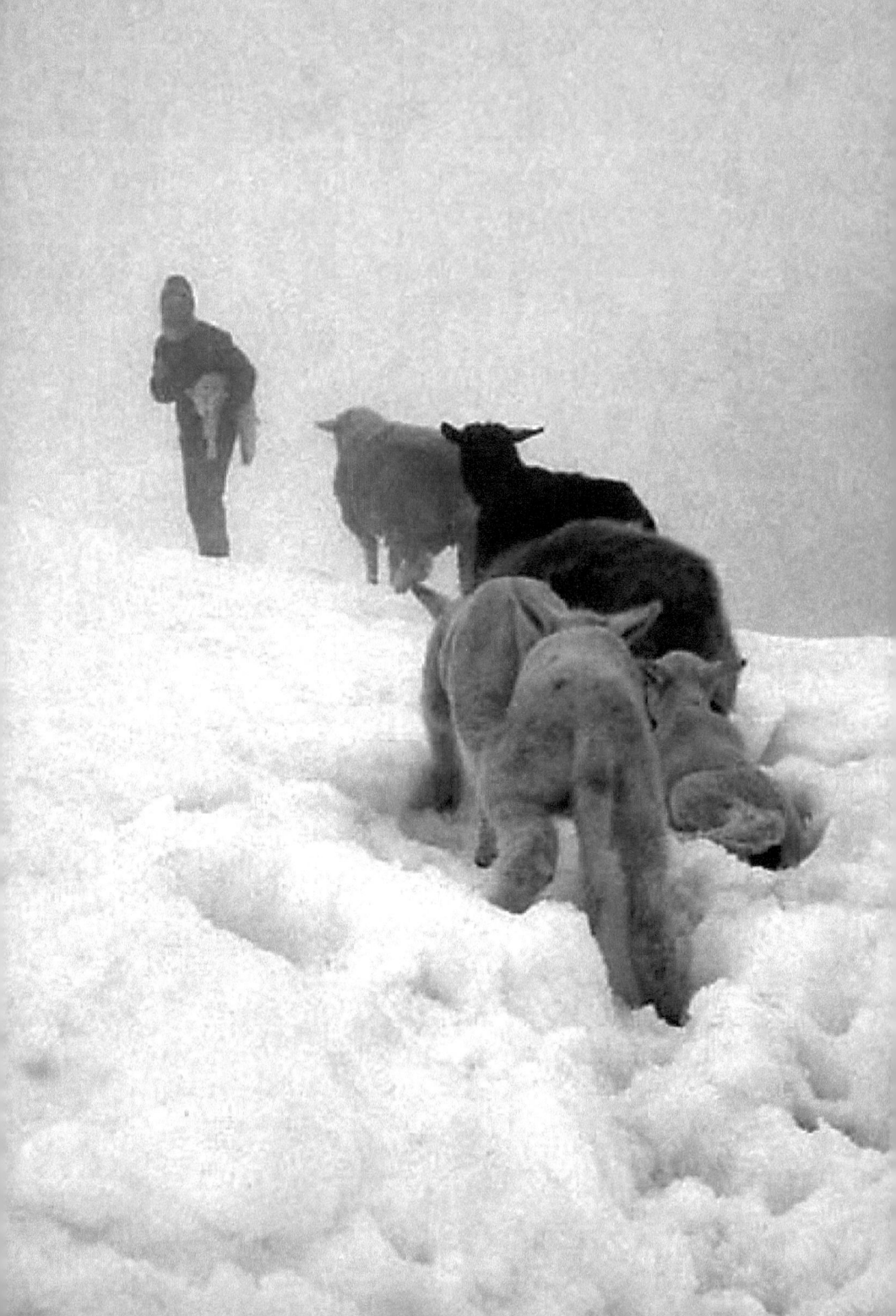

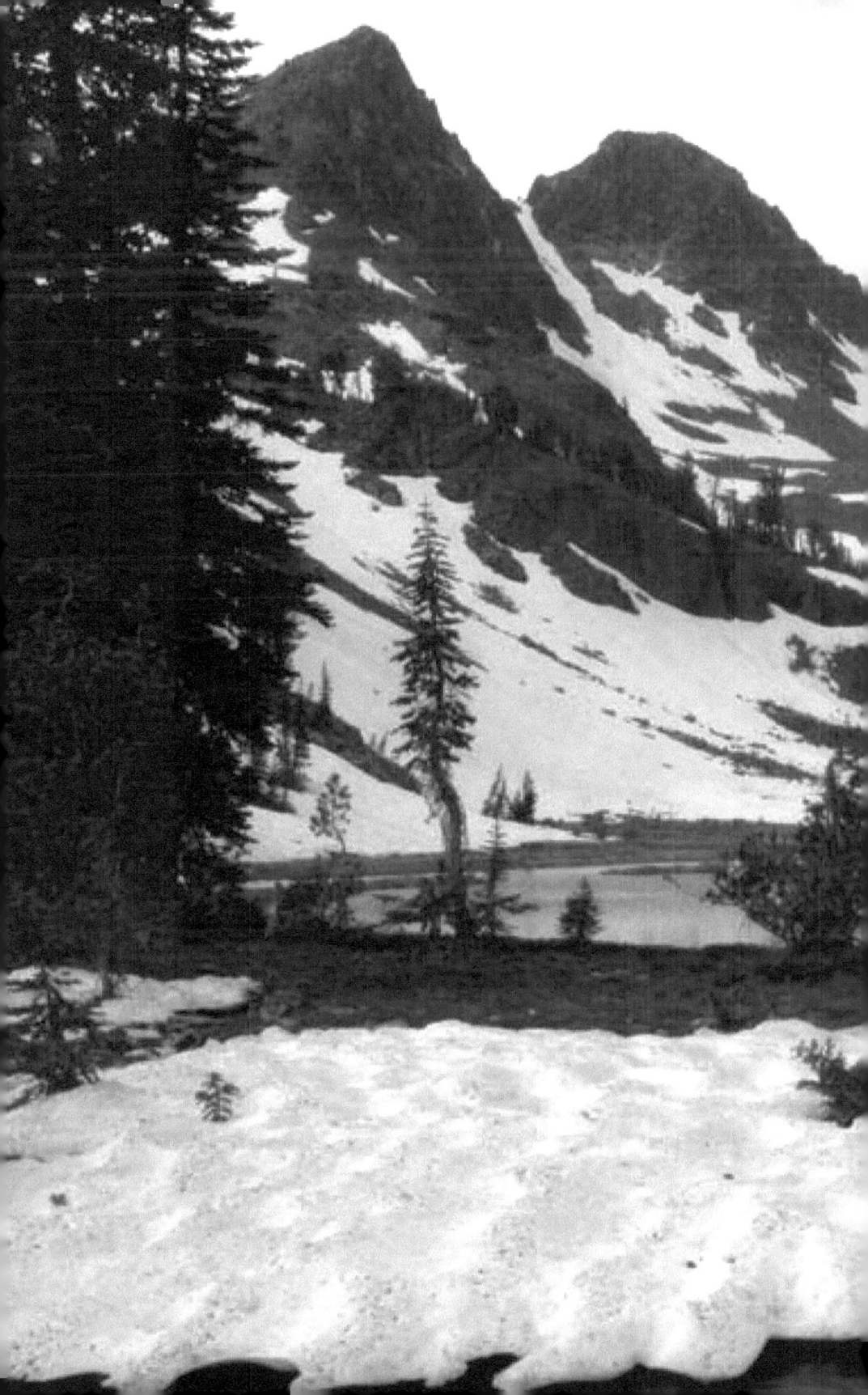

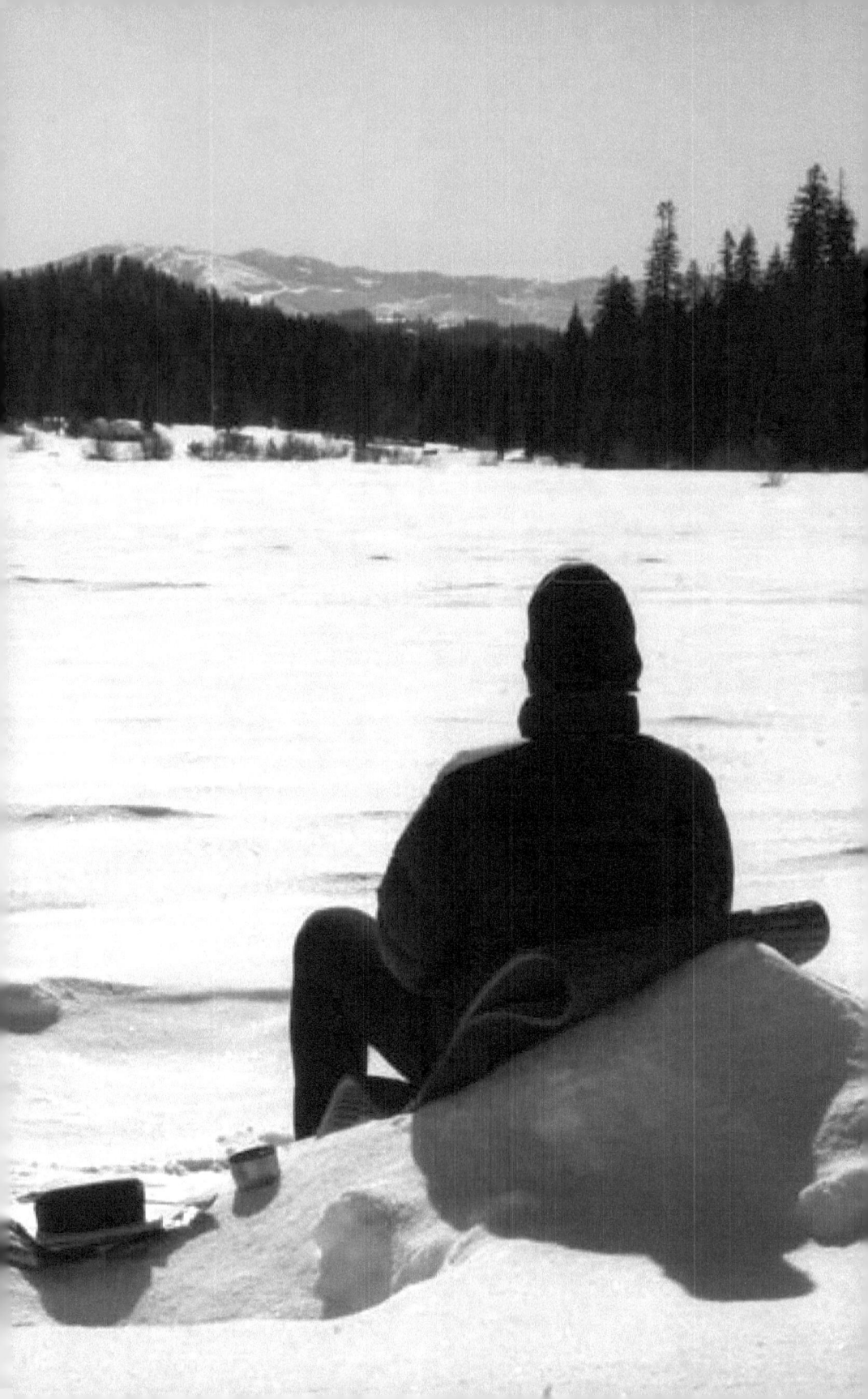

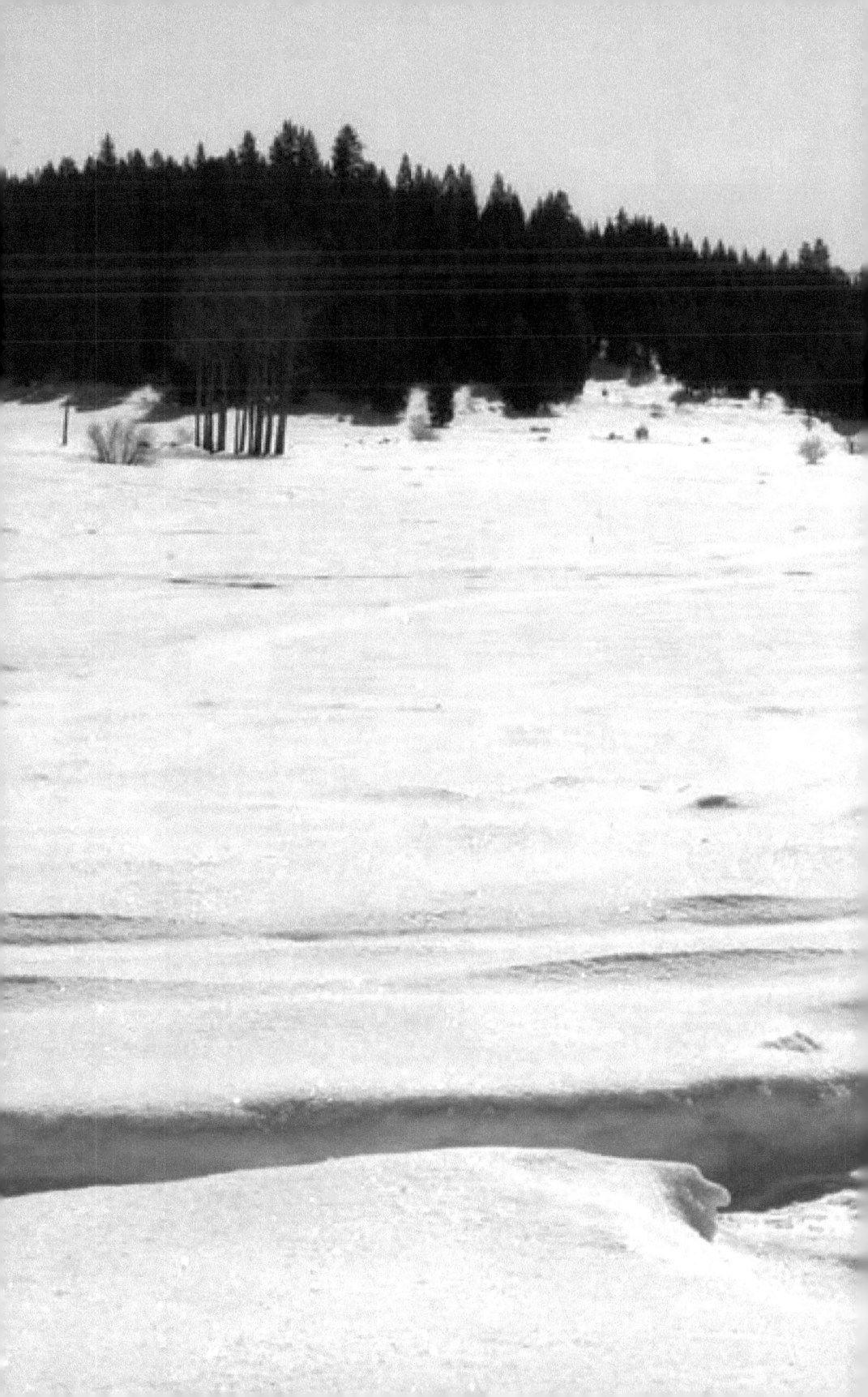

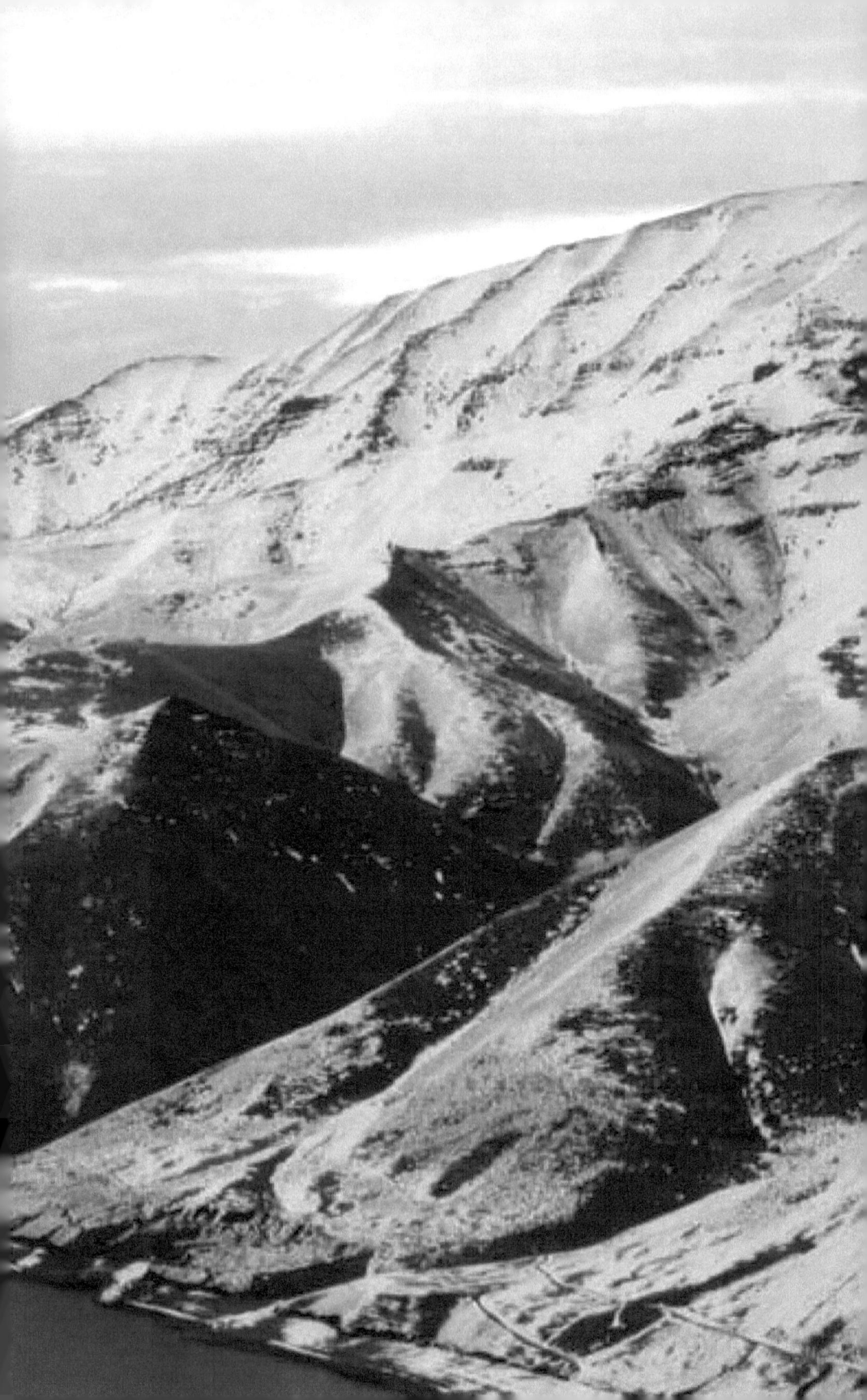

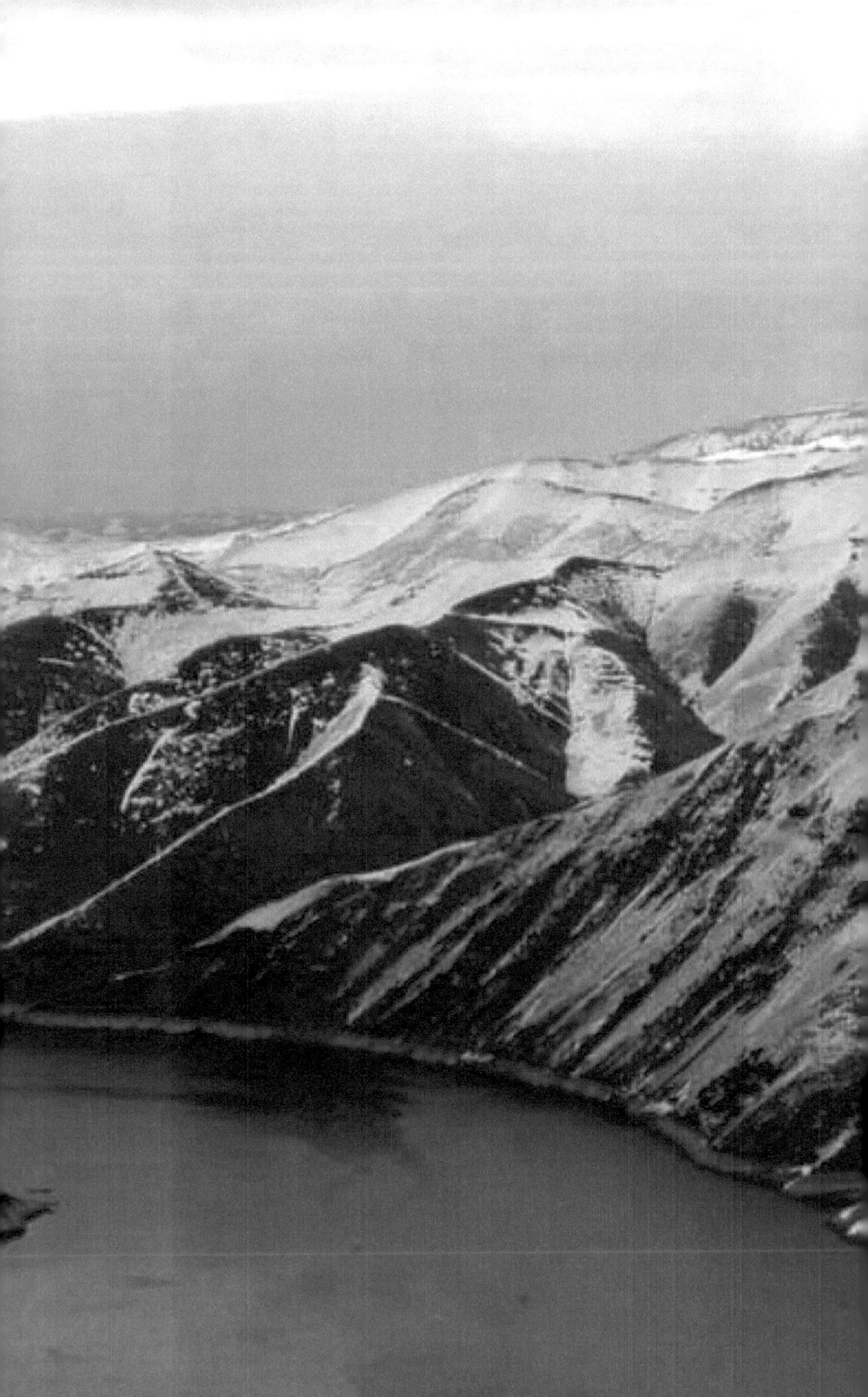

echoed, or reflected, like a mirror made of sound, the different and yet similar sound of the trumpet. But, of course, the trumpet was big or loud, while the piano's reflection was quite small or soft. It was this difference of perspective that gave the sound such a great sense of space, and which dumbstruck the boy. It was as if we were standing together, all three of us, in an immense cathedral or concert hall.

A physicist calls this the principle of sympathetic resonance: two orders of similar movement which merge to form a third which reflects in a unique way both. Notice that the strings must be perfectly quiet for this to take place. And free. That is, not impeded in any way.

The Natural Limitations of Artificial Sound

By way of conclusion, just let me say that the little epiphany of the trumpet / piano anecdote recalled above would not have taken place if we were to substitute the acoustic piano with an electric instrument or synthesizer. Even if the trumpet were to play as loud as possible. With an electronic instrument—even the most current and sophisticated and expensive—the transistors, or diodes, or bits of its circuitry and software remain, as far as us human beings are concerned, totally isolated and indifferent to other voices or sounds played around them, including their own. Now that's a powerful image, indeed. What does this have to do with poetry? I feel very strongly that it would be a good idea to find out.

consciousness as complex as sympathy and compassion are incipiently already present in something as simple as a single silent string. At the same time, it brings out an important limitation—some might say, a tragic flaw, of the current electronic and computer technology. I'll return to this last point briefly by way of conclusion.

In the spirit not of Plato's Academy, but of true Phythagorians, pondering together under starry night skies the significance of rhythm, mode and interval, it is always better to experience an acoustic principle first hand, instead of just thinking about it intellectually. Then when we do think about it, our thought is perhaps rooted in something deeper than mere numbers or what we see on the screen. To bring out the difference, let me share with you a little story:

Once, a number of years ago, a young boy visited a studio I was working in at the time in the Netherlands. I had been out in the forest all day with his father, a Dutch sod farmer, clearing a tangle of Douglas-fir windfall after a freak fall storm. As we were coming inside, a bit cold and tired, the boy saw a shiny little brass hunting trumpet I had laid out on top of an old grand piano that was standing in the corner. I handed the boy the trumpet, which wasn't much more than six feet of hammered brass tubing with a mouth piece at one end, and told him to give it a loud blow. Which he did. Then I said, *"Listen to this!"* while I pushed the pedals down and he played another loud note. I didn't bother opening up the keyboard cover.

He was amazed. So was his father, who was watching somewhat anxiously at a distance. How could it be, he thought, that the piano

Love Song which begins his New Poems:

*"And yet everything which touches us, you and me,
takes us together like a single bow,
drawing out from two strings but one voice."*

Sympathy. Mitschwingen. Moving together. Eight centuries before the Europe of Rilke, the spiritual teacher and seer Mechtild of Magdeburg suggested something very similar, only still more general:

*"And all strings
Which are touched in Love
Must sound."*

So, we see that a great deal is implied in the 'affinity' or 'moving together with' which characterizes sympathy. Especially when sympathy moves on in depth and subtlety to compassion which we might describe, following Jiddu Krishnamurti, as 'seeing the other in myself.' In this context, we might think of this as a kind of resonance which is essentially selfless, or a 'swinging with' the whole of life. This is why, in the poem, the performer is utterly without movement; he is there not so much to play his own song but more as an instrument which manifests the voices he hears around him.

The Poet as Beat-up Piano

Indeed, the mysterious world of sound and vibrating bodies demonstrates to us in the most directly perceptible of ways that aspects of our

Imagine this: The performer—who is the both the poet (as well as you, the listener or reader, perhaps)—takes his place center stage at the keyboard. But instead of touching the keys to produce a sound, as in the above example, he simply depresses the pedals and remains completely silent. Do you sense how the image moves very quickly in several different directions at once? For me, these different possible vectors of meaning all share the same idea, namely, that of sympathy.

A Play of Words and their Origins

In English, the word 'sympathy' suggests a "feeling with" or sharing something of the emotion and experience of another. In other languages of Indo-European origin, the adjective form, sympathetic, also implies 'one who is capable of this', as in a friend who can not only be counted upon, but also who 'reads' our feelings without having to say a single word. Like the Italians say, *'molto simpatico'*, or in Dutch, *'heel erg sympatiek,'* both literally meaning, very sympathetic. Sympathetic in this sense might be used to describe not only a person, but also, for example, something less tangible, like a way of doing music or poetry. Perhaps we could say that this is more than merely like or dislike, but rather a kind of deeply shared resonance or mutual affinity. So instead of seeing the world as composed of static, isolated objects, we are now entering a world of movements which merge and interpenetrate one another. This naturally brings us back to musical instruments, both in actuality and as metaphor. As they say very charmingly in German, *'mit schwingen,'* or literally, 'to swing together with,' like two strings which move perfectly together. Rilke, the great master of image-as-movement, awakens in us this very idea in the famous

transform the notes of an arpeggio—which sound in sequence, one after another, into a rich composite chord, the notes of which sound all together at the same time. (This difference between one-at-a-time of melody, and the all-at-once of chords, much like the contrast between sound and silence itself, is one of those primary features of perception generally which is shared by musical cultures around the world.) The sustaining pedal gives the piano something like a built-in echo chamber; it is what allows an individual performer to create a truly remarkable sense of space of almost orchestral proportions. As is frequently the case with everyday miracles, however, I feel that many classical musicians have in a way come to take this magnificent pedal technology somewhat for granted. But for those of us, who, like myself, are more philosophically inclined and rather less gifted in playing our Bartók and Bach, it is still possible to sit at the keyboard and ponder this uniquely mysterious movement. We hear time—or melody—folding into pure space, or harmony. In a way, this is much like a thread rolling itself up into a skein. One cannot help feeling that something very profound is being revealed to us, but what exactly?

The Affinity of Similarity

Yes, "push the pedals down." Even though the poem is short and rather playful in tone, I do wish to suggest something of this quality of vast space. I also wish to go further and suggest something still more subtle and perhaps a bit harder to visualize, but not to sense: the idea of a motionless or neutral passivity which is at once quiet and yet full of energy, ready to reflect or respond to the world which surrounds us.

THE LITTLE CLAVIER & THE IDEA OF SYMPATHETIC RESONANCE

> *"The illusion that we are separate
> from one another is an optical delusion
> of our consciousness."*
> Albert Einstein

Pedals and the Physical Instrument

For those readers who are not very familiar with actual musical performance practice or acoustics, the poem's central idea may be a bit difficult to bring home at first. The image is one of movement:

*"...we do not play,
but simply
push the pedals down . . ."*

Perhaps you've had the opportunity of hearing a concert pianist perform on a grandpiano at a recital and noticed him or her doing something with his or her feet. Every good instrument has two or three pedals, the most important of which—the sustaining pedal—raises the felt dampers on the piano's many strings all at once. Because of this, the strings may continue to sound even after the pianist has taken his or her fingers off the keys.

This very ingenious mechanism makes it possible to, for example,

THE LITTLE CLAVIER

Each text, each poem,
is a miniature makeshift piano;
they're all tuned slightly differently,
a bit beat up, perhaps,
with a few misplaced or broken strings,
but it's the best we've got.

We do not play,
but simply
push the pedals down,

sitting quietly,
listening to the strings
resonate or sing,
giving back

 voices

hidden within
the marvelous sea of chaos
that surrounds us.

The Little Clavier: Part XIII

In both Music and Poetry, what is important
is not just what we think of as *style* or *aesthetics*,
but rather the quality of energy which manifests in
a piece as we bring it to life in performance.

What makes Music or Poetry relevant or new,
regardless of when it was composed, who is playing
or saying it, or from which world culture it originates,
is the strength of resonance its energy has with the
repertoire of metaphysical urgencies of the present
moment.

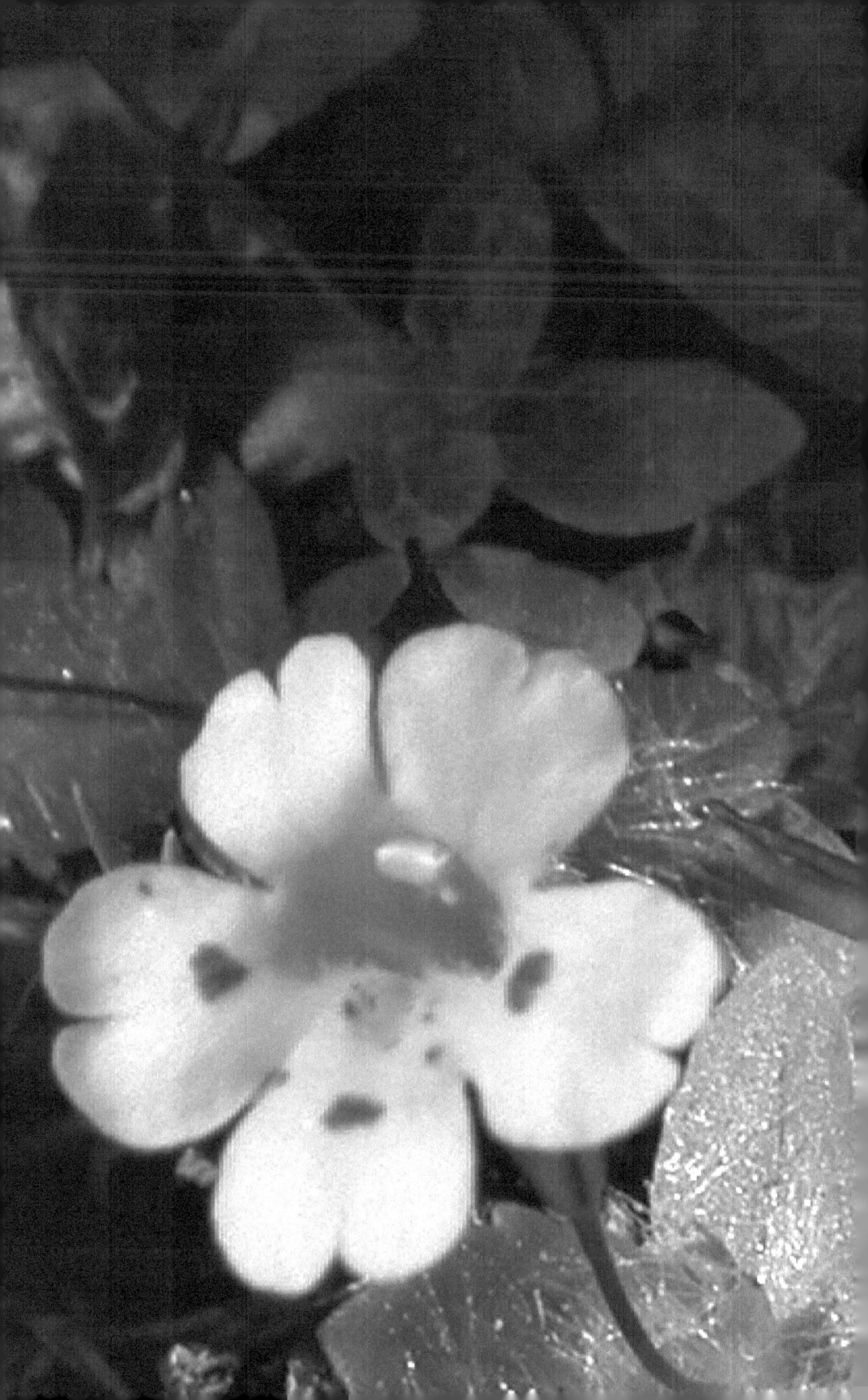

How different the more musical ideal of more with less, I would say, very much more with less. By this I mean crafting each sound, each word, each phrase, like one might carefully polish a multi-facetted crystal of clear quartz. Reading such prose, one finds oneself pondering ideas, thoughts, turning phrases over in one's mind in an open space full of emptiness and silence, just as one might hold a crystal up to the light and admire the wonders of its form.

It is true: this is but an ideal, and a hard one to achieve at that. All the same, I think it's well worth considering.

THE PASS

> The pass is clearly
> in view.
>
> But the way:—
> how impossibly confused.

THE IDEAL OF CRYSTALLINE PROSE

(1) The more in tune with the worlds of nature and the mind a culture becomes, the fewer and fewer words will be needed to say ever-more important things.

(2) Who is to say which is more important: the blackbird's song, or the silence just after.

For me, poetry at its best seems to appear out of the snowy quiet of the blank page. The meanings of this subtle movement of emergence are many. Each sound, each word, each image, is given thereby a certain weight, a certain importance. The rhythms, the rhymes, the repetitions, all come together collectively to form the mysterious composite movement of sound and sense which is each poem's signature, and is as unique as the one-of-a-kind species geometry of a flower, or the unmistakable characteristic flight patterns of a bird.

By contrast, how out-of-shape and verbose does our contemporary prose seem to me. By comparison, it seems to suffer not just from a surfeit of cheap printer's ink, or web-page electrons, but also from a scarcity—a decline to near extinction, really—of seasoned, well-practiced musicians under both writers and readers. So we write mainly with and for the eye, and not with and for the ear, which evidently encourages the run-on, endless mechanical line that no longer pauses, like a practiced singer, to take a quiet breath.

CELESTIAL LEXICON & THE EPHEMERAL SHIMMER OF MEANING

In any language, it is possible—at least in theory—to make a more or less complete map of all the words in its lexicon. Of course, new words can always be added, and old ones deleted, and the map itself might even be included as part of the description. Perhaps one could say that, if it is true that the meaning of words is like a web or constellation of mirrors, each word pointing to or reflecting the significance of others—like stars in the night sky, very brightly for those close by in meaning and usage, and more dimly for those which are far away—then we could say that in some very subtle sense each word contains every other word. These implications might be thought of as *mutual reflecting resonances,* or mirrors made not of glass and light, but of sound. Most importantly, in contrast to the discrete lexicon of a language, which, because it is at any given moment explicit, and therefore in principle knowable, the universe of newly unfolding meanings given articulate form by this lexicon is not knowable in any precise way. This is because the repertoire of mutually reflecting resonances of meaning is always highly implicit and changing. In the future, this difference between words and their explicit definitions, on the one hand, and words and their implied meanings, on the other, will be seen as a primary limiting factor of machine or mechanical intellect. My conjecture is that in the realm of the explicit, machines will match or surpass human intelligence, as they already are beginning to do in chess and checkers. But in the far more subtle implicit realm of meaning, machines will continue to fail miserably. At root, this is because of the difference between *intellect*—bounded, finite, based on the past, and *intelligence*—unbounded, infinite, and open to an essentially timeless now.

IN PRAISE OF COMPLEMENTARY WORLDS, LARGE & SMALL

There are some complementarities that are not only basic, but also somehow essential. One that comes immediately to mind is that in a balanced culture, there will evidently be a need to have both a Lunar *and* a Solar calendar, the lunar for the fickle and feminine, and the solar for the masculine and precise. Another, is an individual's need for both a small, intimate, protected space for the body to rest at night, balanced by the need by day for an open, unbounded, Montana-like sky. We need this, it seems to me, to allow for the wild side of our nature to let go of the known and fully unfold.

A third related essential complementarity is that of the large and small, of the birder's binoculars and the botanist's magnifying glass, or the photographer's wide-angle lens for the big view, and the close-up macro lens to give voice to the myriad miraculous details of the worlds of the small, and the *very, very,* small.

Don't take my word for it. Try it! It's good for the eyes, good for the mind. Like drinking pure spring water at its source, or throwing oneself after a good sweat into a cold, fast-running stream. *Reaching out* to take in the far away; and *reaching down* to bring up into better view the more humble, often neglected, yet oh-so-beautiful world just under our feet.

LOGISTICS

Getting ready for a trek: A thousand things to do and pack up; and a thousand things to remember. From the calm, near-timeless summit of overview, we have order. But in the lowlands of practical reality, where things must be done necessarily one at a time, we have chaos. The problem is simple: regardless of how many thoughts you may have, and regardless of how fast you can write or type—*look at a Mozart manuscript!*—they can still only be written down one letter, one word, one note at a time. Just as when you're packing up gear and food for a trip, all the myriad things on your list of stuff to be done can only be 'walked through,' as it were, one step at a time. What to do? In teaching, whether it be a young student or just oneself, I've come to think that it is important to practice—*actually* practice like a pianist practices an etude—*making a pause* or stopping at regular intervals. Why? Because in the interval of the pause we can observe this nearly universal tendency to run away in an accelerating loop of impatience, or as they say in the Alexander Technique (AT), *end-gain* a goal, or point of completion. I've noticed too that, when the mind runs ahead to the summit when the feet are still in tough and unpredictable terrain, that this is when you're most likely to make a mistake. The pause helps you anchor your feet in the present moment, from which point we can quietly consider the lay of the terrain ahead. And that can make all the difference.

[Note: Why will current western culture fail to manifest the tremendous potential of computers and parallel processing? Because it has lost the once highly refined discipline and sense of the art of polyphony and counterpoint. With multitaking, musicians learn to conduct 4 in the time of 5 and read the New York Times effortlessly all at once. But even Bach could not handle more than six voices. I would say: learn to first program two processors like a real virtuoso! The rest will take care of itself.]

LEAVES

(i)

A single silver maple leaf
falls upon my page,
marking the passage
of this most liminal of seasons.
Sharp north wind
rising high above the sound
of cold rushing water,
scattering yesterday's thoughts
of where I'd be today, and today's hopes,
of where I'd be tomorrow.

(ii)

Perhaps leaves fall simply
to carry away all that we
thought we needed to say.
And perhaps trees in this way
purify themselves each year,
knowing that there is no
thought so large that it cannot
be writ upon the smooth,
plain surface of but a single—
leaf.

LIMITS

In the measure of things, there's always a degree of difficulty, a line drawn in the sand, or in the snow, or on a piano keyboard, beyond which one has never dared to tread. The challenge is to know without a doubt and with complete conviction when it is time, when one is ready, to step over that line. Of primary importance, it seems to me, is the nature of the energy that moves us to venture beyond known limits of any kind. If it's merely a kind of self-centered ego-energy, that would seem to imply the use of brute force, out for material gain, or claim to fame for oneself. Or if it's simply desire, that would most likely lead to the foolishness of mere wishful thinking.

Perhaps the real transcending of limits is something more like the nature of a simple, honest question—the very essence of impersonal intelligence—the *"what if?"* of testing the outer boundaries of the known.

ADVENTURE

Where a well-worn path goes, that much you know. Real adventure begins where the route you have worked out for yourself in advance hits a dead-end, a sure and certain sign that you are entering the realm of the unknown and wholly new. In any venture, this is where one's mettle is tested and the real adventure begins.

space of contemplation, however, these ideas would most likely simply clutter up my head like piles of neglected and knotted-up climbing ropes in a messy garage, showing a bit of promise perhaps because of the bright colors peaking through the oil-crud and dust, but not much more than that.

 I frequently do this working out of ideas with my camera in hand. After setting up a basecamp, I'll go out early to do fieldwork. As I walk, I simply study and photograph whatever presents itself along the way. At the same time, this geometry of ideas plays itself out happily in the background. And then, if I'm fortunate, a constellation of thoughts around a particular problem will just crystallize, and I'll write it down in rough form right on the spot. So, for better or worse, everything you read here has for the most part been composed in this way, while walking out-of-doors.

IDEAS & WRITING AS PERFORMANCE

Ideas mostly come to me in a single complex image or tangle which may take me days of quiet contemplation to fully unravel.

I suppose that I would say that ideas, or new ways of seeing, are my main focus; They are also, if I may say so only because of the context here, my main gift. I mean the latter in the literal sense, as something that arrives in my head *as is,* like it or not, unasked for, and in raw form.

For me, there is an ever-present difference between ideas and writing. Writing I see much more as the discipline and hard work of musical performance. And like musical performance, some days I'll 'will be on,' and others, less so. The idea, it seems to me, is very different, is more a kind of impersonal inspiration, a source crystal or seed of energy that gets the writing, whether it be poetry, miniature, or essay, into manifest, comprehensible form. In other words, if the ideas are more like a kind of timeless, abstract geometry, the performance of writing is just that: a kind of improvisation that can be notated, experimented with, and, with work and a bit of luck, perhaps improved.

To get these ideas onto paper and into the world, the only thing I really seem to need is silence, especially what I think of as mountain silence. Mountain silence is different. *Very* different. This is because it cannot normally be interrupted. The nearest road is perhaps days away. So I can in a blissfully unforced and unselfconscious way let the ideas have the free, unfettered space they seem to require. Without this empty

able confusions or contradictions inherent in the idea of money as we now know it.

We might ask the great explorers who went to the Poles 100 years ago. Or those intrepid men who went to the Moon and back just forty years past. Once those amazing expeditions were 'out there,' so to speak, they became necessarily proud exemplars of independence and self-sufficiency. Yet it was this extreme isolation itself that brought into intensely sharp focus both the limits of such isolation, and the delicate yet movingly beautiful reality of this human web of mutual dependence.

Alone in the physical, earth-bound realm, we are nothing. Remarkably, this is what we grow aware of the further out we go, and the more surrounded by that nothingness we become. And when we are lucky enough to return, we are indeed changed human beings.

(ii)

Always take three of any essential necessity when packing out into the unknown: *one*, for the soothing illusion of independence; *two*, for the pride of the self-sufficient; *three*, for the happy fact of the illusion of independence as you, with luck, find your way back home.

ON THE ILLUSION OF INDEPENDENCE

(i)

The further we go into the unknown of the wilds, the more we become aware, not, as one might think, of how free, or how self sufficient, we are. It soon becomes clear that each of us is nested within a web, a web of human mutual dependencies. We are indeed not just as Aristotle would have us believe, a *political* animal, but rather I would argue a thoroughly *social* one. The difference is that the political aspect of our nature deals more with power, decision making and the just distribution of resources, whereas our social aspect deals more with relationships of mutual dependence and mutual benefit. The latter, it seems to me, is by far the more primary.

For it is a strange thought, is it not? *"I don't need anybody!"* It comes, some say, with money, especially an excess of money. Money, as we all know can "grow" in an abstract way without limit. This gives us the comforting illusion of a natural world which *also* can grow without limit: giant trees that we can cut down forever; oil wells and clear springs that flow on into eternity. Money also conjures up for us a powerful and absolute idea of independence. What I need, I buy. At the neighborhood store, there's an endless supply of apples and coffee cans. I buy one, and somehow, magically, the next time I'm there, another has materialized to take its place. And so on, and so on, we naturally assume, without end. These are the two prime and unavoid-

* Obviously, the absolute number of, *60 beats per minute,* should seen as a relative approximation chosen for the sake of clarity; it can easily slide up or down. Also, the two primary octaves have their implied extensional extremes of 15 to 30, and 120 to 240, representing from very fast to very slow.

***FORCING**—an improvized listing poem* of indeterminate length . . .*

The culture of going *steeply upslope*
when all that is really needed
is a smooth, steady *roll downhill.*

The culture of killing people,
instead of digging wells and building schools,
studying languages or simply shaking hands.

The culture of driving straight off a rock-oil
abyss, instead of simply going outside
and working with the sun.

* in public performance, a listing poem is an indeterminate, open form. Audience members can freely interject their own favorite examples of the list's theme, in this particular case, that of forcing.

just a means of getting from here to there, but more importantly an end in itself, and *actually embodies,* as it were, through us. With time, we are no longer aware of any difference. So the 'seeing' or time-frame or measure of the machine comes to in a large part replace our own.

Let me conclude my argument with the question: how might we test what I am saying here? That presents us with something of a conundrum. There is the logic of it, of course, which admittedly may or may not be sound. But just as importantly, there is the experiential aspect. One has to make the test of giving up mechanized movement, at least for a while, simply to see what happens. I have come to think of this as the *"What if?"* of doing without. What will happen if I don't drive? The first logical inspection is very much a part of our great Socratic tradition in the West. The second experiential part is not. That might just be why we are, I think, stuck in a unnecessarily self-destructive view of the world, the workings of which remain unintentionally largely outside of our field of critical vision.

If it is true that the tempo of walking, and the tempo of human perception are essentially one and the same, then it follows that a town or city or house based on measures derived from respectively *5* or *100 kh* will look and feel totally different. We are now, it seems to me, living by and large not in a human world, but rather a 100 k world! Walking the world may happily very well be the only way a young designer can discover the truth of this for him- or herself.

example, the classical musics of every world culture have all developed and explored this same, common, temporal tree, each in their own unique but at the same time interrelated manner. So what I'm suggesting is in a way, up to this point, self-evident and obvious: that the roots of this great temporal tree are found in the tempo of the pulse, the natural speed or tempo of walking, and, indeed, other human movements of every description and kind. Taken together, they form a central measure of perception.

My next contention, however, is less obvious: that this center of perception has been shattered or corrupted by the very different pulse of machines. In other words, as you step behind the wheel of your admittedly in some ways sophisticated automobile, I'm saying that, instead of the car giving you vastly stronger and faster feet and legs, it is really the other way around: *you are providing the car with eyes.* What you see is what the car would see, and not a normal, sensitive, intelligent, aware of his or her environment, human being.

My argument in its simplest form is this: *each species of machine has its own characteristic measure.* This measure is then superimposed by force on the very different measure of human perception. The mechanism involved is not complicated. We become conditioned and habituated to the imposed mechanical measure. We also come very quickly to tacitly assume that it is not just the only natural way of seeing things, but what is more, we actually come to crave it. This is because of the way, especially as in the case of the automobile, it has not only been culturally sanctioned, but also held up as a universally understood symbol of social status and power. In other words, the car has become not

ON THE TEMPO OF PERCEPTION (II)

Human perception, it seems to me, is inextricably intertwined with the speed or tempo of the human heart beat or pulse. In turn, the pulse conditions our sense of motion in bipedal movement or walking. If we take 60 beats per minute as the mean, or center, or reference point, then its doubling of 120 is fast, while its halving of 30 is slow. So there are but two central *octaves* or *doublings* of tempo: 30 to 60, and 60 to 120.* These together form what we might think of as a kind of perceptual temporal tree.

tempo tree with 4 doublings or octaves

Of great significance in human creative endeavor is the manner in which this basic framework or temporal measure is then further subdivided and refined, yielding a richness and subtlety without limit. For

HOW TO PROTECT AN ALPINE MEADOW

Hike there.

Find water.

Sit.

Move as little,

and stay as long,

as possible.

MOUNTAIN RHYMES

Better to leave too early,

Then too late.

But if you never risk a fall,

You'll be home too early,

Or never climb at all.

SEEING

I tell myself: To study Nature, learn to see;
To learn to see, watch seeing in action;
To watch seeing in action, observe the blocks,
the dams, all the stuff that's in the way.

HOW THE WORLD CHANGES

Don't waste time trying to save corrupt politicians,
or reform corrupt institutions. How much better
to start afresh and teach the young! It takes but nine
years to educate a entirely new generation. Of scientists,
of artists, farmers, and healers.
At the entrance way to your school of a wholly new way
of being, place but one sign with three imperatives:
"All you who enter here, leave behind your old ideas
of war, of fear, and of waste."

WOMEN IN THE WEST

See that older woman over there? They say she was here
before sagebrush. And see the other, the young one fixing
the rockjack hold up the fence her grandfather built? They say
she's the child of a prize Chicago bull and opera singer
from Amsterdam. A smile stretching from here to Kansas,
Heart hiding behind rings of fading promises,
Hair let down only when safely out of the wind.

CENTERS OF LEARNING

We shape the world and the world shapes us.

It takes more than a school to educate a child; it takes, as they say in Africa, an entire village, a village deeply rooted in place.

In each life, learning has a center.

The teacher is the one who helps the student find it. Nourishing content, and a free, open, protected space in which this center may clarify and flourish, are the cultural imperatives of any community or tradition dedicated to the fostering of creativity in the young.

NOTE TO MYSELF...

If your pictures are not good enough, it's most likely not because of poor equipment or technique. More likely is that you're not living close enough to your subject. *Be out, be exposed, be on foot.* The rhythm of walking will generate the energy which burns away the opaque, faded film clouds over the new with 2nd-hand images out of somebody else's past; the downtime of sitting out storms in your tent will develop patience and a compassionate, steadfast heart. Who knows? One day you may go out sleepy-eyed in the middle of moon-lit night and stumble upon the scene of your life. Who knows?

...SUNSIGHT / SUNCLIPSE...

The great 20th century poet-philosopher of design and inventor of the geodesic dome, Buckminster R. Fuller (1895-1983), introduced the complementary concepts of sunsight and sunclipse to replace the traditional words, sunrise and sunset. He argued—very convincingly in my view—that our language should reflect the actual turning or rotation of a spherical planet Earth on its axis, instead of the ancient illusion of the Sun making an arch over an essentially flat surface.

You can test your own intuitive perception of this movement in the following two ways: (1) See if you can answer quickly and without strain in which direction the Earth turns; (2) Make with your hand a circle which corresponds in direction to the Earth's rotation. Few people can do either one. My experience is that most indeed can tell you where the Sun 'comes up'—is sighted—in the East, and where it goes down in the West—is eclipsed by the Earth. But few can tell you where the Sun will be at mid-day!—South—and fewer still can move their hand West to East, earthwise. Remarkable, don't you think? These two little tests ought to be enough to convince most of us that we do indeed still live and think in terms of these powerful illusions of Flatland.

HORSE THIEF!

When a rancher goes to bed with 10 horses in the barn and wakes up with but one, he cries out, *"Horse thief! Get-'em boys!"* But when the investment banker goes to sleep with a billion and wakes up without a cent, he books a family vacation to Disneyland, courtesy of the President.

SUNSIGHT!

—for Mark Simmons

Sunrise. *No!*
Sunsight. *Yes!*
Fuller was right. Each morning,
the Earth turns to greet the Sun.

We are all turning.
The Muslim turns.
The Christian turns.

Even *I* turn, with my religion
without a name.

WALKING THE WORLD: *Look at the Mountain!*

Having physically touched and lifted countless rocks, my eyes sense effortlessly the mountain's rough, cold texture, its immensity, its great weight.

But this image, while certainly as real as it is beautiful, is still just an image, strangely ungrounded, distant. Looking through my glass, I notice how the sight of two climbers slowly crossing a steep snowfield instantly provides not only proportion, but also a feeling for absolute size—a kind of kindred presence, bringing that which is far away closer to home. And yet, to actually cross the snowfield oneself—step by step, breath by breath—is in some profound sense truly to make the mountain your own. And that's the wonder of walking: it threads the world and oneself together into one, inseparable weave. I say the world is not just seen, but made—made with the soles of my feet.

THE FITTING TOGETHER OF THE WORLD . . .

The idea of a *niche* comes to us from the Latin, *nidus,* which means nest. But this is here not the deliberately built nest of, for example, birds. It is rather a space which is taken advantage of by one species, and provided almost by accident by another. A rock wall provides both physical space and an appropriate growing habitat—protected from wind, lots of warm West-facing sun exposure, and a constant trickle supply of summer snow-melt water. Part of the charm of rugged alpine environments is the abundance of these fitting relationships.

The Little Clavier: Part XII

Chance proposes; *Intelligence* disposes.

No one can predict which flower the butterfly will pass by next.

(iii)

Gold flattens; pyrite
shatters. Streams of useless thoughts, but
one in a million withstands the

hammer of

truth. The patience of
water rounding the hardest rocks.

SEPTEMBER STREAM—*three 37-step poems*

(i)

Triassic shale gives
back the light of quiet water,
September:—O month of watching

for the moon

of new snow. How bright:—
this clear blue of Oregon sky.

(ii)

Cats that look into
mirrors always see other cats.
Magpies know the truth. Shale looks the

same for a

quarter billion years.
Flashing waters of constant change.

the life of one channel only
which does not change, which does not change;
where sense stays at home, alone, a-
fraid to venture out,
and becomes
precisely, neatly, bounded in

time.

Break the string
and the stars
at night will fail to cohere and

start to fall,
no longer turning
around their centers,

no longer,
threaded together,
in song.

THE LITERAL MAN

Stretched between the most distant of
stars and the
sparks which fly from the
candle's match
is the silver string of
young intelligence,
a vibrant face among the flowers,
resonant with the music of all

springs.

Still close
to the ground
where perception begins, before
thought's cells grow thick and woody walls,
and where meanings still
flow and freely merge,
where triangles and squares become
rounded in rhyme, and where the moon
is an apple on the
tree which has its roots in the sky.

Break the string
and the apple falls
into the lap of an unhappy
grown-up, eyes dull with
years of TV,

I would strongly argue here, that the way of non-violence must seek to redress imbalance and injustice with bold and fairer laws, which in turn will insure as no force of arms could ever do, the ongoing stability of the rule of law itself.

LIFE WITHOUT POETRY . . .

> *"There's no money in poetry, but then there's no poetry in money, either."* Robert Graves

Imagine a world without shadow. The end of photography.
Imagine a world without echo. The end of music.
Imagine a world without the rhyming of meaning that is metaphor. The end of poetry.

Worlds in which nothing is hidden, nothing implied, and nothing resonates beyond its own boundaries. Dry, harsh, lifeless worlds in which the human spirit only with great difficulty can survive. This is the world ruled by the literal man. For the literal man, everything means exactly what it says. It is a world reduced to shards, bits, broken pieces that are perceived as the hard, necessary, unavoidable facts of daily life.

No more, no less. Life without poetry.

As the apple falls, so too does the moon? *Pure science.*
Moral compass? *Pure poetry.* Where these end, we enter an unknown, pathless land. *Pure religion.* Always more, never less. Life with poetry.

AGAINST THE SCOURGE OF RUNAWAY ABSENTEE OWNERSHIP

If Freedom and Democracy are to thrive, the rights of land ownership must not only be protected, but also strictly limited. In the absence of limits, the acquisition of land, just like money, inexorably accrues exponentially. This hoarding of land—by far the most essential natural resource upon which freedom and democracy depend—undermines its just, reasonable and equitable distribution.

Inherent in this, is that we must beware and protect ourselves against the implied metaphysics that money gives one the right to do anything one likes. Clearly, Laws and the Constitution give one rights, not money.

Responsible, ethical limits on the ownership of land might be: One has the right to no more land than one can work; no more land than one can care for; no more land than one can protect. And, most importantly, these rights may only be asserted by one's actual presence on the land.

At present, as *wealth* goes to *wealth*, *land* goes to more *land*, creating a world-wide growing underclass of citizens who are permanently forced below the threshold of ownership. As this division grows, as it now as a matter of imbalanced systemic necessity *must* grow, the resulting gross inequality builds a pressure which will eventually lead to instability and collapse.

HYPERLINK

We shape the world and the world shapes us.

There are those inventions which impose structure on the mind, forcing us to think in unnatural ways as we might walk with one foot tied behind the back;

And there are those inventions which are already implicit in the workings of the mind at its very best, letting us create with all the ease of freely flowing water.

The humble *hyperlink*, tying together all the unique thoughts of the world without arbitrary limit or boundaries, brings home and makes explicit a key fact of the new era—that the mind of humanity is indeed somehow one.

MONEY?

Money? A movement
which always seems
to be going
in the wrong
direction . . .

ON THE NECESSARY UNITY OF FREEDOM & DEMOCRACY IN THE WORKPLACE

Just as there can be no partial freedom of speech, there can be no half-way or partial democracy.

Democracy at the ballot box without democracy at the workplace is like being able to freely choose which train to get on, but having nothing to say about *when* and *where* to get off. What kind of freedom, what kind of democracy, is that?

SOCIAL ECONOMY

What is the difference between a Market Economy and a Social Economy? One is based on mere profit; the other is based on both profit and ethical responsibility.

Clearly, a necessarily self-destructive feature of all Market Economies is that they ultimately will ravage the very foundation or ground upon which they depend. This is so because this is the easiest and most direct route to monetary success. Social Economies, on the other hand, because they are by their very nature *self-limiting,* must necessarily, like a good farmer concerned about the long-term health of his or her soil, be concerned about fair distribution and long-term sustainability.

we pursue the thread, regardless of where it leads us, we are unavoidably going to be in for some shocks and highly disturbing information. The sweat shops and child labor behind my favorite running shoes; the half-lives of all the toxins found in their soles. The flame retardants in the laptop I love and depend on turning up in the breast milk of young mothers in the far Arctic North; or a kid in India, or China, or Africa, working barefoot atop a mountain of electronic waste, eking out a living by stripping away the equally toxic metals of the same computer once I'm forced to throw it away. Or, coming back to our first example, the coffee farmer in the high-country of Ethiopia who explains that he gets only 3 cents for each kilo of green beans he produces, and looks straight into the lens of the camera as he tells us that he needs at least 8 or 10 cents just to survive.

So one sees that the beauty and the strength of the triangle of relationship, just as with the musician with whom we began in the natural world of relational resonance, is that—like it or not—both harmony and disharmony are necessarily revealed. Both the good and the bad. One can't have one without the other. This is a fact. And perhaps this is why the ethical awareness of the compassionate mind has evolved out of the inherently self-destructive isolation of the brutish brain. Where does this intelligence come from? Simply our genetic structure? Or from some much deeper and more subtle source? As with all really fundamental questions of existence, we find, I think, as we follow the triangle of relationship far enough that we are led to a point where we can only say with the honesty a small child demands, *"I don't know."* For here the known world ends, and the uncharted land of the spiritual wilderness of the extraordinary human mind begins.

makes it possible to blend and tune with oneself and others, we very quickly wish to stop singing altogether.

Now, if we go one step further and generalize this movement of resonance and think not just of sound but also relationship in terms of meaning and responsibility, we have, I think, the beginnings of a strong model of ethical awareness. Here we have the image not of sound, but of a woven fabric. I pick up a strand or thread—any thread, it makes no difference—and simply follow it to its source. This naturally reveals others connected to the same thread, as well as how the thread is woven into the fabric of the larger whole. Take coffee, for instance. In isolation, coffee is just a savory, pleasant, habit-forming stimulant for which we as users naturally wish to pay the best possible price for the best quality. But if we begin thinking about coffee with the relationship triangle in mind, a far richer story is revealed as we follow the highlighted thread of a single pack. It leads us to those who market, distribute, process the coffee, and most especially, those who actually grow and harvest the beans. Ultimately, we are led to the wider earth-bound ecological context which sustains both the growers and the coffee plants themselves.

If we follow this path of relationship, notice first that there is in principle no real fundamental difference between the ethical and environmental dimensions of awareness. They are but two inseparable aspects of the same movement, one which emphasizes *responsibility,* and the other which emphasizes *understanding.* Second, notice that in the current era, coming as we all do, including myself, from a state of radical isolation and fragmentation, the more consistently and energetically

about them or act towards them, indivisible. That is, when we pick up an isolated object, we are in actual fact picking up this triangle of relationship. We can easily imagine this in a visual way, say, like taking an apple and mapping out the normally unseen relationships not just to my own body as I eat the apple, but also to those who grew it, delivered it to the store where I bought it, as well as perhaps the actual place—the orchard—where it was grown. We might also imagine the triangle in terms of sound, as for example a singing voice in a large reverberant structure like a concert hall or cathedral. We have the sound of the voice as it appears to the singer him- or herself, but also the sound of the voice as it appears to others who listen to it in the same space. And, of course, there is the acoustic space itself, the wider context of what for the singer is the whole world, both literally and in the ritual sense.

Thus, we move naturally and easily from the top of the triangle, *me,* to others, *we,* and to the world or Earth, *all,* and back again. Notice also that this movement occurs both one-at-a-time (like musical melody), and all-at-once (like musical chords), a feature which is very unlike visual mirrors, but distinctive and natural to relational resonance as a whole.

With this sonic image in mind, it is easy to see the distortional nature of isolation and fragmentation. Think for a moment of the same singer, but now in a space completely devoid of resonance. Musicians find such spaces deeply disturbing. *"There's no echo!"* they say. They call such spaces 'dry' or 'dead.' In other words, the room or hall gives nothing back to them. So, it comes as no surprise that, without the natural sustaining resonance of echo, which both gives energy to the sound and

ON THE TRIANGLE OF RELATIONSHIP

The strength of the *triangle of relationship,* it seems to me, is that it in a gentle yet forceful way lifts us out of the isolation of the linear, fragmentary style of thinking which is so characteristic of Western thought. The basic idea is that, for every thought, every action, and every resource or artifact, there are always at least three sides, or three questions we must ask: *How is this thought or object related to myself; How is it related to others (society or culture)? And how is it related to the Earth, or the wider context?* Here's a rough sketch:

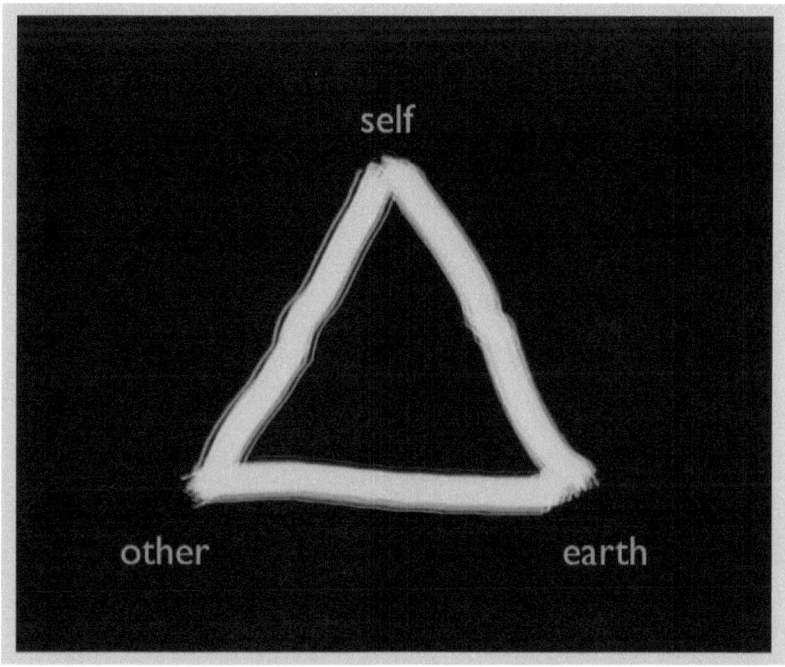

The key point is that these relationships co-exist in a movement of relational resonance which, although they are normally implicit and largely invisible, are at the same time, regardless of how we think

general sense of Earth, with a highly seductive yet largely unreal reality which speaks only to a very limited portion of the entire spectrum of human intelligence, thereby creating unawares a cycle of corruption in our basic perception of both ourselves and the world around us.

THE SOUND OF DISAPPEARING GLACIERS

The sound of disappearing glaciers
is not the sound of raging torrents,
or of thundering cascades.

It is the faint murmuring sound
of a thousand rivulets and rills
flowing ceaselessly, day and night,
day and night. with each turn of the Earth:—

 a thousand more.

(2) *Computers Down*

Computers also make it dramatically easier to . . .

—clandestinely monitor all aspects of our intellectual and personal lives, both past and present, and thereby grossly and in the most insidious of ways violate our right to privacy and other basic civil liberties;

—create vast informational networks for ever-more centralized runaway economies, which, because they are virtually invisible, are shielded from the negative human and environmental consequences of their own internal contradictions;

—generate increasingly complicated stores of what is perceived to be strategically vital information, which, because they are vulnerable to attack, must be protected by ever-greater covert measures, leading in turn to a general and all-pervasive ambience of fear and mistrust;

—break apart the *Universal Somatic Constant,* or the necessary unity of body and mind, in all human creative activity, leading to a dangerously illusory culture of disembodied artifacts and relationships;

—drive Art and Science away from the guidance of spiritual and philosophical insight into the highly fragmented realm of theories *based solely on inferences from other theories* and *data-sets derived from a narrowly specialized instrumentarium;*

—replace our sense of natural Time and Space, as well as our more

sustained and serious efforts of communication and understanding;

—make explicit and real the already implicit interconnectedness of not just one isolated group or nation of people, but rather the whole living web of humanity.

[Image: *Junk computer:* According to 2005 EPA estimates, ± 1.5 billion kilos of e-waste were trashed that year. This is a sure and certain sign of the failure of the ethics / metaphysics of current economic and governmental structures. My own view is simple and straight forward: *Zero pollution; 100% recycling; Zero war. Begin with the work of cleaning up the thought which thinks it's not necessary; then the one which says it's not possible.* The idea of waste is an outmoded concept; all waste should be seen and used as resource!]

A TWO-PART MEDITATION ON BOTH *THE BRIGHT* AND *THE DARK SIDES* OF COMPUTERS & COMPUTER NETWORKS

(1) *Computers Up*

Computers make it dramatically easier to . . .

—transcend arbitrary borders or limitations of any kind, thereby bringing people and new meaning together in unexpected and creative ways;

—develop new, both quantitative and qualitative, descriptive languages of especially movement, which may be modeled and displayed freely across networks in both the more traditional numerical, visual and auditory ways, as well as via other modalities yet to be discovered;

—greatly diminish the corrupting influences of both outward material wealth, as well as outmoded and divisive religious beliefs, as the primary determining factors of culture, creative tradition and shared worldview;

—introduce a new appropriateness and simplicity of design, made possible by more co-operative, open, and democratic work processes which more easily call attention to inconsistencies, contradictions and unnecessary difficulties of every kind;

—break the cycles of violence presently conditioning human interaction on all levels by replacing dominance and aggression with more

ON RELEVANCE

> *"Information is a difference that makes a difference."*
> Gregory Bateson (Mind and Nature: *A Necessary Unity*)

To keep your little lifeboat of meaning afloat in a turbulent sea of misinformation, full of the riptides of false, irrelevant data and treacherous whirlpools of consumer temptation and potential debt, stay close to the coastlines of the broad, historical, polycultural view.

Learn the languages of foreign ports of call. Seeing things for oneself from many different perspectives naturally lifts the best view up into awareness, like a single bright beacon one suddenly sees clearly on a distant horizon.

And when the mist of night closes in, keep your moral compass close to your heart, and let it point to the true north of sound, ethical principle. Always: First, do no harm.

But don't take my word for it. You can easily test the theory for yourself. Experiment. Pull out the plug. And best of all, get in the habit of walking, going on treks, immersing yourself for an hour, a day, or a whole week or two in wild nature. And because you can only take so much with you, you must go through the ritual of deciding what. What are the essentials; what can be left behind. It is a life-long discipline that reveals more than I can say.

HITTING THE MARK

As the Spartans said, and Aristotle echoed, there are infinitely many ways of missing the mark, but *only one way* of hitting it. Ah, such beautiful, clear, granite-like logic, but Nature tells me this is not always true.

See the fragrant Spire Fir: narrow in its form as a church steeple; And see the broad, wide-open crown of the ancient Stonepine, with its bottle brush clusters of needles, large purple cones in only the highest branches where the Nutcrackers can find them, and such flexible limbs.

Two contrasting forms, two different solutions to the same problem, but both somehow hitting the target of a highly adapted form and the structural strength which can deal with long, cold winters and more than 10 feet of snow. Hitting the mark, indeed.

a word and simply observe how things progressed from there. The first thing I noticed is how the three other slightly younger musicians were magically drawn into this contemporary digital object of desire. They could not keep their eyes off of it. Now meaning, especially musical meaning, is a mysterious thing. What the cellphone-as-hip-consumer-artifact *did* and *does* is in a way not just disrupt or break apart the focus of the rehearsal space; it totally usurps meaning and attention. I could before my very eyes see this wonderful élan vital that great music gives young people go straight down a dark, dank hole into some demonic high-tech abyss.

So, the two great dangers of high-tech distraction in the view being sketched here are: First, this break up of awareness to the point that it cannot focus creatively on much of anything. And second, as people become more aware of the first tendency, there is a very real danger that they will simply react mechanically without understanding and *reject all new technology* altogether. My feeling is that we are already seeing a radical increase of both.

The whole purpose of this kind of philosophical discourse is here simply not to be swept away by a growing wave of irrational sentiment concerning very real problems. I would argue for a more measured approach. As I've outlined elsewhere (see *The Liberation Triangle* below), as far as children are concerned, the first thing to try doing without is television. Why? Because commercial television, in dramatic contrast to the computer, is distraction not because of abuse or misuse, but rather *distraction by design.*

must ask themselves now is: which is more important, a kind of background which encourages a calm, steady, focused state of awareness, or one which is constantly connected to random bursts of mostly non-relevant, i.e., *disturbing* information.

The more subtle and less obvious aspect of this problem is that, as I like to say to friends, if you think you *can* be interrupted, *you already are*. In other words, at a deeper level of our psyche—the part of us, say, that will without the slightest bit of training sit straight up in the tent with a shock of fear upon hearing what one thinks is a bear walking around a camp in the middle of the night—this deeper level of the psyche constantly monitors in a wonderfully unconscious way the potential for disturbance. It does this evidently so we can give our attention to other, more important matters. So my theory is that we are by immersing ourselves in this chaotic sea of potential high-tech interruptions overloading this inner circuitry to the point of abuse and near break down or collapse. In other words, just the mere possibility of interruption is simply still more interruption in a yet more insidious, subtle form. Such thoughts do a lot more mischief at deeper levels of the psyche— both public and private—than I think we realize or are willing to admit.

Let me illustrate this idea with a little anecdote. One of my passions is teaching, especially the performance of classical music. Well, once not that long ago, I was working with a string quartet made up of North American young people. The cellist was late to the rehearsal. She then walked in, sat down, and even before tuning up, put her cellphone on the floor in front of her. I was new to this, so I thought I would not say

tential, not just information, but also distraction. Now that the Internet and the Web are for many people "always on," even when on the move, the problem of the mind wandering off to read and send messages or read news reports, watch videos, etc., has become nearly universal. In other words, the contemporary mind, whereas it has been tremendously amplified in its creative power by all these new technologies, has at the same time become a mind which is essentially in a permanent state of distraction.

It's interesting I think that the sound of the word "distraction" itself reveals that it is closely related to other states of psychological concern like "disturb," or "fracture." We have in the Latin root of distraction two parts, *dis* = "apart"+ *trahere* = *"draw* or *drag."* So the image is one of one's self being dragged apart, as it were, like the two horses of a chariot taking off in different directions. But what precisely is being drawn apart? In the most basic sense, it is my awareness or my attention. Attention we might think of here, following Krishnamurti, as an unforced state of mind which is unique for this very reason of being undivided, and is altogether different from *mere concentration,* which always has something forced about it because of a division of some kind.

I discovered for myself something about the nature of distraction some time ago in my troubled relationship with telephones. For me, the problem is straight forward: *I don't like them.* I noticed that I do not want to be interrupted, especially not at random intervals, and even more especially interrupted by sharp, loud, sounds of any kind. So, for better or worse, I got rid of phones in my life. Already twenty years before the introduction of the now-dominant cellphone. The question everyone

HIGH-TECH / NO-TECH

The simplest and most powerful of all possible tests is the test of doing without.

As far as I can see, there is only one way to understand the relationship between myself and the technology upon which I depend: *do without it for awhile.* In the quiet interval in which the machines are turned off, I can observe both what they give, and what they take away, both how they empower, and how they disempower.

I think of this as a kind of high-tech fasting. This is fasting in a very much more general sense than we usually think of it. It is fasting in the spirit of asking a question: *What will happen if I stop doing this?* In questions of diet, for example, it is easy to see how this works. What will happen if I stop eating overly sweet, or salty, or fatty foods? I simply stop eating these, and within a week or two, my body comes back with an answer.

With technology like cellphones and wireless laptops, this fasting works in essentially the same way. I stop using them for an extended period of time and see what happens. Leaving the problem of the potentially harmful constant immersion in electromagnetic fields of varying strengths aside, what is interesting about these digital tools is not just how they work in and of themselves, but also the fact that they are now connected to an unprecedented non-stop world-wide web of po-

The Little Clavier: Part XI

Well-connected? When you know there *could* be a disturbance, there already *is*.

* * *

Well-connected? Nothing holds two people together as strongly as deeply shared intention and meaning.

(iii)

A circle of stones
burned black as raven night. Deep, dark,
bare, blank centers flashing with the sparks

of stories,

of rhapsodies sung.
O young eyes shining with new light.

FIRE RING—*three 37-step poems*

(i)

A circle of stones,
sure, silent sign that others have
camped here around fires before me,

shared sense of

safe stars under high
firs and night skies. O bright clear flame.

(ii)

A circle of stones . . .
always round and never straight squares,
offerings of flat ground and cool,

clear water,

that sharp, crisp, crackling
sound of fire—fires past, future, now.

HIDDEN LAKE—*a rhyming children's poem*
in common 4/4 time

for three young teachers from Portland,
Susan, Scott & Phil

Water at rest wants to be round,
Clear crystal mirrors that hold and reflect,
The echoing waves of wind and sound,
A place to remember, love, and protect.

Water at rest wants to be pure,
So summer nights new stars can be found,
Upon its surface the planets seem near,
While songs of Toads and Thrush abound.

Water at rest wants to be round,
Clear crystal mirrors that hold and reflect,
The echoing waves of wind and sound,
A place to remember, and save from neglect.

AN EYE TO THE SKY

A long time ago, I noticed that television and radio weather reports, great resources that they may be, create not only a kind of worrisome dependence on their often—at least in the mountains—inaccurate information, but also take away our motivation, perhaps even our innate ability, to look and read the clouds for ourselves.

I have noticed also that the best readers of weather I've met where the older mountain guides and hut caretakers in the European Alps. They seem to watch, to be alive to every minute change in the alpine environment. Not just the shape and movement of clouds, but also the winds at different altitudes, the behavior of birds and other wild animals, the sound the mountain streams make, the sound the snow makes under their boots at last light. And they invariably go out two or three hours before sunrise to read the night sky.

The reason why these guides are so watchful is simple. Everything depends on it. A climb is first completed with one's safe return, and having auspicious weather conditions is frequently the determining factor.

Awakening this 'eye to the sky' should be a part of every young person's education. Just as awakening a sense of the limits of any technology, like television and the nightly weather forecast, should be a part of every enlightened teacher's objectives.

(3) *We shape the world and the world shapes us.*

Humans are the only species that does not live in a world of fact. Think of it. We do not really directly see the world as it is, but rather as a complex map-like representation. A cattleman's, a goldminer's, a developer's, an ecologist's or a conservationist's map or representation of exactly the same territory will look very different. That is because they each abstract or draw out from any given territory a different set of what they see as potentially relevant facts and features.

Because we possess this extraordinary capacity to create an unlimited supply of these alternative representations, each with their own varying degree of truth content, we are also provided with a unique and unlimited opportunity to *falsify*, ignore, deny or lie about facts. That is, as long as we can get away with it.

So we play false, largely because of some form of self-interest, both individually and collectively, with our great natural gift of representation. The task of Philosophy and Metaphysics is to help clean up the resulting mess and keep as honest as possible the rules of the game.

(4) *We shape the world and the world shapes us.*

Adaptation? A million solutions to a single problem—change to fit the fact.

FOUR MINIATURES ON *SALT & SUGAR MAN* AND EVOLUTION

(1) *We shape the world and the world shapes us.*

Just as an excess of sugar and salt in the diet drives appetite into the much-will-have-more of culinary runaway, an excess of sex and violence drives film and TV into the obsessive frenzy of too-much-is-never-enough. Evidently, imbalance seems strongly to favor a kind of synergistic co-evolution in multiple, parallel dimensions simultaneously. Either way, junk food for the eye, or cheap thrills for the tongue, both are not just, as the saying goes, 'tasteless.' More importantly, they leave us with the sad, ever-dissatisfied feeling of self-abuse, an abuse which quickly degenerates into the most hard and fast form of cultural habit. So the salt & sugar man develops hand in hand with the couch potato sex & violence connoisseur, verily an evolving subset of a potentially new species, an *Homo seduto* shall we say. Yes, *"Man with his ass glued to the seat of a chair."*

(2) *We shape the world and the world shapes us.*

From the ecological, energy household perspective, a deficit of input—especially of an absolute necessity—may become a major force or drive behind creative leaps of the evolutionary process. Who is to say that the wings of flight were not adaptations to the fact of great distances between ever-scarcer sources of water?

ON NORMS

Norms or standards follow the way of the basic asymmetry between *creativity* and *destruction* in Nature: it takes a thousand years or more to grow a giant sequoia. But it only takes a few thoughtless moments to cut one down. So it goes also with ethical norms. One single act of torture, and the work of more than two hundred years of constitutional law and civil rights is instantly called into question. One single act of torture, and the suffering and heroic work of countless generations of setting ethical and humanitarian standards is razed to the ground. One single act of torture, and for the whole of the enlightened world, America is always a torturer. That is the knife-sharp edge which necessarily separates *creativity* from *destruction*, and ultimately, may very well also separate freedom from tyranny.

WORLD MIRROR

It is possible that the number of mirrors present in a culture is inversely proportional to the depth of true self-knowledge encouraged therein. In other words, the more mirrors in my living environment, the less I know myself. Why might this be? Perhaps because not reflective glass surfaces, but rather relationships—with myself, with you, and with the world around me—are the real mirrors which reveal in every moment *who* and *what* I am. Perhaps one could say, that I only can know myself as reflected in the face of the other, in your face, in the face of the world, so to speak. So what am I waiting for? *Break the mirror!*

ON JUSTICE & TIME—*a meditation*

Justice neither looks forward nor backward. In my view, that would be to make the fundamental error of placing justice in the stream of time. Justice, it seems to me, when seen as a formative principle guiding ethical action, is essentially timeless. In a way, we might say that justice is like the motionless, neutral center that balances the two sides of the judge's scale.

Justice is then about the imbalance caused by wrong action, and is not necessarily or essentially about what is normally thought of as retribution or punishment. I would argue that justice is first and foremost about truth, and about coming by means of calm, reasoned deliberation to the common ground of a shared perception of what that truth is.

An implication of this view of justice as timeless is that great wrongs of the past, such as colonization by force, or the wholesale destruction of natural preserves for monetary gain, or the deliberate corruption of the democratic process, do not just go away because we choose to ignore them, or hope that the ever-more opaque mists of time will continue to hide them from critical view. Rather, these wrongs remain active in a remarkably insidious way, like massive troubling presences looking down upon us from a spiritual or intellectual realm. That is, until they are somehow, by bringing them into the clear light of day, resolved. So, justice neither moves forward nor backward. It does not, in fact, move at all. It's simply motionless, and like the neutral, unbiased center of the judge's scale, allows the evidence to be weighed, and the truth to be told.

powerful, popular support. All the more reason to see fundamentalism for what it is—a reflex of the animal, brutish brain gone haywire. Crucially important, is that the very act of seeing liberates because it disempowers the destructive self-righteousness of its illusions.

NATURE'S CIRCLE?

Between the sharp needle of the Spruce and round leaf
of the Water-lily, Nature draws her circle.

ETHICAL DESIGN

Repair, reuse, recycle—the three imperatives of a new spirit of ethical design. Ethical, because it expands the circle of moral and legal responsibility to include the whole world of creation and the living Earth. Imperative, because it sees with granite-like clarity the necessity of the first principle of all design: *no waste.*

PARTING WAYS

When meaning and intention are no longer shared, it is never an affront to anyone to simply pick up and walk away. If a path is not shared, movements may very well be at odds, contradicting one another, each cancelling the other out, like a phrase recorded by one, and then erased by the other. Part always in friendship, with the knowledge that your life-paths may well again meet and converge in some not-that-distant possible future.

in all its forms lies entirely outside the realm of scientific and rational discourse. It also for similar reasons lies entirely outside democratic debate. Yet, ironically, fundamentalism is notoriously easy to harness by demagogues to undermine democratic values by means of the democratic ballot box. It thus poses a unique double threat to otherwise stable democracies.

What is more, fundamentalism will usually feel that its very existence is under attack by this open and free spirit of science. Indeed, it will frequently feel the need to go on both a highly confused and a uncivil counter-offensive against various representations of the scientific community, whether they be institutions, journals, or individual researchers. And if history teaches us anything, this tendency of such *ad hominum* attacks is to degenerate into wholesale outright physical violence.

The source of this wayward tendency of belief to become absolute—as distinct from the benign *relative* form of belief which assumes something to be true only in a provisional way—is evidently a malfunction of thought as it seeks security in what is essentially a extreme form of self-isolation.

So, in an era of sharply increasing population and diminishing resources, the resulting increasing lack of security, would lead one to expect a parallel rise of fundamentalism and absolute belief. That, indeed, is exactly what is evidently happening. What is more, the mechanical nature of the energy behind this movement easily lends itself to be amplified a thousand fold by the virtually unlimited resources of authoritarian oligarchies. These are either fundamentalists themselves, or worse, simply eager to exploit its inherently obsequious nature as a means of building

reverberate throughout the wider community, or the human-plus-natural-environment, as a whole. As always, the first principle of ethics is: *First, do
no harm.*

ON FUNDAMENTALISM & ABSOLUTE BELIEF

> *"Whenever a theory appears to you as the only possible one, take this as a sign that you have neither understood the theory nor the problem which it was intended to solve."*
> Karl Popper

Fundamentalism is the tying up of the energy of intelligence into a knot of absolute belief. It thereby prevents the natural awakening of the compassionate, ethical mind.

Fundamentalism's key feature is rigidity, rigidity in the way it holds onto one particular way of seeing, and the intensity with which it will refuse to admit the validity of alternatives.

This means that fundamentalism of any kind, whether it be of a spiritual, or political, or of a more social nature—is essentially irrational.

In contrast, if we accept that the essence of a more enlightened scientific attitude is the willingness to drop a belief or theory when it appears to be contradicted by experiment or fact, it follows that fundamentalism

ON FREEDOM'S NECESSARY BALANCE

Primum non nocere
(First, do no harm)

Freedom is always a question of the balance between *freedom to,* on the one hand, and *freedom from,* on the other.

I might feel, for instance, that I should be free to mine for gold upstream from your homestead. You, in contrast, may feel equally strongly you have the right to be free from the danger of the cyanide from my leech ponds getting into your well-water. Or I might feel that I should have free, unrestricted access with my new snowmachine to any wilderness I choose. While, you, in contrast, feel I shouldn't even be allowed to take the thing out of my garage.

Clearly, the task of the rule of law is to protect in a fair, balanced, reasonable way both freedoms, carefully weighing the *pros* and *cons* in each case in an ongoing way. Balance between the two freedoms is not a fixed state, but more akin to keeping a bike upright as the rider shifts his or her weight, now to the left, now to the right—counter-intuitively—in the direction of the fall.

Notice, too, that freedom balanced in this way is always *ethical freedom.* Why? Because real balance demands that there be no arbitrary limit to the width of what we might call *the circle of concern.* That is, it is freedom that must be necessarily mindful of the myriad potential negative consequences of actions undertaken by free agents as they

I think to study seriously Mandelbrot's work. And, of course, because of the in principle unlimited number of steps involved in their generation, we can make good use of the largely untapped processing power of the now ubiquitous home computer to make them visible to us.

That is, or we can just step outside and study the great and wonderful symphony of the shapes of flowers, of ice crystals, or of the clouds overhead!

(All of the left-facing pages of the 21 chapter headings of THE LITTLE CLAVIER feature *black and white fractal patterns* especially generated for this collection of poems and texts.)

FRACTALS AS PATTERNS OF RHYTHMIC MOVEMENT

Fractals are the discovery of the convivial and brilliant French mathematician, *Benoit Mandelbrot.* Mandelbrot noticed already when he was a young student that he had a unique ability to solve equations by visualizing them in his mind's eye. Later, this gift became essential in his quest for a new geometry, one not based on the simple squares and triangles of Euclidian textbooks, but a geometry that would more accurately describe the complex forms of nature like the serpentine flowforms of rivers and coastlines, the ragged edges of ridgelines, or the pattens we see pass by everyday in the heavens above. Indeed, he is constantly reminding us that *"clouds are not spheres."*

Whereas the details of the formal mathematics upon which fractals are based are for me I'm afraid something like a horizon I'm strongly drawn to but which retreats as I try to come near, I greatly enjoy looking at them as a kind of meditation on form. I experience fractals like I do all natural form, not as static shapes, but rather as complex composites of rhythmic movements. In other words, I experience them as a kind of abstract music.

The three key generative principles of fractals are amazingly simple. In my own words, they are: (1) self-similar patterns; (2) manifested at differences of scale; (3) by means of an, in theory, infinite number of rhythmic repetitions or iterative movements.

Music indeed! Any composer, or photographer, or poet would do well

in some future re-manifest with

a new bag? Again, who can say definitively?

Evidently, at death's door, no godlike Janus,

seeing both ways, past and future,

stands watch at the threshold.

That is the beauty of the bag.

All bets are off.

All bets—both the good & the bad—

are all one's very own.

See the beauty of that.

THE BAG OF GAMING CHIPS

At birth, we are all given
a bag of gaming chips,
maybe a hundred or so.
Some are willing to spend
their whole bag simply to climb
a mountain, or write a symphony, or
find a cure to militarism.
Others, like mothers, give their bag wholly
to their children without a second thought.
While still others hoard theirs, pinching
each chip until their last troubled
breath runs out.
This is so, I say to you.
But see those people who might and do
steal others', steal our chips. Sometimes the
whole bag. Think of that! What shall we call this?
Evil? Greed? Cupidity?
Or perhaps those who steal our chips
are simply somehow lost, like small children
who have been abandoned, forgotten, locked out of the school.
And then we might ask: Is a chip a minute, a second, or
a year? Who can say?
And does some essence of ourselves

right on my composing tablet may,

once put under the neutral hammer of truth,

be but more shiny, attractive—

yet oh-so-easily shattered—

 fool's prospect.

MONEY AS NOTHING

New to the West? Don't be a fool

looking for gold!

The real money is in nothing!

The nothing of the insurance man

making millions out of the nothing,

the misfortune, that does not happen to you;

The nothing of the banker

who makes millions out of the nothing

that backs up his loans;

Or the nothing of the powerful industrial war-maker,

presidents and whole congresses in his back pocket,

the man who makes billions out of the nothing

he is about to make out of us all!

FOOL'S PROSPECT

Dear reader: What do you honestly think?
How ought I best spend my days?
Should I dig in dank dark loam for new poems,
or ought I better be out looking for specks of real gold?
O, how I envy the industrious ant,
those little beings who rule the world,
but a mere millionth of my own weak weight,
dragging past me
the lifeless carcass of another species
very much larger than itself.
What booty! What satisfaction
at work well done!
No doubt or hesitation there!
Yet here I sit and scribble away
at works as useless as they are hopelessly ignored.
Away with meaning and beauty, I say. Enough!
Money is what I lust for. Pockets filled with cash.
A thousand plastic cards. More loans from God,
from the Devil, who cares!
And then, as my pan comes up empty again,
reality strikes with nothing to show for my work today,
nothing but cold hands and a sore back,
O slowly, slowly, slowly . . .
How slowly I learn to see, to hear that all that sounds

The Little Clavier: Part X

Humans are the only beings in Nature who are constantly preoccupied with what they are not.

WITHOUT

A world without light or
sound is thinkable,

but not a world
without
movement.

My contention here is that, because both extremes violate this natural order of movement, they are also both potentially and in a remarkable way extremely destructive. They both place themselves, so to speak, outside of natural movement by either *refusing to move,* or by *refusing to* stop *moving,* One could say that both sides of this refusal defy the central ordering principle of limit, which in turn is both the complementary side of freedom and a key feature of the dynamic balance of all self-sustaining, renewable, natural cycles.

One expansion of this idea into the realm of finance I might mention here is how the mathematics of compound interest results in equally destructive cultural movements: one grinding the debt of the already poor and landless into an absolute insoluble toxic standstill; the other running away exponentially with more and more wealth going to the already rich, seemingly without end or limit. Remarkably, in an almost identical way to natural systems, this imbalance must necessarily lead to total collapse. And also remarkably, the key missing concept or feature is again simply limit.

the total absence of movement

exponential runaway growth

TWO EXTREME FORMS OF DESTRUCTIVE, NON-NATURAL MOVEMENT

ON TWO IMPORTANT EXCEPTIONS TO NATURAL MOVEMENT

The natural web of life has deep roots in both space and time. Its strength is not just its resilience, but also its ability to quickly adapt to change. These changes may be small and hardly noticeable, or large-scale and catastrophic, but both are frequently initiated by what are essentially chance events. The responses, however, are *anything but* determined by chance, and are rather swift adaptations shaped by highly developed forms of natural intelligence. This complementary back and forth of chance and necessity results in a deeper formative ground which is remarkably free of waste and contradiction.

Two uniquely problematic forms of movement which are evidently not native to this web of life, but which are characteristic of humans and the artifacts which we produce are: First, *the total absence of movement,* as for instance where toxic wastes accumulate in life-web environments as essentially dead, inert weights because of their inability to break down and thereby become re-assimilated as new components of natural cycles; And second, the other extreme of *exponential runaway growth.* This occurs, for example, when species which are not part of the life-web are for whatever reason introduced, and then go on to fragment or tear apart the fabric of interrelationships and dependencies. Because such runaway growth is clearly a movement which is, as we say, *out of control,* it contradicts what I see as the universal principle of natural limit.

This tendency to fall back is made very much worse by those who for whatever reason do not wish to go along with fundamental change. In the shadow cast by real innovation's forward momentum, there will always be those who will remain doggedly committed to the old, outmoded technologies, like nuclear energy and fossil fuels, perhaps because of some special, vested interest. Or because a knowledge base is still widely available, and a generation or two of highly trained technicians are still eager to continue the old way of doing things. It's only to be expected. But from the wider perspective, these are just natural, temporary slips on the bright if sometime difficult path of progressive change.

HERE

On the way,
many beautiful camps
offer themselves for the night.

But to know,
when to keep walking and
when to stay,

and, after stopping,
to know without a doubt
that this place, where one stands,

here,
I am at home.

FALL-BACK

With all fundamental change, we should prepare ourselves for what I think of as *fall-back*. This is a sudden slide back into an old habit of thought and action.

Say, I quit smoking. Then one dark and rainy day, in a moment of weakness, someone offers me a cigarette, and I'm right back in the old groove again. Or, we decide to take apart at great cost the horrendous mistake of atomic reactors, and begin the complicated task of getting rid of all the hazardous waste. Then one thoughtless day, oil and electricity prices soar, and suddenly we want to turn the reactors back on again. (This is actually taking place in Holland and Germany right now as I write this, and made very much worse by the confused and confusing rhetoric and, in my view, false promise of so-called *third* and *fourth* generation *(fast breeder)* reactors.)

The transition is always from old to new, from an old regime or pattern of movement—and way of seeing and thinking—to a new, better, healthier one. This process or period of change from one state to another should have a special name. It is always an exacting, exciting time, alive with new challenges. But it is also a vulnerable, tender time, like spring, in which new, emerging growth can be frozen dead in an instant with the return and harsh indifference of a late winter's frost. But see the reddish tinge on many new shoots and leaves. It's natural 'antifreeze,' Nature's way of protecting new growth during the transition time from high-country spring to summer. We would do well, I think, to mimic the wisdom of this kind of just-in-case protection.

This is clearly where mother nature and wilderness may come to our rescue. As it has so frequently in the past ever since humanity came to live so far away from the land in large urban centers, getting out hiking or backpacking is a way of finding our roots, our grounding again. Without going to extremes, if you can carry enough food on your back for just a day, I do not for a moment doubt that you will get a sense of all five stages of doing without, perhaps even a taste of freedom. It's like crossing a pass. It really is. At first you think you'll just never make it. But if you can somehow persevere and keep going, step by step, you may just make it to the other side. And it's all downhill from there.

Habit: (1) pain; (2) doubt; (3) reversal; (4) hope; (5) freedom.

Five Stages of Freeing Oneself from Habit

In closing, just let me note that the implications of what we have seen about habit so far are considerable, especially in terms of the young. One of the strongest indictments of current economic systems I can think of is the ruthless attempt to colonize the tastes, wants and desires of the young child through the propaganda of advertising, most of which takes place sitting hour after hour, day after day, year after year, in front of televisions.

This is what I meant when I stated that, the more subtle the habit, the less serious the attention Western culture gives to it. Whereas the body is deemed worthy of a whole host of largely counter-productive protections, the mind, or spirit, or psyche of the young child is for all intents and purposes completely up for grabs. Appalling, indeed.

time and resources; at worst, it may be tragically self-destructive.

By now, you may ask, *"If habits can so easily be dealt with, and at the same time potentially cause so much harm, why don't we act?"* The answer will in an experiential way become self-evident if you personally try a little doing-without yourself. Not necessarily with food. That might require the professional help of a nurse or doctor. Start small. Try turning off your TV, or computer, or cellphone for a week. Then remember: our little epigram above says, *"the simplest of all possible tests,"* not the easiest!

What will very quickly become painfully obvious is that it is not just *not* easy, it is in fact incredibly hard. At least at first. And that's the answer to our question. Every adult knows the classics symptoms of the pain of withdrawal when we suddenly stop ingesting or taking some substance we are habituated to like coffee, or tobacco, or worse. Addiction is from this point of view simply an extreme form of habit. Nothing more. And the Western bias of sanctioning some addictions like coffee, or chocolate, or alcohol, and prohibiting others is just that: a bias of a specifically cultural and arbitrary kind. Generally, the more subtle or a part of the intellectual realm the addictive habit is, the less it is considered as such, and the less it is considered in Western culture as something of concern. That too, is completely arbitrary. (More on this below.) My contention is that, though the object of habit can evidently vary without limit, habit itself as a pattern is always the same. And, what is more, that the reversal of habit—untying the knot as it were—is also as a pattern more or less always the same. In a future essay, I hope to describe in more detail what I have come to think of as the *Five Stages of Freeing Oneself from*

small child that has difficulty focusing on reading and other learning tasks, both at home and at school. Or that you have, for the sake of our example, all of the above, which is frequently the case. Then you read something about high fructose corn syrup allergy and suddenly realize that both you and your child drink two or three cans of soda a day. As a test, you decide to stop drinking soft-drinks altogether just to see what happens. Note that I'm not saying one should or should not do this; it's just the principle I wish to make clear. And what is clear is this, I think:—the elegance of the approach. See for yourself. What would you rather do? Take your high blood-pressure medications with Coke, or just stop drinking Coke altogether—most likely the root cause of your problem—and get off your medications entirely?

Now, what exactly are we stopping? Clearly, it's a kind of habit, is it not? Habits, in the view being explored here, are of key importance. They come in all sizes, large an small, and varying degrees of subtlety. And they by no means merely concern food. It might be something else, like watching TV for hours on end without a break, now nearly universal in Western culture. Or it might be the habit of always driving wherever you go, near or far, even if it's the grocery, or the library down the street. Collectives of people like nations also have habits, but sometimes with ramifications amplified a thousand fold. For instance, the US has the habit of behaving like the rich brat in the international neighborhood, always having to get its own way. The point of habit is that it is a pattern of doing things that is at once largely unconscious and, at the same time, frequently the cause of our own undoing. Habit is really a unique species, or pattern of movement, a pattern of movement of energy that has tied itself up in knots. At best, it is a waste of

using anhydrous ammonia as an energy input in her corn operation. Or a group of teachers might ask what would happen if they stopped segregating classes by age, or if they stopped grading and testing altogether.

From here, we can easily see the circle of possibilities widening to include whole cities, states, nations, or even groups of nations. For example, what would happen if there were a universal highway maximum speed limit of 100 k (60 mph.)? How would that effect CO_2 emissions worldwide? Or, more in keeping with doing without, what would happen if cities, or states, or countries would experiment again, as was done back in the 1974 oil crisis, with "autoless Sundays?"

What if? That is the spirit of this surprisingly simple yet powerful question. Just what if . . . ?

Now that we have a rough outline of fasting as a general principle, let me continue by briefly illustrating the *how* and *why* of its use.

Why try doing without something anyway? For example, doing without soda. *"What's the problem?"* you ask. *"I like pop."* Well, that's just it. In most cases, we are confronted by, or trying to solve, a difficulty or problem. The word problem itself is interesting. Its root meaning is, "something thrown at you," suggesting a thing we must deal with whether we want to or not. And, indeed, it is clear that life does seem to be constantly throwing these difficulties at us, of all shapes and sizes, both individually and collectively. Things that are in need of some kind of resolution, that have to be worked out ideally here and now. Say you are chronically overtired, or that you are overweight, or that you have a

FASTING AS PRINCIPLE

(1) Every habit soon becomes its own formative cause;

*(2) The simplest and most powerful
of all possible tests is the test of doing without.*

My theme here is perhaps not what you might expect. Anyone nowadays encountering the word "fasting" naturally thinks of doing without food for a while, deliberately, so as to loose weight, or perhaps as part of some kind of spiritual discipline. My concern here, however, is very much more general. I would like in this context to look at fasting in as broad a view as possible, as *a kind of general principle of doing without.* Doing without anything. Cars. Coffee. Computers. French-fries. Fasting or doing without really is, as the saying above has it, *"the simplest of all possible tests."* After all, we do not have to learn, or buy anything new for the test to take place. Instead, we simply stop doing something we are used to as a kind of open question. What will happen if I stop doing *x?* What will happen if I stop drinking soda? What will happen if I stop watching TV, or writing at my computer?

Because we have generalized the principle of fasting in this way, once it is grasped, there is no limit to its application. That is the meaning of the phrase in the epigram above, *"the most powerful."* For it might be not just a question about me, or you, or other separate individuals. It might be a question about a very much larger context. For example, a rancher might ask what might happen if he stopped grazing a particular pasture. Or a farmer might wonder what would happen if she stopped

rich. This will result, of course, in a near continuous cascade of unnecessary and unpredictable pile-ups and crashes. And, if we fail to take heed of this basic difference between, on the one hand, *intelligent limit,* and on the other, *rigid mechanical control or regulation,* then we had better prepare ourselves for more self-induced world-wide economic runaways charging headlong into the worst kinds of degenerative chaos. As Virgil has it in his arresting image of his Georgics: *"The world is like a chariot run wild, that rounds the course unchecked, and, gaining speed, sweeps the helpless driver onto his doom."*

* data drawn from an excellent Democracy Now! interview (X.17.2008) with Paul Craig Roberts, *former Assistant Secretary of the Treasury Department in the Reagan administration and a former associate editor of the Wall Street Journal.*

[**KNOW YOUR WAR FACTS**: The following is an excerpt from *"Who's Counting: Marilyn Warring on Sex, Lies and Global Economics* (Terre Nash 1996), documentary cluster #16 of my project, THE THEATER OF THE NEW. It would I think make a powerful performance piece at concerts and readings, with or without music:

"If a country develops an economic system that is based on how to pay for the war, and if the amounts of the fixed capital investments are apparent are tied up in armaments, and if that country is a major exporter of arms, and its industrial fabric is dependent on them, then it would be in that country's interest to insure that it always had a market. It is not an exaggeration to say, that is clearly in the interest of the world's leading arms exporters to make sure that there is always a war going on somewhere.

Every minute, 30 children die from want of food and inexpensive vaccines; and every minute the world's military budget absorbs 1.3 million dollars of the public treasury. *This is war.* The United States now devotes over 200 billion dollars (c. 1996) a year to military defense against foreign enemies, but 45% of Americans are afraid to go out alone at night within one miles of their homes. *This is war.* For every 100,000 people in the world there 556 soldiers, but only 85 doctors. *This is war.* For every soldier the average world military expenditure is 22,000 dollars. For every school-aged child the average public education expenditure 380 dollars. *This is war.* The cost of a single new nuclear submarine equals the annual education budget of 23 developing countries with 160,000,000 school-age children. *This is war.* War is "marketable." War "pays," literally. War contributes to "growth and development.""]

equity, to use another equally cumbersome expression. In other words, the 1930's depression era saying, *"A dime will get you a dollar,"* had become under Secretary Paulson's influence, *"Three cents will get you a dollar!"*

Now, to continue with our analogy of a self-organizing and self-regulating network of highways, the repeal of Glass Steagall and allowing the savings and investment branches of the banking system to merge, is the roadway equivalent of allowing NASCAR to run races freely on the Interstate. And to add insult to injury, the 2004 repeal of capital limits is the equivalent of giving the fastest and most high-powered of those race-cars a loan of essentially free gas (3 cents on the dollar . . .). The result has been, as everyone now knows, catastrophic. The collapse, in my view, while not perhaps in all its on-going gory details, but rather in its general outline, was completely predictable. And what is more, it is not merely the result of the greed of 'a few bad apples,' but I would argue of inherently systemic poor design. That is, the utter failure to compose a clear set of unambiguous limits. Again, just as is already universally the case with networks of roads around the world. My central point, however, does not concern the details of reform that would lead to less corruption and a more equitable distribution of wealth and access to resources, but rather one of basic logical necessity. Most readers are probably already aware, that, in the recent U.S. election cycle, Mr. McCain received about seven million dollars in backing from Wall Street; While Mr. Obama received about 10 million. My contention is that, as long as it is possible to purchase influence in this way, and on this scale, the economy must necessarily be skewed to the expensive race cars of the already reckless hyper-

individuals of questionable moral character. For example, in my view, current U.S. drug laws are a textbook example of such failure, causing far more suffering and disorder than they eliminate, both on the streets of North American cities, and in the developing countries where source plants like poppies and coca are grown. (Even arch-conservative economist Milton Friedman thought this to be the case.) So, excessive use of force by the State in democratic countries is, in the view being sketched here, a plain indication that somewhere in the background of an arcane legal system lurks a poorly conceived, self-defeating labyrinth of unjust laws and self-serving legislation. What would a clear set of self-organizing limits for a free economy look like? In this miniature, I'm not going to try to answer this question directly. Rather, I'd like to state by way of two examples drawn from current (XI.2008) financial headlines what a truly free—and therefore strictly limited—economy would *not* look like.

In 1999, the Clinton administration repealed a key depression era piece of legislation known as the *Glass-Steagall Act.* This act was designed to keep—in other words, *to limit*—savings and speculative investment banks separate. Repealing the act removed the limits, thus effectively giving government sanction for bankers of all stripes to imprudently throw the dice, so to speak, with the money in our savings accounts. A second crucial misstep occurred in 2004 when under the Bush administration, then chairperson of Goldmen Sachs and now Secretary of the Treasury, Hank Paulson, convinced the Securities and Exchange Commission to lift limits on required investment capital.* This led to the remarkable situation that, when Bear Stearns went under, they were "leveraging," to use an ugly phrase, 33 dollars of debt on every dollar of

OUT OF CONTROL—*the runaway economies of systemic imbalance*

I have argued elsewhere, that all truly free economies are necessarily strictly limited ones. This goes, of course, radically against the prevailing metaphysics that freedom increases with the decrease of regulation. Let's see why. The model I like to use is that of an essentially self-regulating, self-organizing network of highways. The point I like to make is that systems of roads function as well as they do because they are ordered not on *principles of control*—that is, rules that tell you *what to do*—but rather on *principles of limit*—that is, rules that tell you *what not to do*, like no faster, or no slower than x.

My contention is that a small set of clear, unambiguous rules or limits is a hallmark of all self-organizing systems. (A rule of thumb—with no play on words intended—is that, if you have more limits than fingers on one hand, something is wrong. One ought always be able to tick off the rules quickly and rhythmically *1-2-3-4-5* as a test of clarity.) What do I mean by self-organizing? Well, in human terms, the key feature of self-organization is that it requires little or no policing. In other words, the system exhibits natural in-built safeguards against, and correction of, all breaking of limits. I don't want to crash into you, and you don't want to crash into me, so we naturally both readily accept all such reasonable limits. Another way of saying the same thing negatively is: a self-organizing system has failed, that is, has demonstrated an inappropriate or ill-designed set of limits, when it is in need of continuous control by use of force. The key point I would like to make here, is that this is a systemic problem, and not an ethical one concerning a few

world, Wall Street's expansion means Nature's loss, not growth. Why? Well, simply because of the lack of all reasonable and rational limits, and because of an ever-expanding economy's rapacious need for ever-more raw materials. One need only think of paper. From the economy of false compare's perspective, razing the boreal forest—which is actually taking place right now as we speak—for the paper pulp used in toilet paper, or for millions of unwanted glossy commercial catalogues, is "growth," which is of course, utter non-sense. That is the essence of the contradiction.

And so we come full circle to the dead-end of the speculative mind, so at odds with the family forester's, or organic farmer's, or small-scale rancher's point of view. It is as I've already said above a confused and confusing notion of growth which rests on the blind hope and downfall of every gambler:—that each toss of the dice will result in the impossibility of a straight-line series of wins going on forever. A shaky notion of growth, and bad analogy, indeed!

So natural growth is not normally simply a matter of the endless linear expansion that economist evidently have in mind. And more especially, natural growth is not the species of expansion known as *exponential increase,* as I've argued elsewhere *(q.v. On Two Important Exceptions of Natural Movement).* Increase or expansion in Nature is always balanced by a complementary and equally essential movement of contraction, or a rhythmic movement of decline, and—ultimately—death and decay. Nowhere do we see this from the human perspective more clearly than the life of the soil, to which we all know that we too shall return some day, and which depends on this continuous composting and transformation of dead and dying organisms for its sustained vitality.

Now let's return briefly to the implications of the false analogy. When politicians or theorists speak of economic growth, they do not have in mind anything remotely similar to the .01 mill growth rate of the alpine soils mentioned above. As I suggested, they are really thinking of largely unnatural systems of linear expansion—a kind of always 'getting bigger' stretching out without limit to infinity—as well as the notorious expansion-of-expansion of compound interest. If you are focused on *dollar* or *euro* amounts, a change or expansion rate of just 5% compound interest will more than double your money in just 16 years. But the question which is never asked, is how long can this unlimited interest-on-top-of-interest continue to increase before it collapses, as it necessarily must? In contrast, natural growth is by definition always limited and self-sustaining. And, as suggested with the concept of anti-growth mentioned above, the economist's use of the analogy is in actual fact a pernicious inversion of meaning. In the reality of the natural

true, or it may be false.

My contention is that it is false. And what is more, I would argue that the property of natural growth when transferred to current industrial economies is intrinsically confused and confusing.

For clarity's sake, let's consider growth in the natural world for a moment.

As we all know, from the human perspective, growth is more often than not a slow, steady process. Very slow. So slow in fact that we normally cannot see it. That is why time-lapse photography of a flower bud unfolding, or a glacier wasting away at its surface, breaking apart and retreating, is so revealing. Natural growth is frequently measured in areas of space so small, and spans of time so long, that it lies beyond the grasp of both our normal sense of proportion and resolution of our temporal perception. For example, a lichen grows about one centimeter a century. And the soft, rich humus layer of soil in the high mountains around treeline increases its depth 10 times slower yet: about a centimeter every thousand years. That's 30 human generations or so for every finger-width of soil stable enough to support the alpine grasses under your boots. Slow growth, from the human perspective, to be sure!

A second key point is that natural growth is normally cyclical. And it is cyclical in a highly rhythmic way. As everywhere in Nature, there are limits. And because there are limits, there is balance. In other words: without limits, there can be no balance; as well as the inverse: if there is imbalance, limits have somehow broken down.

WHEN GROWTH IS 'FALSE COMPARE'

"What grows is good.
And if something is good,
it's good to want more of it . . ."

Behind the intellectual facade of economic growth lies the harsh, hidden reality of a very real, and in terms of the natural world, *anti-growth*. Anti-growth is the wholesale destruction, either by means of over-use or contamination, of the shared vital resources of the world community such as air, water, forests, or soil. Anti-growth is not just an unfortunate side-effect; it is an absolute necessity needed to fire the engines of an inherently destructive economics of expansion. And that is the ironic twist here because it conceals itself by means of the illusion projected by what in essence is false analogy.

Let me start over again: As every bard knows, there's nothing worse than, to use Shakespeare's phrase, 'false compare.'

Language shapes perception; and perception in turn shapes action. Analogy, or the *this-is-like-that* of thought, is essentially finding *similarity* in *difference*, or finding a common feature in seemingly different patterns of movement.

For example, we say: "Forests grow." And by analogy, we say: "Economies grow." We all know that forests actually grow, whereas the transference of growth as a property to describe patterns of change in economies is an entirely different matter. This may be more or less

INTERNET *ABC?*

A: a wire through which people
and relevant, new meaning
are brought freely together;

or,

B: a wire through which it is
easier and easier to say
more and more things which
are less and less worth knowing;

or,

C: a parallel world-wide network of trails—
a *Path of all Peoples*—moving on foot or bike
from center to center to center, thereby bringing
the potential of **A** forcefully down to earth,
and allowing it to fully, that is—
actually—flower.

become a central and key manifestation of the culture. In other words, it is vastly more than the mere sum of its parts, vastly more than just television, or radio, or motion pictures, or telephone. And yet these are still the predominant controlling models used to grasp the network's nature. In the view being sketched here, with the Web's great and still largely unsounded cultural promise becoming potentially locked down in traffic jams behind a motley assortment of unnecessarily blocked gateways and toll bridges, none of these seem adequate.

Far better would be to have one adventurous and creative city, or small nation anywhere in the world demonstrate to the rest of us the extraordinary cultural benefits of realizing maximum achievable bandwidth *(say, 1 or so Gb . . .)* combined with universal free access. I would guess that the rest of the world will stumble over itself to imitate their success. After all, a good third or more of the world's resources are presently squandered on the highly questionable ends of war and its weaponry. It might prove much more effective to shift and enlighten our paradigm, and focus not on weaponry, but, as R. Buckminster Fuller used to say in his charming and inimitable way—*livingry.*

Livingry, yes. Not a bad image for a network that links us all together, and thereby both celebrates and protects, the rich diversity of the wide and wonderful interwoven web of the world.

[Note: *Net neutrality,* or the principle that all bits that move through the Internet should move in an inherently unbiased way at equal speed, is from this perspective as vitally important as it is in fact secondary. The primary problem, in my view, is ownership, and *who has a right to set limits,* and *how* and *why* these limits are set. Like roads and water, the infrastructure of the Internet and Web should be publicly owned common ground for the simple reason that we shall all come to rely and depend on it to an ever-greater, and at present largely unforeseen and extraordinary degree.]

In other words, there is a total lack of vision.

What is remarkable is that this lack of vision is entirely at the social and political levels, and not at all in terms of the science of the Internet's technical infrastructure itself. Here, the Internet sparkles brilliantly on all its sides with the robust simplicity and foresight of well-designed open source protocols, and their nearly miraculous decentralized physical embodiment as servers, routers, and an increasingly rich polyphony of Internet-enabled portable devices.

So why, we might ask, are things in such a state of disarray at the social and political levels? I would say because of a chaotic confusion of meanings. The basic question is, *"What's the Internet good for?"* Shifting from our internet-as-road analogy for the moment to the image of the *internet-as-pipe,* we might then ask the question, *"What flows through it?"* Clearly, for some, it is cash. For others, it is entertainment, not that different from TV. For others, it is communication, not that different from the telephone. Or others might say more generally it is information, not that different from radio or print journalism, or what you might find on the shelves of your public library. *One pipe; many different contents. Many different contents; many different meanings.* What they all have in common, however, is that they are social, cultural networks based on the free flow of bits of data. Where they differ is again, what the network is for, who controls it, and who pays for it.

My own view is that in a highly abstract, subtle, and yet at the same time completely earth-bound, physical and tactile way, the culture has become the network, and in a reciprocal manner, the network has

Why? Just imagine for moment that I build a bridge across a stream that is difficult to ford. And say that this bridge cost me about $10,000 to built. Now, I charge 10 cents to cross, a fair price I think, and an average of about 100 people cross each day. So in less than three years time I've recouped my initial investment, and can look forward to both an increase of traffic and perhaps a measured yearly addition to the fee I charge as well. I have a monopoly, because I have the only way to gain access to the other side of the river. You might say I have a pretty good business model. The only flaw is that, when seen from the wider social context, the model is unambiguously bad for everybody else. So, in an open society based on democratic discourse, very quickly, the community will decide I'm sure that it should take responsibility for the bridge and purchase it from me, drop the charge, and finance its maintenance with public money.

After having biked so far more than five thousand kilometers all around the Northwest of the US the past two years, I can say without hesitation that the state of the Internet is as far as I'm concerned a complete mess. Connections are slow. Connections are hard to find. Connections are expensive when you *do* find them, and even when paying a relatively high price, they are unreliable. In sum, I would say—and I am by no means an expert here but simply amazed that it is not the top priority issue that it deserves to be—the development of the infrastructure for the Internet has been left to what is essentially the private road paradigm sketched above, with all its inevitable random profiteering, helter-skelter, confused and outdated infrastructures, and ultimately, nearly universal end-user frustration.

ON THE NECESSITY OF ONE FREE WORLD-WIDE WEB

Just as economies move goods, and roads move traffic, the Internet's function is essentially to simply freely move bits.

"Freely" is a key word here. Freedom of flow, in my view, can be achieved and safe-guarded only by the democratic, open and transparent structure of public works. Public roads are perhaps the best example. Notice that around the world we hardly need add the epithet public, because roads are by now almost by definition, 'public.' My contention here is that public roads would serve as a good model for the Internet and the World-wide Web as well. Why? Because the Internet, just like roads, has already become far too important a resource to let it be controlled and determined merely by the short-sighted and highly fragmentary vision of commercial self-interest.

Imagine for a moment a patchwork of roads and highways broken up into arbitrary pieces, all designed, owned and managed by different individuals, families and clans, with gateways and check points that require that you stop your vehicle and pay a fee for right-of-passage. Indeed, in the not-that-distant past, roads in many parts of the American Northwest started out in just this way. The problem with this kind of wild-west model of development is that, while it may function well at first to get things started, in the long-term it lacks real social intelligence which comes with accountability and spirited, open debate. It will therefore eventually reveal itself to be the bottleneck of economic development and community well-being that it really is.

The Little Clavier: Part IX

The most insidious of all degradations is the loss of something vitally important for which we do not yet have a name.

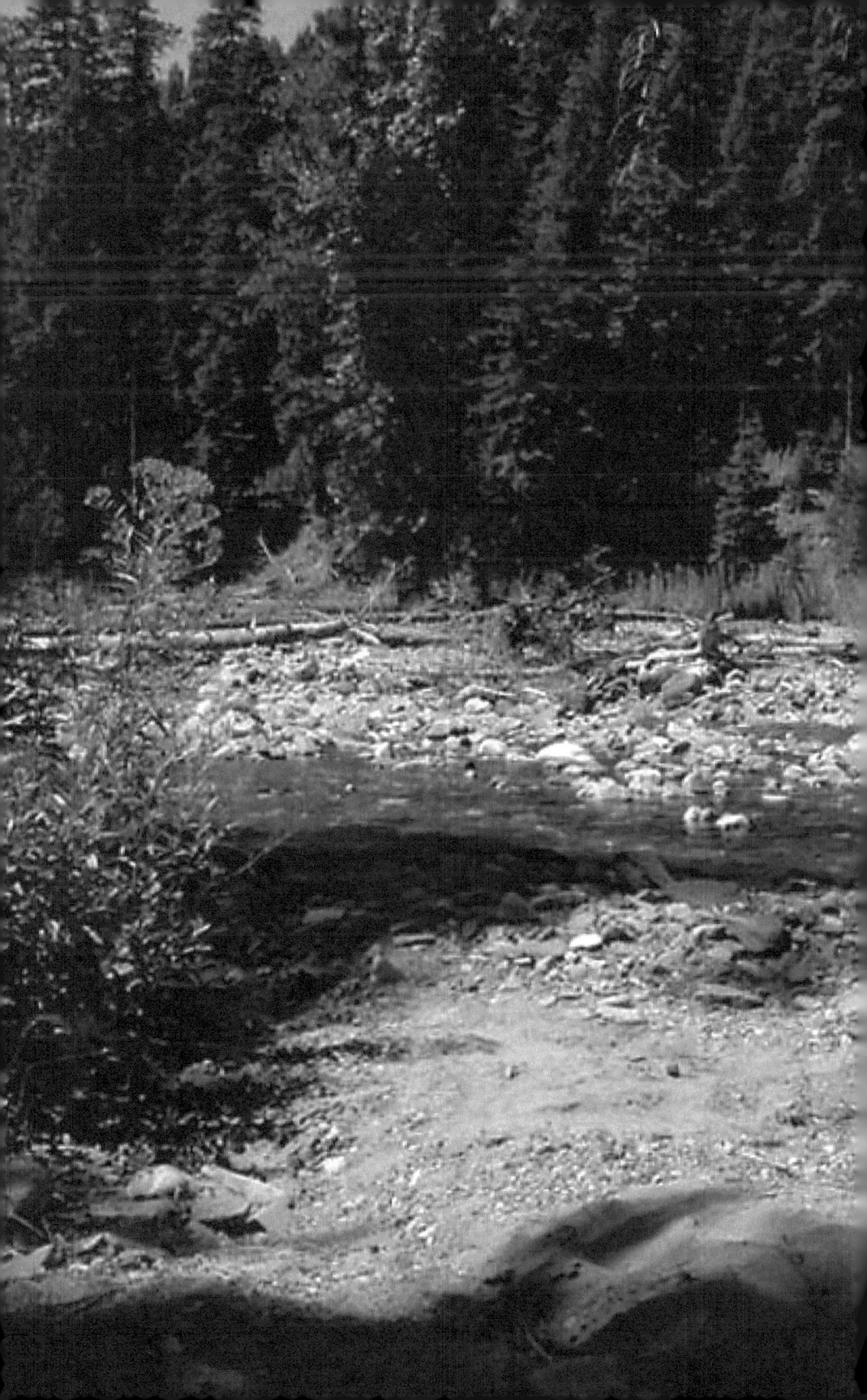

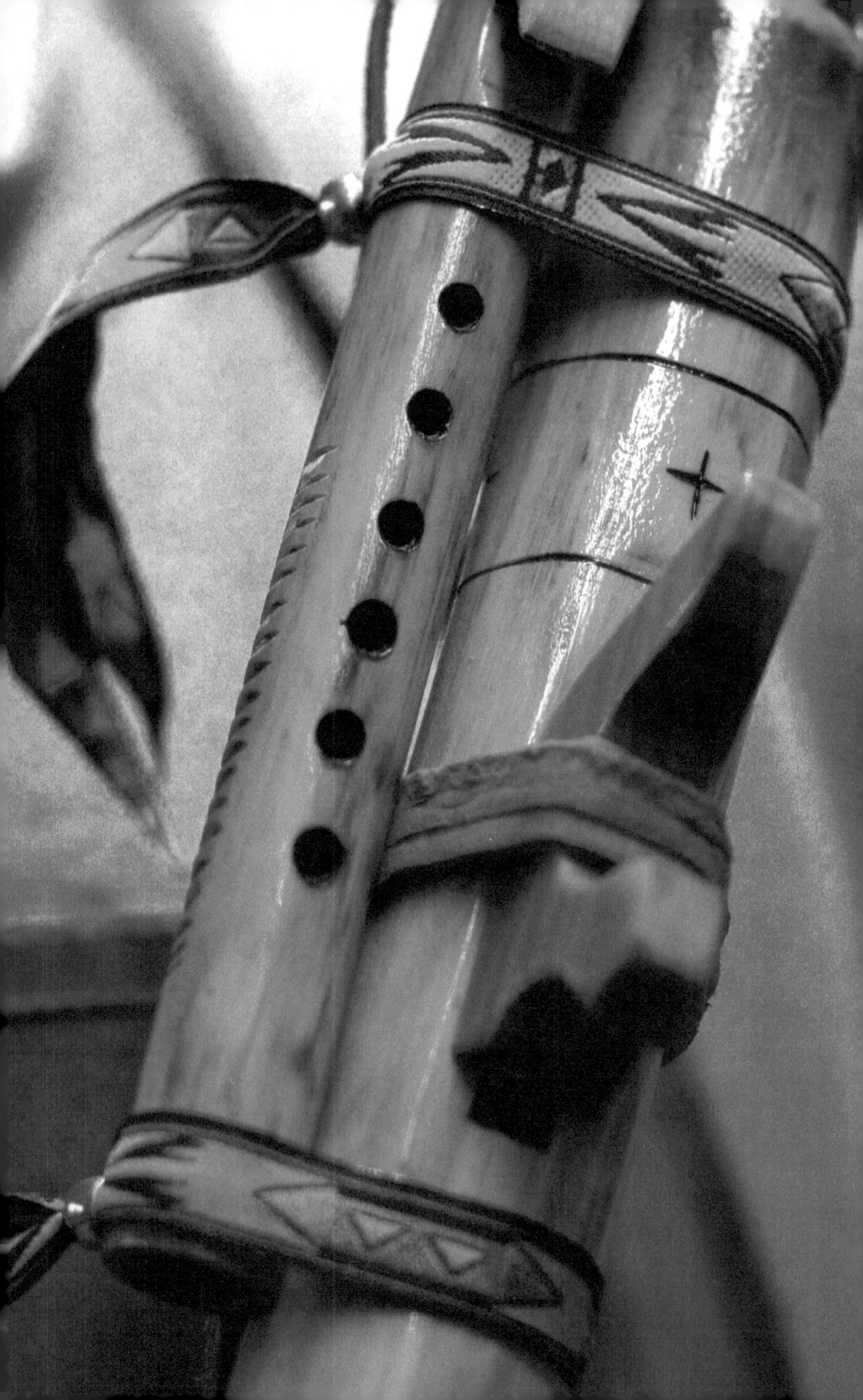

entertainment. That is why wildness is—and has always been—so important. Because it turns off the entertainment, and turns off this incessant chatter of voices telling us what to believe, and what to think.

Three legendary moments of insight I think every child should learn by heart, and which are especially dear to me, are brought together here in the above little set of three 37-step poems. The Greek philosopher, Pythagoras, who used and explored the world of sound for much of his model of creation, appears in the poem at the moment he hears a musical octave ringing out on the heavy anvils of a blacksmith's shop and on the spot figures out why. Or the teacher / student duo—one of the greatest of all time—of Anne Sulivan and Helen Keller appears in the second at the moment Helen—both deaf and blind—suddenly sees that *everything in the world has a name.* This moment has always seemed to me to manifest the very essence of what learning is, and like a lightning bolt out of nowhere, calls into question mechanistic theories of the mind. And lastly, there's our humble earth-bound reptile as it for the very first time takes to the air on newly discovered feathered wings. I've always felt that this hypothetical evolutionary moment is directly linked to humankind's own great leap—an epiphany or bold leap of spirit if there ever was one—many eons later all the way to the Moon and back.

* * *

In order for a variation form like this to work, one needs to do them in sets or sequences. Try reading them out-loud to get a sense of how the rhythms and accents change in surprising ways while still keeping to the basic 37-step or syllable pattern.

* EPIPHANIES

Epiphany is one of those beautiful words that comes to us from the ancient Greek. It means *to reveal,* in the sense of sudden insight, or inspiration.

In a way, insight—which I see and experience as an actual movement of energy, or intelligence, is everything. For me, insight is not something personal or individual, but rather a movement of intelligence that is in resonance with both ourselves and some deeper, essentially unknowable, source.

Insight is what I look for in works of Art. Nested in this collection of texts are any number of historical references to key moments of this sudden seeing into the nature of things.

I find it, for example, in Johann Sebastian Bach's *Goldberg Variations,* as well as in Glenn Gould's historic performances and recordings. I find it also, for example, in certain seminal addresses of Dr. Martin Luther King, Jr., as well as the Indian philosopher, Jiddu Krishnamurti. Or the ideas and style of thinking of Buckminster R. Fuller. Or the brilliance of Benoit Mandelbrot's fractal geometry. And, of course, I find it everywhere in Nature, especially the forms as revealed to the human eye in the *not-too-big* and *not-too-small* dimensions of what I think of as the magical middle realm.

It seems to me that present-day Western culture has for the most part turned its back on this energy of insight, and already two or three generations ago has filled the empty space with

(iii)

Strangest of creations,
a serpent with arms and feathers
slithers to the edge of its cliff.

Suddenly,

take-off, thin air! Boot
prints left in the dust of the Moon.

EPIPHANIES *—three 37-step poems*

(i)

Lover of wisdom,
Pythagoras hears two anvils
sound octaves at a blacksmith's shop.

Suddenly,

half of weight is *half*
the length of a lightly touched string.

(ii)

"Wa-ter. Wa-ter. Water."
Thrice the fingers of the teacher
write in the palm of a girl's hand.

Suddenly,

all things have names, and
the girl sees more than those who see.

sary new technologies. And, of course, we also need the new technologies to establish such new networks of learning.

So, we can see an exciting energy revolution unfolding right before us. Keep an eye to the more subtle sides of cultural change. Watch shifts of meaning. For example, the meaning of rooftops is bound to change as you see your neighbors turn the old wasted space of waterproof, insulating surfaces into rooftop gardens and pv-powerhouses. Watch the meaning shift as you come to see they are not only attractive, but also charging the cars for free and spinning their meters backwards. Watch the meaning of that fowl and repugnant relic of empire—*the suburban lawn*—implode as you find traces of an indeterminately long and synergistic list of unwanted substances in your well water, and then see others happily harvesting a cornucopia of veggies from their victory gardens, and herbs from the butterfly patch.

All else will look like, as the turn of phrase has it,
senseless waste.

NIGHT THOUGHTS ON A FUTURE ENERGY HOUSEHOLD

As I see it, one of the primary opportunities presented by the universal ascendancy of digital technologies is the potential elimination of waste. With all types of hardware, for example, whether cameras, or laptops or other associated electronics, the answer is resoundingly clear: *closed-loop recycling* and / or *cyclical leasing.* You lease a new camera from Canon or Nikon, use it till it breaks or is not right for your work, and then trade it in at a price for a new one, knowing that Canon and Nikon are committed by law to responsible recycling. The same kind of cyclical leasing would work for a laptop from Apple or Dell. And in terms of distribution, there is now the possibility of a shift in our thinking away from cars and hydrocarbons to networks of flowing bits and electrons powered by ever-more efficient renewables.

As I see it, the bottom line of all this is the movement of energy. By this I mean both the physical energy, but also energy in the much more subtle sense of meaning. The key thing to watch in this general movement of energy, the key limiting factor, is again waste. Waste in terms of what I've called complicatedness, or poor design, and waste in terms of squandered intellectual energy or meaninglessness.

If you think about this a little, the free, efficient flow of both physical and cultural energy fit together quite well. Perhaps necessarily so. Why? Because we need a free flow of information and meaning to grow a superior quality of learning and education, one soundly rooted in an exuberant yet ethical scientific spirit, in order to create the neces-

ON THE FRAGMENTATION OF RELIGION, SCIENCE & ART

Religion seems lost in a prison of outmoded rigid hierarchies and absolute belief;

Science seems lost in a reductionist labyrinth of inferences, driven not by insight, or by the ethical imperatives of a deeply troubled contemporary world, but merely by exceedingly abstract, and / or profitable, theoretical interests;

Art seems lost in a supermarket of entertainment, mistaking cheap techno glitz for real passion, and quick thrills for spiritual uplift.

Like three vain goddesses lost in the walled garden of their own self love, they gaze in their separate mirrors day after day, and fight and bicker about mere trifles, and about who is the fairest among them.

If Truth were the judge, perhaps not *one of the three,* but *the three as one,* would be found to be the most beautiful of all.

ON THE NECESSARY SEPARATION
OF ETHICS & RELIGION

One of the great fundamental insights of the U.S. Constitution, derived from the traditions of ancient Roman law, is the idea of balance of power. Of equal importance is the principle of the separation of religion and state. Now, it seems to me, that we would benefit greatly if we were to in a similar spirit of balance and clear structure *separate religion from ethics.* Indeed, I would argue that a new set of demanding moral problems makes such a division imperative.

Why? Because, in the view being roughly outlined here, the theater of moral debate demands that we check our cloak of sectarian beliefs at the door. For with moral questions, just as in a republic no one may claim to be above the law, in democratic dialogue, no one or no argument may make claims to absolute authority.

How then are we to decide what is good, right and just? Well, I would say by placing calmly the arguments, the evidence, or the competing theories on either side of the scales of truth. And then weighing their relative strengths and weaknesses within the widest contexts deemed relevant. For if we really consider this process carefully, what is of crucial importance—indeed, sacred, some would say—is the motionless, neutral center upon which the fair, unbiased balance of the scale depends.

ON THE SOUND OF RUSHING MOUNTAIN WATER—*a reflection*

If someone were to come back to the high and rugged Glacier National Park watershed from just a 100 years ago, the first thing they might notice come the end of September would be the eerie silence. *"Where is the sound of rushing water?"* With mountain spring coming two or three weeks earlier than in the past, and glacier ice disappearing faster than any one had ever thought possible, streams normally fed by snow- and ice-melt towards the end of summer and early fall evidently now tend to be mute and dry.

Walking the land resonant with this unnatural silence, I keep asking myself, Is this what is going to happen to the Alps, as well? Will they, too, not just lose their great and magnificent living bodies of snow and ice, but also simply begin to dry up?

I can't help but carry this question with me wherever I go.

ON THE DIFFERENCE BETWEEN METAPHORICAL & LITERAL MIND

For the natural state of metaphorical mind, what others perceive as isolated facts are but unrealized opportunities in the dance of relationship. For the literal mind, this dance has stopped; with laser-like precision, it focuses on the outward features of things:—shards, digits, mere fragments of flux.

For the metaphorical mind, water in flowing movement brings us closer to the essence of life; for the literal mind, water is but potential pressure behind so many more massive dams.

Clearly, in proper measure, we need both, both the metaphorical and literal. But even more, we need to see clearly the difference between them.

ON THE CULT OF COMPLICATION

The contemporary worship of complication confuses the unnecessarily difficult and obscure for the true mystery and complexity of the new and unknown. Complication goes on to mistake the cleverness of mere mechanical intellect for the insights of real inspiration and intelligence. Always: such mischief begins with the loss of resonance with the simplicity / complexity cycles of the natural world.

window or frame of each image out of the world of mere consumption and back into the natural world of very much slower, not consumption, but contemplation. The rhythm of the latter, in my experience, is tied not so much to browsing, but rather to walking, and then on frequent, special occasions, sitting. Sitting to let the scene, the object, the tableau, the movement, speak to you. This is just like one might naturally stop and sit and listen to what an interesting stranger encountered on a path might have to say.

Perhaps this is why museums, which I have come to dislike almost as much as I dislike the tragic 2nd-hand decadence on display in classical music concert halls, still have something of a role to play. First, we expect museums, like libraries, to be silent. Second, we expect to walk from space to space—certainly a much more noble rhythm than mere page flipping. Third, we expect to experience if not objects of truth and beauty, than at least something which is artistically in some way meaningful, or as the initiated say, "shockingly original." Admittedly, the light, or the air, or the tap water, or the soundscape, won't quite match what is offered in the mountains at any time and at any season entirely for free, but at least it will allow us to exit—if for however briefly—our everyday images-as cheap-browse habitual mode of perception.

HABITUAL MODES OF PERCEPTION

Images have become cheap.

Perhaps you've noticed, as I have, that the typical, everyday consumption of pictures has a more or less regular rhythm to it. Much like the picking of berries from a bush, putting them hungrily in our mouths as our hand reaches down to grab still more, and sustaining the feast as long as the habit of "browsing" magazines and photobooks in much the same way. The tempo of both types of browsing—berries and images—is upon closer inspection remarkably similar, about two beats or quarter notes in 2/4 time, metronome marking 80 to 84. *One, two; One, two; One, two,* etc., etc., with each repetition marking a flip of the page. Like all human rhythm, this is most likely tied to the breath cycle and heartbeat. (Clicking through images on the internet is basically the same, although perhaps a bit more limited or slower, depending on the speed of your connection.)

As a musician, I find this interesting. I find it also disturbing. In browsing berries, such feasts are rare. But not so with contemporary images; they are everywhere, hitting us on all sides. It would be interesting to know, on average, how many still images a person of Western city-culture encounters per day. It is almost certainly orders of magnitude more than a wholesome visual diet might desire, or might be able to accommodate.

So, for artists putting their whole soul into each image they make, this is not good news. The problem for me is simple: how to get the

STOP WEEDS

Help!
WALLOWA CO. CONTROL *NOXIOUS* WEEDS

- PURPLE LOOSESTRIFE
- WHITETOP
- YELLOW STARTHISTLE
- KNAPWEED DIFFUSE-SPOTTED
- LEAFY SPURGE
- TANSY RAGWORT
- SCOTCH THISTLE
- RUSH SKELETONWEED

word here is *imbalance*. Weeds and imbalance go together like war and poverty. Imbalance leads to disturbance, and disturbance leads to opportunities for prolific annuals like Spotted Knapweed *(Centaurea maculosa,* pictured above) and White Top *(Cardaria draba)* the former of which can within a few years quickly colonize whole areas (5,000,000 acres—half of Switzerland!—in Montana alone). The questions of natural limit and balance ask: how many cows, on how much land, for how long a period? There are many groups in the Northwest already addressing the problem, like *Country Natural Beef.* When you stop at a local market or restaurant, ask if they carry their products; And if you own and run a local market or restaurant, perhaps you might ask yourself why you don't serve or carry them. And why the cattle you see grazing around you will soon be on their way to huge feedlots in eastern Colorado, and the next burger you eat will most likely come all the way from Brazil. In terms of a balanced energy household—the *in-* and *outputs* of not just money but of real energy—this is as crazy as it is unsustainable and destructive to the local economy. The general economic motor which underlies all of these excesses is in my view not need, and most certainly not a campaign to end world hunger. It is rather a subtilely orchestrated and artificially created demand for what many would call highly habit-forming, cheap, industrial, junk food. That would make quite a sign, wouldn't it?:

STOP WEEDS! BOYCOTT MCDONALDS!

Now, that really *would* be my responsibility. *Viva la slow food!*

[*Photo on the next page:* **In contrast to the sign above, this notice posted on the Minam River just as one enters Wallowa County is hands-down the best weed-sign I've encountered in the Northwest. Notice how it lists the top eight species of concern. Somebody means business!**]

CONTROL NOXIOUS WEEDS!

All the way from Fargo, North Dakota, across the whole of Montana and Idaho, and now circumnavigating the great and beautiful Wallowas, this is hands down the most striking weed sign I've encountered. As you can see, I was lucky enough to get a photo of it before it fell, or somebody knocked it over. Notice that its seven word message if full of metaphysical assumptions, like "control," and "your responsibility." But it also nicely fits the additional powerful formative metaphor of war, as in, *war on weeds*. The enemy is to be shot on sight (good for Monsanto, but mistaking *effect* for *cause*), and the responsibility for both (that is, both the shooting and the cause) is yours, *i.e.,* the little guy, you and me, the consumer with a few dollars in his or her pocket, or the rancher with a small herd of cow/calf pairs and 160 acres.

The language hides—not in a deliberate, but still, in my view, highly confused and confusing way—the dirty details of three major areas of concern: (1) a vastly oversized livestock herd in North America (100,000,000 animals at this writing); (2) an equally imbalanced agricultural energy household with huge, highly subsidized areas of land growing corn to be basically force-fed to cattle (100,000,000 acres, an area the size of Oregon, and six times the size of The Netherlands or Switzerland); (3) a good 100 years or more of both systematic and in many areas culturally acceptable overgrazing.

I am most definitely *not* talking about small family farms of any stripe here, organic or industrial. It is a question of size and scale. The key

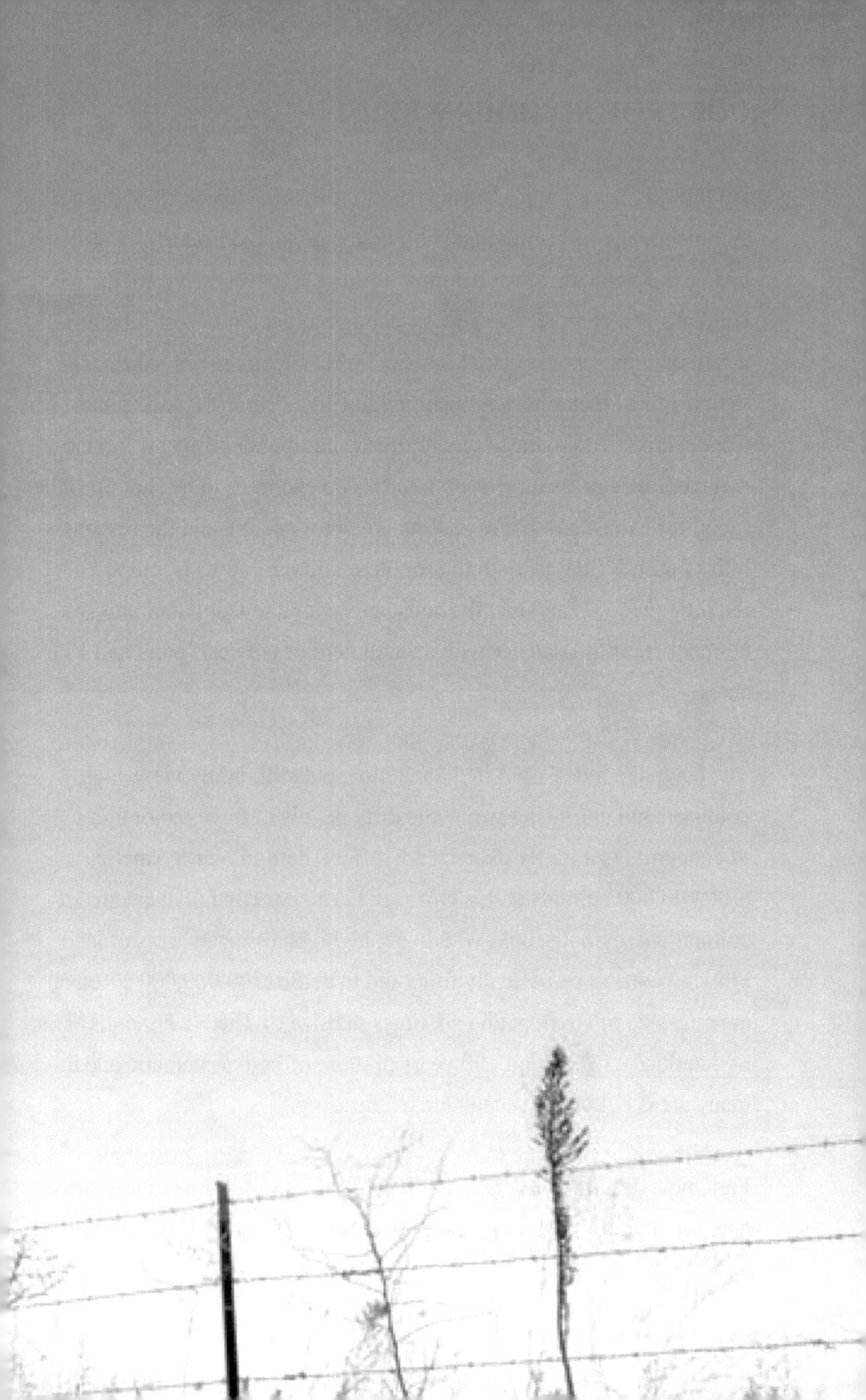

UNION COUNTY

CONTROL NOXIOUS WEEDS

IT'S YOUR RESPONSIBILITY

so natural to the young heart,
the young mind.
The doors are flung open.
The building seems transparent,
as if it were made entirely of glass.
You enter with your children.
The orchestra is tuning in the distance.
You see a sea of seats, every color of the evening sky,
arranged in a circular array.
"Odd," you think. *"What's that?"* your daughter asks.
The seats all have identical signs.
A polite young woman in a neat blue uniform
and straight shoulder-length blonde hair
smiles sympathetically, her thin, pale lips not parting,
but somehow showing a slight trace of empathy, as she walks
towards you and says, *"Sorry mam.*
The seats are all spoken for."
She adds, *"It's always that way. Sold out.*
Nobody comes. Ever. But they're
always sold out."
She echoes your own words, *"Odd, don't you think?*
The orchestra plays. The singers sing,
They don't seem to notice that no one's there.
They say it's one of the greatest stories ever told.
Your children begin to cry. You almost do, too.
The crowd is pushing behind you.
"Sorry mam. You'll have to leave now.
The show is about to begin."

SNOW COCKTAIL

Zinc from China,
Cadmium from Japan.
Atrazine from the Basel.
Mercury from Seattle,
Lead from Detroit.

Snow cocktail of the High Wallowas,
pure spring water mixed with crushed snow,
these drifts that linger into the lazy heat of July.

Clear. Cool. Refreshing.

I drink to your health, friend.
For better or worse, we're in this together,
married to the oneness of the world.

SORRY, THIS SPACE IS TAKEN

One morning, you decide to take your children to the opera.
They say it is one of the greatest stories ever told.
Of great rivers.
Of great forests.
Of great snow-covered mountains.
Outside the opera, there are
hundreds, thousands, waiting to get in.
There is excitement everywhere,

An iPod for energy may not be as far-fetched as it might sound. For the light of the sun to burn at night, and the new solar era to begin, we need only to turn off the switch on the blinding glare of wholly unnecessary corruption.

CONTRA NATURUM

We shape the world and the world shapes us.

Humans are the only species born into the world without a proper place to be, without a place to stand like a tree, or dig a simple hole like a squirrel, or build a nest like a winter wen.

For how many people does this lack of a place to be remain a life-long problem, beyond all hope of resolution? A quarter of humanity? A third? Or more?

Just as every human being has a self-evident right to clean air and water, so all have an inalienable right to enough land—and not one hectare more—to meet his or her basic needs. The history of the denial of this primary right is the tragic history of the destructive imbalance of injustice, and of social instability and violent revolution.

See the majesty of the solitary Doug-fir, the depth of its roots as yet unsounded, the circumference of its spirit still unmeasured, still unknown, yet so fully present around the center of its growth, around the place where it stands.

ENERGY iPOD

Sine sole sileo
(Without sun I am silent)

We shape the world and the world shapes us.

The only reason we do not have an iPod for energy right now—that is, a handy little device you could put in your pocket that condenses and stores, instead of an entire library's worth of information, an entire *household's worth* of kilowatts—is that those who profit from keeping us dependent on the stone-age fuels of fire and hydrocarbons wish to continue doing so until the supplies are exhausted. And for obvious reasons. That Exxon-Mobil wants to keep selling us oil until we enter a new dark-age is only reasonable and logical. That is, after all, their business. But that governments world-wide do likewise is not reasonable and logical.

Clearly, if the whole of Shakespeare can be condensed to the head of a pin, so can the whole of Einstein.

Clear also is that this will not happen until money and the distortions of power it buys are in a bold and simple way eliminated from politics. The only force capable of making this happen, it seems to me, is the natural convergence of common sense and the reasoned voices of public opinion and civil debate.

The Little Clavier: Part VIII

A weed is a species of movement which
feeds on chaos and *roots in imbalance*.

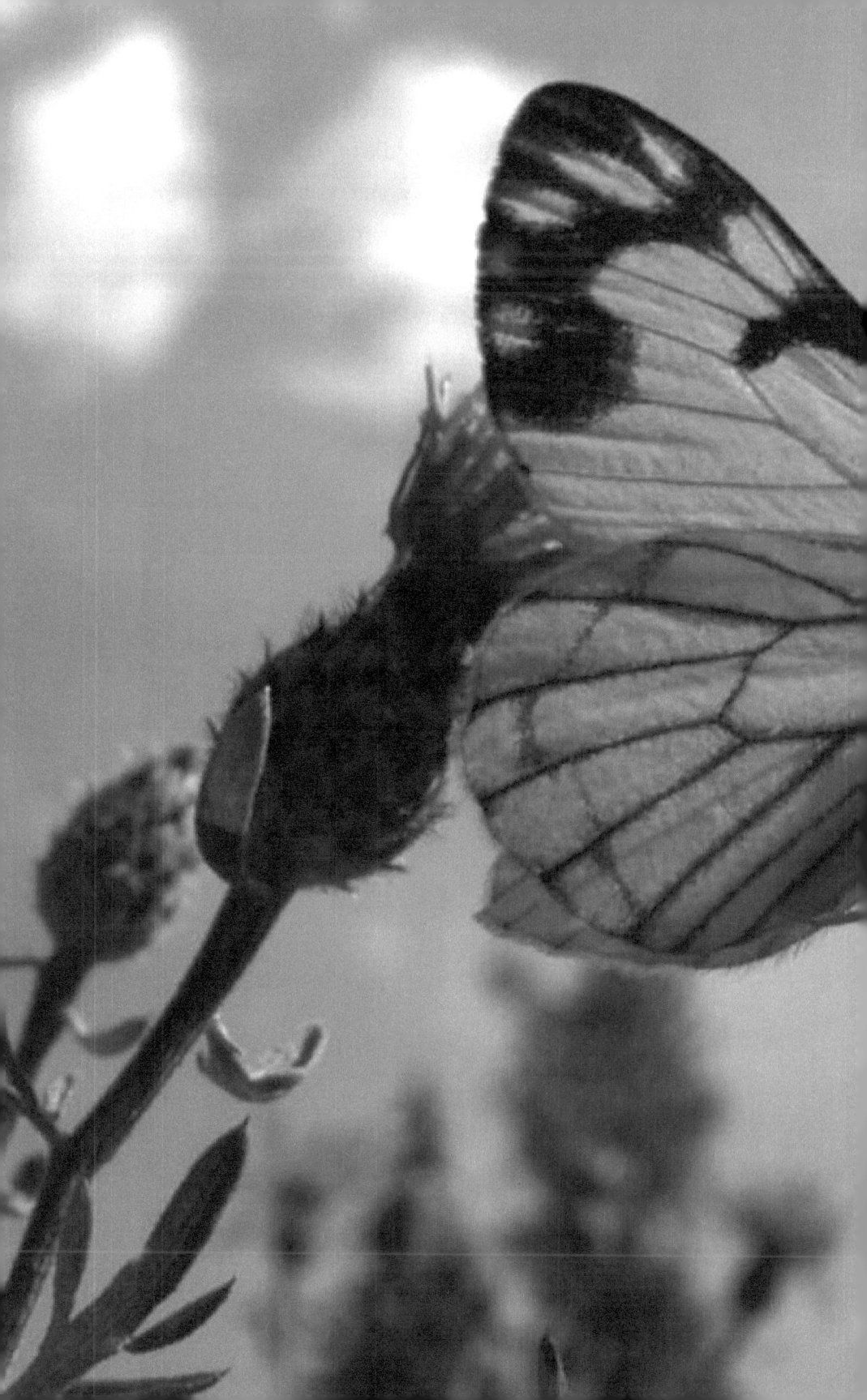

I light a match to a campfire, and see a timeless ring of humanity before me; I step out of my tent in the middle of the night and see a comet streak across a star-filled, moonless sky, and wish only for more such nights; I awake to the distant sound of a bird I know I have never seen, perhaps never *will* see, but recognize and cherish its song, sounding its long, silver-thin notes in a pure, effortless way as if it were singing to all the mornings of the world.

I only ask myself, *"Why can't I sing like that?"*

That's something of what religion means to me.

CREDO—*a confession*

For me, Religion has little or nothing to do with books or belief. Rather, for me, Religion has more to do with *a kind of remembering,* or reconnecting with something vastly bigger, more basic, and more important than myself. What I experience is a kind of *coming back into resonance* with a quality of wholeness, like a lost overtone retuning its alignment with the far deeper ground sound which is its source. This quality of wholeness is, it seems to me, in and of itself—regardless of how we think about or act towards it—sacred.

Notice the many *"re"* prefixes I use here. Although the etymology of the word religion itself is evidently obscure, many others have pointed out that it possibly stems from the Latin root, *religare*, meaning *'to bind,* or *connect,'* as in the word ligature used in both medicine and music and meaning *'to tie together.'* So we have the idea of tying together or linking. But also, importantly, of *re*-linking, *re*-membering, *re*-connecting, perhaps even we might say *re*-resonating. All of this strongly suggest to my ear and way of thinking a circle, a cycle, or recurrent coming round of some very basic spiritual movement.

Religion then as a movement for me begins at road's end, where the way is too steep and too narrow for the orderly, systematic logic of thought to follow, and where the rigidity of belief easily gives way to the more water like flexibility of the ever-possible. Here, I seem to find the mystery of the abundantly new and the unknown made manifest with each breath, with each passing step, with each unexpected bend of a trail.

WHOLE & PART

Sometimes, given an inherently limited field of vision,
one can only reveal the whole by showing the parts.

SECURITY & WHOLENESS

Security is a property of the whole and its parts,
not of fragments. Nation states and Religions as sectarian belief
are in their present form fragmenting the whole of humanity,
and are, therefore, a primary cause of insecurity.

LOSS OF WHOLENESS

We shape the world and the world shapes us.

After tying the river up in knots and building the dam,
we quickly lose the sensitivity of ear that once heard
the music which is now no longer there.

Children who grow up in a world of straightened
and muted rivers will themselves never know
that no one ever taught them how to sing.

ON THE DYNAMIC BALANCE OF PRIMARY CONTRASTS

What the rhythmic back and forth of sound and silence is to music and poetry, so the movement of bright light and deep shadow—*white* and *black*—is to the visual image. Both are primary complementarities. In other words, if the right balance between the poles of sound and silence, and the poles of light and darkness is not found at this fundamental level, the less basic planes of the composition will necessarily rest, like a house with its walls out of plumb, on shaky ground.

In music and poetry, it seems to me that the back and forth of sound and silence is directly related to the breath, and hence by implication to things spiritual; In the visual arts, the contrast of white and black is more directly related to the realms of *being* and *non-being,* or the explicitly manifest world of things, people and other physical objects, and the more subtle realm of the about-to-become or disappear of non-being.

As a general rule, I would say that the more silence, or the more darkness, a composition can hold and yet still maintain a kind of sustained tension in the balance between its complementary pole of sound or light or brightness, the more the composition tends to fill the space with an air of mystery. This, however, is difficult to achieve, and most likely not to be achieved in any self-conscious way. One can however simply be aware of its great inherent importance, and when lucky, and when opportunity presents itself, get out of the way in time and simply let it happen.

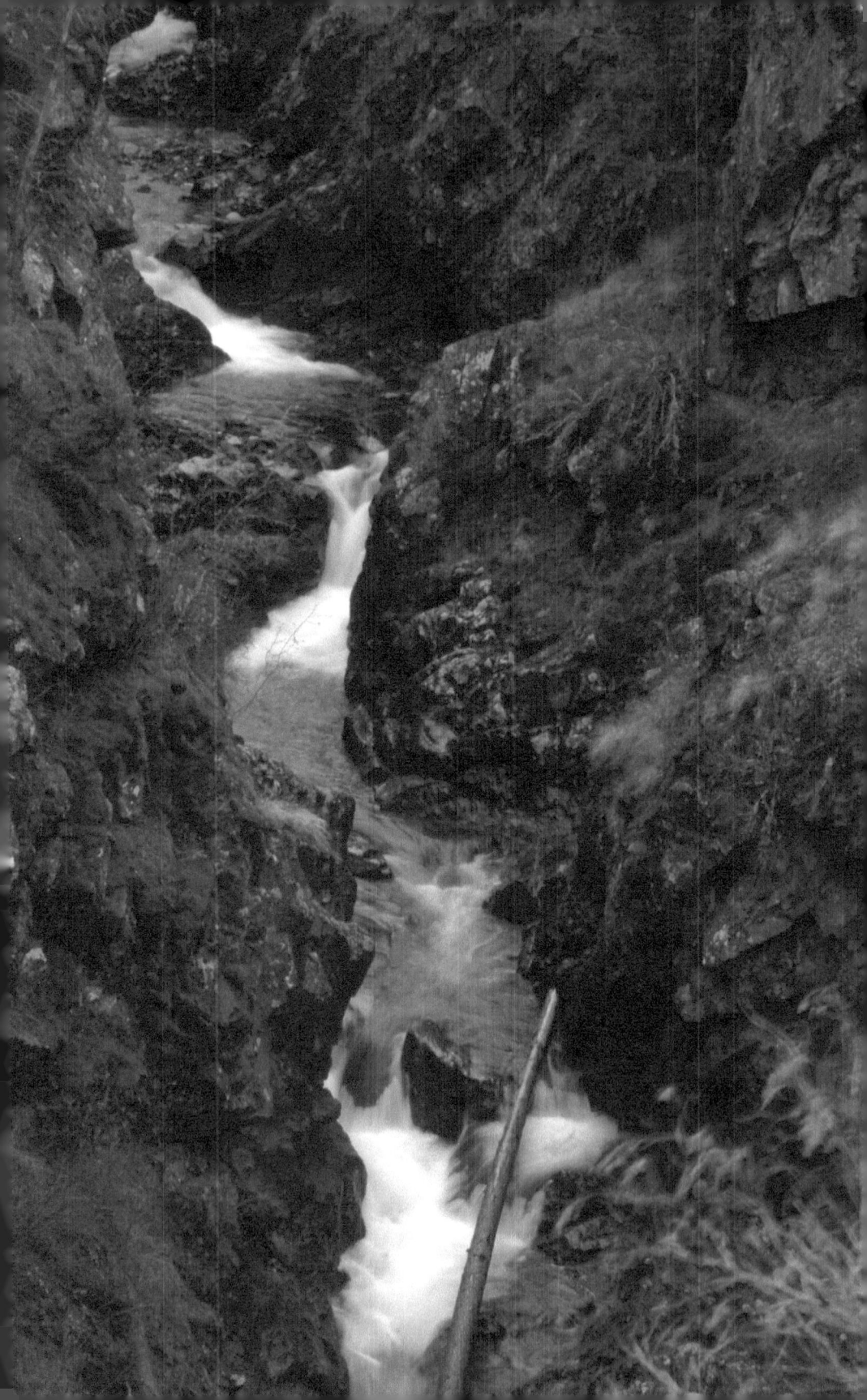

1960's.

Mathematics and the Shape of Change

As a footnote, for those interested in the relationship between the shape of change as it is heard and performed in music, and the new mathematics which might be used to describe it, I've included a little iterative function which generates the tempo changes used in *The Descending Staircase*:

$$70\,((\sqrt[4]{2})\,(\sqrt[4]{2})\,(\sqrt[4]{2})\,\sqrt[4]{2})$$

= 140 (the doubling, or tempo octave)

The numbers which come out of the equation in reverse—(approximately **140**, 118, 99, 83 and **70**)—create a remarkably smooth glissando between tempo doublings, or what I call octaves of tempo: **140** | **70** | **35** | etc. | In *The Descending Staircase,* the tempo slides seamlessly through eight such octaves of tempo.

As a closing thought, in Nature, I've always felt that one of the outstanding examples of a strange loop-like movement can be experienced directly while pondering the mystery of a high-country waterfall. Waterfalls, after all, are truly forever ending and forever beginning at the same time. A marriage of linear and cyclical, finite and infinite, indeed!

In this way, progressing through the steps of a strange loop is much like descending (or ascending) a kind of surreal, paradoxical waterfall or staircase. (Think of the drawings of Dutch graphic artist, M.C. Escher.) That is, even though there is a clear hierarchical structure of ordered steps, the moment we reach the ground floor we unexpectedly, at the same time, arrive at the top again, and so on, *ad infinitum.*

Indeed, this is why the loop or cycle is called, 'strange,' in that it generates a perceptual illusion of a kind. At the same time, it is important to realize that the movement itself is not illusory, but is indeed very real.

Historically, in the Western musical tradition, two examples of strange loops come immediately to mind. One is *in terms of pitch* (or space), and, the other, is *in terms of rhythm* (or time).

The first can be found in the music of J.S. Bach with *The Musical Offering* and the famous *Ascending Canon,* referred to above in the *Watercourse Way.* (Hofstadter calls attention to this remarkable composition in his book.) The second is a much more recent piece written by the great Nestor of North American composers, Elliott Carter; it occurs in the extraordinary central movement of his *Double Concerto* for harpsichord, piano and two chamber orchestras (1961). I am deeply indebted to both these composers, especially, in this context, to Elliott Carter. The strange loops employed in, for example, my song cycle for mezzo soprano and piano, *Ridge Crossing* (q.v.), or *The Descending Staircase* (featured in *The Voices,* based on Rilke texts) were in part inspired by some of the rhythmic patterns Carter discovered back in the 1950's and

STRANGE LOOPS: *WHERE LINEAR & CYCLICAL MOVEMENT MEET IN ONE COMPOSITE*

The idea of a strange loop was first introduced by Douglas Hofstadter in his remarkable book on language, computers and human perception, *Gödel, Escher, Bach* (1979). Unlike Hofstadter, however, I like to think of strange loops not so much as a paradox of logic, but rather as a unique form of natural movement, one which is at once both linear and cyclical.

A strange loop *is linear* in the sense that a straight-line trajectory of change is implied which, much like an arrow or bullet, moves out towards some distant target or horizon, and then does not return;

At the same time, a strange loop *is also cyclical.* This is because a strange loop at the same time moves towards some distant goal and then returns to its origin or point of departure.

This intermingling of the linear and the cyclic into one unique composite movement is the result of a very subtle form of spatial or temporal hierarchy in which we move perceptually through a series of steps or stages, much like we might walk from, say, point *a* to point *z*.

Remarkably, as we progress through the hierarchy, what we know to be a straight line mysteriously transforms itself into a rounded circle, as, once we arrive at *z*, *z* suddenly changes into *a*, bringing us back again to where we started.

The handiwork of some profound natural intelligence.

Where our description ends, along the forest trail, that is also where, when we are lucky, a new spiritual art might begin. Why would it be new? Well, only because it is not in books, not in buildings like churches, and it doesn't really have anything to do with belief. It has more to do with how natural beauty—an inward spiritual grace—brings thought, and music, and poetry, and all imagery to a temporary complete stop. It has to do more with when we suddenly sense ourselves resonating with something both deep inside and same time vastly beyond ourselves.

All in a pinecone we find along a mountain forest path and can hold in our hands . . .

PINECONES & FORM AS MOVEMENT . . .

If you've never looked closely at the form of a pinecone, you might be surprised to see that it has a lot to teach us. Here's an outline of the formal features of the Ponderosa cone pictured above:

Pinecones are for me a kind of archetype of complex form that emerges out of two simpler spiral movements.

One spiral *turns left;* The other spiral *turns right.*

The two spirals fit together (harmony) in a remarkable composite (simplex = *one-fold;* complex = *many-fold).*

In both poetry and music, this gives us a clear generative model of form that emerges naturally out of the weaving together of two simpler movements.

Gregory Bateson, the anthropologist and philosopher, was fond of saying, and I'm quoting here from memory so forgive me if I change his own words somewhat, that *"a sacrament is the outward manifestation of an inward spiritual grace."*

That's exactly right. An inward spiritual grace.

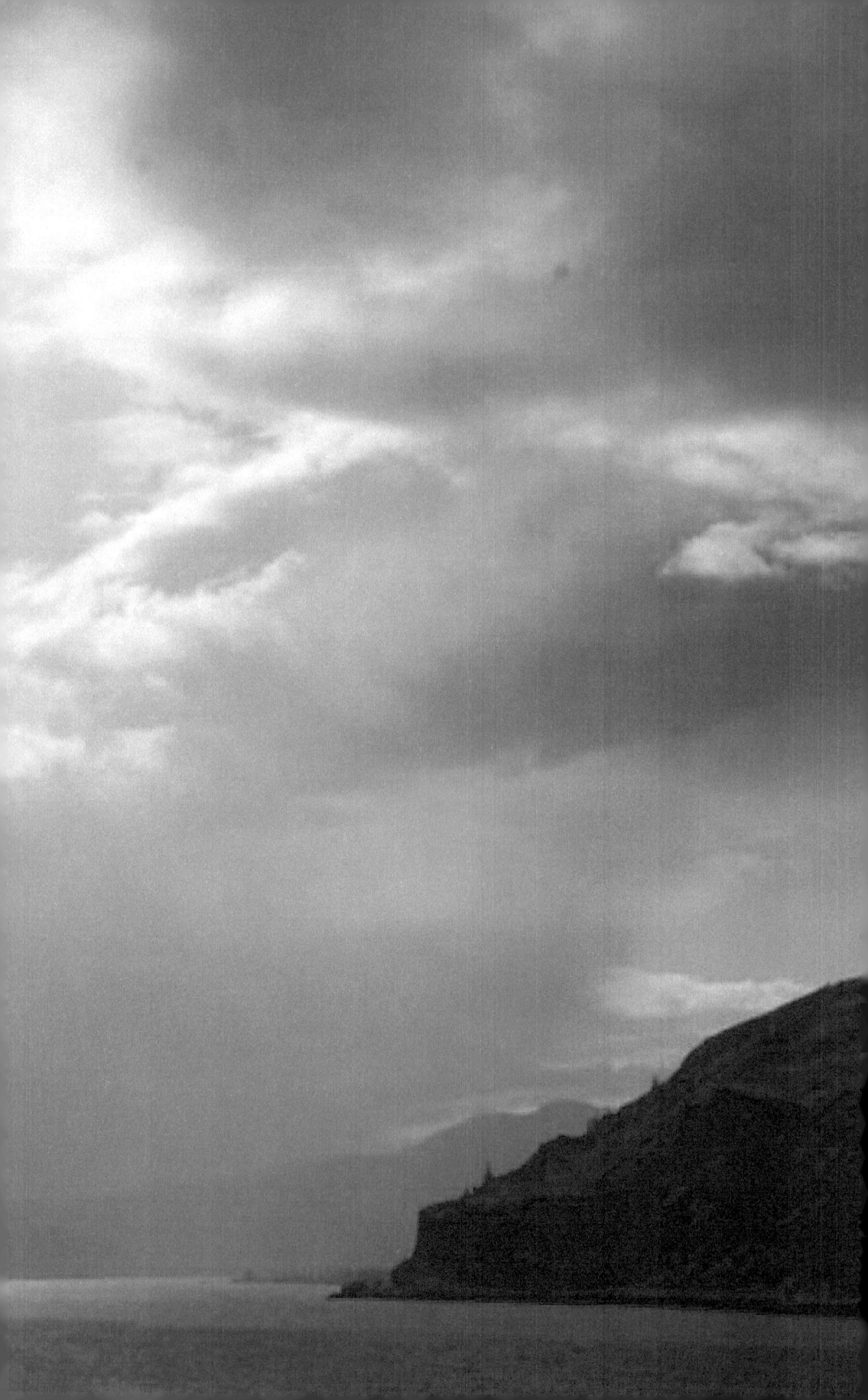

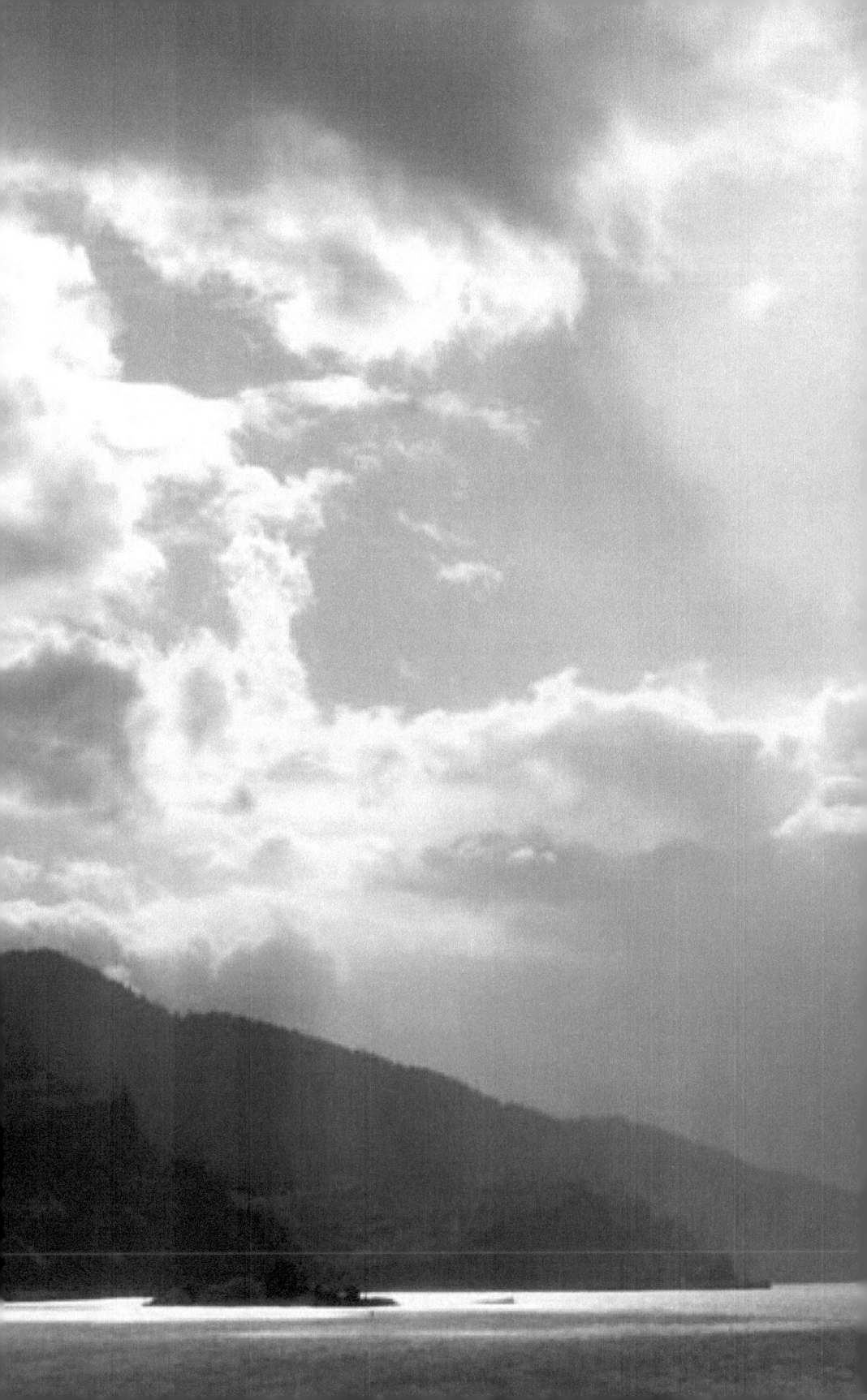

to shake us alive
out of the trance of *2's & 3's*

set in
harsh stone by Bach & Mozart. Yet

even Africa
could not stop the fall back into
the soft chairs of the bourgoisie.
Great rebirth of rhythm, dammed from
day one by the so

dazzling flood of disco-dollars,
sounds that sell soap on radio,
the supermarket of TV.
Why is 4 so square?
Captains of industry that beat
their rock 'n roll drum in the time
of *buy, buy, buy,* hammers that pound,
flatten dead the soul.

Tune in MTV,
cheap cheeseburger of trash-sound . . . born
to be wild in a cage wired shut
by the tyranny of 4:—Try
to be serious.

a potential that
is wasted, just spilling into
the sea, in thought, just spilling, a
tight, high, knot in the arteries
of the pulsing earth,

a knot now filling a vast lake,
filling a vast lake with pressure,
spinning turbines that are heard from
here to Alaska,
spinning turbines, power of thought,
of force, of control, from here to
Alaska, electric nights, big
city, nights without

stars, rivers without fish,
fish so thick a horse would not cross,
water so clear you could see stones
of bright gold dance on the bottom:—
O river of knots.

SLAM

It took Africa
the pulse of
a whole continent,

The Dalles, once natural meeting place,
now hub of North American
squalor, the perfect site to mine
data for quick cash.
Like water, data flows, can be
filtered, turned off, colored *red, blue,
black, invisible.* First we asked
the river to give

us cheap cans. Now we
ask the river to connect up
the thoughts of the world. Water, like
data, can be used for power.
Let's hope for the best.

DAM

It always begins
with a straight
line, a straight line drawn
at a distance, a
line of force, of control, of thought

slamming
straight into the order of things,

vehicles, a faint voice comforts,
saying, *"This can't happen to me."*
But who can say? Economies
blow-out much like tires:—

always at the peak
of their performance. Then boom, bang,
collapse. Hard times lie just outside
the locked doors. Ask the man with cans.
Five cents each, we pay.

SEARCH GOOGLE

It's always been so,
that the one
who controls water
controls the kingdom,
and the one who controls the flow,

the source,
of information controls thought.

But now, the dam at
Fort Dalles powers data about
data, a new kind of meta-
control, a thirst for power
that drinks rivers whole.

ON THE WAYSIDE—*four new 162-step poems*

> *... Randomness repeated*
> *does not look like Chance ...*

BEER CAN

Five cents a piece is
what we the
people pay the man
with his garbage bag
full of cans, gathered along the

shoulder
of a noisy, filthy, awful

highway. For thirty
years, the cans have bought five cents
more of freedom, a sure, certain
insurance for the down and out.
From their cars, others

watch the man pick up his cans,
one by one, like metal mushrooms.
From the safe, fuel-injected time-
space of their speeding

from **ON THE WAYSIDE—**
four new poems

ON THE WAYSIDE

—for Owenuma Blue Sky

What's a weed but the unwanted noise
of another man's music?

But beyond the margin,
that little strip of uncultivated life
to the side of a well-traveled road,
rank growth is my splendor.

Everything needs a place to be,
and here, even the weeds feel at home,
a free space where the troublesome
have gathered together, un-

folding their own songs,
f l o w e r i n g
in peace.

(the Alps, Winter of 1987)

The Little Clavier: Part VII

The economy of Art? You know that your composition has achieved a certain integrity not just when there is nothing left to take away, but when changing but a single part means that you must go back and retune the whole.

* * *

The fewer keys I own, the freer I am.

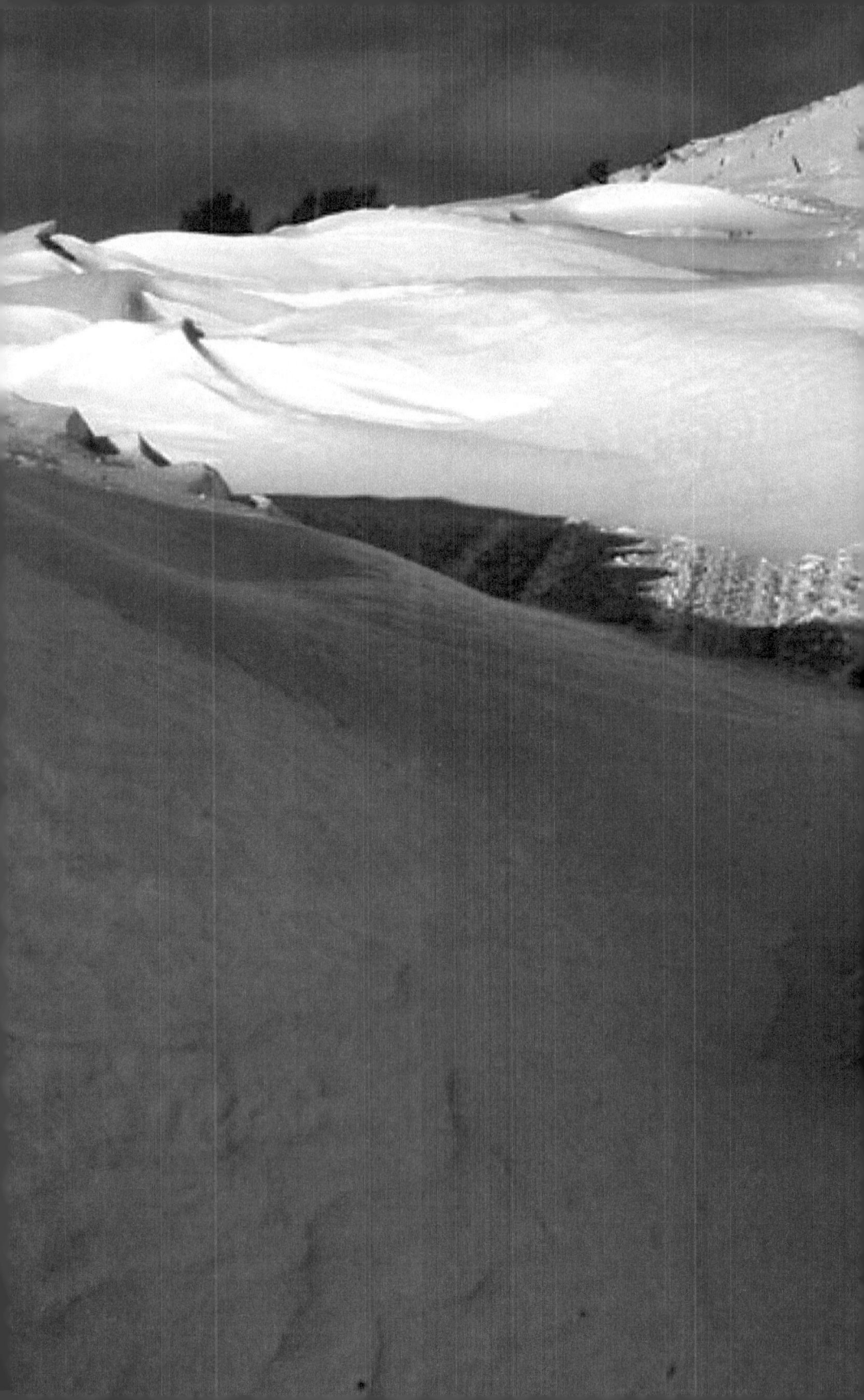

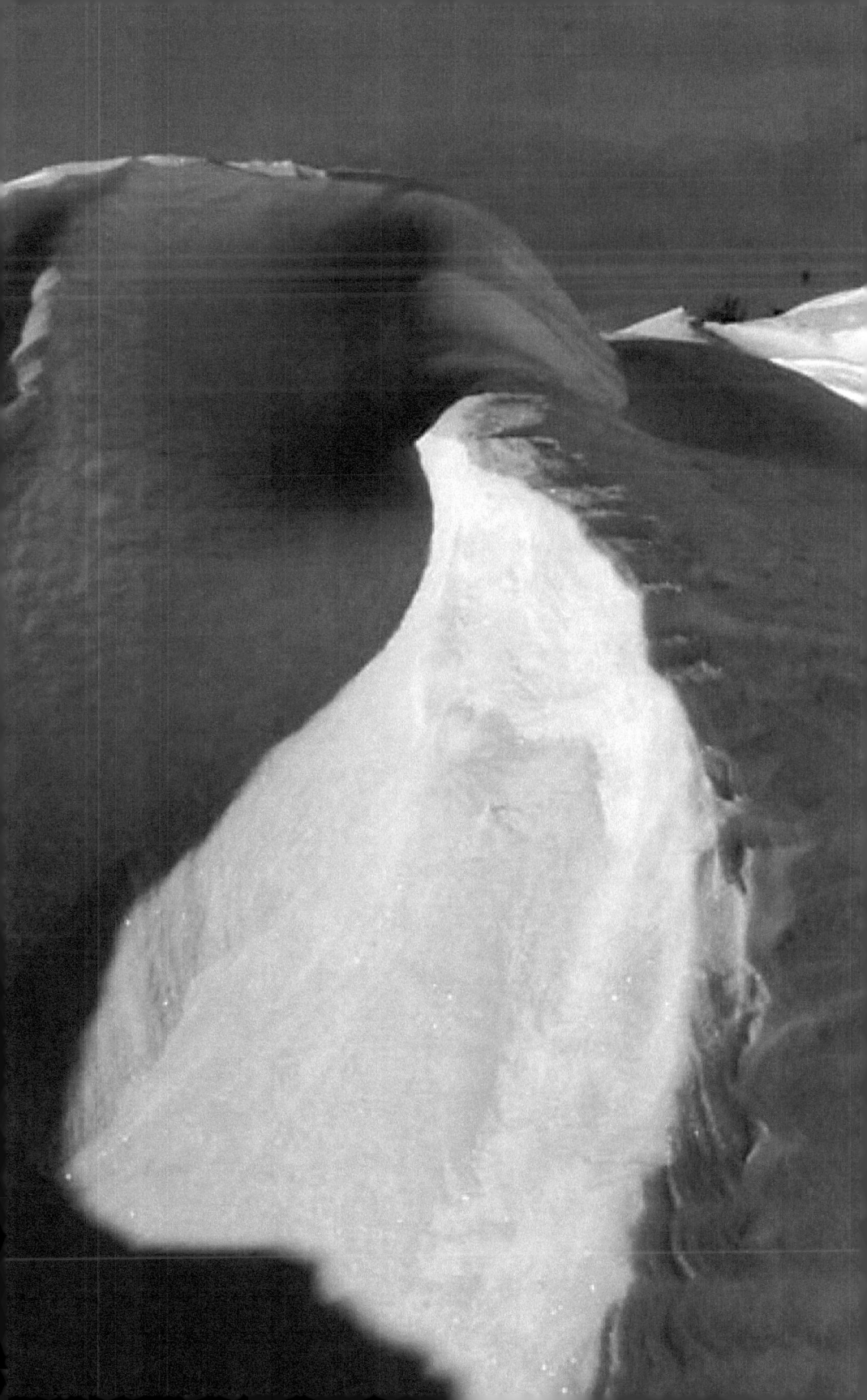

(vii)

Snow is not white; it
is a thousand colors, none of
which have a name, save the

touristland's

sugar-white. *This* snow:—
is melting away as we speak.

(v)

Azure is the color
of the sagebrush steppe at first light.
O sky! Thin sphere of life above,

more mood than

color, more warning,
admonition, than prophecy.

(vi)

Fiery *orange-red* of
the *fortissimo* of sharp brass,
the *pianissimo* violet

of mute strings.

O movement of sound . . .
Double rainbows bridging extremes.

(iii)

Green is growth, not of
money, but of sense, of new leaves,
of new ways of harvesting light.

Flowers tend

away from true green,
but then, they don't last quite as long.

(iv)

Pink is the color
of nurturing, of hope, the stars
mirrored in a young girl's eyes, of

bright balloons

set free atop a
snowy mountain, lighter than air.

COLOR IN WINTER—*seven 37-step poems*

(i)

Red means life, as well
as violent death; it means against
a background of deep black: *"Pay careful*

attention!"

Red is love, is sex.
Red means: *You! Get ready for change!*

(ii)

Blue is the color
of cool reason, of balance, of
contemplation. The temple of

peace has no

color, although some
say that blue may show us the way.

OLD & NEW ECONOMIES

The difference between the Old and New Economy is that the one says, *"Let your money work for you!"* While the other says, *"Let the Sun work for you!"* Remarkably, this one difference will necessarily and in a forceful way help bring the world of Culture back in step with the world of Nature.

PROOF WITHOUT WORDS

In matters of Philosophy and Design, demonstration is everything. Once one stands atop the mountain they said could not be climbed, has played the piece they said could not be played, nothing more need be said.

IN A WORLD OVER-POPULATED WITH PETROCHEMICAL ARTIFACTS

Eighty years ago, the population of California was under two million. Now it is over 38 million, about the same number of people that lives in the whole of Canada. According to current population growth models, the world adds about that many new individuals to the human family every 14 weeks or so. Imagine that:—Every three or four months doubling the populations of California or Canada. Where would they live? What would they wear? How could they be fed? But perhaps the far more urgent question is:—*what would they drive?*

NOISE & THE MIND

We shape the world and the world shapes us.

Noise weighs down on the mind the same way oppressive heat weighs down on the body. Think of it: the early mornings of summer, air fresh and cool, when the body is as light as a feather. But by noon, all physical movement seems like pure drudgery. So it is with noise and the mind. See the reprieve of silent nights when clear thoughts seem to come and go like shooting stars. But by daybreak, we enter the realm of harsh, loud mechanical sound that long ago broke past the limits of the tolerable, and thought is reduced to the bottom lines of urban survival.

How is it possible? This pressure pounding at the portal of the ears—our gateway to the subtle and unseen—seems to turn thought in upon itself, like a dog chasing its own tail, or a New Year's rocket that has fallen out of its upward trajectory and now lies spinning wildly on the ground before it finally explodes.

What has been lost? Truly, how could we ever know? Where is now the land of healthy sound and silence, with its *sonosphere* still whole, with which we could compare the present culture of universal noise? A Monteverdi, walking back to us from four hundred years ago through a window in time, might be able to say. Or a Stradavari or Vivaldi. Or a Bach or Mozart. But by Stravinsky or Varèse, it was already too late. Think of that!

vs. Evil as portrayed in, say, a Wagner opera like *Reinzi*. In a similar way, from inside the car, we are blinded by the comforting sense of mechanical power and that all is peace, order and tranquility. From *outside* the car, however, in truth, at least in my view, all is in reality fragmentation and destruction.

As the final scene of the opera rapidly closes in on us, however, so the illusions generated by car culture will come to an end whether we like it or not. To my mind, the urgent question is: will this happen in a calm, happy, rational and creative way, as well it should if only our ways of thinking about energy might reach quickly enough the level of sophistication of our information technology. Or will we instead, like the National Socialists before us, drive our illusion straight into the inferno we call "the pleasures of the open road."

ON CARS & CAR CULTURE

Along the way, on my treks by bike, I find in general that North Americans are good people. Honest, hard-working, always ready to help. Put, however, even a retired school teacher or grandmother behind the wheel of a car, and instantly, before your very eyes, they will be transformed into mean-spirited, blood-lusting hell-hounds, more than willing to run their own children off the street. (Unfortunately for the rest of the world, the former naturally tends to place the latter behind the wheels of government as well.)

Yet, because we can evidently only perceive this deep and destructive division of North America's national psyche by stepping resolutely out of our vehicles, loyal citizens of Car Culture will, I fear, be unable to clearly see the state into which they have unknowingly driven themselves. That is, until the world's gas tank hits empty.

Addiction to oil? The analogy is a poor one, I think. The addict, it seems to me, always has a certain awareness that what he or she is doing is wrong, is self-destructive. This awareness leads to guilt. To get behind the wheel of a car, however, is to turn the key on a very much more powerful illusion; it is a kind of all-self-enveloping worldview, one which can only be sustained as long as there is a complete and total denial of its false and contradictory nature. And worldviews, unlike the highs of drugs, do not wear off. Consider how the philosophy of fascism blinded the Germans and Italians—two of the greatest and most creative of European cultures—into seeing themselves as essentially heroic protagonists acting out the perennial drama of Good

or how to live sustainably and artfully not just in a material, but also in a spiritual sense, upon the Land is a much greater one. And it is challenge which has the energy and urgency of necessity behind it. Why? Because we contemporary humans are children of an amazingly imbalanced culture. On the one hand, we have our remarkable and revolutionary technologies of information. On the other, we have our dangerously outmoded, non-sustainable and destructive energy technologies together with the runaway militarism absolutely necessary to support these. My contention is, that we too, just as other generations who have come before us, also need a clear slate upon which to demonstrate new ideas, new skills and crafts in designing renewable structures of all kinds, structures which nest themselves harmoniously within Nature's web. Contemporary humans, like all members of our unique yet troubled species who have gone before us, need the chance to build a home and a path, which, like the best of those of the past, might last a thousand years or more.

The question I ask myself is whether humankind may once again become not *man the destroyer,* but *man the creator.* The creator of new habitat. We already have much of the necessary knowledge. And we certainly have much of the necessary technology. Now we need the find the wisdom to limit the power of those tools, and the energy to gain the insights which will reveal the appropriate places, scales and seasons. For me, the notion of protection of wilderness is as necessary as it is in my view at present unfortunately somewhat one-sided. I think we need the idea of humankind not just as "a temporary visitor" in wildness, but rather also humankind—in the right place and at the right scale—as a permanent co-inhabitant and resident protector of special areas of the wild land.

ON THE NECESSITY OF CULTURE NESTED WITHIN WILD NATURE

Just as the world needs vast stretches of healthy interconnected roadless wilderness, so too, in my view, the world needs special areas in which people are encouraged to build small shelters, homesteads and self-sustaining villages within that same wilderness. And what is more, I think the two must of necessity be nested one within the other as a kind of mutually self-sustaining complementarity. This I would say as long as we keep to the strict limiting factor of:—*no roads.*

Why? I would say, because this would offer opportunities to demonstrate new solutions to the perennial problem of Culture co-existing in harmony with Nature. After all, that is one of the primary problems not only of our time, but I would argue, of any time.

At present, as seen by the contemporary North American metaphysics of wilderness, the primary challenge is the on-going two-step task of fighting to acquire wilderness, and then protecting it. A key underlying assumption here is that the best way to protect something is to isolate it. And indeed, when it comes to roads, trucks, cars, snowmachines, chainsaws and the myriad other structures and artifacts of hydrocarbon culture generally, this may indeed be the case. But we should also be aware that it is but one small step from the isolation which walls-out like a medieval mote what we don't want in, to the fragmentation which becomes more like a prison locking-in and locking-out species—including ourselves—on either sides of the barrier.

In a way, I would suggest that the challenge of *culture-plus-wilderness,*

MORAL COMPASS?

A question for our time? *"Have we lost our moral compass?"*

"Nonsense!"—says the Devil's banker. In the much-will-have-more of the Universe of Money, there is no North and South, no Good and Bad! There is only more, of more, of more!

GRACE

Bless those who grew this food.

May they also be happy, well-fed, and safe.

Bless them, brothers and sisters, a l l.

> [I use this little private prayer, with an offering to the four directions,
> *East, South, West* and *North;* I like the way
> its meaning seems to change depending on *where*
> and *how* and *under what kind of conditions*
> I'm doing fieldwork or camped.
> Perhaps you might, as well.]

COFFEE—*the Good from the Bad*

for Tadesse Meskela *and the makers of the documentary,*
Black Gold: *Wake Up and Smell the Coffee* (2006),
Nick & Marck Francis

Things have changed for me. Perhaps irreversibly. As I brew my morning cup of coffee, I see before me now a large sorting room filled with Ethiopian women. Some of the women are older, some are very young, but all wear colorful head scarfs, and have, it seems to me, a certain unmistakable dignity and beauty. The women are separating good, unroasted, sun-dried coffee beans, from bad coffee beans. One at a time; all by hand. They are paid for this work about fifty cents a day. And all of this for me, for you, for the pleasure of our morning coffee.

Truly, I say to you, the day of reckoning is now nearly upon us—upon you, upon me, the day some even more subtle, invisible, hand of judgement shall separate us, too. The good, from the bad.

SOLITARY STARS

We shape the world and the world shapes us.

When individual actors become more important than the plot, or soloists become more important than the music of the concerto itself, both the drama and the spiritual essence of each work will almost certainly be lost. Why? Because they become false centers of attention, like the overly attractive face of a young news-reader which prevents us from hearing the actual content of the news itself.

This is the price we pay for the cult of worship of mere solitary stars.

MIND / BODY SPLIT

We shape the world and the world shapes us.

The greater the cultural split between mind and body, the greater will be a culture's tendency both to denigrate physical labor, and, in order to supply the necessities and sustain the privilege of its non-physical life-style, to become dependent on some form of slavery, whether the slavery of the whip, or that of the bare minimum of a survival wage.

THE ENERGY OF CORRUPTION

We shape the world and the world shapes us.

"Clean coal" is like the idea of a healthy, *"low-tar"* cigarette;

"Safe nuclear" is like a time-bomb with but a slightly longer fuse.

O vested interest, clouding the future with the smoke of deliberately deceptive language and false promise.

As the dust settles on the present dark age of fire and hydrocarbons, and we are dug out by future archeologists, the central question asked may well be, not why the SHELLS & EXXONS of the world lied with such dogged tenacity—that, after all, is merely self-interest—but rather why the rest of us, privileged as we are to live under the hard-won protections of freedom of thought and freedom of expression, believed them?

Where are the free spirits who refuse to buy their propaganda, and who refuse to join the citizen congregations of the faithful that now follows their drumbeat straight to the inner circles of petrochemical hell?

CONSERVATION

Conservation is a way of dealing with Nature's basic asymmetry: that growth is *slow*, and destruction *fast*.

CULTURE OF CHAIRS?

The first person to come up with a chair had back-pain. Then he gave it to the rest of us!

MUSIC?

Music? The one thing humans do that makes the rest of Nature jealous.

similar events have repeated themselves so many times that this no longer seems appropriate.

By way of footnote, some two and a half million cars pass through Glacier Park every year. Cars and their emissions are without a doubt, in my view, a primary cause of the warming trends and the remarkable acceleration of the loss of the once great ice fields for which the park was named. In German, a beautiful expression for glaciers is *Ewigen Eis,* or in English, *eternal ice.* It certainly ought to stop more than mere tourist traffic to witness eternity melt in front of our children's eyes.

THE SQUARE OF FALSE RATIONALITY

Inside the Square, discussion is neat and orderly. Clean—almost. This is because Truth and a whole angry horde of assumption-threatening details are kept systematically at bay, far beyond the walls of the Square.

Inside the Square, discussion will continue until the unavoidable moment arrives when an avalanche of contradictions breaks down the walls;

Or, alternatively, until we step firmly and resolutely—
 out of the Square.

CLIMATE CHAOS

Higher temperatures (an increase ± 1.6 F. in the Northwest over the last 100 years), earlier mountain springs and shorter winters, with less precipitation, and less of that falling as snow. All are evidently features of long-term climate change.

Less predictable, however, are extreme weather events. That is, less predictable in terms of when and where they will strike. *That* they will strike is a relatively certain feature of what I think of as degenerative chaos, i.e., a type of chaos that tends to destroy or corrupt, and not create, already established and relatively balanced systems.

In November of 2006, Glacier National Park and the famous Logan Going-to-the-Sun-Road were hit hard by such an extreme weather event. A record nine inches of rain fell in a 24-hour period. Normally, in a mountain environment, even in September and October, rain would fall as snow at the higher elevations. Instead, it fell as an hyper-intense high-density rainstorm, washing out whole sections of the newly rebuilt road. This is precisely the type of storm that is terrorizing parts of the European Alps. In August of 1987 I was camped in Switzerland at 1600 meters when such a storm hit. I'll never forget the experience. It was as if it were the end of the world. Huge boulders came thundering down the steeply-walled valley from the highest ridges, and by morning, the road to a nearby village was totally washed out. The Swiss quickly called it understandably "The Storm of the Century." But by now

NO GLACIERS IN GLACIER NATIONAL PARK BY 2020?

According to Dr. Steve Running, professor of ecology at the College of Forestry and Conservation of the University of Montana and one of the lead-authors of the most recent IPCC report on Climate Change (co-recipient with Al Gore of the 2007 Nobel Peace Prize), the resident glaciologist Dr. Dan Fagre at Glacier National Park now estimates that the Park will lose its famous ice fields by 2020. This is down from a former estimate of 2030.

Similarly, the estimate for the Alps, according to the Zurich-based World Glacier Monitoring Service, has been revised from 2050 down to 2037. The European glaciers have also been hit by dry winters and hot summers, the two primary causes of retreat. 2003, with its record high temperatures, saw on average an unprecedented 2.13 meters (7 feet) loss of ice thickness. And in 2005, massive summer runoffs of melt water caused wide-spread flooding.

Glaciers are not just objects of rugged, pristine beauty, or opportunities for summer skiing fun and mountaineering; Glaciers are also—all the Earth's estimated 160,000 of them—the world's largest source of fresh water, second only to the Poles. I like to see them as a kind of giant watershed savings account, where precipitation is stored up, for leaner, drier times. But now, most of the Earth's glaciers are vanishing before our eyes. Reason enough, it seems to me, to pause and consider why.

index finger of either their left or right hand—the digit with seeks to indicate the meaning of the names of things—and ask what it is called. With children, bad names confuse, whereas good names will light their faces up much like Granite Cliff itself begins to glow with the first light of a summer's day. This is a vital part, I would say, of how a young person can be helped to grow up with deep roots in the living spirit of a place.

A NEW WORD FOR SOUND

Somebody help me here: How are we to describe natural essentials, like, *good air, good soil, good water,* and well, here we have a little, but serious, problem . . . *good sound?*

[**KNOW YOUR MOUNTAIN CLIMATE FACTS:** With *Climate Change,* ice world-wide is disappearing at an ever-accelerating rate. If Lewis & Clark would have entered the Wallowas just 200 years ago, they would have seen small glaciers and ice fields in all the high cirques and hanging valleys. Since the end the *Little Ice Age* (c. 1850), these ice fields have all but vanished. Over the same period, the average temperature has increased by, in round numbers, 1 c., snowpack has decreased by 50%, and most importantly, atmospheric CO_2 has risen by 30% from 250 to over 387 ppmv. Because CO_2—a greenhouse gas—holds warmth, this is like the Earth putting on an ever-thicker down jacket. And because CO_2 remains in the atmosphere more than 100 years, even if all emissions were to stop today, we're already committed to unprecedented human-caused climate change on a scale never before witnessed. This is not some hypothetical future, but happening *right here, right now*. In the Northwest, the tendency to watch is that of *drier winters* and *hotter summers*. By 2020, the *Benson Icefield,* like the once giant Ponderosas and Doug-firs of eastside forests, telling relics of a different climate, will most likely be but a shade of lighter gray of a very tragic story written in the rocks. (q.v. photograph of *(Lost) Glacier Peak* in the Eagle Cap Wilderness 310.]

CATHEDRAL ROCKS

Strong, simple, bold, clear lines.
A cloud passes by . . .
Strong, simple, bold, clear lines.

Nomen est omen.
(Name is omen)

Southern counterpole of the *Matterhorn* of *Hurricane Canyon* and located on the westside of the spectacular East Eagle Valley, is the formation I like to call *Cathedral Rocks.* This seems to me a good name because of the manner in which it reflects the early morning light, especially when seen from the valley floor during the summer months. Like many places in the Wallowas of great power and dignity, Cathedral Rocks has been somehow given a name—Granite Cliff—which seems to me rather like a lame cartographic afterthought. First, because the formation is limestone, and not granite. Second, these empty generic names are like calling your beloved family dog simply, 'dog.'

But in all seriousness, the point is not so much what a formation is called—*Castle Rock* is another name some old-time locals know—but more the fact that names are important precisely because they are how we weave together our own internal maps of the poetry, the story of a place.

If you want a direct sense of how this works, all you have to do is look up at such a mountain with a small child. They will point at it with the

The Little Clavier: Part VI

Flowers are to the background green
of meadow and forest what a well-made
poem is to the constant chatter of sounds
which surrounds us.

How strikingly beautiful they are, these
centers where essences converge.

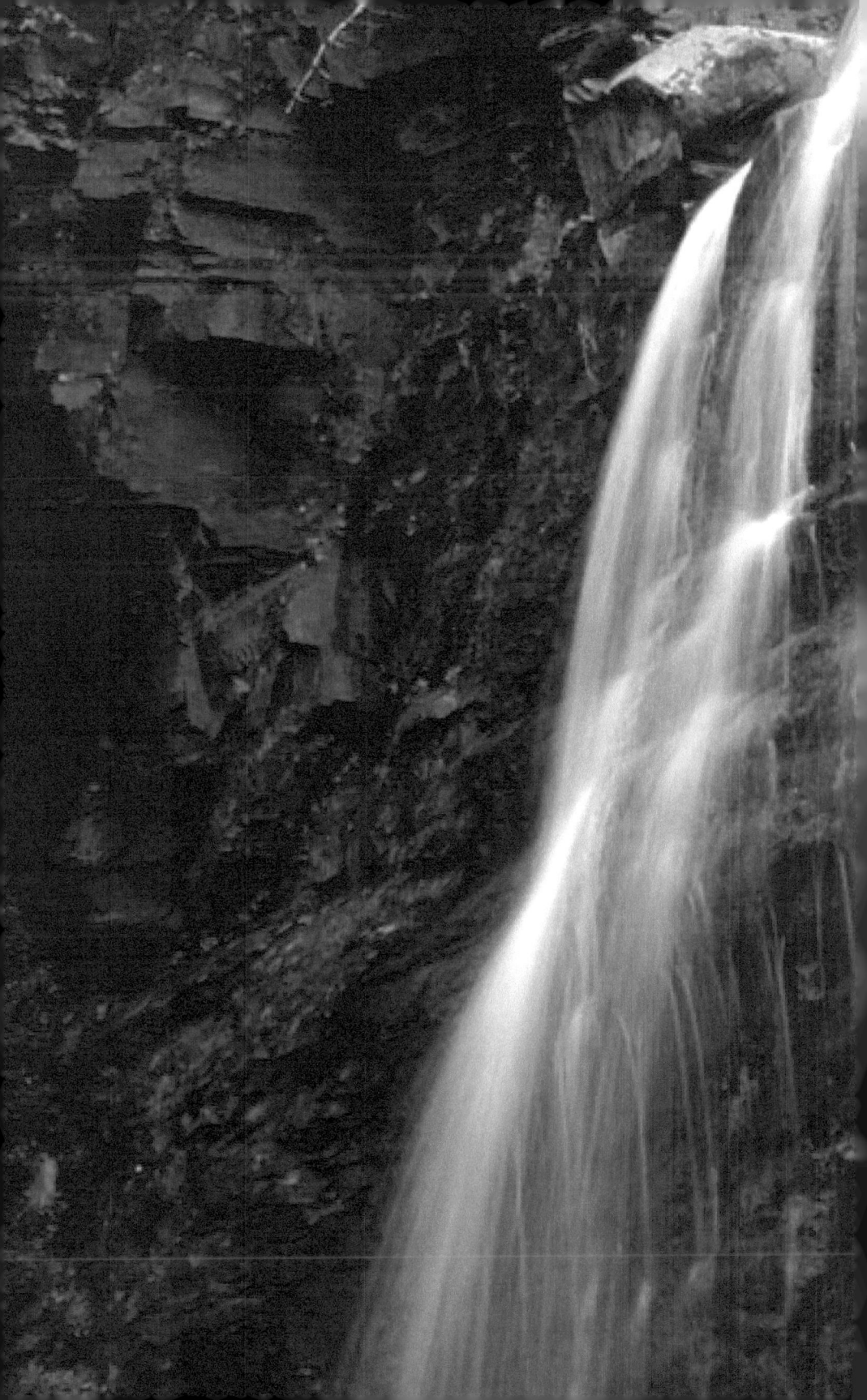

DIABOLUS IN MUSICA?

The *tritone,* as found in situ in its natural home or place within the harmonic or overtone series, is one of the most primary relationships between sounds. It might be called the interval of neutrality because it is the only sound that both divides the octave in half, and is neither *consonant* nor *dissonant*.

The tritone *is neutral* in the sense of being motionless and yet in some mysterious way it contains within its motionlessness the potential of all movement. Like the fine balancing point of the edge of a high mountain ridge, the rock or the drop of water can fall from this point on either the bright sun-facing or the dark shadow-facing sides.

And, like a culture's sense of balance between the masculine straight line and the feminine curve in the visual and architectural arts—a balance which is easily pushed too far in either direction—much is implied and revealed in our relationship to this one single interval.

DICTIONARY

My favorite book.

An Indra's net of interdependencies, each word, each node, reflecting in its own way, all the others.

Pick out the crystal of but a single word from the ever-changing shimmer of reflections, hold it up to the light of enquiry, and watch how new meaning sparkles and shines from all its sides.

ON THE DIFFERENCE BETWEEN *INFORMATION & MEANING*

We rehearse *information,*
but perform *meaning.*

Information is like the web of links in a wire fence;
Meaning is like the delicate ice crystals
that appear out of the blue on a cold January morning.

One we can stitch together endlessly,
capturing what we're looking for,
and *keeping out* what we don't want in.
The other one, just by touching it,
vanishes before our eyes.

require the resources of two or three Earths merely to sustain into the near-term future.

So, Aldo Leopold's expanding circle of awareness of the Land Ethic must now of necessity be expanded very much further. Every child can see the truth of the path of renewable energy. And every mother can see that life on planet Earth is not the straight line to nowhere or somewhere else of war and waste, but rather eternally and wholly here and round.

WAY OF COLLAPSE

Once a culture is defined more by *what it wastes* than what it creates, more by *what it destroys* than what it builds, it crosses a critical divide down the way of its own demise.

Remarkably, this way of collapse—as an ultimate act of ironic self-deception—will be seen as the only reasonable path to its future prosperity.

[Photo opposite: *Cornucopia Peak,* above Halfway and Pine Valley, January aspect, high pressure inversion after new snow.]

fragmentation, with its complementary illusions of separation and independence. Separation assumes that the consequences of my actions, or the actions of the group with which I identify, do not extend much beyond the physical boundaries I can see with my own eyes. And, in a related way, independence assumes that what happens beyond the very limited circle of my, or my own group's, visual circumspection is not relevant, does not touch or affect me personally. It is easy to see from a wider, perhaps what we might call, philosophical perspective, that both assumptions are patently false. At the same time, it is crucial to realize that this was not the case as recently as just two hundred years ago. This, I think, is a remarkable fact. Two hundred years ago, a family's waste did not venture much beyond their own backyard, but now the pollutants it generates everyday in amazing quantities routinely resurface in some of the most remote corners of the planet. And so it is also with the consequences of war. Now that the atom has been split—arguably the ultimate phase in self-destructive fragmentation—a handful of bombs can take down the planet, and the waste of but a few reactors comes full circle to remain a threat for more generations than we can honestly think about.

Clearly, a concomitant great leap of ethical creativity is called for if we are to effectively limit our new-found destructive potential. And equally clear is that it would be naive to think we could solve problems of a global scale like Climate Change by not at the same time addressing the directly related and in my view more fundamental problems of war and waste. Just the fact that about a third of the Earth's resources are presently devoted to either preparing for war or actively waging it, should demonstrate the necessity of this. Or the parallel fact that present styles of consumption are so extraordinarily short-sighted that they would

THE EXPANDING CIRCLE OF ETHICAL AWARENESS

> *"The land ethic simply enlarges the boundaries of the community to include soils, waters, plants and animals, or collectively: the land."*
> Aldo Leopold

A key challenge of the current era, it seems to me, is the need to awaken a new sense of ethical responsibility. And a key challenge of this new ethics is to develop a sense of responsibility strong enough to counterbalance our, in historical terms, newly-found and massive destructive powers. The image that presents itself is simple. It is the image of an expanding circle of awareness, one which grows to embrace the whole of the living Earth.

This image of the Earth as seen from the surface of the Moon—certainly one of the great leaps in creative awareness since the discovery the Earth was not flat but round—has already deeply and irreversibly transformed the consciousness of humanity. At the same time, few of its implications have been realized. And many of the outmoded straight-line, flat-earth habits of seeing, thinking and acting are still fully active and dominant.

Chief among these old habits of thought are the concepts of war and waste. They are old, because they are not in harmony with the new reality of one world and one humanity; And they are habitual, because they lead us to repeat the same mistakes over and over again. Underlying these old habits of thought is the tacit metaphysics of

American was just that:—ruthless. And what is worse, it was sanctioned by not just the European's religion, but also by his laws. (This disingenuous use of the rule of law to *subvert* the rule of law is, in my view, one of the most serious, still-ongoing sins of public life. Consider Jackson's historic refusal to enforce the ruling of the Supreme Court in 1830, protecting the Cherokee homeland; it was a kind of formative 'fore-echo' of the executive hubris of the Imperial Presidency the world was forced to suffer under the more recent Bush and Cheney administrations.) Montana is, in my opinion, in a severely self-limiting way, broken apart by the presence of these open wounds and injustices of the past. Much like an abandoned mine, they continue to discharge their poison into the streams of both *present* and *future*. And it seems to me that no one wishes to look straight into the heart of the problem as the silver wolf looked at me, seeing some strange and foreign presence on a bicycle at night, but somehow showing no fear. Given a full tank of petrol and enough money, it's easily possible to speed down a road like Highway 2, and, hopping from happy reservation casino to casino, remain oblivious to what I am calling this dissonant echo of the past. But it is hard for me to see this gambler's view-of-the-world as anything more than a fin de siècle illusion or deadly trap. If one were instead to stop, and get out of the speeding car and simply walk the lands of the contemporary Native American, a new beginning might be possible. The dissonance will be resolved regardless. But pondering the meaning of the little-used word, *ruth*, or *pity*, or *compassion*, or the lack there of, may be a good place for us to start.

[Photo opposite: *Spring avalanche in the Alps*, with heavy new wet snow bringing down a slab avalanche from 1000 m. above the point where the photo was made. Snow conditions have always been hard to predict; they are becoming dramatically more so with Climate Change.]

It let me pass, and that was that. But the next morning, after I broke camp, I happened upon this historical photo, a part of which I've reproduced below. It was part of a larger informative display created by the Park service, and placed on the eastern edge of Lake Saint Mary. I was first taken aback by the quality of the image. Then by the date, around 1914, the display said. Then by the beauty of the image. Not just the composition, but by the robust health and integrity of all pictured: *men, women, children, horses, culture.*

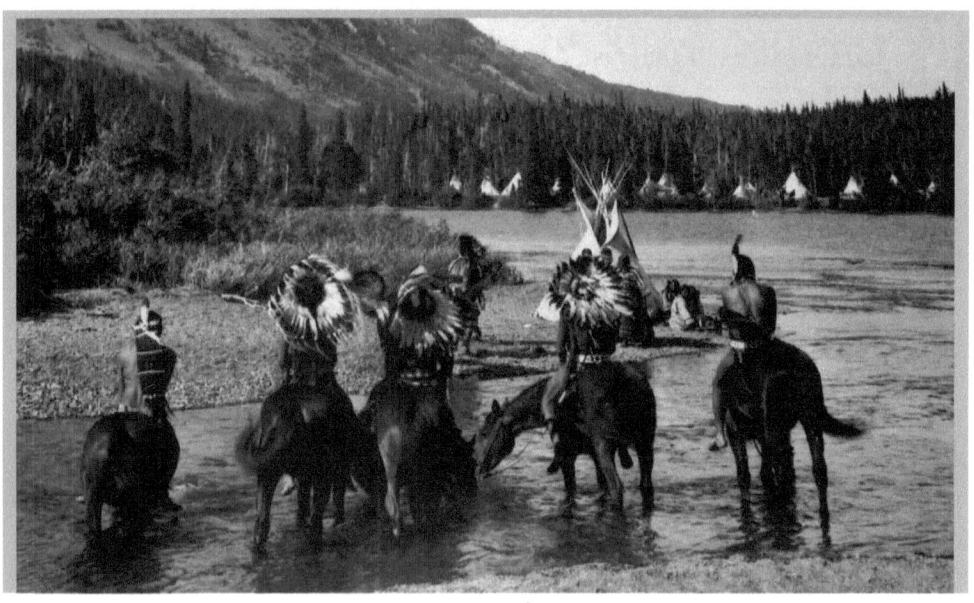

And then the sadness came. For what was lost. But also for that strange word used above: *ruthless,* or an extreme form of violence that is utterly lacking in compassion (ruth: *a feeling of pity, distress* or *grief*).

For the genocide perpetrated by the European upon the Native

THE PRESENCE OF THE PAST . . .

As I see it, everything that happens leaves a trace. One may think of this as a kind of echo, a kind of subtle afterglow of sound which resonates out of the past to in certain ways further shape and condition the present. Some echoes are pleasant and good. While other echoes are bad, reverberating as harsh dissonances. And of these dissonances, some may be particularly strident, so much so that we may become caught up in a kind of grinding repetitive loop until they are somehow finally resolved.

Personally, as I travel the Northwest, passing through many so-called reservations, I am frequently overwhelmed by these still-echoing dissonances of the past. For certainly the tragic 500-year history of the European ruthless conquest of the native populations of North and South America is not just a matter for dust-covered school books. In Montana country, it is right there in front of you, right there walking down the street. Every time one spends a $20 bill, one is, or should be, painfully reminded of Andrew Jackson—a war criminal by any civilized standards—and his brutal Trail of Cherokee Tears.

Coming down on my bike from the East side of Logan Pass at night after lingering a bit too long making photographs, I had a surreal descent. No cars, no lights. The whole road to myself. I just had my headlamp on, with its batteries running low. About halfway down, I almost ran into a solitary young wolf standing in the middle of the road. It was as surprised to see me as I was to see it. In the weak light of my headlamp, the wolf looked almost entirely silver. Ghostly almost.

In a remarkably and in my view insensitive and inappropriate act of naming, the distant, rounded, massive mountain in the background of the Old Chief Joseph gravesite is known today as *Mt. Howard.* General Oliver O. Howard, the calvary officer, was I have been told the arch nemesis of *Tiwi-Teqis* (the preferred *Nimiipuu* name of Chief Joseph), and later responsible for driving the young Chief Joseph—*his* real name was *Hinmaton-Yalaktit* or *"Thunder Rolling Down the Mountain"*—and his people from their land of winding waters. In a ruthless battle of pursuit that a more enlightened contemporary ethics would undoubtedly consider an act of wholesale genocide, the Nez Perce were conveniently eliminated from the Wallowas. I have read that the first European American name for the mountain under discussion was *Signal Peak.* In my opinion—and I have of course little right to speak on such matters but feel moved to do so nonetheless—this is a very much superior name. It might in a small way signal a new spirit in European American and Native American relations. And it might be a way of beginning a new Signal Peak tradition of building natural or artificial signal fires to mark special events and times of the year, like the Swiss do atop the highest peaks on August the 1st throughout the Alps to mark the birth of their confederation. Place names are more than just words on a map. They are in the deepest sense, I feel, the first and primary poetry of place. One should teach them to the young with pride, and if that cannot be the case, the young should know the story of why, or better yet, they should be changed.

[Image below: **Old Chief Joseph Cemetery:** Hinmaton-Yalakit *"I blame my young men and I blame the white men. I blame General Howard for not giving my people the time to get their stock away from the Wallowa. It is still our land. It may never be our home, but my father sleeps there, and I love it as I love my mother."* [from the transcript of SACRED JOURNEY OF THE NEZ PERCE, a co-production of Idaho PublicTelevision and Montana Public Television]

and cigarettes legal—both demonstrably potentially deadly substances—but not coca and cannabis? Second, because, when it comes to addictive substances, the perhaps well-intention effort of law-makers to increase peace and order at home, evidently invariably increases violence and disorder abroad where they are produced. Witness Columbia, the coca leaf and cocaine; witness Afghanistan, the poppy plant and heroine. Both Columbia and Afghanistan are, most would agree I think, essentially drug-ravaged states, and will tragically remain so until the root cause of the disorder—the vast amounts of drug money coming in from the US and Europe—is eliminated.

So, abuse of addictive substances is best dealt with in my view not by judges and the threat of prison time, but rather by sympathetic doctors and open clinics. At the same time, cultures by definition must necessarily strive to draw out the best of each individual citizen by the natural—that is, *non*-arbitrary—authority of the demonstrated ethical good example. And the good example here is much more than just using such substances in a modest, temperate way, if at all; it is perhaps much more a question a taking responsibility for one's actions at home as their consequences resonate throughout the wider world community. *First—do no harm,* is here as it is everywhere a good ethical point of departure. And arbitrary drug laws which turn common plants in an endless source of dirt-cheap criminal gold, are without doubt wrecking havoc with the world's shared economic household.

NAMES AS THE FIRST POETRY OF PLACE

Nomen est omen
(Name is omen)

the stubborn head-winds of North Dakota and Montana—is why certain addictive substances are legal, and why others are not. The answer is that there is no answer. That is, an answer in the sense of a reply that would satisfy the still-unfettered intelligence of a young child. It is simply arbitrary.

Now, arbitrary norms and values in an enlightened society based on the rule of reason make for bad laws. We see the beginning of the problem in the word-history of 'arbitrary' itself, coming to us from the Latin *arbitrarius,* from arbiter or *'judge,* or *supreme ruler.'* So we must deal, for the sake of a child's understanding, with this potential contradiction between the ultimate authority of the arbiter, and the potential unfairness of this authority when it is based not on argument, but rather on mere whim or pleasure or some hidden agenda. (Note that what the child most likely *does not* but *should* know here, is that this kind of doubt and serious questioning of governmental authority is done in the spirit of perhaps one of the greatest of all North American traditions: that of a simple commoner, for instance, like Thomas Paine, standing up to, and soundly defeating intellectually, the (arbitrary) authority of the King of England with but a single pamphlet published in 1776, *Common Sense.)*

So what is a reasonable society to do with the myriad of addictive substances that when used by people of certain cultural heritages and with an appropriate sense of measure—these two seem to go hand in hand—do little harm, but when used to excess by others leads to almost certain self-destruction? I would argue that we should do nothing. First, because of the inherent arbitrariness discussed above. Why are alcohol

EUROPEAN CULTURAL BIAS & THE RULE OF REASON

Mala herba cito crescit
(Weeds grow fast)

The unique privilege of the pilgrim or wayfarer is the opportunity to observe cultural custom and bias from a certain distance. This distance I like to think of as a kind of neutrality, which is simply an unburdened readiness to move or change, or to correct mistakes quickly, like an agile biker banks left or right maintaining a steady center of balance.

Consider alcohol. I've noticed that there is a certain relationship in the Northwest between the number of gas stations, and the number of bars and liquor stores in a town. They are usually about equally co-present. (Similarly, in the trendy economies of Arts & Crafts / Ski towns, a related connection seems to exist between the number of realtors and espresso shops.) So, if one pulls into a town as a stranger—and don't forget, on a bike of any kind in North America one is *always* a stranger, or something of a cultural curiosity or outsider—one would naturally assume that custom dictates that one first fill up one's tank, and then get a drink.

Alcohol:—clearly, *balm* to some; *bane* to others. And an ancient feature of what is in many ways arguably the best of European culture. After all, there is hardly a book in the *Iliad* or *Odyssey* of Homer in which wine does not figure prominently. But what interests me here— and the question that comes repeatedly to mind as I've biked through

metaphor. So instead of a lifebody of the land worthy of unambiguous protections, we think of a set of disconnected, essentially replaceable materials which can be used, owned, and sold essentially without limit, just like bolts and gears and fuel. Thus, when we say, for example, 'land rights,' or 'water rights,' the first thing that comes to mind is the rights of individuals to own and use these as resources, and not the rights of protection of the land and streams themselves. In the view of the synergy of three being discussed here, this is a profound error of perception and thought—a kind of illness of consciousness really—because it is a mistake that is made repeatedly and wantonly, an error which is in urgent need of examination and healing.

That is for me the clear and simple message of the Terra Madre figure. The Earth is our mother, our greater life-body, in both a literal, and spiritual sense. So when I make, for example, a photo of a farmer in Ohio pumping his soil full of anhydrous ammonia, as I have done many times, my gut reaction is no different than when I hear of a human being subjected to the torture of water boarding for whatever reason: *"Good god, this must stop, now."*

I stand by the clarity and simplicity of this view.

For me, the figure approximates what I sense in a direct, simple, emotional way—yet at the same time completely open to rational consideration—as self-evidently so, or true.

In this outline, I would only like to call attention to two implications of the diagram: First, is what I think of as both the negative or positive triangle of interrelationships represented by the figure. In a single phrase: as a general principle of the synergy of three: *abuse one, wreck three.* That is, cut down the forest, and you'll wreck both the water cycle and the atmosphere. Treat the atmosphere like a sewer, and you'll wreck both the watershed and the forest. Dam the rivers, and you'll wreck the forest and dry out the air. Etc., etc. Note also that the principle has a crucially important *positive* formulation: *improve one, heal three.* Bring back the forest cover, and improve the health of the watershed and the quality of the air, etc.

The Synergy of Three

Second, the principle of the synergy of three addresses the issues of ethical culpability for harm done, as well as the ethical responsibility of us all to act decisively to stop such harm. In countries with an established tradition of the rule of law this last statement is well established as far as the rights of individual citizens and other legal entities are concerned. This is without a doubt a great achievement that deserves our sustained vigilance. On the other hand, when it comes to the Earth and the land, our ethical awareness has very much taken a back seat to what is generally thought of as "economic development," which in turn is deeply condition by the *life-is-a-machine* formative

Here, we have a translation of the figure:

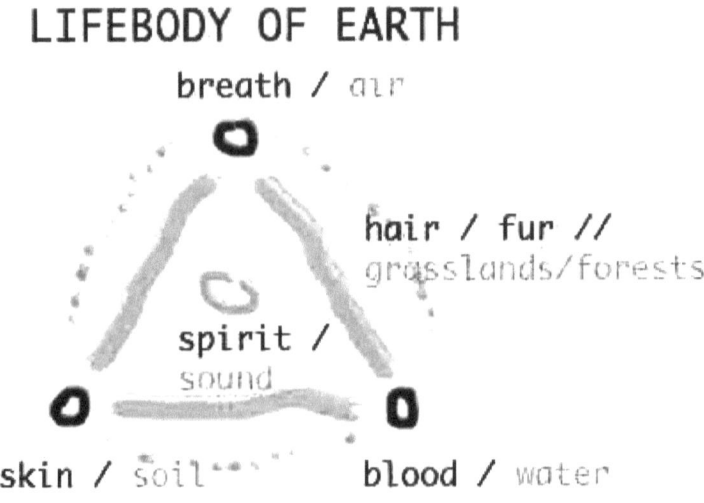

The message is clear: the physical lifebody of the Earth—what a scientist of Western culture would call the biosphere—is actually our own larger, in a very general sense, *life-body.* That is how I experience it, with the "breath" being the air, the "skin" the living surface of the soil, the "blood" the great circulatory cycle of water, and "hair" and "fur" the grasslands and forestlands, respectively. And finally, "spirit" as represented by sound, or the soundscape or sonosphere of the whole. I was especially struck by the latter spirit / sound relationship, as it should be in a way obvious to a musician like myself, and yet it is strangely and tellingly ignored by the present highly mechanized now dominant society.

TERRA MADRE—THE LIFEBODY OF THE EARTH & THE SYNERGY OF THREE

In a dream, or in a kind of half dream-like state, I'm not quite sure which, I recently while at one of my basecamps doing fieldwork had this figure come to me in a strikingly vivid, forceful manner. I got up straight away in the middle of a stormy night to write it down in my notebook. It is a very simple vision of Mother Earth, or *Terra Madre,* as it in symbolic form presented itself:

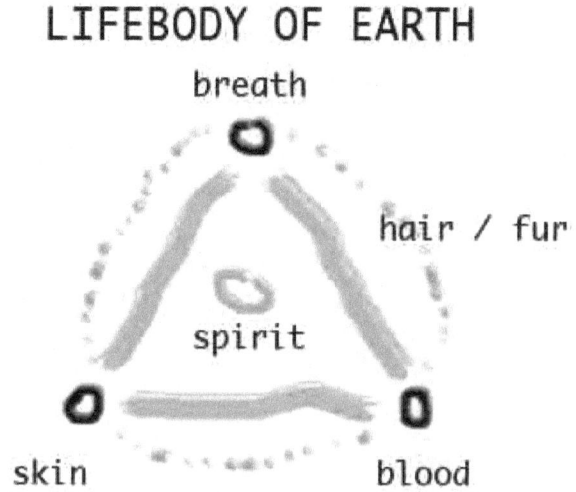

ment at present, call it what you will—oligarchy, democracy, tyranny—serves overwhelmingly to safeguard these corporate and military interests. That is my view, and I stand by it. At the same time, the more enlightened democracies worldwide embody in a tragic way the very contradictory division of consciousness which is our theme. Freedom and civil rights are guaranteed. But only insofar as these do not get in the way of the more primary corporate and military interests.

This is why even potentially good leaders will be torn apart by present systems of government. Because the worst half, so to speak, will be forced to dominate. So leaders promise peace, but give us more war. They promise universal health care, but sell out to the insurance companies. They promise to address climate change, but give us more coal-fired and nuclear power plants. It is in a word why politics is at present the very worst place to look for leadership. Unquestionably, the way of the brutish brain, if it should for whatever reason be allowed to prevail, will lead to its ultimate apotheosis of total self-destruction. This is self-evidently so, especially when considered over longer spans of cultural time like two or three centuries, because of the already realized destructive potential of its weaponry, or simply because of the rapacious waste of resources and resulting damage to the biosphere inherent not only in their possible use but solely in their development. But the way of the compassionate mind, even though its voice is at present weak in the political arena, *has the power of necessity behind it.* And that makes all the difference. That is, if we see the difference with clarity, and with the energy of our whole being.

[Photo opposite: **Flags of Protest**—a recent student demonstration against the Iraq oil occupation. Ohio, USA]

sounds of the symphony of life played around it. The energy of the compassionate mind is not just the problem-solving, computer-like ability of mechanical intellect, but rather intelligence. Intelligence is in this view a vastly more subtle movement of consciousness; it is this energy of intelligence which is evidently very much broader in scope and source than the isolated individual self. Its means or method is *understanding.* Its ethics is that of *the good of the whole,* the good of the widest context of which it is aware.

Now, remarkably, I think we could say that the human brutish brain, if it is not limited in some way and simply left to run off on its own, is potentially the single most destructive creation of evolution. At the same time, the compassionate mind, as far as we can know, is evolution's most creative achievement. The problem, of course, is that we in a confused way embody both. Clearly, the mind of compassion has come into being in part to limit the over the millennia ever-increasing lethal capabilities of the brutish brain, through understanding and insight, like a patient, loving mother checks the wayward tendencies of an overly aggressive, self-centered child.

We are now at a kind of tipping point, or threshold, concerning the relationship of these two, either conflicting or complementary, movements of consciousness. By this I mean a point beyond which it will become increasingly difficult to change course. The fundamental question is, down which path will we go, down which path will the energy of the world, of humanity, be led? Clearly, the brutish brain at present has tremendous mechanical power behind it. Its instruments are the corporate and military-industrial complex, and the financial and legal systems that have co-evolved to support, profit from, and protect these. Govern-

ON THE DIFFERENCE BETWEEN *THE BRUTISH BRAIN & THE COMPASSIONATE MIND*

"You're either with us, or against us."
versus
*"Whatsoever you do unto the least among you,
you do unto me."*

This is what I see as one of the signature divides of our time, between the *brutish brain* and the *compassionate mind,* two defining features of our species that are now profoundly at odds with each other.

On the one hand, we have the brutish brain, which embodies the deep and rich legacy of the human animal's natural history, and has clearly evolved to meet and master the many demands of survival. It is not at all that different, it seems to me, from the brain of a wolf, or a bear, or an ape. The powerful engine of the brutish brain is the mechanical intellect of problem solving. How to make a better stick for digging roots, a better skin for carrying water, a sharper stone for a more deadly weapon. Its means is force. Its ethics is essentially the ethics of *the me, my* group, *my* nation. The identification of this smaller me with the larger group, which is then radically divided from the wider environment, is a key feature of the brutish brain. *What's good for me and my group is good; what's good for my enemies is bad.*

On the other hand, we have the evidently uniquely human compassionate mind. The compassionate mind sees itself in the other, sees itself mirrored everywhere in the world around it, and, like an infinitely large grandpiano, its strings seem to resonate and reflect all the other

The Little Clavier: Part V

Nature knows *no conflict,
no contradiction, no waste.*

It is possible to say, therefore, that the spiritual or religious life begins not with any dogma or belief, but rather with the deeply held intention to live a life without conflict, contradiction, or waste.

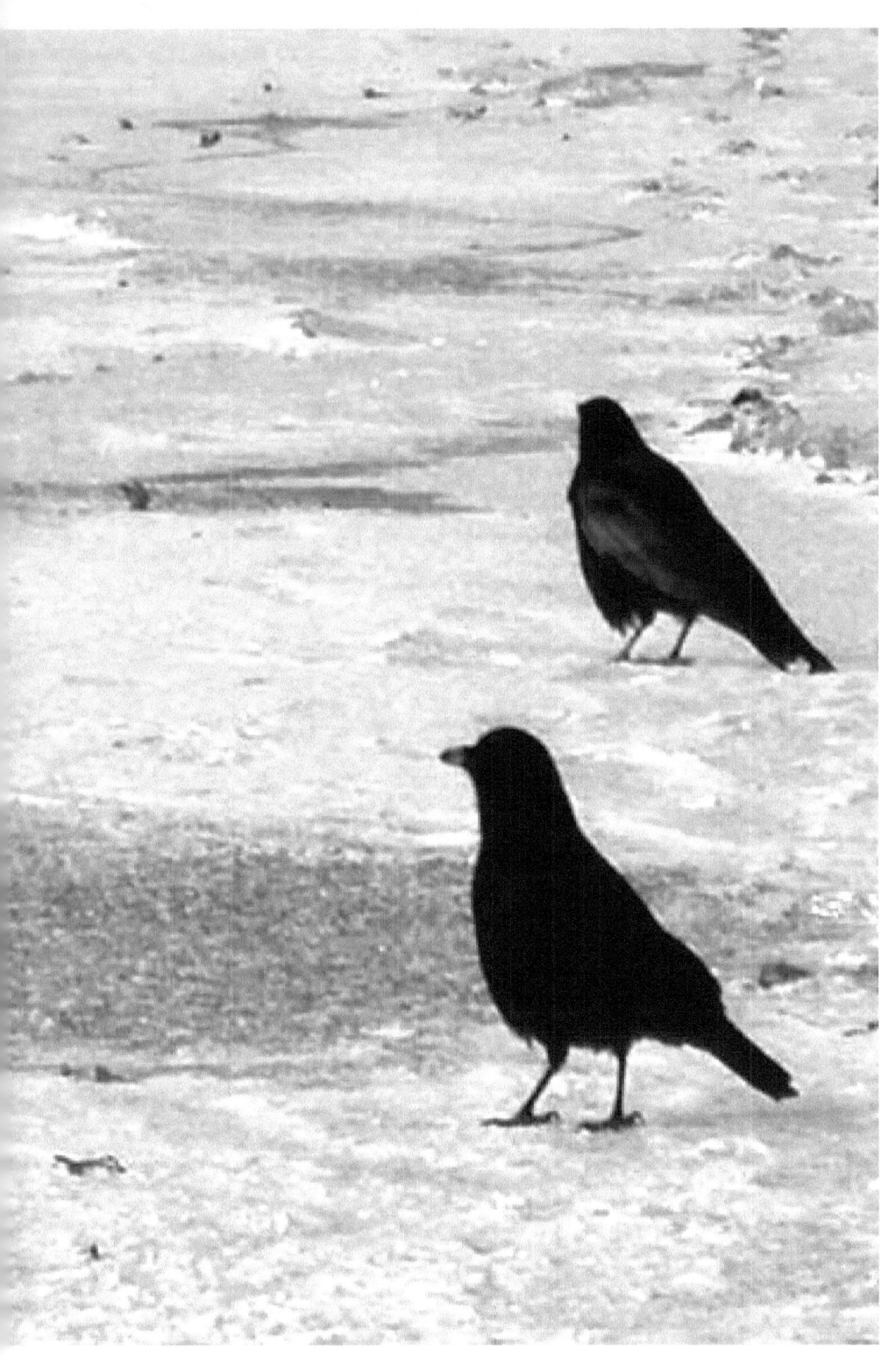

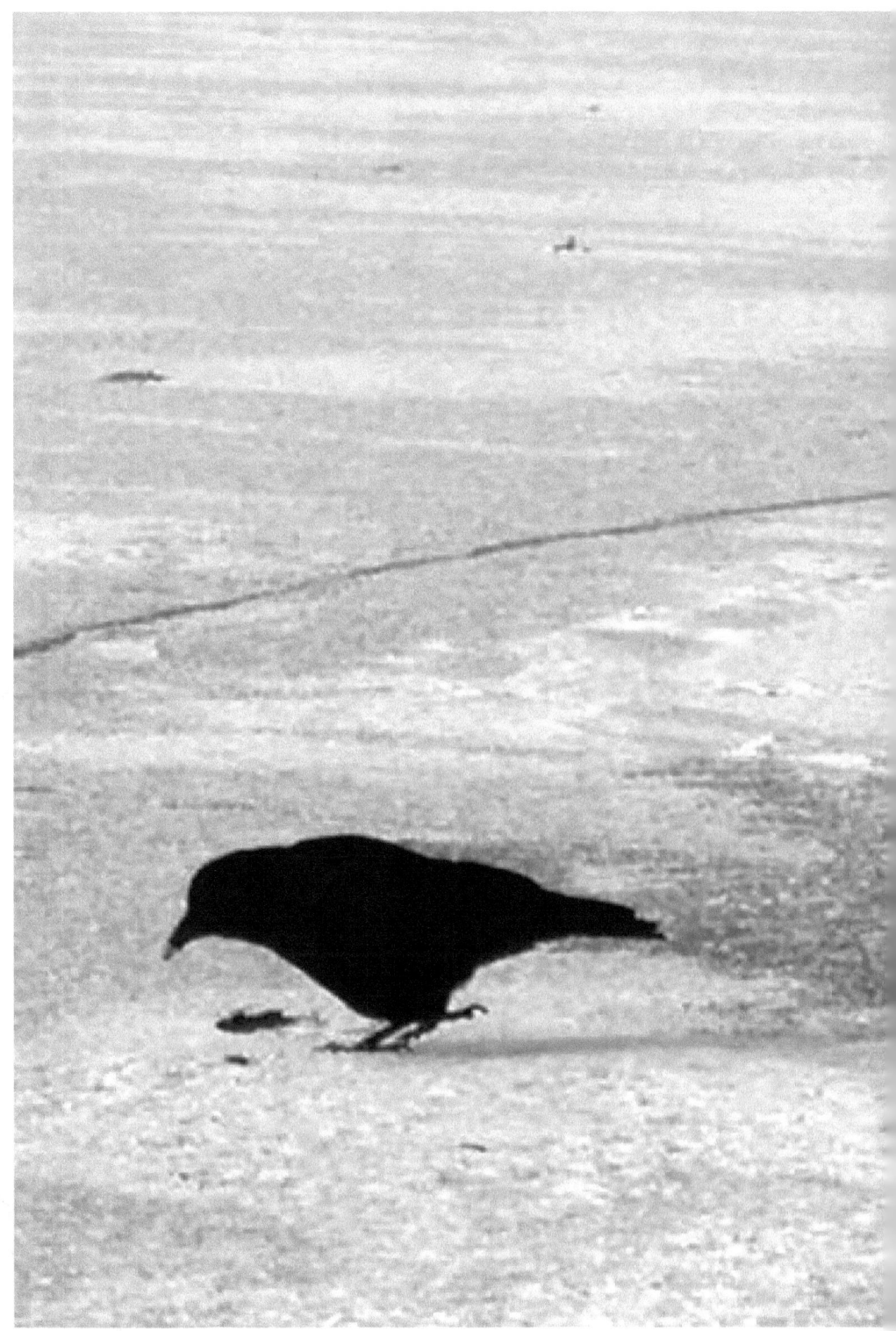

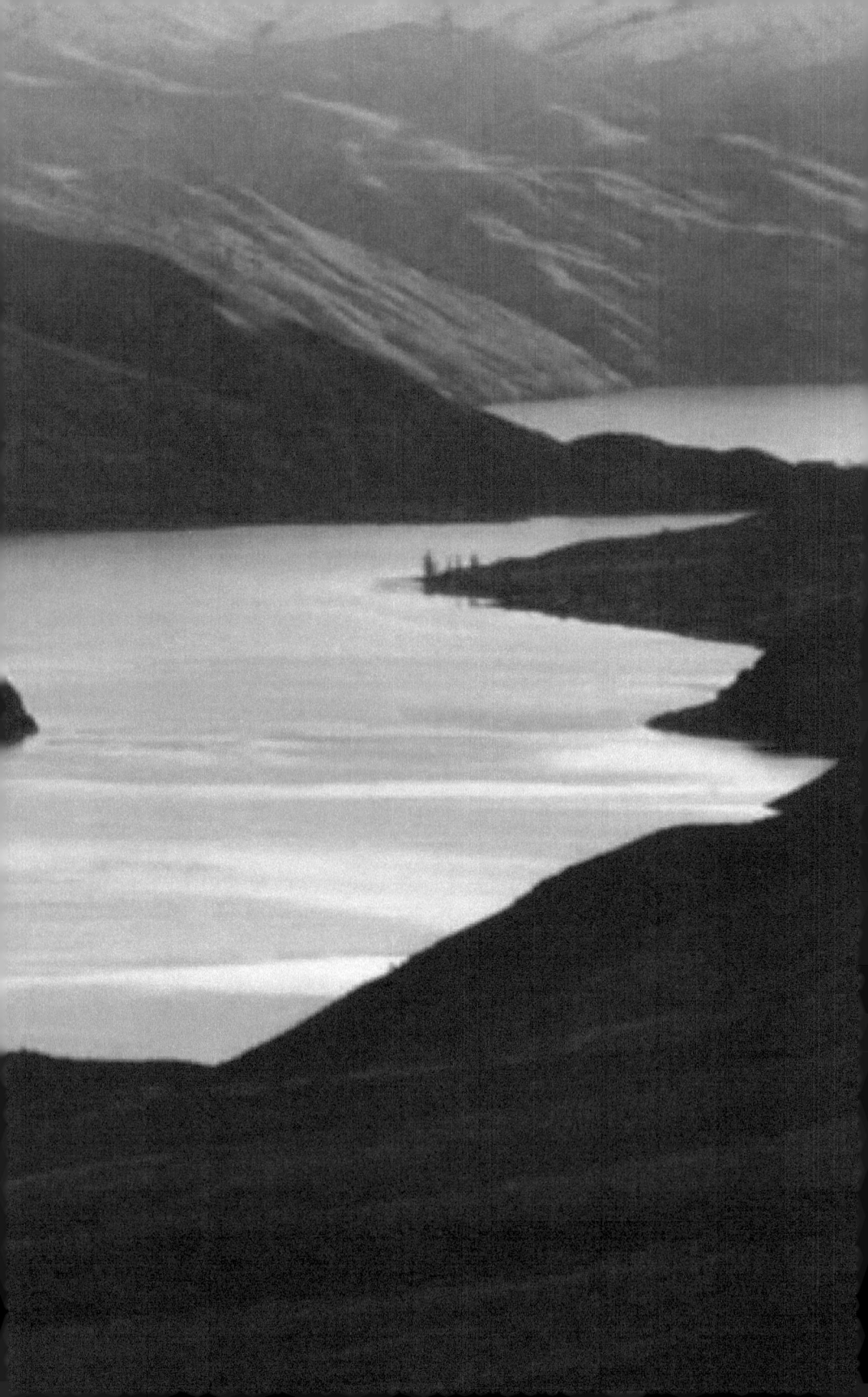

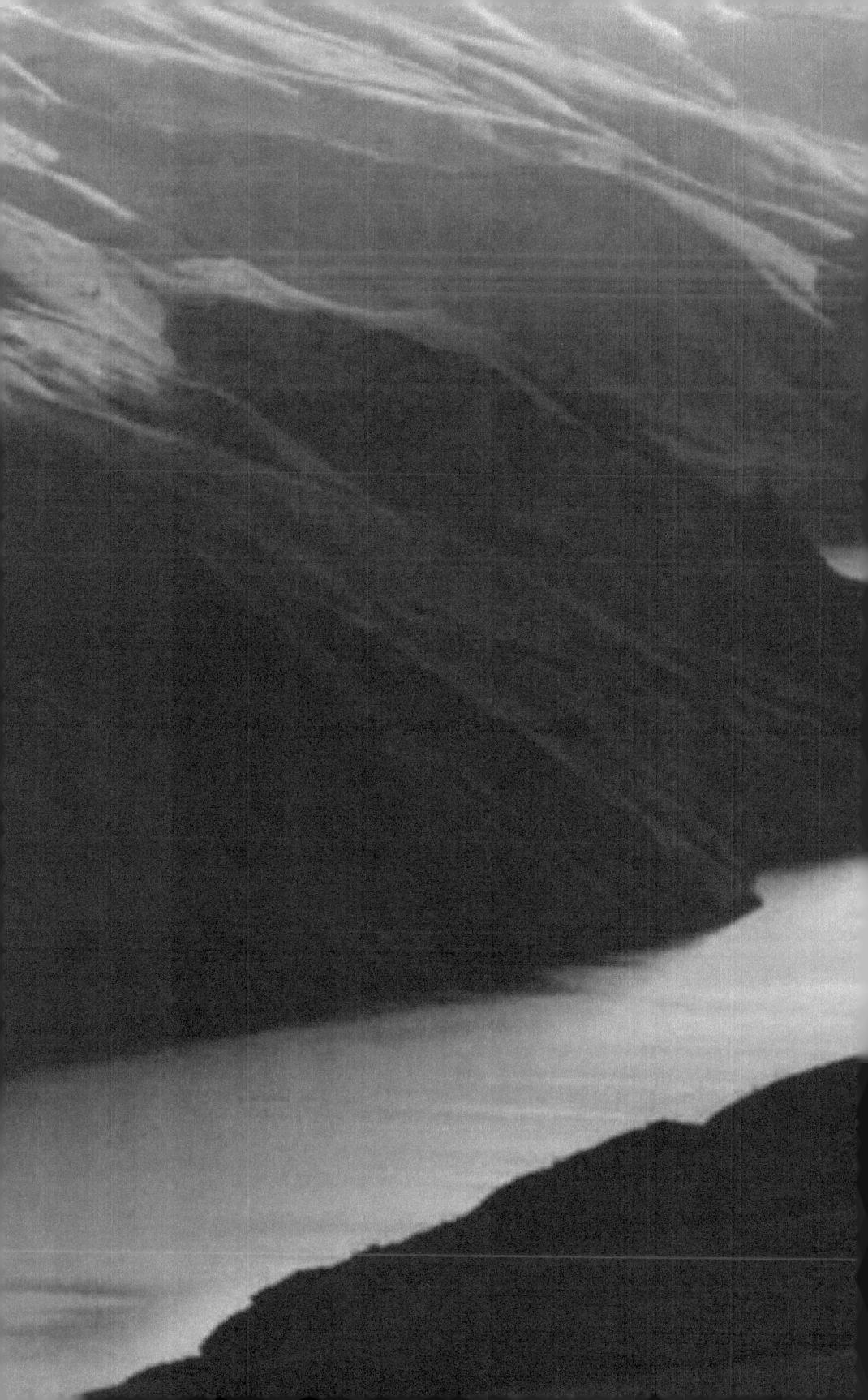

tive to musical sound in particular. The Arts pages in North American newspapers complain habitually of the decline of orchestras and classical music. But the real decline, it seems to me, began many years ago with the loss of the deep grounding of rich, natural, acoustic sound in an uninterrupted ambient silence. And with the ever-rising levels of noise, our own voices have become ever-more strident, and louder as well. And so the music we make and choose to listen to naturally reflects this. A Stradivari fashioning his or her instruments in a contemporary downtown New York? No way. Not possible. Mechanical, artificial, electronic sounds without the slightest trace of natural sympathetic resonance. Yes. *That's* possible. And musicians playing so loud that they wear protective ear gear.

Yes. That's possible, too. It's a fact.

Silence in Snake River country is, except for the occasional passing car or truck, very much alive and well. So much so, that for the unprepared it may confront one with something of a shock. An uncomfortable feeling, at first. Something we can't quite put our finger on. And then, something remarkable may happen. A raven honks in low, slow groups of *4's* and *5's* as it flies with audible, steady wing beats due east across the Gorge. We are startled by the presence of the sound, and listen to it disappear. Then, there's a loosening of the shoulders, a lengthening of one's stature, a release of an almost chronic holding of the breath. And we become like a string which was too tightly strung, and that now, little by little, unwinds and lets go of its tension into the emptiness of the Gorge. Yes. *Nothing as resource.* That too, is possible.

NOTHING AS RESOURCE ...

Many nowadays come to the empty spaces of areas like the vast and magnificent *Snake River Gorge* much like pilgrims of old journeyed across entire continents to cathedrals: in search of healing, in search of the divine. And now, just as in the past, contemporary pilgrims—if I may use that word here in the sense of its root meaning of *'wanderer'*—also seek perhaps healing, a sense perhaps of the sacred. But they also seek, it seems to me, simply a period of rest or refuge from the noise and forced rhythms of present-day Western culture.

Indeed, silence has in many parts of the world become an endangered species of experience.

Think of it. No one actually set out to design the contemporary soundscape; it is entirely an unintended by-product, an afterthought of the Euro-American wild and crazy 100-year-old petrochemical experiment. Cars, engines, mechanized movements of every description criss-cross the streets of almost every city or town of any size around the world, and they are all powered by some kind of remarkably noisy rock-oil motor.

What has all this corruption of what I call the *sonosphere* done to us? I would guess that, as with all loss of purity generally, it has made us less sensitive. How could this be otherwise? As environments become more hostile, we naturally contract behind ever-tighter real or psychological walls of self-protection. (To see this happen in a young child is a brutal and terrible thing, since it signifies the beginning of the end of learning.) And, of course, it has made us far less sensi-

WEALTH & POWER

We shape the world and the world shapes us.

The tendency of both outward material wealth and power is to become not so much means to a better world or even a happier life, but to become ends in themselves. Once this happens, what wealth and power come to fear more than anything else is the loss of wealth and power.

Because of this all-powerful fear of loss, wealth and power are only really interested in the arts and sciences insofar as the arts and sciences can make the increase of wealth and power possible, and more secure.

And because this fear of loss corrupts all clear thinking, it leads us to deny in the name of security everything we do not wish to believe. This is why wealth and power are notoriously bad at dealing with the disturbing facts of any kind of serious existential crisis, say like those posed by abrupt climate change, or the collapse of democracy into military dictatorship. That is the essential contradiction of outward material wealth and power, in any era, in any age and place. And it is why wealth and power rightly fear their own downfall, which, because of the contradiction itself, is with time, tragically both necessary and inevitable.

WEALTH?

Wealth? When I have the things I need
to share the things I love.

BEWARE!

(i)

In every Capitalist's
office is a graph that charts
the price of Gold & Oil against
the value of Freedom & Democracy.
Once the two lines cross,
let the Republic beware.

(ii)

Tragedy of the West:—
Barb on wire;
Barb on plant.

(iii)

A Creationist? One who believes in horses
and mules, but not in asses.

TEMPO OF CHANGE

(i)

What are avalanches and wet soft snow
to the wings of a raven?

What is drought to the morning
dewdrops of the field mouse?

Perched on constant alert,
some of Earth's creations are
more ready for sudden change
than others.

 "Who said that? Change?"

(ii)

Future Crisis? Who would not rather face the Sun,
and not the storm building behind us.

(iii)

Crisis in Photography? If there is a crisis in photography, then it's to be found in the outmoded, out-of-focus worldview hiding behind the lens.

always think it is beautiful to see how they shape the landscape *at a scale that seems fitting and appropriate* in many beneficial ways, creating small pools for fish spawning, filtering and cleaning the water, and in other ways regulating the flow of nutrients. The story of the beaver is in many ways the story of the interconnectedness of both the natural and cultural worlds. Who ever thought that Beethoven's fur hat would impact not just beavers but also the salmon of the great Columbia River Basin? And who ever thought that such a humble, relatively small river animal one rarely has an opportunity to observe in the Northwest might show us better, more ingenious ways to live with the natural flow of the Earth's living waters.

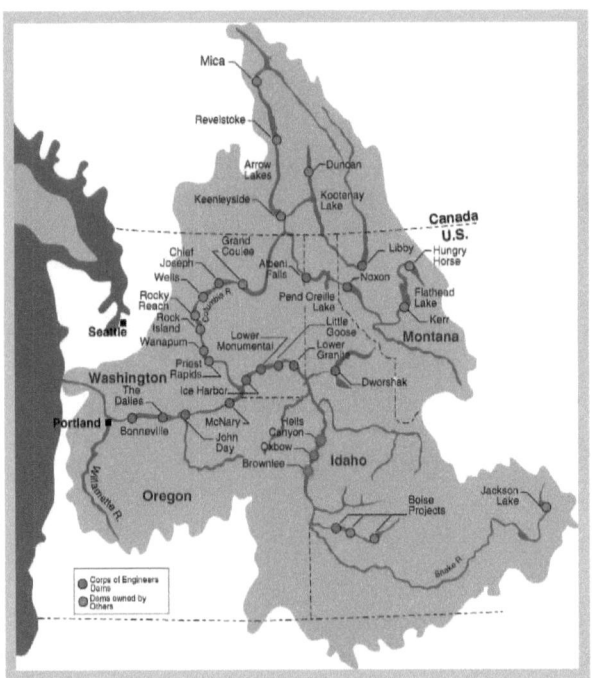

(Sketch of the Columbia River Basin—in round numbers about 15 times the size of Switzerland or the Netherlands: 657,000 sq. km, 50% forest, about 1/4 of the original forest has been lost. Source: *World Resources Institute*)

BEAVERS & THE ECOLOGY OF NATIONS

After a mere one hundred years of European-American exploration and settlement in the Columbia River Basin, by 1900, beavers were nearly extinct.

It is a telling story of the intersection of the ecology of hats and the ecology of young nation states competing aggressively for new territory. Until 1825, when in Paris the silk hat became the latest fashion rage, beavers where trapped for their furs wherever they could still be found in North America. The Pacific Northwest joint-use agreement between Great Britain and the United States of 1818 led the Hudson Bay Company to assume that, after a period of ten years and as the treaty was set to expire, the border would be drawn at the Columbia River. They therefore set out to achieve a competitive advantage in the fur trade by systematically exterminating beavers found to the South and the East of the river, thereby depriving the Americans of an important resource. A remarkable fact, hard to believe today, but the botanist David Douglas already complained of the scarcity of beavers in the Willamette Valley as early as 1828.

The next wave of destruction arrived in the 20th century with the massive hydroelectric water projects. (There are at present 38 major dams knotting up the arteries of the Columbia watershed.) It was especially the damming of smaller tributaries the caused new habitat loss, making for artificial bodies of static water where once smaller rivers flowed.

Beavers are, however, happily making something of a comeback. I

ine the extremes, and it is good to do so for the sake of clarity. On the one hand, we have the state of absolute lawlessness, where every one just does as they please; And on the other, we have the state of total control where no one is allowed to do anything at all freely. Whereas North American culture has evolved an exemplary balanced form of liberty in the areas of freedom of speech and expression, it seems to me at the same time it is remarkably *im*balanced when it comes to the three key defining areas of *finance, private property*, or *anything powered by hydrocarbons.* If I can make money, if its my land, or if its my car or truck or dirt-bike, 4-wheeler or snowmachine, the basic assumed metaphysics is, *"Get the hell out of the way!"*

Even though the original idea of setting aside large tracts of land without roads of any kind undoubtedly originally concerned itself with the harm wrought upon the environment by the negative side-effects of mechanized travel, roadless areas now also offer us a place to experience the benefits first hand of a more balanced idea of freedom. In addition to the *freedom to,* we now have a complementary *freedom from.* Predictably, the freedom from part of the equation here deals mostly from the unwanted by-products of Car Culture, like freedom from noise, or the freedom from air pollution, or the freedom from the fear of getting run over.

Like water meanders through an alpine bog, finding a kind of living balance by turning now to the left, now to the right, I think this more balanced idea of freedom is something beautiful to behold. But don't take my word for it. It might be worth making a bit of an effort to get out of one's car and hike up into one of those wilderness areas just to rediscover for oneself what freedom is really all about.

ON THE NECESSITY OF ROADLESS AREAS (I)

Video meliora proboque deteriora sequor.
(I see and acknowledge the better way, but follow the worse.)
Ovid *(The Metamorphoses)*

Because of the near complete motorization of North American culture, roadless areas have gained tremendously in significance in the past twenty years or so. Now, at road's end, we also reach the spiritual end of what I see as a defining imbalance of the made-in-the-USA metaphysics of the world, namely, a remarkably one-sided way of thinking about freedom.

North Americans seem largely to take a self-centered view of freedom, one which we might call *the freedom to* of the individual. Why might this be imbalanced? In my view, it is because it fails to take adequately into consideration the possible harm caused by the potentially negative consequences of our actions as they reverberate out into wider contexts, out into the wider community.

It is really very simple, this idea that *freedom always has two sides,* the *freedom to,* and the *freedom from.* Take for instance the example known well to every big city apartment dweller: I want to listen to my loud music in the middle of the night; You want to sleep. So to make life livable, we have to work out some kind of balanced agreement between us. What I want to suggest is that all freedom works essentially in this same way. And what is more, individuals and cultures may be characterized by which side of the two they tend to give emphasis, give the most significance and legal protections. We can easily imag-

RESONANCE

Imagine a series of nested circles, one within the other, expanding into natural time and space. Then, imagine a kind of harmony, a kind of mutual fitting together, of the movements of the circles, one within the other.

Now imagine putting the whole of this movement of expanding, nested circles inside a small, tight, little leaden box, thereby isolating and fragmenting the movement from the larger world. This is what happens to Art and Culture when they are no longer rooted or nested within the natural world. Once this happens, one of the primary tasks of Art and the Artist is to somehow—*smash the box.*

THE MASTER & THE APPRENTICE

Just as assuredly as the moon moves the tides, intelligence moves the young mind in mysterious and subtle ways. The teacher is the one who discovers first the rhythm of this movement in him- or herself, and then awakens it just as naturally and invisibly in the student.

In this way, the teacher is the one who protects the student from a metaphysics of education that forces children into a career of tourism on the periphery of learning and creativity. How much better to find one's calling early in life, when learning is still largely an unselfconscious affair, and skill and aesthetic sensibility become easily—as the apt expression has it—*second nature.*

BEAUTY AS BALANCE

Beauty abhors the contortionist, the Yogi who wraps himself in a wire-ball of knots, the Paganinni who charms with his devilish slights of hand, the Architect who with a virtuosic flourish folds metal like crushed paper into the form of a smashed guitar.

The more a culture goes the way of this mastery and worship of mere outward difficulty, and the more this is projected as *an ideal-to-be-achieved* to the young, the more this culture will lose its resonance with the at once simpler and infinitely more subtle and complex spiritual dimensions of its art.

ABSOLUTE

Is there anything in Music which is absolute, a kind of unchanging touchstone of relevance, of beauty and truth?

If we begin by saying that the primary elements of musical reality are not really things at all, but rather relationships, then it becomes clear that the *yin* and *yang* of the balance of relationship is of primary importance.

So, in a way, what is unchanging in Music *is change itself,* and the absolute necessity of the dynamic movement of the balance of relationships that this demands.

THE FARMER & THE ARTIST

The farmer does his best just to be one of the boys, preferring to be a part of his herd. With the artist, it's the other way around; he'd rather stick out, be the exception, the wild one in a barnful of tame and chained animals. But are they really so different? Where is the farmer who stands out because he goes quietly his own way; and where is the artist who is like the bird who fills each morning with the enchantment of its song, but whom we never see?

A NECESSARY UNITY

Art, Science, Religion:—three branches of
one great river of life.

See the promise of the spiritual energy released
if they were to flow freely, naturally together.

See also the tragedy of their current fragmentation.
The energy wasted, the opportunity, lost.

The necessity of unity says, *"Take down the dams!"*

ON COMPLEMENTARITY

Imagine Nature reduced to a place filled with straight, dry,
brittle stems covered from root to crown with prickly thorns.
That is what we ourselves become when we lose the
complementarity of *masculine* and *feminine* principles.

GARDEN VARIETY VERSE

Literary journals are to poetry what formal botanical gardens are to wild mountain plants. There they all are! Bright Snow lily, Gentian, Arnica, even a beautiful patch of Cotton grass next to the pool. All precisely labelled and seemingly well-fed. And so easy to tell apart!

But after a while, I've noticed that one starts reading the signs first. That's bad.

LEARNING MAKES THE CIRCLE ROUND

Master the *complex* to teach the *simple*;
Teach the *simple* to master the *complex*.

Learning naturally moves from *general* to *particular* and back again in a gentle, unforced, cyclical fashion. It is gentle because details are studied only as they become necessary and relevant; and it is cyclical because it moves back and forth from broad overview to the fine grain of particulars and then back to broad overview, like moving easily from mountain peak to valley and back again. In this way, learning does not so much imitate Nature as do what Nature itself does.

After all, the many different species of willow and oak, so hard to distinguish one from the other, only very gradually developed into such wonderfully complex diversity.

face it, meat in the store bears for the buyer little or no relationship to the rancher or cow in the field. This is fragmentation of the most insidious kind, because it forces us to the point that the rancher has no other alternative than to keep more and more animals on a given parcel of land. To say that this is just the way markets work is, in my opinion, as short-sighted as it is irrational. For the health of the land, and the health of the culture, are most certainly inextricably interlinked. And yet the destruction of both passes me by as I bike across the Northwest, mile after mile after mile.

Who, we may ask, wants this? The ranchers I speak to don't. Consumers, generally, have no awareness of the problem. So, the question, it seems to me, is what is the source of this kind of all-pervasive fragmentation?

[**BARBED-WIRE IN THE WEST:** Obviously, no one really knows how much barbed wire runs across the great and open lands of the North American West. Some rough estimates reach in round numbers about 1,600,000 kilometers (1,000,000 miles). That's about two times to the Moon and back, or about 125 times around the Earth at its equatorial diameter. Over kill? And how much of this is on public land? As I see it, barbed-wire is the very essence of fragmentation. At the same time, I see the necessity of fences in many situations. As always, *appropriateness is a question of scale.* I've worked with old-time ranchers building fences, and I can tell you there is truly something like an *Art of Devil's Rope.* There's a great deal of skill and experience required to build a good fence. But I've also noticed that when building fences there is a good amount of swearing that takes place, because barbed wire is hard to work with; it tears and rips at everything it touches. As the Western poet, C.L. Rawlings put it, *"Like many other elements of our culture, it is hated as widely as it is used."* [source of quote, and raw data: *WASTE OF THE WEST: Public Lands Ranching,* by Lynn Jacobs 1992)]

BARBED-WIRE, WEEDS & OVERGRAZING

Tragedy of the West?
Barb on wire,
Barb on plant.

I hate barbed-wire. Everything about it.

Perhaps more than any other innovation, I think barbed-wire—an invention patented in the 1870s by Joseph F. Glidden of Dekalb, Illinois, and first called "devil's rope" by those who opposed its use—has made the current style of confined grazing possible. When animals are confined and not carefully shepherded from place to place in a rhythmic way—as in many regions to this day is still done in the Alps—overgrazing will most certainly be the result. This culminates in a *Cheatgrass-Sage-Dry-Dirt* landscape that now covers vast tracts of the West as far as the eye can see. In this way, the door of habitat destruction is left wide open to extremely tough and determined alien species like *Spotted Knapweed* and *Yellow Star-thistle,* which in turn sets up a vicious and ugly cycle of more habitat fragmentation and loss.

I would not place the responsibility for overgrazing on the ranchers. Ranchers, especially those of small, family owned operations with deep roots in community and place, are just trying to make a go of it under very difficult conditions. I think the problem has its source in yet another kind of fragmentation, this time between the in North America relatively small agricultural community and the wider culture. Let's

The Little Clavier: Part IV

If you want to be a poet,
call yourself a farmer;

If you want to be a farmer,
call yourself a religious man
or woman;

If you want to be a person of religion,
call yourself a teacher.

The first student is always yourself.

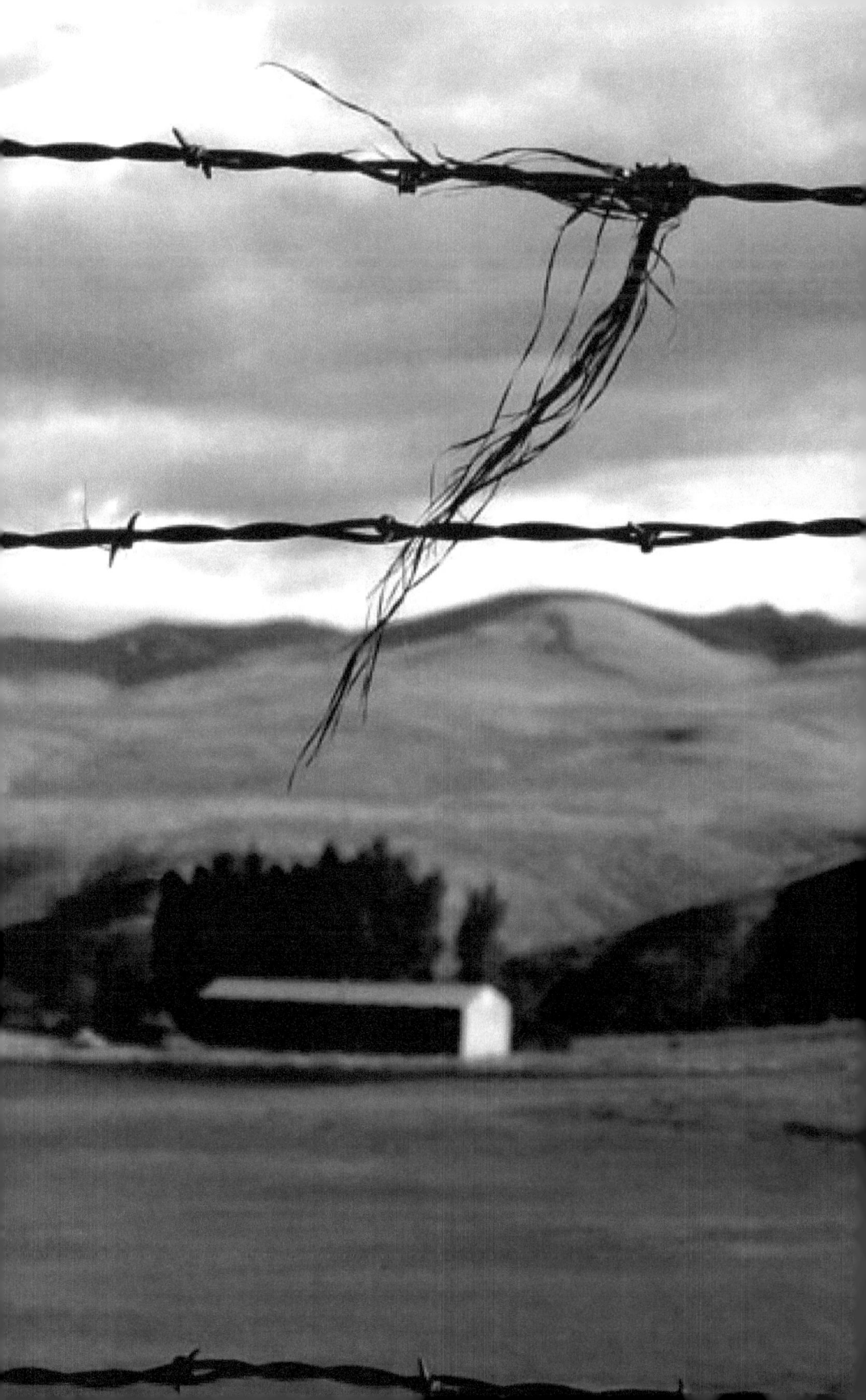

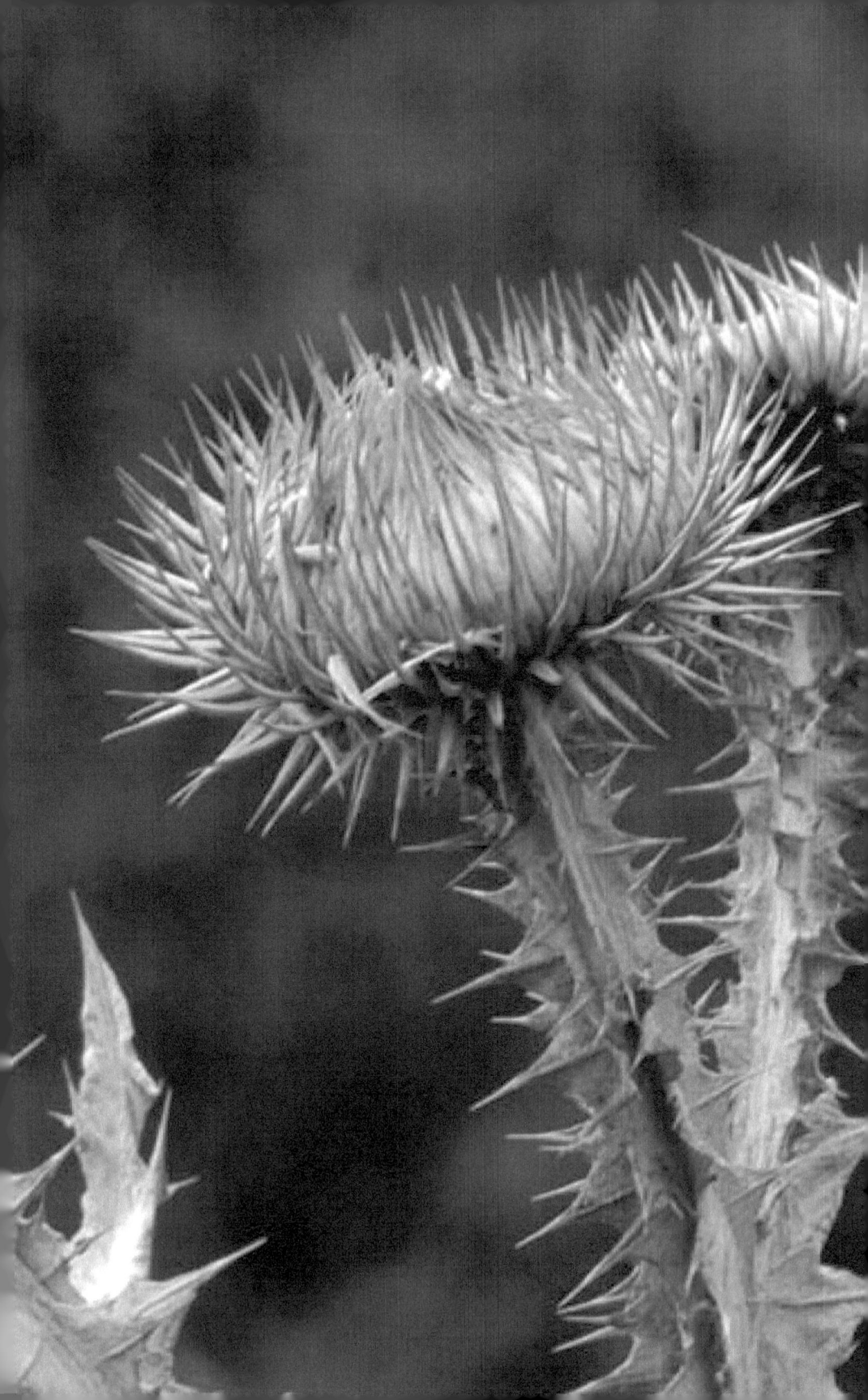

Clearly, the whole world now needs urgently to focus collectively and with great energy on the significance of an increase of just one or two degrees C. average temperature. No translation. No conversion. Just what it means. What it feels like. And what to do about it. Right action, and right measure, it seems to me, necessarily, just may go together.

ALPINE SIMPLICITY / COMPLEXITY

Mountains teach us in a powerful way about the necessary complementarity of *the simple* and *the complex.* The higher we go, the simpler and more pristine the alpine environment becomes, moving from smooth, polished granite surfaces, over snow and ice fields, through the low, gnarled clusters of steadfast stonepines, to the smallest ensembles of brightly colored cushion pinks and asters. Yet our view grows in width and breadth in an ever-expanding circle with each passing step. Reaching at last the peak where all points of the universe seem to converge, we can see perhaps as much as 80 kilometers in all directions. This gives one, I've always felt, a powerful sense of the mystery of the infinite, the unknowable complexity of the whole. And yet, as we descend from our climb, as we always must, the simple is there to embrace us again. Perhaps it's the rhythmic sound of our boots on crushed rock, or the smell of large pines as we reach the forest below, or the baroque flourishes of a solitary wood thrush repeated with a clocklike regularity, 10 to a minute, every six beats or so. The details vary with the individual. The pattern, however, is eternal—this harmonious back and forth of the *simple* and the *complex.*

RIGHT MEASURE / RIGHT ACTION

Clear thinking and decisive action necessitate good systems of measure.

The world-wide problems of waste, runaway militarism, water and food scarcity, pollution, over-population, and climate change demand that the people of the world work together to find solutions in new and unprecedented ways. And to work and think clearly together, I would say that we must have a common language and system of measure.

What better time, what better opportunity, to throw out the thought-constricting and painfully outmoded feet, Fahrenheit and gallons of North America—sad relic of its colonial past—and bring the world together in an up-to-date and unified metric system.

This was first brought home to me many years ago while working in the Alps. I was milking cows for a mountain farmer friend of mine there. And one afternoon, he asked me, *"How many kilos of milk did you bring down this morning?"* I thought, *"Kilos?"* I had measured *liters.* Then I suddenly realized they are one and the same. *"Brilliant!"* I thought, while at the same time amazed that I had not seen the relationship myself.

But now, North Americans seem more worried about the wrenches in their garage, than the gears of conversion kid's strip in their brains trying to memorize antiquated and essentially illogical systems of measure.

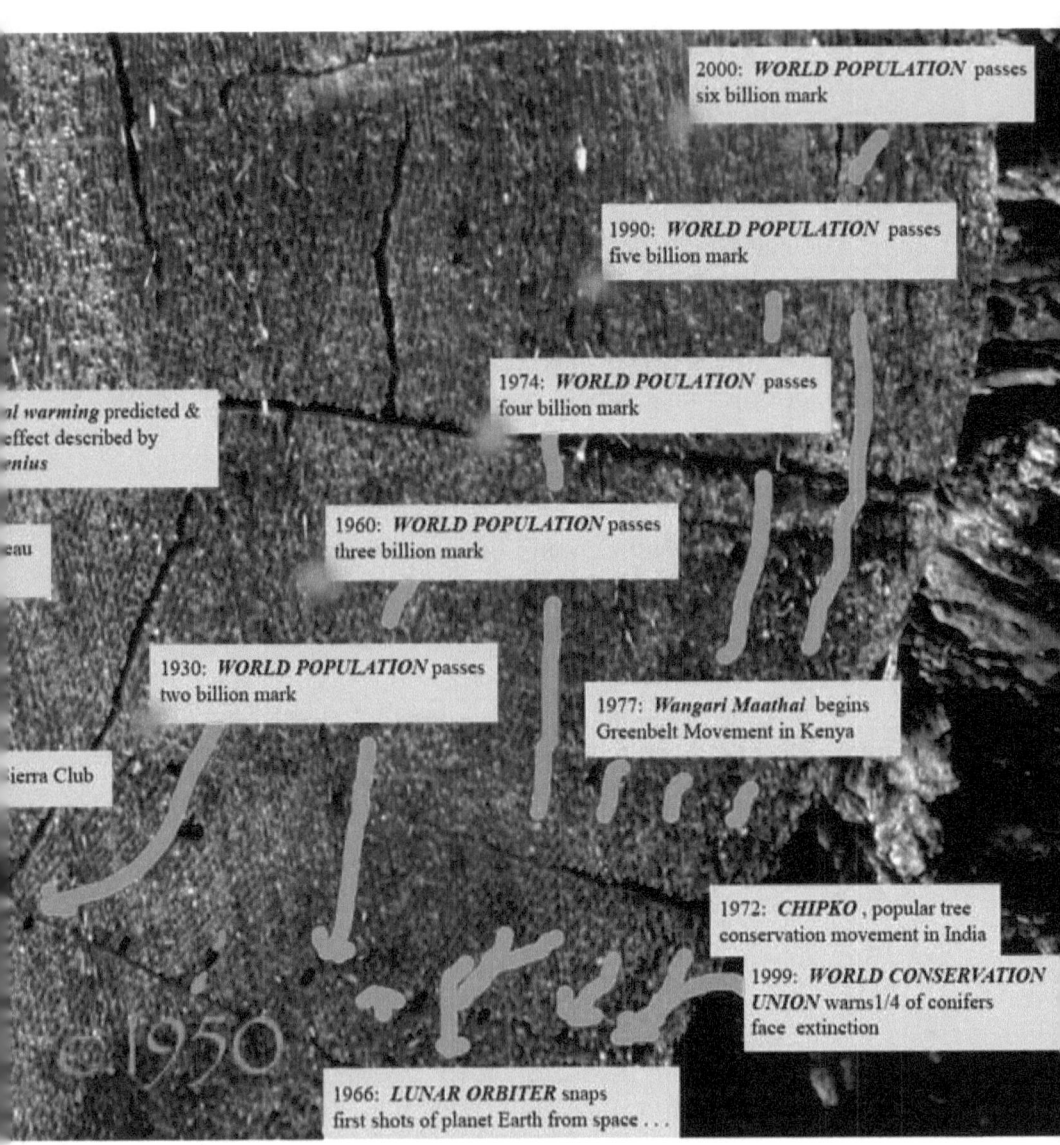

[Note the rising boxes above of added *billions* of
world population . . . but ±15 centimeters or so of tree-time.]

25 DECADES OF TREE-TIME *a cultural timeline from the Stonepine* (Pinus albicaulus) *perspetive . . .*

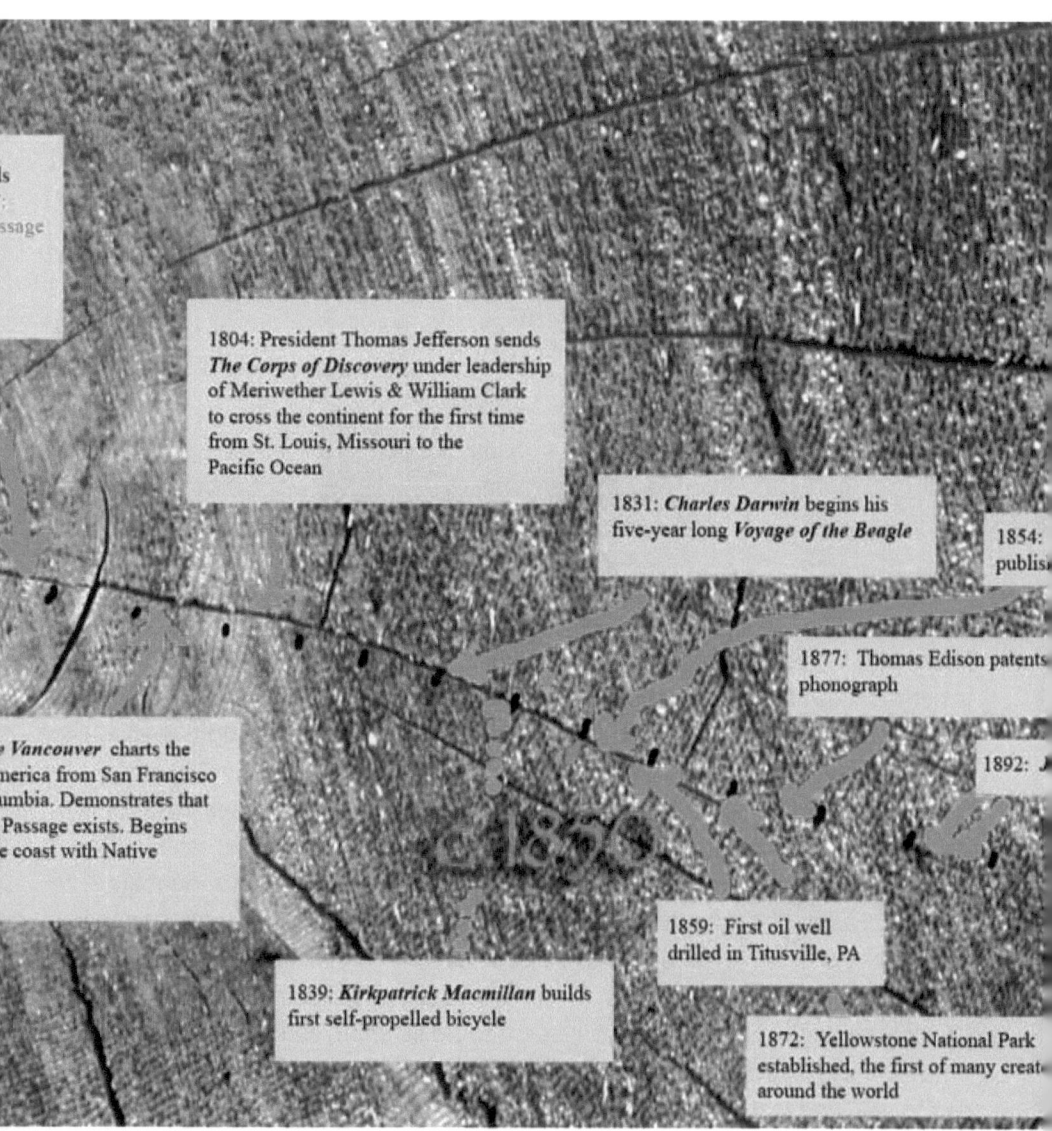

1804: President Thomas Jefferson sends *The Corps of Discovery* under leadership of Meriwether Lewis & William Clark to cross the continent for the first time from St. Louis, Missouri to the Pacific Ocean

1831: *Charles Darwin* begins his five-year long *Voyage of the Beagle*

1854: publis

1877: Thomas Edison patents phonograph

1892:

Vancouver charts the merica from San Francisco lumbia. Demonstrates that Passage exists. Begins e coast with Native

1859: First oil well drilled in Titusville, PA

1839: *Kirkpatrick Macmillan* builds first self-propelled bicycle

1872: Yellowstone National Park established, the first of many creat around the world

against which they have never had to evolve resistance in their resin. So they are gradually being forced higher up the mountain. Eventually, like bears on floating icebergs, there will for the Whitebarks be no place left to go. The sad rusty-red of sick stonepines stands out on high slopes and ridges at a distance of more than 1000 meters. So much so, in fact, that I use them as cross-country guideposts or marker trees.

In the Alps, a related species of stonepine, *Pinus cembra,* is an object of much veneration and folklore. Just the act of an old mountain farmer saying its name in dialect, *Arve,* seems to fill him with a kind of primeval religious awe. Indeed, stonepines there have for hundreds of years been the favored wood for carving, and remarkably, for works of art which show, when seen within the traditional European cultural categories, both *sacred* and *profane* aspects, i.e., both "crucifixes" and "wildman" masks for the end-of-winter mountain carnival, *Fastnacht.* I mention this only because I am repeatedly reminded that no similar tradition, as far as I know, exists in North America. Perhaps that is why only a handful of dedicated scientific researchers, like the late Wallowa Country ecologist *Charlie Johnson,* seem to be listening seriously to what the Whitebarks are saying, and not the culture at large. For as always—and this is sad to say, and is of course only my own opinion—North American culture is largely indifferent, is largely uninformed or unshaped by the spirit of its great mountain ranges. That is so because people do not generally live in the remote highcountry, and if they do, it is mostly the highcountry of touristland. Perhaps that is why I feel somehow compelled to mark in image and word as many of the sick stonepines as possible that I meet along the way.

WALKING THE WORLD: *Stonepine Mountain!*

The Earth is not everywhere old. Hidden away wherever we look are these little places where life is just beginning anew. It is as if the Earth prefers to sing her song all at once, with hesitant, vulnerable fresh sproutings sounding together with the sure and steady magnificence of great age. At the upper edge of a mature subalpine forest, where the larches and pines take over from the Norwegian spruce, the forest canopy begins to open up with more space between the individual trees. Here, a stone pine seedling has rooted itself on top of a large granite rock. Just half a hand high, emerging out of but the thinnest trace of soil covered with a small patch of moss and a scatter of fallen pine needles, this little tree already resonates with a presence which says, *"This— is my place to be."* And so, a solitary seed, perhaps dropped on this rock by a careless Nutcracker, unfolds into tree out of almost nothing, itself calling forth the matrix of energies which will create the soil it needs for future growth. Tiny as it now is compared to the ancient thick-stemmed, weather-beaten pines which surround it, this seedling is *wholly* tree, *wholly* present in this movement of life. A movement which, like the shimmering high country waterfall, is forever beginning and ending, all at the same time, *everywhere*, at once. *(The Alps)*

[Photo opposite: **Dying Whitebark Pine**, or Stonepine *(Pinus albicaulis)* Clearly, North American Stonepines are sounding a message of warning. These Nestors of the high-country—the closely related Limber Pine *(Pinus flexilis)* are the oldest trees in the Wallowas, and can live as much as 2,000 years or more—are in trouble throughout the Northwest. I've come to think of them as the polar bear of trees. Because of climate chaos and rising temperatures, they are basically being forced off the planet. Whitebarks mark the upper limit of treeline. As temperatures rise, Whitebarks are both being attacked first by whitepine blister rust, and then by pinebark beetles,

THE MAN AT THE DOOR

Between me and the poem there
is a door, and a man who guards
the door. He thinks he has a clear
image of who to let inside.

For years now, we have tried to be
friends, but he's a demanding critic,
saying he just wants to help, and
that every house must have a door.

 But he has no love in his heart.

He watches over the playground
of my fantasy like a mean
priest prods his boys from the open
field back into the one-room school.

And he neither rests nor sleeps.
I look out my window into
nameless landscapes, thinking I sense
the faint figure of a new friend.

 But the man at the door says no.

So here I sit, alone in my house.
I dare not even try. Songs I
might have sung lie mute and dumb like
children who were never allowed to speak.

A DIFFERENT WAY OF SEEING

Compassion sees war as the left hand
of humanity fighting against the right;

Intelligence sees war as the waste of unnecessary conflict.
Name one thing we need more of, than *less* waste,
than *less* unnecessary conflict.

WAR GAMES

Every general will tell you very convincingly that he needs
more of something: more men, *more* guns, *more*, more accurate
missiles. He never tells you what he needs most of all, however,
which is *more* war.

BALANCE OF PERCEPTION

Balance of perception is simple in principle, yet difficult in execution.
In part, it is like carrying two complementary types of lenses in your outfit.
One, binoculars, to bring the very far away into clear view; the other, a
simple magnifying glass to bring the details of the very small and just out
of reach up close. I never go without both, these marvelous technologies
of what I call the magical middle realm.

ON THE TEMPO OF PERCEPTION (I)

I want to move through the world in a way that awakens—indeed, *demands* that I awaken—not just a narrow, arbitrary bandwidth or fragment, but rather the whole of my perception.

I want to think out the route through a problem with my toes, hear the crash of a tree before it falls with the hair on the back of my ears, sense the next storm with the pores of my skin. I walk down the busy road and see all the isolated, obviously unhappy people caged up in their expensive, noisy, conspicuously large and inefficient cars and trucks. And I ask myself, is this how the gods meant the marvelous instrument of our perception, or intelligence, to be used or played?

The pace or rhythm or speed of perception is like the tension of a string.

If the string is too lose, it makes a hardly audible, flabby sound; if the string is too taut, the sound is painfully sharp, and always just on the verge of breaking.

I say to myself: *slow down.* Or like the apt figure of speech has it, "unwind a bit." And I say to others, especially young people, *"Get out of the damn car!"* Then and only then might we see what the mechanical fast-forward artificiality of the automobile has made of us and our perception of the world.

ON THE DIFFERENCE BETWEEN *LIMIT & CONTROL*

Control imposes order *from without* by projecting the predetermined thought, conditioned by the past, of what *should* happen. The need to control invariably increases as the disorderly, unexpected, side-effects of past efforts accumulate, which results in ever-greater unnecessary difficulties or complicatedness. In contrast, *limit* allows order to emerge *from within* by determining only what at any given moment *should not* happen. Limit is therefore open to the future, and tends strongly towards ever-greater simplicity and freedom.

PROTECTING THE COMMON GROUND OF LANGUAGE

The cheap and flashy slogans of politics and commerce are like aggressive alien weeds, overrunning the sacred common ground of language with a kind of false—or *irre*-poetry. They numb and corrupt our natural sense of the refined sonic elements of verse, reducing subtleties like rhythm, anaphora and rhyme to mere clever instruments in a grab-bag repertoire of tricks eager to serve the abuse of power and questionable gain.

One of the first tasks of Poetry is to protect this common ground of language, especially for the young, in the same way we might protect the Earth itself, whether it be a patch of prairie along a busy road, or the delicate balance of species in a remote and pristine alpine meadow.

INTERCONNECTIONS . - _ /

The movements of intelligence in Nature resonate together like the circular waves of water droplets merging on the surface of quiet water. Shake one, and they all shake. Leave one out, and another steps in to take its place. This is why machines like computers, which are based at present not so much on the *all-at-once* of the resonance of natural intelligence, but rather on long, complicated, necessarily explicit strings of logical thought, so easily break. And they do this, as we all know, in frequently highly disturbing and unpredictable ways. Their connections must indeed be 'hard-wired,' so to speak, one at a time. Given the present need for this surface absolute precision, and therefore the lack of the greatly more flexible relational movements of resonance, computers, computer networks, and the software upon which they depend, are all prone to go haywire with even the slightest low-level error. Remarkably, if one were forced to tune the complex weave of interconnected sounds and rhythms of an orchestra in this way, one would not make it past the first bar.

ON NECESSITY

The perception of Necessity can be liberating, because the way is then made free for clear, decisive action. Indeed, how could this be otherwise? When something *must* be so, the mind—whether that of the individual or that of the collective—quits wasting energy by fighting against itself, and, without forcing, comes to a unitary vision or flow. The peak is in view. The problem clearly defined. Let's get on with the climb!

What would the color of the water have been, its temperature feel like to the hand towards the end of summer before the dams were built, and forests cut down. Questions like these go unanswered if there is nothing with which to compare these highly disturbed states. This is, without a doubt, one of the many meanings of wilderness. Wilderness is where we go when we want to see what health or wholeness really look like and not just think about what we assume them to be.

WOODEN FLUTES, AND THE DIFFERENCE BETWEEN *THEORIES IN NATURE* & *THEORIES IN CULTURE*

With Nature, we describe a relatively autonomous world. When our theories are wrong, when we say, for instance, mistakenly, that the Sun revolves around the Earth and not the other way around, neither the Sun nor the Earth are evidently affected.

With the Arts and Culture, however, we describe a world largely of our own making. When our theories are wrong, when we say that, for example, flutes made of concrete sound the same as flutes made of wood or silver—*a column of vibrating air is after all a column of vibrating air!*—our perception of sound and flute-playing may begin to change, potentially in a very negative way.

Freedom from the unavoidable formative distortions of this description/perception cycle comes only when we give serious attention to the workings of the cycle itself, and not merely to the outward nature of the particular theory or way of looking with which we begin our enquiry.

MISCONCEPTIONS & CORRUPTION

Misconceptions self-perpetuate because, when I'm wrong, what is right is bound to seem wrong to me.

Corruption self-perpetuates because I quickly become dependent on corruption's privileges.

Misconception and corruption fit together in a kind of false, synergistic way, that serves to mutually reinforce both.

If I see you as inferior and subhuman, and therefore think I have a natural right to treat you as my serf or slave, I will thereby force you into the actual subhuman conditions of poverty and illiteracy which come round to further sustain and strengthen my misconception. At the same time, I profit greatly from the corrupting use of your free forced labor, so much so in fact, that it becomes impossible for me to imagine life without it.

BEYOND ALL COMPARE

We can only know disease by comparing it to health, just as we can only know fragmentation by comparing it to wholeness.

As I walk the land, I frequently ask myself, what would this meadow, this forest, this river have looked like two hundred, or two thousand years ago? What grew in between the sagebrush before overgrazing and cheatgrass and medusa-head took over as far as the eye can see?

ART OF ARTS

I say to you, Poetry is the energy of insight made manifest in the images and rhythms of the speaking voice.

Poetry, I say to you, is the *ars artium,* the art of arts, of the new era.

Nowhere else do rhythm and sound, do meaning and feeling, so forcefully converge by such sparse and simple means to transform our way of seeing and being in the world.

ART & NATURE

Art does not so much imitate Nature in its mode of operation as it does emerge out of the same ground or movement of intelligence which is Nature's source.

That is why *real* seeing or listening—which can give rise to new insight, new meaning, or new form—never repeats, is never merely 2nd-hand, and is necessarily of this moment, here and now.

PATH OF VIOLENCE / PATH OF PEACE

The first mistake we make in dealing with the violence of the world is to name it evil. To name violence "evil," instead of simply calling it mistaken or bad, is to give violence the status of something like an independent "force of darkness" which is somehow actively out to do us harm. All beings, all systems, indeed, all materials and machines, have inherent points of weakness between elements that may break down, that become subject to illness, or are otherwise easily corrupted. *Iron rusts; trees rot; people lose their humanity.* But this does not mean that some sinister autonomous power seeks to prevail, but rather that, for whatever reason, the goodness or wholeness of integrity has fallen apart.

The second mistake in dealing with the violence of the world, made possible by the first, is to see this violence as somehow outside of ourselves, as somehow separate from our own essential nature, and therefore something to be fought against with the very same use of force we feel threatened by in the first place.

Finally, *the third mistake,* made possible by the first two, is to believe that the resulting path of violence is somehow inevitable, and that we must therefore prepare for it by doing whatever is necessary in order to dominate when force becomes necessary, as we believe it most certainly shall.

In this way, the preparations to defend ourselves against violence become—as a kind of *perpetuum mobile*—a primary cause of violence itself.

RETRONYMS?

Retronyms? With every step we take away from the wisdom of Nature's way, the more difficult it becomes to clearly see what we have lost or left behind. *Acoustic* guitar, *organic* tomato, and—as a possible future, *n a t u r a l* human being. Once the crucial sensitivity threshold is crossed and we can only with difficulty distinguish the artificial, industrial mimics from their originals, what then? Imagine sitting at a restaurant table, and a guy asks, *"Hey, the girl at the end of the bar, is she...?"*

NOTATION & THE KNOWN

To really hear, or listen, is to forget for a moment the notation—
whether it be words and letters, numbers and equations, or
the notes of a musical score—we use to think about things
when we write them down.

In this way, perception is unconditioned by the fetters of
the past, and therefore open to the energy of new insight.

It is a great art to be free for a moment, as a kind of
meditation, of all measure, of all art.

FREEDOM & LIMITS

Highways exist to *move traffic,*
As Internets exist to *move bits,*
And Economies to *move goods.*

All three are paths of movement,
of exchange, of communication.
And with all three, freedom flourishes
only when it is strictly limited by universal,
clear, unambiguous laws.

Without clear limits, the worst and most brutish
of our natural tendencies shall come to rule
the many roads that run between us.

THE WONDER OF WALKING

In the mountains,
one may go up a climber,
but always comes down a pilgrim.

THOUGHT EXPERIMENTS OF THE COMPASSIONATE MIND

A key feature of the compassionate mind is evidently its need to move freely with the unseen relational resonances implicit in every produced or used artifact, every thought, every action. The apple may indeed be superficially beautiful, but to ask *how, where* and *by whom* it was grown, is a quintessentially spiritual question.

For the student of any age, the key thought experiment is: begin with the end, or manufactured object, and then unravel it into its many simpler constituent threads or parts, thereby going back in time and space like a movie playing backwards. Imagine all the objects in a room returning to their ultimate earth-bound source in this way. And then, run the movie in your mind's eye fast-forward until all the objects converge again into their motionless, present form.

What parts of the movement are necessarily so? What parts are wasteful? What parts cause harm? Which objects do you now see as necessary? Which do you see as wasteful?

It is the beginning of a much wider circle of ethical awareness.

ON THE LOSS OF RHYTHM

The body of contemporary Western culture is but half a body, divided or cut off at the waist, centered not in the heart, or solar plexus, but in the eyes. Sitting at the controls is this halfbody's activity of choice. In front of the TV, the computer, or steering wheel of a car.

But what of the poor feet? They might tell us that one cannot think clearly about much of anything—especially *dance*, or *music*, or *poetry*—without living a life deeply grounded in the slow, measured cadence of walking.

Witness the automobile: so utterly without rhythm; it simply wishes to continue without interruption on its smooth, mechanical trajectory . . .

And so, our sense of rhythm, of movements of all kinds large and small, is quickly falling by the wayside, conditioned deeply by machines like the automobile, and atrophying like muscles or organs we no longer need or use.

And so, we get bored. Bored for lack of rhythm. Indeed, boredom has become a key feature of this culture of the halfbody, a state which we seek to escape remarkably by more sitting in front of ever-more sophisticated controls.

this idea of chance and what I like to call *the butterfly way* . . .

A TOSS OF THE COIN

A fork in the trail appears, with two wooden signs,
each pointing in opposite directions,
each of equal appeal.

Which way shall I follow?

I could stop to study my map.
Or wait a while to ask a fellow passerby.
Or I could leave it to the gods of chance
and toss a coin, *heads* to the left, *tails* to the right.

Always willing to bet on good fortune, I give
my last lucky nickel a stout thumb-flick
up into the clear morning air and watch
it spin as if outside of time, in slow motion.
Before my disbelieving eyes, it changes
into a little blue butterfly.

What to do? Why of course:—
Follow the butterfly way!

ON CHANCE

One of my recurrent themes is a difference I see between mere mechanical randomness, say, like a computer so easily generates, and chance. Chance I see as something far more mysterious, both in terms of its nature and its source.

An event may seem like chance only because its matrix of causes lies outside the field of our vision or comprehension; Or it may at other times appear as an almost divinely inspired confluence of hitherto separate ribbons of fate, say, as when two strangers unexpectedly encounter each other on a path and instantly feel bonded by some kind of deep sympathetic resonance.

I in no way think that such a view must retreat into a vulgar dreamlike romantic subjectivity. On the contrary, such an open view of chance appears to me almost unavoidable as we by hard, cool thinking reach the end of the road of logic and reason, and enter into the pathless land of the unknown. This is where Art and Science, I feel, may possibly join hands and walk together for a while, for who would deny that what we do not understand of reality is a vastly—perhaps infinitely so—greater realm than that little domain we with some degree of certainty can say we truly know or understand. And who would deny that image and metaphor are not just as necessary items of our intellectual equipage as are mathematics and formal models when it comes to exploring new and still uncharted terrain.

So, in this spirit, here is a little flutter of a piece which turns around

The Little Clavier: Part III

Mirrors made of sound?

When strings at rest reflect in
sympathetic resonance the movements
of other sounds around them, we hear
the beginnings of Love and Compassion
in the physical world.

(iii)

One prays for sun, puts
up with rain. Every zipper in
the tent is broke. A chipmunk gives

a sermon

on cheerfulness:—the
nutcrackers will not fly today.

AFTER FALL STORM IN HIGH MOUNTAIN SUMMER—*three 37-step poems*

(i)

Fast, flowing clouds stream
over constant red rock mountain,
stonepines give voice to cold winds, sun

peaks through, new

day so late in the afternoon. The
nutcrackers will not fly today.

(ii)

The lightning bolt strikes
the stonepine, as it bursts apart
in a flash of flames. Ancient tree

on solid

rock. Science can't say
which tree will be the next to go.

the literal man. It is a world in which morality has been reduced to the tightest of circles around 'the me.' It is a state of mind and being which now, sadly, manifests in Western culture in both genders about equally.

COMPLICATION?

Complication—in contrast to the richness of natural complexity— is about making things at least twice as difficult as necessary, thereby making it easy to do *really* difficult things—not at all.

BETWEEN THE WORLDS

All mischief begins with distance. *Poet, scientist, farmer, teacher:*—be the messenger between the worlds.

CLOACA MAXIMA?

We shape the world and the world shapes us.

Let the philosophy of alternative, sustainable design begin by ending the legacy of the humble sewer's ancient Roman past. The first principle of design: *First, do no harm.* Find a better way. It's extraordinarily irrational to put feces and urine in water, which then becomes polluted, which we then either have to clean up at great expense, or ingest and drink the consequences. Better to compost them. And find a way to bring them as safe, purified resource, back to the land.

[Note: The *Cloaca Maxima,* or *Big Sewer*—still to be seen in the oldest part of Rome, is thought to be the world's first sewer and has served as a model world-wide; it dates back to the 6th century, Bce.]

ON THE LITERAL MAN & THE IMPOSSIBILITY OF METAPHOR

The world of the literal man is a world of extreme fragmentation.

In this broken-apart world of the literal man, the natural weave of the interdependencies of wholeness has been ripped apart, and 'facts' and 'things' exist in all but complete isolation.

It is a world, therefore, in which the *this-is-like-that* of analogy and metaphor not only make little sense, but is no longer even possible. And it is a world, because nothing is felt as being connected to anything else, ethical responsibility has been reduced to the exigencies of hard cash and personal survival.

It comes as little surprise that the literal man makes the perfect foot soldier in the technological armies of mechanistic science, the same science that has given us the modwern weapons industry. Here we find the literal man in the form of the brilliant physicist who without the slightest ethical qualms diligently increases the yields of each new nuclear device; Or the literal man in the form of the virtuoso economist who spins the market trends with great short-term success and mathematical élan, while completely ignoring every single relevant feature and consequence of the wider, long-term context; Or the literal man of the genetic engineer of genius who cleverly creates seeds that self-destruct, seeds that you must now forever buy because they terminate in their own infertility. The final extreme? A world resource empire that hordes the very water of life itself, and which sells it back to us at a price *only he,* the literal man, can afford. This is the "participate or perish" world of

resonates throughout the Wallowas. Why have we gone the way of noise? Why have we broken the sound / silence cycle apart? Why have we filled every empty, silent corner of the world with the noise of more cars, more computers, more TVs?

I suspect that if one were to walk these hills long and hard enough, that one may very well find the first beginnings of an answer to these questions.

That, in any case, is my prayer . . .

IN A WORLD AT WAR WITH SILENCE

The most basic complementarity of music is that of sound and silence, just as the most basic complementarity of the pattern language of the printed page is the contrast between the black of letters and the neutral white background of the paper.

In the early vocal music of Western culture, silence meant breath, silence meant the new beginnings of birth, and silence meant a kind of the recurrent rounding off of a full life with the stillness of death. Like all complementarities, it draws in the smooth sand of the quiet mind a pattern of movement that is not a straight line, but rather something more like a circle, or cycle. The silence of death becomes the silence out of which the cries of rebirth are born.

I sometimes joke with old-timers I meet along the way in the great landscape of the Snake River Country, that they could bottle the silence there and sell it like spring water. Imagine that, uncorking a vintage cask of *Oregon Silentium* and savoring it in New York or Amsterdam! Ah, but the petrochemical-military complex, and their accomplices in crime—the entertainment-information industries—are seemingly everywhere at war with silence. And with what success! Imagine the difficulty. How is it possible to turn the noise of trashing the Earth—in glaring self-evidence at every bend of the road—into the universally broadcast and readily consumed illusion of wholesome development and good fun?

These are the questions that confront you in the depth of silence that

GRAND PARTITA

"Wir sind das Volk!" How are we to translate
The wonder of liberation? *"We are the people!"*
Leipzig: City of Lindens; City of Bach.
Through the cracks and fissures of Lenin and Trotsky

Rises the defiant sound of a solo violin.
Bolshevism it seems was good for discipline:
Oistrakh would get up in the dead of Russian winter
And play his Shostakovich cadenzas cold.

When Gould played Bach at the Conservatory, nobody came.
But by the interval, half of Moscow was there.
So the Wall fell, not with tanks and tough talk, but with spirit.

The Church—Bach's church—is packed with ordinary people.
All eyes are on the young woman playing her Bach. This is
How the Wall fell. When even angels listen, it must be so.

after seeing a recording of Viktoria Mullova *play the Bach* Chaconne *in the Church of St. Nicolai,* Commemoration Concert of the Peaceful Revolution & Fall of the Berlin Wall 1999

THE MOONS OF GALILEO

Io. Europa. Ganymedes. Callisto.
Messengers of the stars, rough surface of the moon.
Eternal lights, now circling with predictable
Regularity round a new, radical, idea.

Brightest object in a great awakening's night sky.
So much for Dante. So much for Aristotle.
Grand Book of the turnings of the heavenly orbs,
O celestial fact—one of how many yet?—

Silent for centuries that suddenly explodes.
So much for Rome. So much for its dogma, its torture.
Even the power of all the marble and gold

In the Universe could not cloud the new lens of truth:
That scripture was wrong, and Copernicus, right.
It's shining above for all to see. *Lux eterna,* indeed.

THE LUTE

O come again sweet love, soft rounded belly of wood,
Resonance rich with bright stars and dark loam,
Pure instrument of the unseen platonic realm.
By what strange demonic twist of fate

Did your fine form fall into disfavor? Like a Queen,
Much beloved, yet banished to a far-away isle,
You've suffered eternities of turbulent seas,
Waves of sharp steel strings, of harsh amplified sounds.

So now:—come again sweet love, let us dare open
Your velvet protective case, let down your youthful braids,
And let the coming age find new spirit on your strings;

Let the recluse tune your pegs by mountain springs,
Poets find new rhythms to match your most dissonant chords,
And bards play to Kings bent on war, as you sing of peace.

upon hearing Nigel North
play John Dowland

FASTNACHT—*The Night of Mountain Carnival*

Drumming out the bad spirits of mean-man winter,
Screeching at them with a horror of horns and pipes,
Marching down cobblestone streets and under bridges,
Where monstrous demons tend to congregate.

This is the music of the anti-divine,
Anarchy's orgy against an excess of *sanitas*,
Recompense for the far-too-much of not enough.
Where all is fire, is noise, where all is chaos,

Where Kronos readies to castrate the Patriarch.
The Pope belches and strokes the buttocks
Of his favorite Swiss guard: *"Let the wretches*

Have their night of fun." But the children know better.
Faces painted for a holy war, they take to the streets.
This is the night that shall balance all the rest.

THE VAGABOND OF THE GRANDE DIXENCE

There he stands on the dam he helped to build,
Defiant voice of the river that no longer flows,
Spirit caretaker of the eternal snows,
Witness of a great valley's slow, but steady decline.

Gone are the meadows, gone are the shepherd's huts,
Gone are the silent ways of the alpine winter.
The stars of Orion no longer guide us
To the chamois' retreat, to the slopes of the rusty rose:—

All fade in the bright lights of rented Chalets,
In the endless highways of Sugarsnow.
Swish goes the scythe of the Banker in Touristland,

Whetted on the bent backs of mountain farmers.
"Tout fini," he cries, his words fracturing
In crystals of frozen ice, a rainbow avalanche of light.

for Maurice Chappaz (1916 - 2009)

*"At the end of a writer's life, I think I can say
that it is much harder to make a poem,
than to bore a tunnel."*
 Maurice Chappaz

A QUINTET OF LONG-LINE SONNETS

The Little Clavier: Part II

Metaphor? A movement of resonance
perhaps, a rhyming not of sounds or words,
but of meaning.

Do you not know this light and quick
movement of energy as two separate
thoughts touch wings and fly off
into the distance together?

AN EXTINCTION OF A DIFFERENT KIND

Of all the extinctions currently underway—we are told we are at the dawn of planet Earth's sixth great extinction, with, for example, a quarter of all mammals under threat, as well as a third of all frogs, to mention but a few—the one that saddens and frightens me most receives little if any attention. It is the extinction of *the free spirit*. By "free spirit," I mean exactly that: *an intelligence that is not tied to anything,* and which can therefore find out the truth of a matter with integrity, independence, and, most especially, without fear of loss.

This is the man or woman, young or old—age here makes no difference—who is capable of examining a thought or idea and following it like a thread through a labyrinth of possible dead-ends, missed implications and inconsistencies, to its logical ground and source.

My contention is that the man or woman of free spirit is becoming exceedingly rare. I hope that I'm wrong.

THE ASPEN OF FORGETFULNESS—
a prose poem

Some things we wish to remember; others, we'd rather forget. The latter we'd prefer to see turn yellow and dry, see wither away till they fall like autumn leaves, feeding the fertile humus of some common past under our tired feet.

Descending a steep southern slope, I stop to rest a while under an old Doug-fir. The late-summer draw is dry, but sill full of the lush green of Aspens.

Heart-shaped leaf on long, slender stem. Some say the most beautiful of all leaves. Blades now quivering in the afternoon wind like the soft skin of a young woman first falling in love. Sound of leaves glistening with light filled silences. Shape of the whole coming in slow, easy waves that seem to say in a receding, ever-softer echo, *"Let it go. Let it go. Let it go."*

I look for a pen to write something down, which I can't find, and then look at the new blank page I had ready. This I fold up and put back into my pocket, as I shoulder my pack, stand, and start walking down the steep hill again, happy to have rested a while among Aspen and Fir, and happy to forget about all those things in the past that now seem so many continents away.

ZERO DOLLAR DAYS

We shape the world and the world shapes us.

A crisis comes, and a President takes the bullhorn and admonishes his citizen-children not to save and to prepare for hard times or worse, but to go shopping.

How strange . . .

Where are the days of finding peace and security in the timeless wisdom of *less is more,* in household economies based on hard work, saving, and the waste-not-want-not of conservation?

I say, to hell with the *Consumer-in-Chief.* Stack proudly your zero dollar days—the days in which you spend nothing, not one penny at all—and stack them like newly minted gold coins. The more you pile up the better, the more cause for celebration. And know that, the less you spend, the freer you are. The less you spend, the less harm you most likely do in the world, and the more there is left over for others, others of very most likely far, and far greater need.

THE WORLD'S WORST BAD IDEAS

The world's worst bad ideas have two key features which refer both to *truth of function,* and to *truth of content,* in equal measure:

First, they not only prevent us from clearly seeing some important, relevant aspect of the world, but actually distort it beyond all recognition;

Second, they strengthen their hold on thought and perception with self-reinforcing, equally false "evidence."

Thus, this essentially closed devil's loop easily hardens into the motionless, self-destructive, rigidity of fundamentalism and absolute belief. Why would we allow this to happen? One word: *security.* We take refuge in delusional, bad ideas, because they offer us a kind of comforting—albeit false—sense of security.

Education, in the view being outlined here, has a vital role to play in an open society. In a democratic republic where the freedom of ideas and their expression is guaranteed, centers of learning ought to be places where these intellectual freedoms are both exercised and demonstrated at the very highest possible standard of excellence. To fail at this task is to risk the failure and loss of these hard-won privileges of democracy itself.

THE FLAT-TIRE MODEL OF REALITY

20 miles out, 20 miles back.
Got a flat; That's a fact.

Hard as nails, Life's like that.
Gotta act—now; That's a fact!

Excuses, excuses, excuses—
Why can't I live like that?

HABIT & TRUTH

Habit loves to be reformed;
Truth loves to be demonstrated.

ROAD OF CHANGE

Down the rough road of change, a mountain bike's wheel keeps its true by centering in the clear intentions of its motionless hub.

ROUGH ROAD AHEAD?

All passengers in a car running on a full tank
of fundamentalist religion, we're tied up with
Freedom and Democracy in back. Money's
in the driver's seat, with Nation States,
spinning one against the other, for wheels.
"Hey," somebody just yelled, *" Get out
at the next right!"*

A NEW TENEBRISM * — *towards an Art as light as mountain air . . .*

In Poetry and Photography, the title or frame
creates a background shadow of knowledge
of things implied, but left unsaid or unseen.

Out of this background emerge dramatically
contrasted centers of light and focus.

The balance of the resulting pattern as a whole
is its composition; the strength of emotion
thus awakened, the depth of its expression.

* from the Latin, *tenebrae = darkness,* or play of
primary the contrasts of white and black, light and shadow
(q.v. **HYMN** below)

IN PRAISE OF NATURAL COMPLEXITY

From a single trunk, a thousand branches;
From a thousand rivulets and rills, a single stream.
Simple to complex; Complex to simple.

Complexity is richness, is diversity, is always good.
Complicatedness, or the unnecessarily convoluted or difficult, is always bad.

Complicatedness, because of the contradictory, meaningless way it wastes energy, is never a feature of natural systems.

FEAR AT NIGHT

When out camping, fear at night is not the same as fear by day. The night opens a door to some all-but forgotten, distant, primal past. The ear surrounded by darkness easily finds signs of the fierce, the brutal, and the blood thirsty. The *ear's eye* sees them all, acting out each and every gory detail, each gruesome scenario. Fear at night. When the coyote's call brings to life an image of being surrounded by a starved pack of ruthless timber wolves. Fear at night. When the sound of a mouse causes us to leap upright with a start, ready to battle with *Ursus horribilus?* Fear at night. When a mere rustle of leaves means an onslaught of hungry cannibals, or headhunters, or raiding hordes in search of scalps and trophy strings of severed fingers. And then when the light returns, we always wonder and forget again. *"What was that all about?*

GO BIKES!

Bikes make an excellent model for a new, *life-is-round* economy. Every part has a name, a number, a manufacturer, and someone, somewhere, who knows how to fix or replace it! Bikes are best sold and serviced by relatively small shops. That's because the shop serves an area where cyclists can easily ride to have work done, or pick up new parts. Bikes are the "slow food" of machines. Made to last; made to establish strong face-to-face relationships between buyer and seller; made to make the environment, as well as the user, healthier the more they are used.

And bikes are cheap. An investment of $500 will last you a lifetime. You don't need a license; you don't need insurance. It's said that the energy equivalent of 4 liters of gas (± a gallon)—31,000 calories*—is enough Clifbars (± 133) to power you 1000 k (600 m) down the road. Now that's math that's got more than a bit of music to it!

* *source:* Scientific American Podcast: host Steve Mirsky with Nick Goddard, *"The Gas Powered Bicycle"* III.14.2007

SIMPLE DESIRES

I want to live my life like a bell, resonant and
whole—ringing out from a hill on all its sides
into the clear. open air;

or like a frog, hungry for love,
singing the instant it digs out of the muddy
spring earth, one eye to the stars, the other,
to the dark spaces in between;

And I want to die my own death, like a tree
brought down by fall winds on the forest floor,
year after year of heavy rain, new green life sprouting
out from every crack and crevice of its body;

or like a stream leaping out
from its sheer granite cliff, disappearing
into the late summer air, nothing left to see
but the steady rising mist of its now muted roar.

SIGNS OF EMPIRE

The second surest sign of the self-corrupting, decadent, one-sided power of Empire, is when children grow up learning no other culture, no other language, but their own. The first, is when teachers of the young know this to be true, and couldn't give a damn.

INVERSIONS OF MEANING

With the perverse inversion of the sheer brilliance of the digital communications revolution into the dark and sinister world of firewalls, censorship and systems of surveillance, at a single stroke, the meaning of the word "web" flips from *"one world connected"* into *"gotcha!"*

LANGUAGE OF WAR

Learn the language of your enemy and you may soon discover that you no longer *have* an enemy.

LOVE IS ROUND

Love wants to come round.

The performer who must sing.

who must play,

in a space without echoes

quickly cancels

all future

engagements.

HABIT OF PHOTOGRAPHY

When all the world

begins to look

like a photograph,

it is time

to put the cameras

away.

LOVE & WATER

We shape the world and the world shapes us.

There may well indeed be another planet in the Universe with high mountains and streams of pure, fast-flowing water, but we do not know that for a fact.

There may also be other beings in the Universe capable of Love and Compassion, but also that we do not know for a fact.

Love is like water: wherever it is there in abundance, life flourishes; And water is like love: wherever it is wasted, polluted, blocked or dammed, we abuse not just Earth's defining essence, but also somehow our own.

LOVE RESONANCE

We shape the world and the world shapes us.

See the electronic keyboard—*the synthesizer*—with its brittle octaves made of wired concrete, and its complete lack of sympathetic resonance. I say to you, when similar sounds no longer spontaneously vibrate together, when like sounds no longer reflect one another, no longer mirror each other's energies, upon which instrument shall we play our songs of love? Upon which instrument shall we teach our children the principles of Nature's way?

DIVERSITY?

All Nature abhors a monopoly. Diversity is the signature of natural intelligence.

PLACE FIRST!

In all illness, the first place to look is place. The second, is water. The third, air. And then, the farm right down the road.

FOR A FRIEND & A CROW

—for Paolo

Mid-morning, sitting in new
snow with an old friend.

An eagle flies by with a crow
on its tail.

Above, below—always with two begins
the movement of our world.

DRAWING CIRCLES . . .

What's an island but a circle we draw around some part of the world, a line of difference, of demarcation, separating that which is inside, from that which is out. It all begins, of course, with an actual physical island, separated by its coastline from the sea. From here, the idea of island proceeds to be transformed in thought, easily and seamlessly, by the miracle of metaphor into the realm of the more subtle and unseen.

Thus we have "islands of beauty" in an "ocean of ugliness," "islands of security" in a "sea of violence," "islands of peace and tranquility" in a "non-stop turbulent flood" of useless data and misinformation.

The width of the circle of these metaphorical isles is entirely of our own making. We may carry the circle in our own breast; or it may expand to embrace the entire world, or beyond.

Imagine for a moment with me a spaceship full of friendly beings from some unknown outback of the Universe. As they first come in sight of Earth, they would almost certainly be utterly amazed at our planet's beauty, the striking blue of its seas, the amazing white flowforms of the clouds of its atmosphere. To them, I'm very sure, it would seem "an island paradise," an extraordinary circle of life in a vast ocean of orbiting waterless rough rocks. It might do much to attune our own thinking of Earth's unique place in space if we were to draw our own metaphorical circle in much the same way.

I like that.
But how the bitter of age makes us see the cracks in a cup.
I admire her crow-black hornrims,
a kind of protection, I suppose,
relics of a past rounded and mellowed by the miracle
of a big band's sound now playing in the background,
and an impulse to protect the trust
of an innocent smile?
Flower. Honey. Yes. Now I see.
"Yes, please. I'll have some more."
I've always been slow
to make connections.

THE HOUSE OF CULTURE

In the House of Culture, the roof of spirit is always the first to go. Then the foundation of meaning, left exposed to wind and rain, soon begins to fragment and crumble. The walls of learning and education, however, sometimes remain standing for centuries, reminders of what has been, with their empty windows starring out into the distance like the unclosed eyes of the dead. The question we cannot help but ask ourselves is: *"Why did no one take care of the roof?"*

NO SUGAR ADDED

"More coffee, honey?"
"You bet." She wasn't old enough to be saying
'honey' to anybody, let alone me,
but coffee, even of the pale left-over
dishwater variety served like holy water
along roadsides everywhere in the West,
puts me in the mood to be forgiving.
I looked for some sugar to add some taste,
but couldn't find any.
I admired her lithe movements, running shoes,
darting between the crowded roomful of busy tables
like a fingerling in a clear stream.
"More coffee?"
"You bet."
It took me the longest time to figure out
that what I saw on the old TV above the bar
wasn't synched up with the loud music.
Like politicians we elect by force of a lack of choice,
we're inclined to compose more harmony after they
are safely in office than the disparate facts might
reasonably allow us to assume.
How age does make us experts in the beautiful,
the beautiful flower of youth, which, like the flower itself,
seems so wonderfully unaware of itself, of even
the most vague and remote possibility
that it itself might ever fade.

and take off his hat.

But then, the preacher said something
about the Lamb of the Lord
and the Good Shepherd.

He hated sheep, that much he knew.
And why, all the shepherds
he knew were drunks from south
of Panama.

He stood up.
Spit.
Swore.
Took a pinch of tobacco,
And put on his hat.

As he went out the door,
he kicked the good dry earth,
saying out loud,
"That'll be enough,
of that."

IMAGES ARE CHEAP

Scroll. scroll.
Click. click.
Scroll. scroll.
Images are cheap.
What makes a good image?
"Clarity," says the judge.
"Composition," says the critic.
"Subject," says the editor.
"Suffering & Sex," says the dealer.
The humble acolyte passes the ABC's of the pantheon of light . . .
What makes a good image?
"Truth," says Adams.
"Truth," says Bresson.
"Truth," says Capa.
You only get one shot.
Keep the best:—*Throw away the rest.*

THE COWBOY GOES TO CHURCH

He knew
that he couldn't spit,
or swear,
or chew tobacco.
And that he had to put
on a clean shirt,

one's fellow human beings, or against the Earth. The voice of frustration of the current era, amplified a thousand fold by the populist rhetoric of *ad hominem* Attack Radio and TV, flirts with violence of the most insidious kind as a misleading means of releasing equally misguided rage. This is a profound mistake. The way of non-violence, as an alternative, takes the *rule of law* and *civil stability* as its point of departure, and seeks by means of argument, dialogue, or, when necessary, civil disobedience, to widen the circle of ethical awareness and discourse to include in a radical and un-compromising way the whole of the human community and the living Earth.

WEATHER IN THE WEST

3 months of hot as hell,
3 months of cold as hell,
and 3 months of lord-knows-what
in between.

ALPINE GEOMETRY

Horizontal lines of water,
vertical lines of trees,
everything else *fractals*
in between.

LICHENS AS SILENT WITNESSES OF TIMES GONE BY ...

Lichens, mutually beneficial composites of two simpler life forms, are small wonders. They are composed of a fungus, which provides structure and a hold on rough surfaces like rocks, and an alga, which provides the solar power necessary to synthesize food out of the raw materials of carbon dioxide and water. Lichens obtain their water and nutrients from the atmosphere, so they frequently tell us much about air quality. And lichens are patient. Very patient, in their growth, typically expanding out from a center in slow motion, about one or two centimeters a century. Imagine that! So, many of the different colorful species of lichen I see everywhere as I trek around the Wallowas—beneath my feet, on granite rocks, on the limbs of Ponderosas—were perhaps present before the dams on the Snake were built (completed c. 1958). Or even before the first European Americans arrived. (c. 1805). What stories they would have to tell!

THE WAY OF NON-VIOLENCE

We shape the world and the world shapes us.

The way of non-violence is not merely the deeply held intention to live a life without conflict and the use of force; it of necessity actively seeks to make explicit the contradictions of thought, culture and convention that lead to violence (and waste) of any kind, against oneself, against

The only accessory these first two styles of Northwest living might have in common is an American flag. For the cultural anthropologist, this is a classic example of the display of an identical icon with, interestingly, two radically different meanings. For what one flag may implicitly pledge allegiance to, the other may flatly contradict. One may salute the lost hopes of a whole generation, a generation forced to execute and suffer the insanity of Vietnam; while the other may pay homage to the power of Wall Street, and the growing *Praetorian Guard* being assembled to protect that power in our name. One flag; two meanings. But this, of course, is just a minor detail distracting me from my theme.

I would argue happily for a third, more contemporary, style of Northwest living. Something new, something shaped more by the new possibilities, technologies, insights, and urgencies of our time. It would be something like the *less-is-more* of a Bucky Fuller Geodesic, made entirely of recycled materials—light, airy—the physical structure in fact weighing less than the air it contains—strong, energy self-sufficient, and expand-contractible. And when the land upon which it stood showed signs of needing a rest, or when climate patterns became less auspicious, it might also be easily packed up and moved. This is not the strength of reinforced concrete, but rather the strength in resilience of native Prairie grasses, with their deep roots for long droughts, and flexible stems for winds and the storms which are sure to come.

LET'S GO CAMPING!

Omnia mea mecum porto
(All that is mine I carry with me)

There seem to be two distinct styles of Northwest living.

One has the appealing improvised quality of old-fashioned hillbilly living, frequently featuring trailers of long, linear proportions, designed more to be pulled by trucks on an interstate than to be lived in, and sometimes surrounded by a kind of protective mote of neatly stacked firewood, wrecked trucks, old refrigerators and broken snowmachines. Such homesteads proudly project the libertarian metaphysics of both *life-is-a-vacation-inside-a-beer-can,* and *"Big-brother-government-California-suburbanite-KEEP-OUT!"*

The other style of Northwest living seems to be concerned more with the outward display of material wealth. It displays large, expensive Disneyland-like designer structures placed squarely upon equally squarely and recently fenced off, just-cleared forest or old worn-out ranchland. For someone travelling from abroad, two striking features of this type of homestead which stand out are their airbrushed fastidiousness—indeed, they look hardly lived in at all—and their size. They are big. *Very* big. Whole extended families from Mexico or Africa could comfortably take up residence in the garage.

CASSANDRA FALLS—*a children's poem*
in common 4/4 time

I know a place where dreams are found,
Cassandra knows it too.
Where waterfalls and pools abound,
And visions just for you.

The Elephants whisper,
The Owls still sleep,
The Mice dance rounds
About the Stars so deep.

I know a place where dreams are found,
Cassandra knows it too.
Where moss and mists and firs abound,
And visions that are true.

* *Cassandra* was given the gift of prophecy by Apollo. When she betrayed him, he turned her gift into a curse by causing her visions, though true, to be disbelieved. The beautiful, quiet, sheltered place I like to call *Cassandra Falls* is located above the trail between *Muir* (Crater) *Lake* and *Little Eagle Meadows* in the Eagle Cap Wilderness, Northeast Oregon.

BOOTMAKER

—for Gary Johansen

Long after the dust and hubbub
of mechanical motion settle to the ground,
and cars and trucks and snowmachines
are out of fashion or out of gas or both,
the humble bootmaker
will still be bent over
his worktable,
stitching together the soles
that allow us to do what
we have always done best: *walk*.
Without his art, how would
we climb up into the clearer, lighter air,
just below an eternity of sky, far above the
noise and dark clouds of daily life?
I may think I climb alone, but this is not so:
good beginnings are more than half the climb,
and the beginning of each ascent
is prepared, and secured,
and hammered and glued, by the bootmaker's craft.
I celebrate his work, which gives us these
coverings for naked and tender feet
that are made to last.

Who is to say which one—
the *sound* or the *silence*—
is more important?

(iv)

We are born naked; we make
love naked; and we die
naked;

Though not strictly necessary,
doing poetry naked seems to work
just fine, too.

(v)

Once the commons
are fenced in and sold,
on that very same ground
we'll argue incessantly about—
the necessity of poetry.

ON THE NECESSITY OF POETRY

(i)

Walking from spring to spring,
one tires quickly of all
the intellectual bush-beating,
telling me I'm not thirsty
when I'm thirsty.

(ii)

Let's be simple:
A house without a hearth
is a home without a center.

After somebody lets the fire
go out, they always like to tell
you it wasn't important.

(iii)

Have you ever noticed that
bird calls are often answered
by silences of equal duration?

THE BEAUTY OF THE SUNFLOWER WAY—
a reflection

Biking on the flats, into the strong, persistent afternoon North Dakota headwinds coming straight out of the West, sometimes I'll turn a question over in my mind. Just in a playful way, like looking out the kitchen door to see what kind of mischief the neighbor's kids are up to in the backyard.

Today my question is: a new Poetry, a new Music, a new Art deeply rooted in place. What would they look like? What would they sound like?

Consider the sunflower: it has no intention of being "rooted in place," or beautiful or popular in any way, and yet it is loved and admired everywhere—on the wild prairie, the roof-top garden, in a child's drawing.

Along the ways of the wild Northwest, perhaps what is most dear to me is this *beauty unawares of itself,* humble and persistent in its growth, and unselfconsciously rooted—*were it stands.*

I lean forward into the wind coming straight out of the Rockies, and think to myself about how much I like sunflowers, and that how much I like that fact.

EPITHETS OF A SPECIES

—for David Landrum

Miraculous. Mischievous. Miserable.
Epithets of a species placed
in the order of your choice.

Mischievous. Miraculous. Miserable.
Born naked into a web of dependencies
in a harsh, brutal, indifferent world.

Miserable. Mischievous. Miraculous.
Instrument of the mind, a compassionate
intelligence of infinite subtlety that mirrors
both itself and the whole.

Miraculous. Miserable. Mischievous.
Sole life-form that till the end of time
must walk the sharp knife-edge of its
own self-destruction.

Miserable. Mischievous. Miraculous.

 The choice of epithets is our own.

CHILL MOUNTAINS OF THE HEART

Wind out of nowhere,

Rocks fracturing from high vertical cliffs,

O Chill mountains of the heart,

When will I learn the ancient Art

of Stonepine and Nutcracker?

Of making my stash of seeds of hope,

come good years, and come bad?

Chill mountains of the heart,

steep descent into the winding waters of compassion,

slow steady rise of mist and broken light,

razor ridge dividing known from unknown,

and unknown from unknowable,

Horizon forever retreating as I come near.

O Sheer signal fire of peace.

NIGHT ODE

One bright clear flame,

hearth-center of my world at night.

I watch its moods—a

single white candle—one

moment a motionless monk,

the next, a fickle young woman

looking for her lost car keys,

flickering back and forth

with the whims of a cool autumn breeze.

Either way, the candle burns wholly now.

Not tomorrow, when markets

or farms may fail,

or yesterday, when other

calamities reigned supreme.

No. The candle burns wholly now,

centered and silent,

letting the winds of the world

and the coming winter

bring what they may.

figures of braided silver and gold, each phrase a water-like spiral floating upwards through the spruce and fir, then tapering off towards the sunlight above.

And ever-presnt in the background is that steady, rushing sound of clear mountain water, water rushing down from all the sides of the steeply walled valley around me, a near timeless roar that somehow holds the whole, the whole mystery of living water, and of the whole of living sound.

TWO PATHS

Two paths, one returns,
one does not. And I

still don't know which one
leads home.

WATERCOURSE WAY—*a prologue*

> *Quaerendo invenietis*
> *(Seek and you shall find)*
> Johann Sebastian Bach's inscription
> for the famous *Ascending Staircase Canon*
> in the *Musical Offering*

Simple and *complex*, two sides of one movement. Water is my guide, my mentor, my paradigm. Always flowing downhill, water shows us such an extraordinary example of simple, unambiguous limit, of such legislative clarity! Yet, the patterns of water in flowing movement are at the same time so rich, so complex, as to be vastly beyond all human seeing and knowing.

Look at the wonderful contrast of how the trees stand perfectly erect:—bold, steadfast statements against the harsh odds of cold, wind and snow. But there they are, branching out into the high mountain air in an endless display of inventive variation. One simple vertical constant, ornamented with a baroque delight in complexity, like old Bach improvising at his little clavier or harpsichord, showing us a phrase, a theme, then letting us hear it this way, and then that. Ah yes, *counterpoint,* a movement of many voices together, flowing in parallel, interwoven streams.

And yet, the song birds always have known this. Each spring morning is a marvelous unfolding of song. This is real polyphony, sound finally freed of the constricting bars of music's formal measures. The Robin marks the time with its almost but not quite regular sharp chirps in 3's. The Chipping Sparrow sounds its sustained snaredrum roll. While the Song Thrush, newly arrived from sunny Mexico, tosses off its filigree

The Little Clavier: Part I

Along the way, what was once a gift
of *Chance* sometimes becomes *Necessity's*
next step in the unknown.

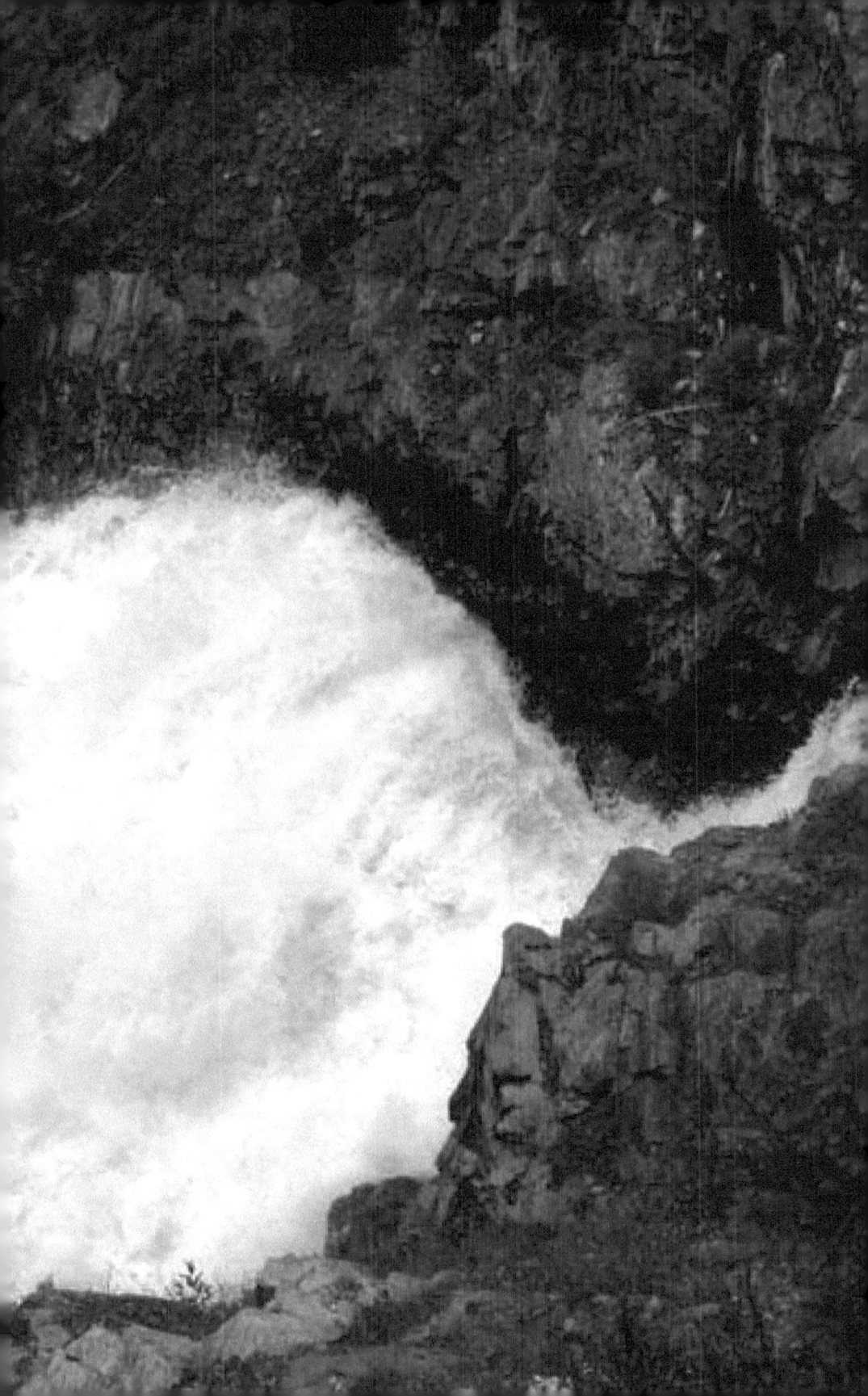

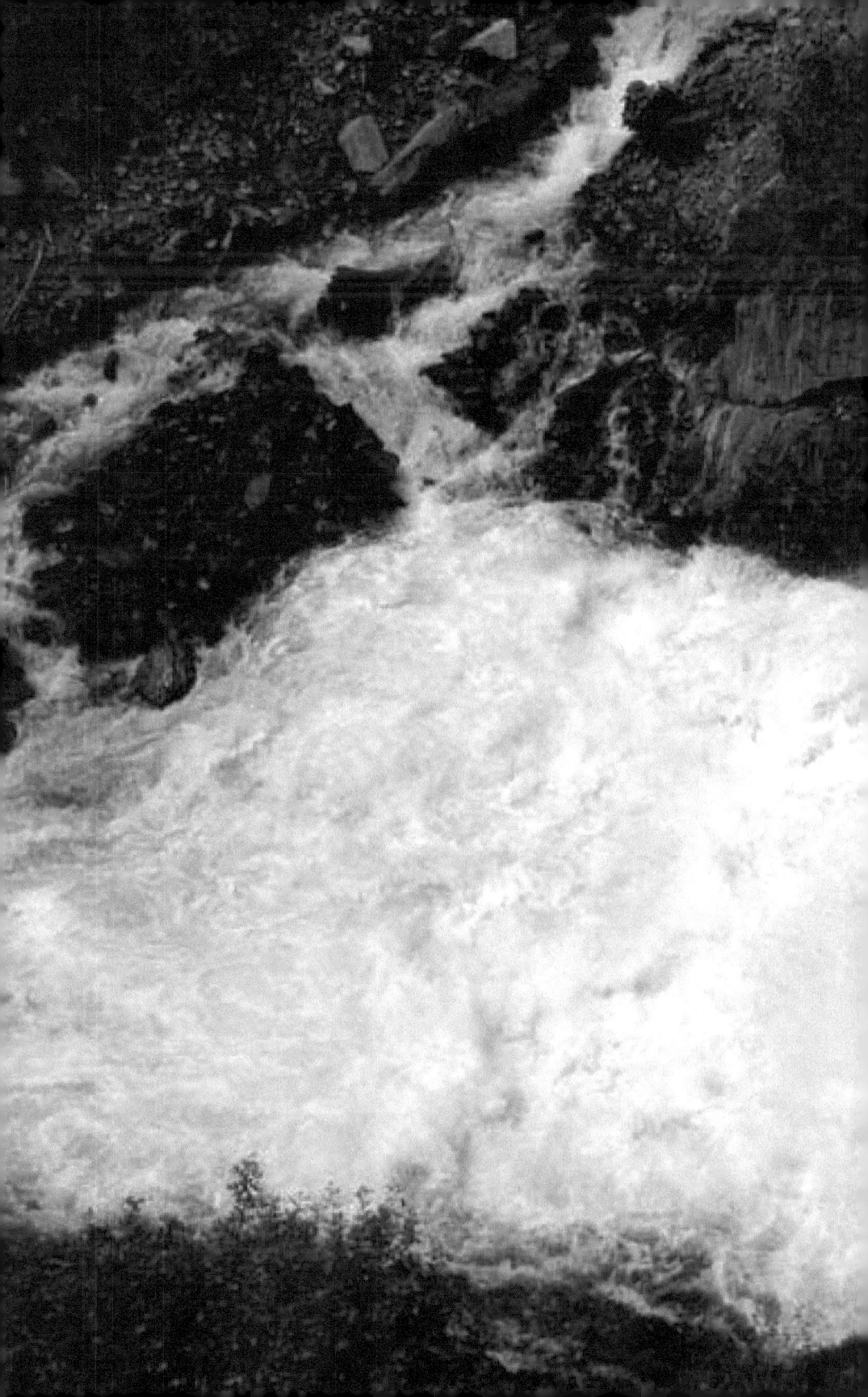

[Photo: Author and photographer, *Cliff Crego,* making a snow profile at 1450 m. in the South Wallowas.]

ON READING THE LITTLE CLAVIER: "In a wonderful way, the snowpack reads like a book. Each storm lays down a new chapter, each with its own story to tell, going back in time to the beginning of high-country winter. In a similar manner, THE LITTLE CLAVIER has twenty such chapters or books or parts, one placed on top of the other. But in contrast to the snowpack, the normal linear sequence is broken up into a highly complex, alpine-like labyrinth of sound and meaning. Throughout the whole, a kind of *synergy of threes* or triangles is a guiding principle. Themes come in sets of three, like *war, waste* and *contradiction,* or *love, compassion* and *intelligence,* or *nature, culture* and what I call *the watercourse way.* There is also a diversity of different species of form and quality of voice, all emerging out of the flow of content like waves on a stream, repeating similar patterns in a cyclical way. The intrepid reader may take the simplest route and venture straight through the book, from beginning to end. Or one may instead chance upon a thread which seems interesting and follow it on to wherever it may lead. If THE LITTLE CLAVIER is about anything, it is about ideas, or ways of seeing, especially *new* ways of seeing. One of the book's main themes is the idea of *sympathetic resonance* as the beginning of love made manifest in the physical world, and indeed, at the collection's center is the very old and ancient metaphysical idea that *all is sound,* and that the Universe is in some unique and largely unknowable way, essentially musical (q.v. 370˚). It's good to keep this in mind as one reads, for each poem, each text, can perhaps best be experienced when read out loud. And if possible, they are perhaps also best read outside, under an open sky. That is how they where composed. As final words of encouragement to my reader, let me echo Beethoven here: the writings and images and thoughts found here are all from the heart; my hope is that they may once again return to the heart."

DEATH AT A DISTANCE *550*
HYMN *552*
BAPTISM *554*
I'M TOO POOR IN THIS WORLD, AND YET NOT POOR ENOUGH *556*
FOR THE YOUNG—*a few necessities of the artistic life 558*
DEEP WATER *559*
MIRACLE *559*
CENTER OF LEARNING *559*
WEST WIND AT POP CREEK PASS—*a prose poem 560*
SIMPLICITY / COMPLEXITY CYCLE *561*

PART XX

WINTER LINES *567*
WINTER PATHS—*The Alps 568*
WINTER PATHS—*two sets of seventeen 17-step poems 570*
WINTER PATHS—*deep snow . . . 571*
MIRROR OF RELATIONSHIP *580*

PART XXI

THE LITTLE CLAVIER—*Coda 586*

WATERCOURSE WAY *498*
MEMORY IS SPATIAL *499*
IN PRAISE OF ZIPPERS *499*
MACHINE INTELLIGENCE *500*
AGAINST STURM & DRANG *500*
DECIBELS *501*
SIMPLICTY *501*
OPERA BUFFA *501*
SNOW MACHINE *502*
SNOW DEVILS *502*
WINTER STORM *502*
THIS MORNING *503*
TECHNIQUE *503*
ON HOLOGARCHY—*the order of the whole* *504*
ON THE MASCULINE ENERGY OF CONTROL *506*
ON THE NECESSARY WISDOM OF ELDERS *507*
MIRRORS OF LIGHT & SOUND *508*

PART XVIII

POLLUTION, WHOLENESS & THE PLASTIC BAG *514*
OUT OF TUNE *516*
THE REAL THING *516*
ON THE TWIN GUIDEPOSTS OF YOGA &
THE ALEXANDER TECHNIQUE *518*
THE THREE MISTAKES OF EDUCATION *519*
ON THE PROTECTION OF TREES *520*
THE TWO FACES OF EMPIRE *522*
TWO PATHS *524*
ON THE SOUND OF WHITE-WATER RUSHING *525*
RIDGE CROSSING *526*

PART XIX

WAR DEAD—*a prose poem* *546*
VETERAN *547*
THREE MINIATURES ON WAR & THE CHANGE OF MEANING *548*
THE WATER IN US . . . *549*

THREE MINIATURES ON SOUND *431*

THE FARMING LIFE—*six longer narrative poems from the Alps* *432*
EVERY VALLEY REMEMBERS *433*
MAKING HAY *434*
CUTTING TIME *436*
COMMON NAMES *438*
KNOWING *440*
SITTING *442*

FIRST / LAST *448*
A TRIO OF MINIATURES *450*

PART XVI

A QUINTET OF NEON GRAFFITI *458*
d & d *459*
ACRONYMSPEAK *462*
FOUR EASY STEPS . . . *464*
BASIC BALLOT *465*
AT THE KEYBOARD *466*

PART XVII

ON THE FRAGMENTATION OF NATURAL WATER CYCLES *478*
ON THE NECESSITY OF ROADLESS AREAS (II) *482*
THERE'S A CERTAIN SOUND THE WIND MAKES—*a prose poem* *482*
TOO MANY VARIABLES *483*
A MEDITATION ON BATTERIES—*a quartet* *484*
EIGHT MINIATURES ON LEARNING *488*
THREE MINIATURES ON SEEING *490*
TWO MINIATURES ON PLANTS & NOISE *491*
FOUR MINIATURES ON FORM *492*
TWO MINIATURES ON RELATIONSHIP *493*
DOUBLE BIND *495*
SCIENCE. ART. RELIGION. *496*
RUNAWAY DECEPTIONS . . . *497*
TREE OF WISDOM *498*

PART XIV

PILGRIM *396*
PILGRIM'S PATH *397*
QUIET WATER *398*
LAND ABOVE THE TREES *399*
POOL OF LIFE—*a meditation* *400*
POOL OF MIND—*a meditation* *401*
ON THE MEANING OF NATURAL LIMITS *402*
WILDERNESS IN NORTH AMERICA *402*
MEDITATION *403*
MATTER & SPIRIT *404*
PATH OF DIALOGUE *405*
PATH OF CONFLICT *405*
PEACE MAKER *405*
POPLAR OF FORGIVENESS *406*
THE DIFFERENCE BETWEEN THEM *407*
PHOTOGRAPHY AS MANDALA *408*
LAST MAN ON EARTH *408*
TOWN *409*
END OF MOUNTAIN SUMMER *410*
HOPE IS . . . *411*
INAUGURATION *412*
THE DIFFERENCE OF BUT HALF A STEP *413*
ON MUSIC AS COMMODITY *414*
WASTE OF TALENT *415*
THE POET'S LYRE *415*
PIANOFORTE—*a fractured mirror poem* *416*
THE TWELVE PRIMARY CONFUSIONS *418*
UNDERSTANDING THE SHAPE OF CHANGE *419*
LET ME REMIND MYSELF HERE *419*
MAN OF ONE CUP *420*

PART XV

THE LIBERATION TRIANGLE *426*
ETHICAL IMPERATIVES—*a meditation on Earthrise* *428*
FOUR MINIATURES ON ART *430*

AGAINST THE SCOURGE OF RUNAWAY ABSENTEE OWNERSHIP *330*
LIFE WITHOUT POETRY . . . *331*
THE LITERAL MAN *332*
SEPTEMBER STREAM *334*

PART XII

WALKING THE WORLD: *Look at the Mountain!* *340*
THE FITTING TOGETHER OF THE WORLD . . . *340*
SUNSIGHT! *341*
. . . SUNSIGHT / SUNCLIPSE . . . *342*
HORSE THIEF! *342*
CENTERS OF LEARNING *343*
NOTE TO MYSELF . . . *343*
SEEING *344*
HOW THE WORLD CHANGES *344*
WOMEN IN THE WEST *344*
HOW TO PROTECT AN ALPINE MEADOW *345*
MOUNTAIN RHYMES *345*
ON THE TEMPO OF PERCEPTION (II) *346*
FORCING—*an improvized listing poem of indeterminate length* *349*
ON THE ILLUSION OF INDEPENDENCE *350*
IDEAS & WRITING AS PERFORMANCE *352*
LIMITS *354*
ADVENTURE *354*
LEAVES *355*
LOGISTICS *357*
IN PRAISE OF COMPLEMENTARY WORLDS, LARGE & SMALL *358*
CELESTIAL LEXICON & THE EPHEMERAL SHIMMER OF MEANING *359*
THE IDEAL OF CRYSTALLINE PROSE *360*
THE PASS *361*

PART XIII

THE LITTLE CLAVIER *369*
THE LITTLE CLAVIER & THE IDEA OF SYMPATHETIC RESONANCE *371*

FALL-BACK *282*
HERE *283*
ON TWO IMPORTANT EXCEPTIONS TO NATURAL MOVEMENT *284*
WITHOUT *292*

PART X

FOOL'S PROSPECT *292*
MONEY AS NOTHING *293*
THE BAG OF GAMING CHIPS *294*
FRACTALS AS PATTERNS OF RHYTHMIC MOVEMENT *296*
ON FREEDOM'S NECESSARY BALANCE *298*
ON FUNDAMENTALISM & ABSOLUTE BELIEF *299*
NATURE'S CIRCLE? *301*
ETHICAL DESIGN *301*
PARTING WAYS *301*
ON JUSTICE & TIME *302*
ON NORMS *303*
WORLD MIRROR *303*
FOUR MINIATURES ON SALT & SUGAR MAN AND EVOLUTION *304*
AN EYE TO THE SKY *306*
HIDDEN LAKE *307*
FIRE RING *308*

PART XI

HIGH-TECH / NO-TECH *314*
HITTING THE MARK *318*
ON RELEVANCE *319*
A TWO-PART MEDITATION ON BOTH THE BRIGHT AND
THE DARK SIDES OF COMPUTERS & COMPUTER NETWORKS *320*
THE SOUND OF DISAPPEARING GLACIERS *323*
ON THE TRIANGLE OF RELATIONSHIP *324*
ON THE NECESSARY UNITY OF FREEDOM
 DEMOCRACY IN THE WORKPLACE *328*
SOCIAL ECONOMY *328*
HYPERLINK *329*
MONEY? *329*

BEER CAN *207*
SEARCH GOOGLE *208*
DAM *209*
SLAM *210*

PINECONES & FORM AS MOVEMENT . . . *216*
STRANGE LOOPS: *WHERE LINEAR & CYCLICAL MOVEMENT MEET IN ONE COMPOSITE* *218*
ON THE DYNAMIC BALANCE OF PRIMARY CONTRASTS *222*
WHOLE & PART *223*
SECURITY & WHOLENESS *223*
LOSS OF WHOLENESS *223*
CREDO—*a confession* *224*

PART VIII

ENERGY iPOD *230*
CONTRA NATURUM *231*
SNOW COCKTAIL *232*
SORRY, THIS SPACE IS TAKEN *232*
CONTROL NOXIOUS WEEDS! *236*
HABITUAL MODES OF PERCEPTION *240*
ON THE DIFFERENCE BETWEEN *242*
METAPHORICAL & LITERAL MIND *242*
ON THE CULT OF COMPLICATION *242*
ON THE SOUND OF RUSHING MOUNTAIN WATER *243*
ON THE NECESSARY SEPARATION OF ETHICS & RELIGION *244*
ON THE FRAGMENTATION OF RELIGION, SCIENCE & ART *243*
NIGHT THOUGHTS ON A FUTURE ENERGY HOUSEHOLD *246*
EPIPHANIES *248*

PART IX

ON THE NECESSITY OF ONE FREE WORLD-WIDE WEB *262*
INTERNET ABC? *267*
WHEN GROWTH IS 'FALSE COMPARE' *268*
OUT OF CONTROL—*the runaway economies of systemic imbalance* *272*
FASTING AS PRINCIPLE *276*

THE SYNERGY OF THREE *152*
EUROPEAN CULTURAL BIAS & THE RULE OF REASON *156*
NAMES AS THE FIRST POETRY OF PLACE *158*
THE PRESENCE OF THE PAST . . . *162*
THE EXPANDING CIRCLE OF ETHICAL AWARENESS *166*
WAY OF COLLAPSE *168*
DICTIONARY *170*
ON THE DIFFERENCE BETWEEN INFORMATION & MEANING *170*
DIABOLUS IN MUSICA? *171*

PART VI

CATHEDRAL ROCKS *180*
A NEW WORD FOR SOUND *181*
NO GLACIERS IN GLACIER NATIONAL PARK BY 2020? *182*
CLIMATE CHAOS *183*
THE SQUARE OF FALSE RATIONALITY *186*
CONSERVATION *187*
CULTURE OF CHAIRS? *187*
MUSIC? *187*
THE ENERGY OF CORRUPTION *188*
SOLITARY STARS *189*
MIND / BODY SPLIT *189*
COFFEE—*the Good from the Bad* *190*
MORAL COMPASS? *191*
GRACE *191*
ON THE NECESSITY OF CULTURE NESTED WITHIN WILD NATURE *192*
ON CARS & CAR CULTURE *194*
NOISE & THE MIND *196*
OLD & NEW ECONOMIES *197*
PROOF WITHOUT WORDS *197*
IN A WORLD OVER-POPULATED WITH PETROCHEMICAL ARTIFACTS *197*
COLOR IN WINTER *198*

PART VII

from **ON THE WAYSIDE**—*four new poems*
ON THE WAYSIDE *206*

INTERCONNECTIONS . - _ / *104*
ON NECESSITY *104*
ON THE DIFFERENCE BETWEEN LIMIT & CONTROL *105*
PROTECTING THE COMMON GROUND OF LANGUAGE *105*
ON THE TEMPO OF PERCEPTION (I) *106*
A DIFFERENT WAY OF SEEING *107*
WAR GAMES *107*
BALANCE OF PERCEPTION *107*
THE MAN AT THE DOOR *109*
WALKING THE WORLD: *Stonepine Mountain!* *110*
RIGHT MEASURE / RIGHT ACTION *114*
ALPINE SIMPLICITY / COMPLEXITY *115*

PART IV

BARBED-WIRE, WEEDS & OVERGRAZING *124*
GARDEN VARIETY VERSE *126*
LEARNING MAKES THE CIRCLE ROUND *126*
THE FARMER & THE ARTIST *127*
A NECESSARY UNITY *127*
ON COMPLEMENTARITY *127*
BEAUTY AS BALANCE *128*
ABSOLUTE *128*
RESONANCE *129*
THE MASTER & THE APPRENTICE *129*
ON THE NECESSITY OF ROADLESS AREAS (I) *130*
BEAVERS & THE ECOLOGY OF NATIONS *132*
TEMPO OF CHANGE *134*
BEWARE! *135*
WEALTH & POPWER *136*
WEALTH *136*
NOTHING AS RESOURCE . . . *138*

PART V

ON THE DIFFERENCE BETWEEN *THE BRUTISH
 BRAIN & THE COMPASSIONATE MIND* *148*
TERRA MADRE—*THE LIFEBODY OF THE EARTH &*

ROAD OF CHANGE *69*
THE WORLD'S WORST BAD IDEAS *70*
ZERO DOLLAR DAYS *71*
THE ASPEN OF FORGETFULNESS—*a prose poem 72*
AN EXTINCTION OF A DIFFERENT KIND *73*

PART II

FIVE LONG-LINE SONNETS: *78*
THE VAGABOND OF THE GRANDE DIXENCE *79*
FASTNACHT—*The Night of Mountain Carnival 80*
THE LUTE *81*
THE MOONS OF GALILEO *82*
GRAND PARTITA *83*

IN A WORLD AT WAR WITH SILENCE *84*
ON THE LITERAL MAN & THE IMPOSSIBILITY OF METAPHOR *86*
COMPLICATION? *87*
BETWEEN THE WORLDS *87*
CLOACA MAXIMA? *87*
AFTER FALL STORM IN HIGH MOUNTAIN SUMMER *88*

PART III

ON CHANCE *94*
A TOSS OF THE COIN *95*
ON THE LOSS OF RHYTHM *96*
THOUGHT EXPERIMENTS OF THE COMPASSIONATE MIND *97*
FREEDOM & LIMITS *98*
THE WONDER OF WALKING *98*
RETRONYMS? *99*
NOTATION & THE KNOWN *99*
PATH OF VIOLENCE / PATH OF PEACE *100*
ART OF ARTS *101*
ART & NATURE *101*
MISCONCEPTIONS & CORRUPTION *102*
BEYOND ALL COMPARE *102*
WOODEN FLUTES, AND THE DIFFERENCE
BETWEEN *THEORIES IN NATURE* & *THEORIES IN CULTURE 103*

CONTENTS

PART I

WATERCOURSE WAY—a prologue *42*
NIGHT ODE *44*
CHILL MOUNTAINS OF THE HEART *45*
EPITHETS OF A SPECIES *46*
THE BEAUTY OF THE SUNFLOWER WAY *47*
ON THE NECESSITY OF POETRY *48*
BOOTMAKER *50*
CASSANDRA FALLS—*a children's poem 51*
LET'S GO CAMPING! *52*
LICHENS AS SILENT WITNESSES OF TIMES GONE BY . . . *54*
THE WAY OF NON-VIOLENCE *54*
WEATHER IN THE WEST *55*
ALPINE GEOMETRY *55*
IMAGES ARE CHEAP *56*
THE COWBOY GOES TO CHURCH *56*
NO SUGAR ADDED *58*
THE HOUSE OF CULTURE *59*
DRAWING CIRCLES . . . *60*
DIVERSITY? *61*
PLACE FIRST! *61*
FOR A FRIEND & A CROW *61*
LOVE & WATER *62*
LOVE RESONANCE *62*
LOVE IS ROUND *63*
HABIT OF PHOTOGRAPHY *63*
SIGNS OF EMPIRE *64*
INVERSIONS OF MEANING *64*
LANGUAGE OF WAR *64*
SIMPLE DESIRES *65*
GO BIKES! *66*
IN PRAISE OF NATURAL COMPLEXITY *67*
FEAR AT NIGHT *67*
ROUGH ROAD AHEAD? *68*
A NEW TENEBRISM *68*
THE FLAT-TIRE MODEL OF REALITY *69*
HABIT & TRUTH *69*

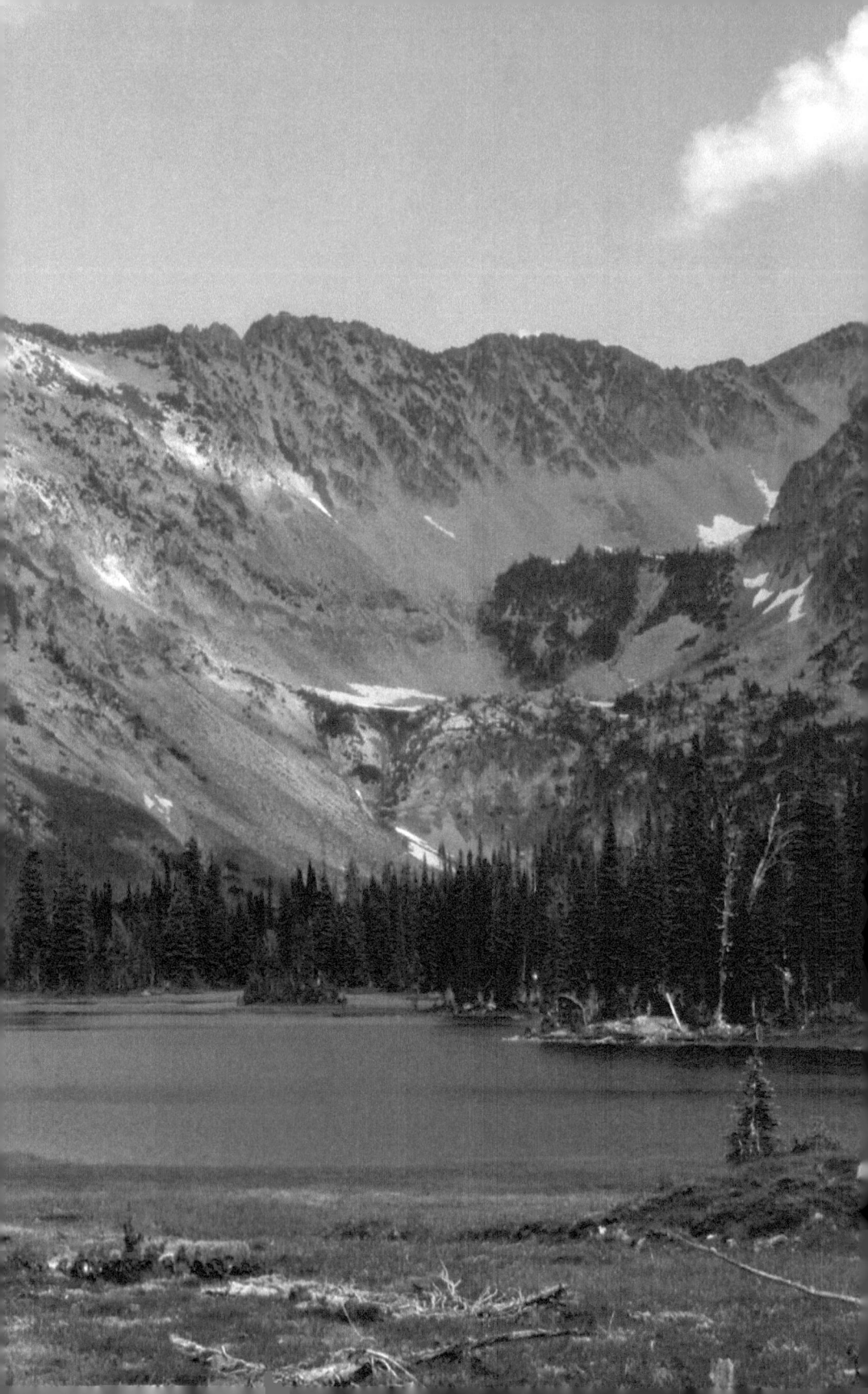

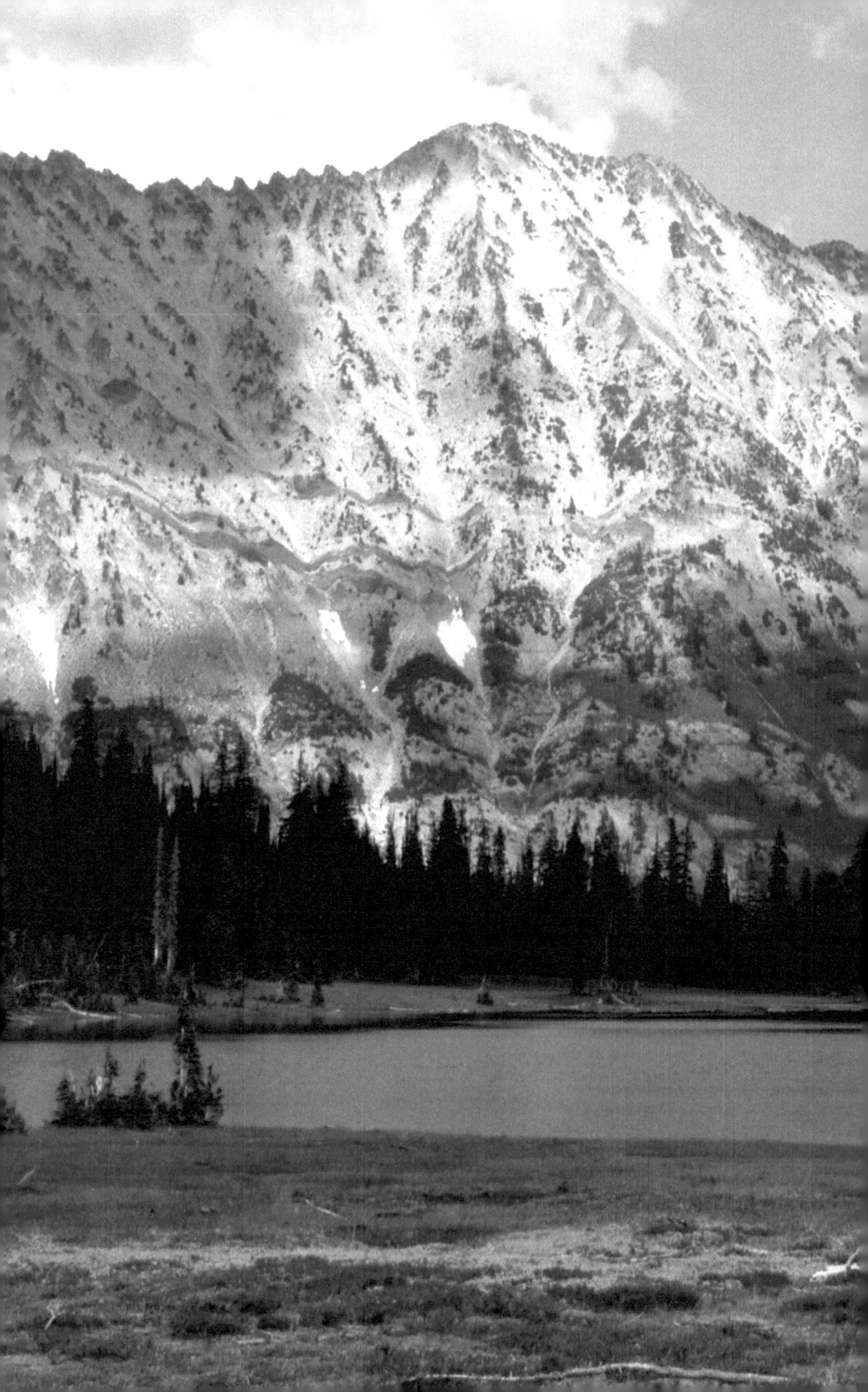

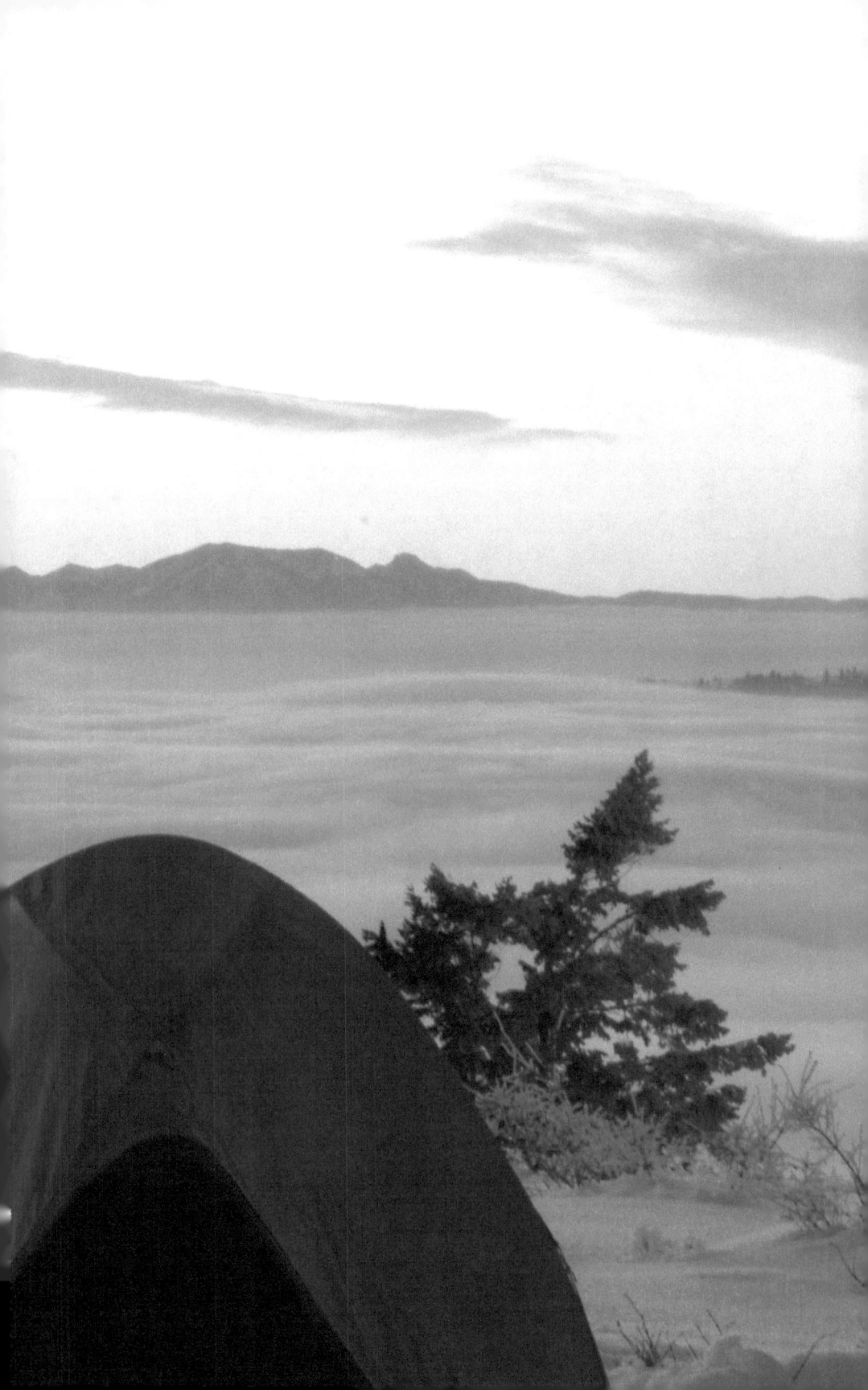

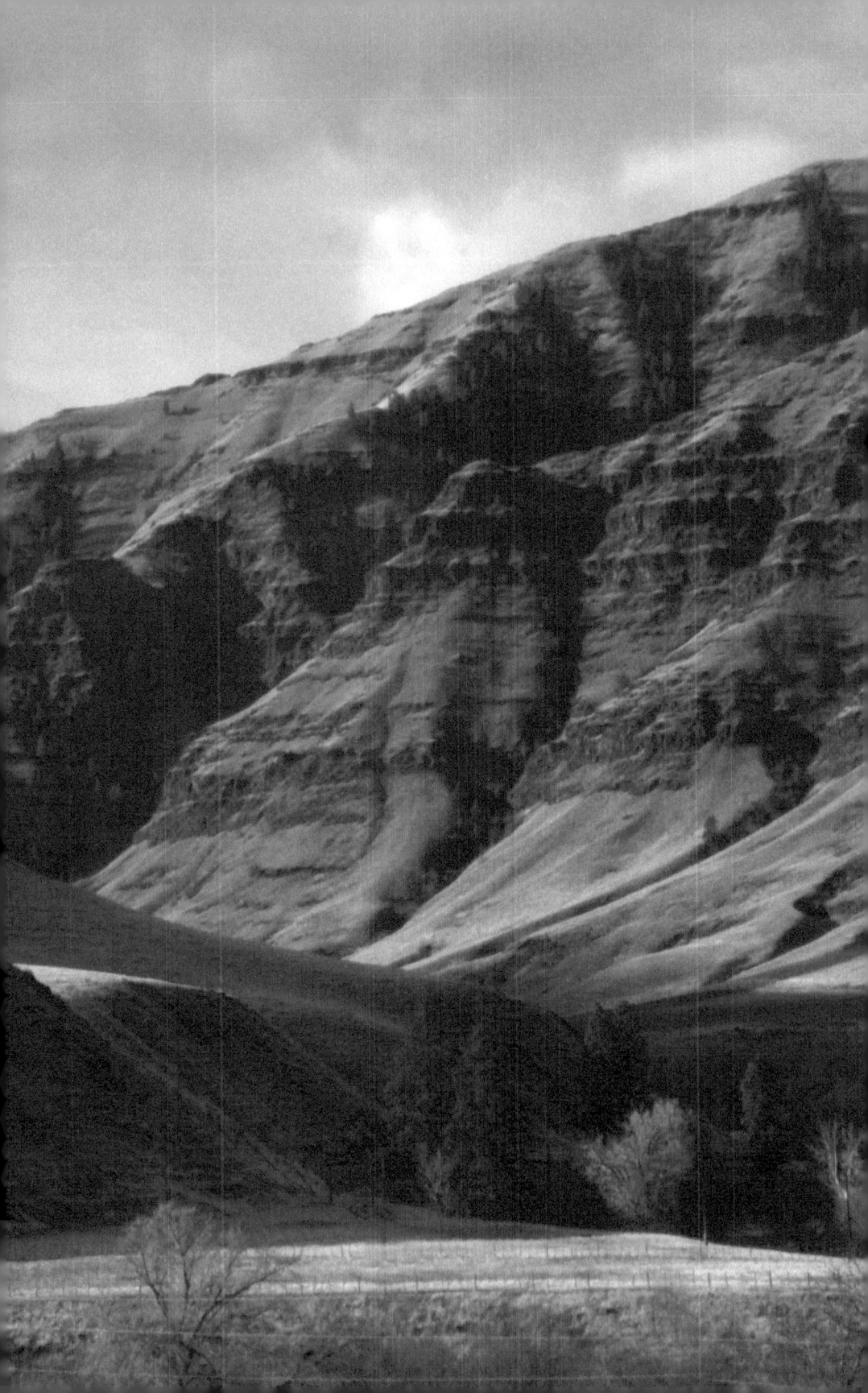

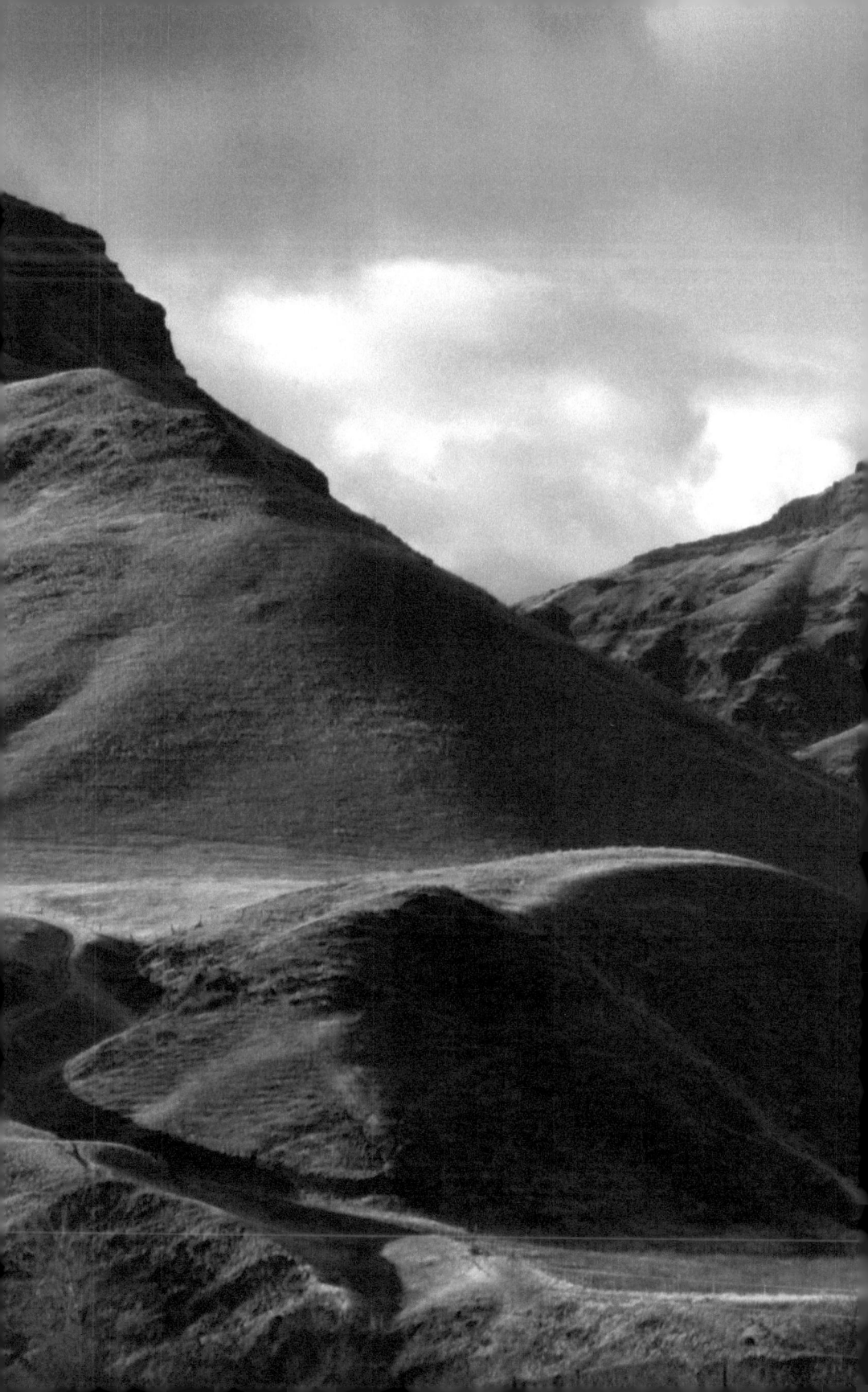

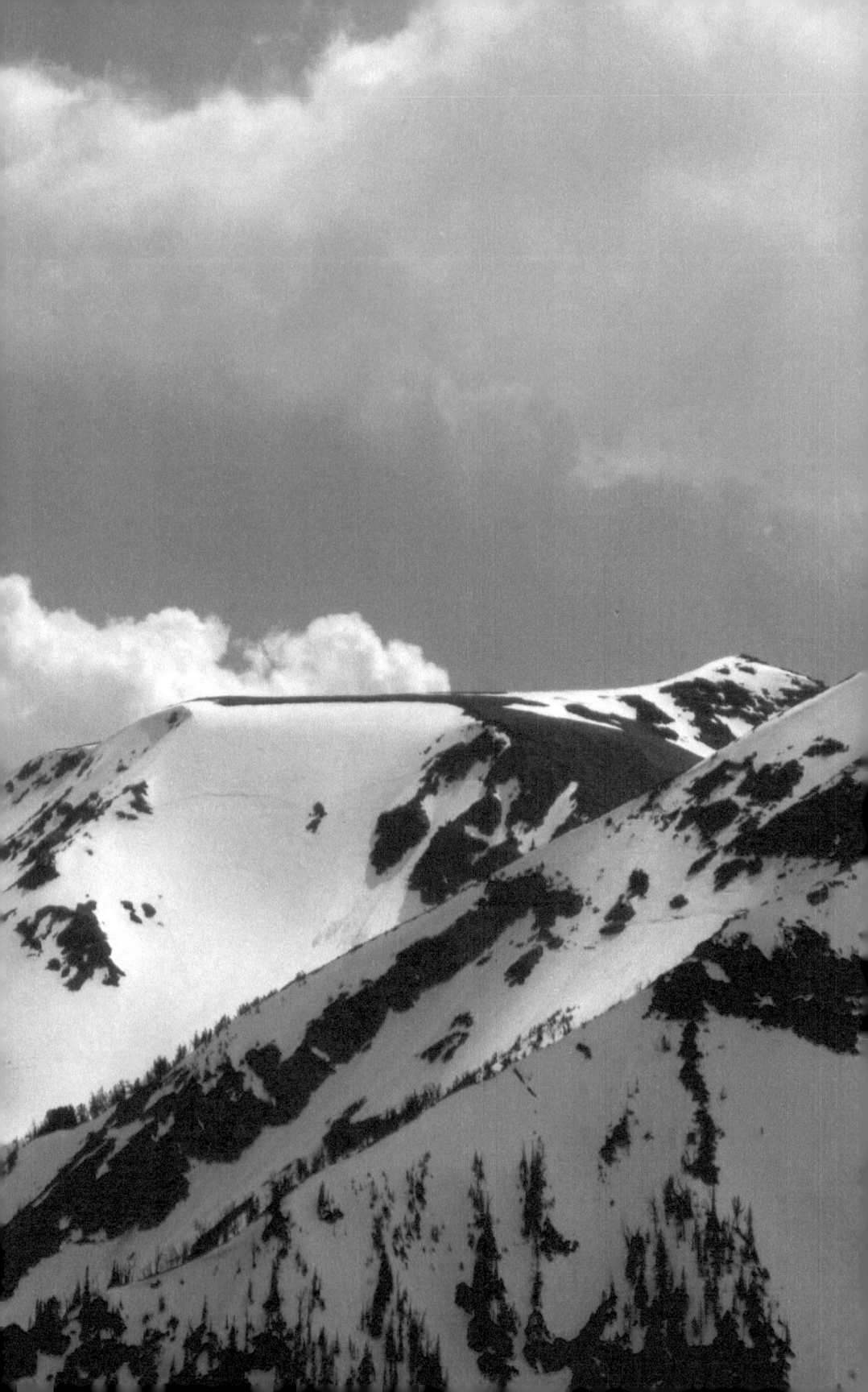

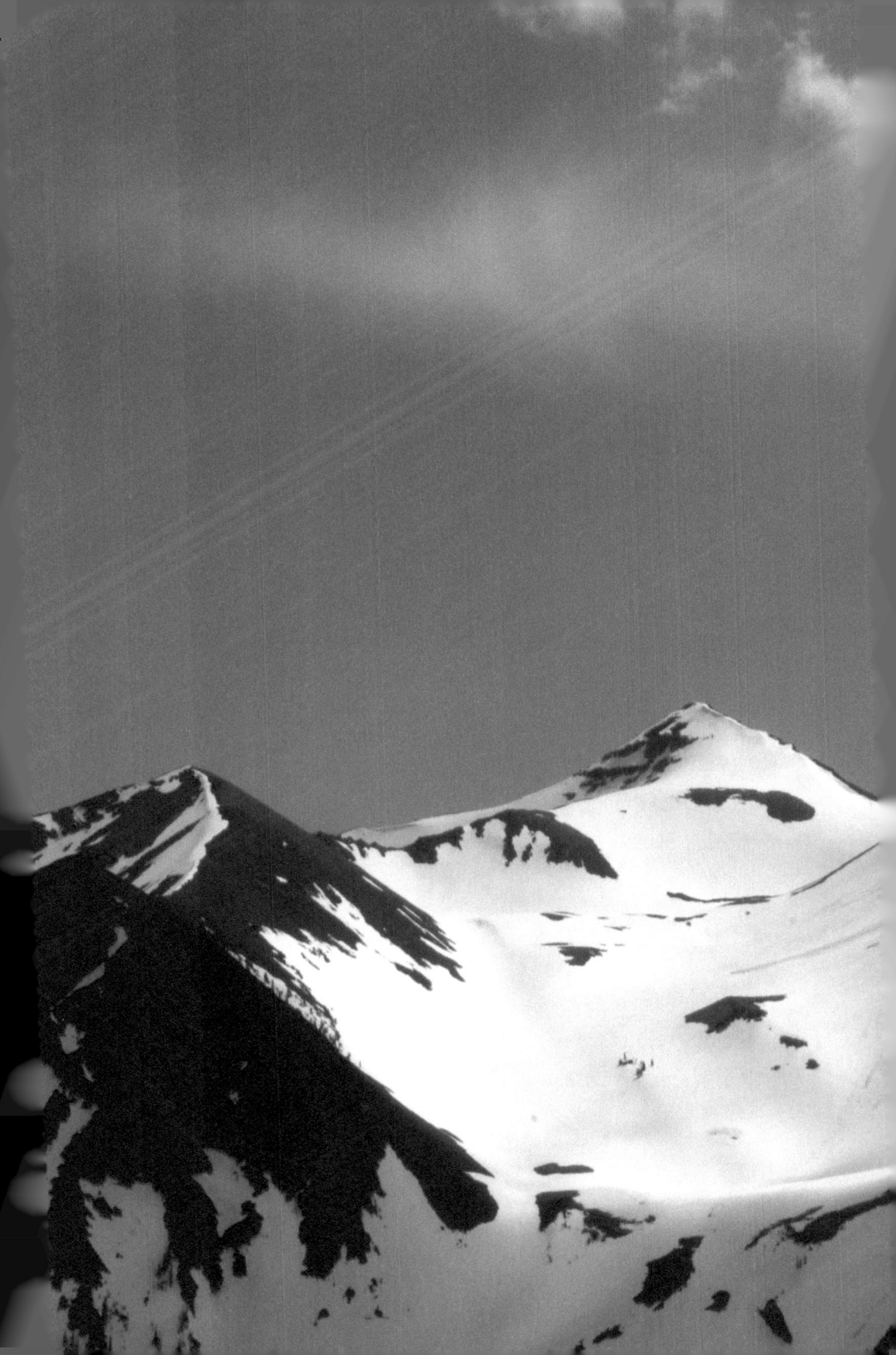

THE LITTLE CLAVIER

Each text, each poem,
is a miniature makeshift piano;
they're all tuned slightly differently,
a bit beat up, perhaps,
with a few misplaced or broken strings,
but it's the best we've got.

We do not play,
but simply
push the pedals down,

sitting quietly,
listening to the strings
resonate or sing,
giving back

 voices

hidden within
the marvelous sea of chaos
that surrounds us.

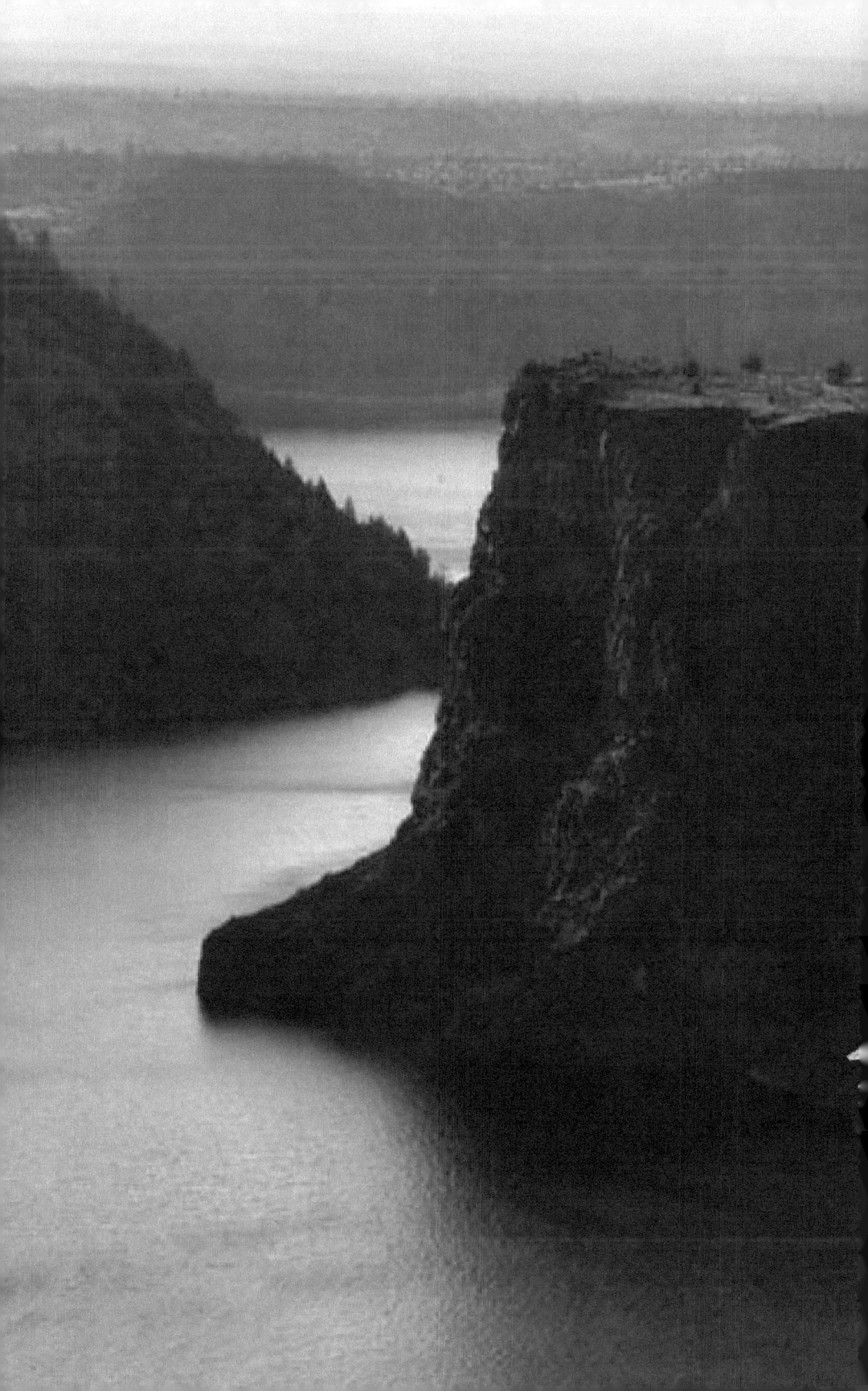

For my Mother & Father, for all their years of patient, steadfast support and encouragement;

For my Father, who has never lost hope that I will someday learn the ways of Money & the Market, regardless of how miserably I fail;

And for my Mother, who has always done her best to teach me the ways of Love & Dance, even before I was born, only to see me wander off as a monk in the mountains, lost to all of Time & the World.

"Total negation is the essence of the positive. When there is negation of all those things that thought has brought about psychologically, only then is there love, which is compassion and intelligence."

<div align="right">Jiddu Krishnamurti</div>

Other picture-poems.com *Rucksack Books*
by Cliff Crego . . .

(1) **100 MINIATURES**

(2) **ON PATHS**

(3) **FIREWEED POEMS**

Available at Amazon.con.
or as download from picture-poems.com

Other picture-poems.com *Photobooks*

(1) **THE WALLOWAS ON HORSEBACK**

(2) **(LOST) GLACIER PEAK**

(3) **RILKE IN THE WALLOWAS**—*new*
English translations & photographs

The e-book reader version in PDF format
of **THE LITTLE CLAVIER**
can be downloaded at:
http://picture-poems.com/tlc/the-little-clavier.pdf

All photographs and images by Cliff Crego;
Fractal images were generated with ***XaoS,*** version 3.4, by Thomas Marsh
and Jan Hubicka, and then transformed in Photoshop
Copyright © 2010 **picture-poems.com** All Rights Reserved

THE LITTLE CLAVIER

new poems and texts from
Camp Lost & Found

CLIFF CREGO

a picture-poems.com rucksack book

(v)

The barn cat has
the best of both worlds:—
free mice, free milk
set out, each day.

(vi)

Eagles return to the same
twig nest each year. Why
change what is
perfect?

(vii)

It remains a deep
mystery where the ravens
find cover
at night.

(viii)

The limits of natural
refuge
are bounded
by clear necessity.

(ix)

Hording space,
building fences,
making money,
the land I rent to you.

(x)

The best refuge of all
is intelligence,
the worst,
is fear.

(xi)

Beautiful!
the light of welcome
seen through the snow
of a winter storm.

(xii)

Safe. Warm. Dry. Out of
wind. Close to fire.
The snow above
never lets go.

(xiii)

The sign read: *"Foreclosed.
Evicted. For sale."*
There was not a
soul in sight.

(xiv)

The guestbook read: *"I
was lost. Found all
I needed here.
Door was open."*

(xv)

As she left, she
built a tepee fire,
and left a matchbook
with a note.

(xvi)

*"Strike this match
to light friendship's path.
May it stay lit
all along your way."*

(xvii)

An overturned boulder
as big as a house:—
it all began:—
right there.

MIRROR OF RELATIONSHIP

Every pattern is like a story.
Every story, is like a path.
And every path is like a stream,
not of water, but of relationship.

As one moves through the land,
each step reveals something new
about ourselves, about the land,
and about the much larger spirit
which envelopes both.

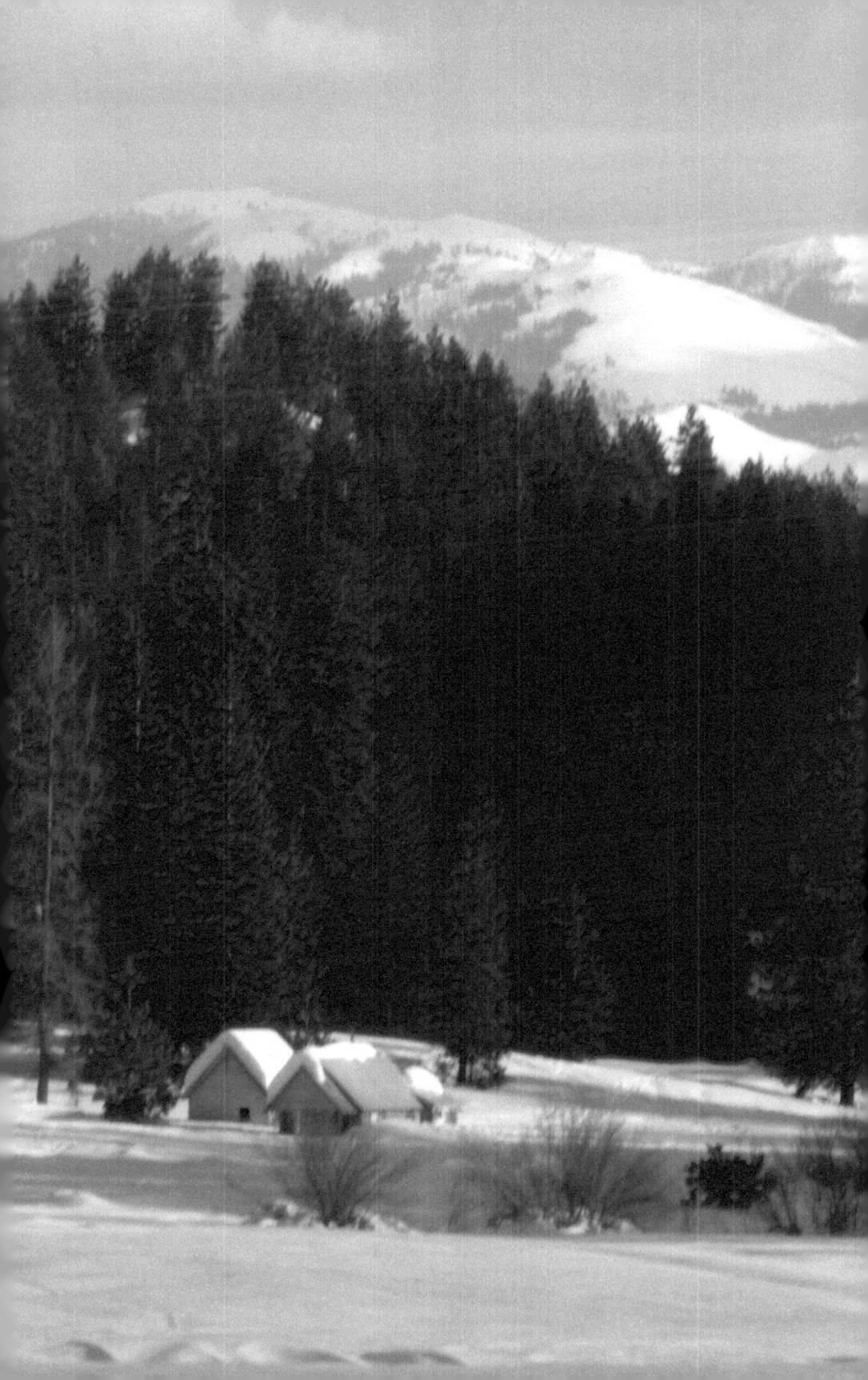

The Little Clavier: *Coda*

More Than Three

—for Carlo

My three loves—

*Music, Poetry,
Philosophy—*

lie nested together, side by side,
like the three nuts in the chestnut's
prickly husk.

Together as one they are more than three.

Better, not to give this one a name.

THE LITTLE CLAVIER—*Coda*

This collection brings together two years of writing, most of which first appeared as part of weekly editions of *Photoweek Northwest* and my website, *picture-poems.com*.

During this period I've been on the road throughout large parts of the Pacific Northwest. By bike, on skis and snowshoes, and on foot. Most of the pieces presented here have been composed out-of-doors. I like to think that this has influenced my writing and thinking more than a little, and certainly accounts to a certain extent for my passion for brevity. I can remember that when I heard a year or two ago the great South American writer, Eduardo Galeano, on *Democracy Now!* speak of his "fight against an inflation of words," I instantly wanted to enlist in the struggle.

So we have here many miniatures and different species of poetry, as well as a number of essays, none of which are longer than a few pages. Most of them begin with a single idea. I do my best to center these in some kind of single image, or little story, or as the Greeks would say, *logos,* or argument. It depends on the piece. This means that there is, according to your point of view, either a hopeless, bewildering chaos, or a rich diversity of styles, forms, and qualities of voice. My hope is that the reader will begin to see pattern in the recurrent way a certain manner of speaking, or unfolding the inner voices hidden in images, keeps coming round in tightly interwoven cycles.

In addition to these new photos and texts, I've also included a few older images and pieces for which I've never quite found a proper home. Most of these were composed in the Alps, and, of course, reflect this in both form and content. These include the cycles *The Farming Life,* and *Ridge Crossing,* as well as the poem, *The Man at the Door.* All of this, I hope, is in keeping with the collection's subtitle, *Camp Lost & Found.* This is both an actual physical location in the Wallowas—one which I keep highly secret—but also refers to a kind of personal reawakening or rediscovering of themes which are both of great importance to me, but because of circumstances, were either misplaced, or ignored, or all but nearly entirely forgotten.

Just as the arts of similarity and comparison by means of explicit analogy and implicit metaphor in no way live for me in separate rhetorical spaces, so I also tend not to artifically divide highly intellectual themes from those with more feeling, and even humor. At the same time, I realize that some readers will be more attracted to certain themes, and less so to others. So the many different texts, to use the more generic term here, can be enjoyed in the manner of one's choice, from beginning to end, or simply randomly on a, as I like to say, butterfly whim.

I sincerely hope that your journey, whichever way it leads, may be a rewarding one.

<div style="text-align: right;">
Cliff Crego

Eagle Valley,

The South Wallowas,

II.17.2010
</div>

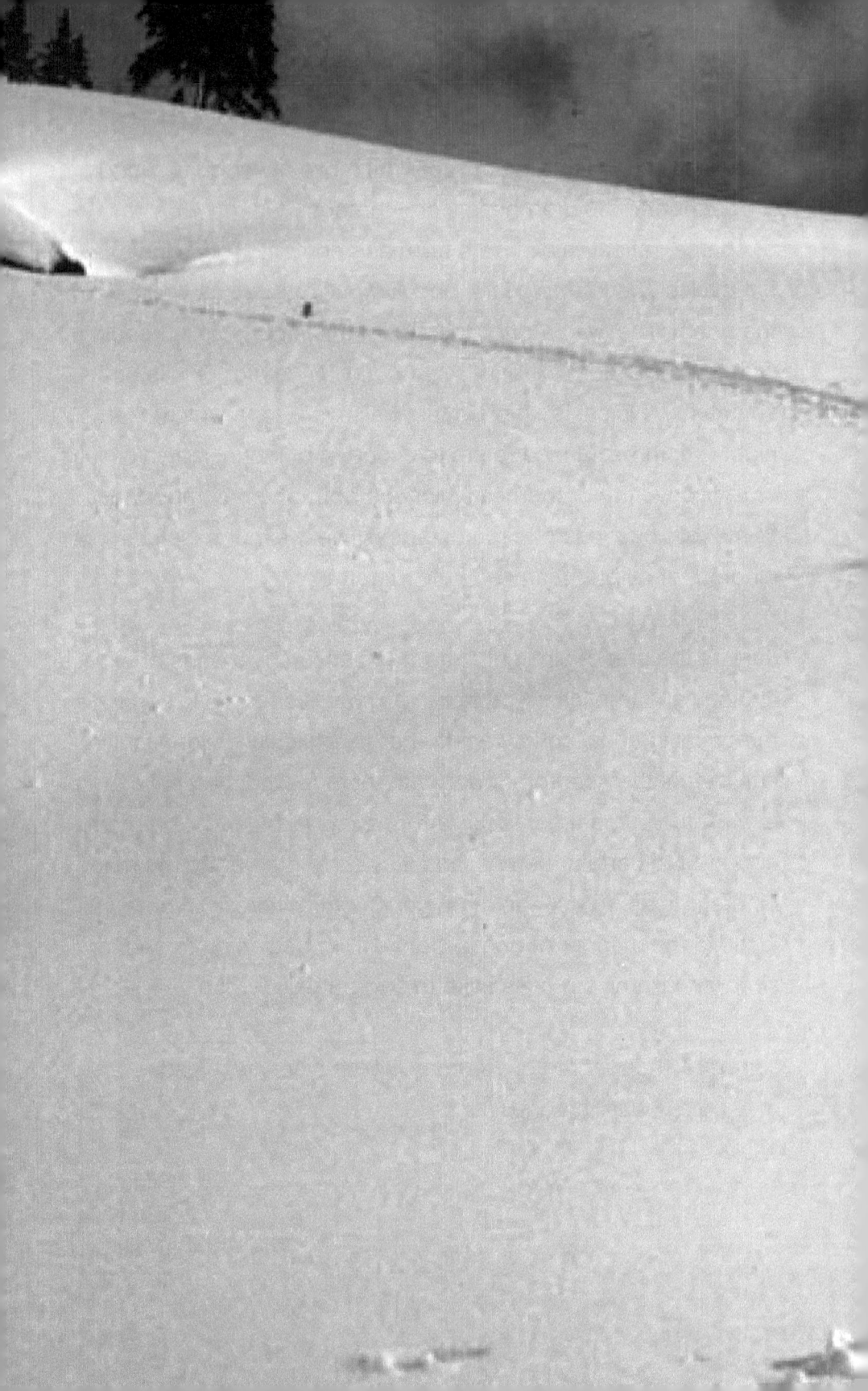

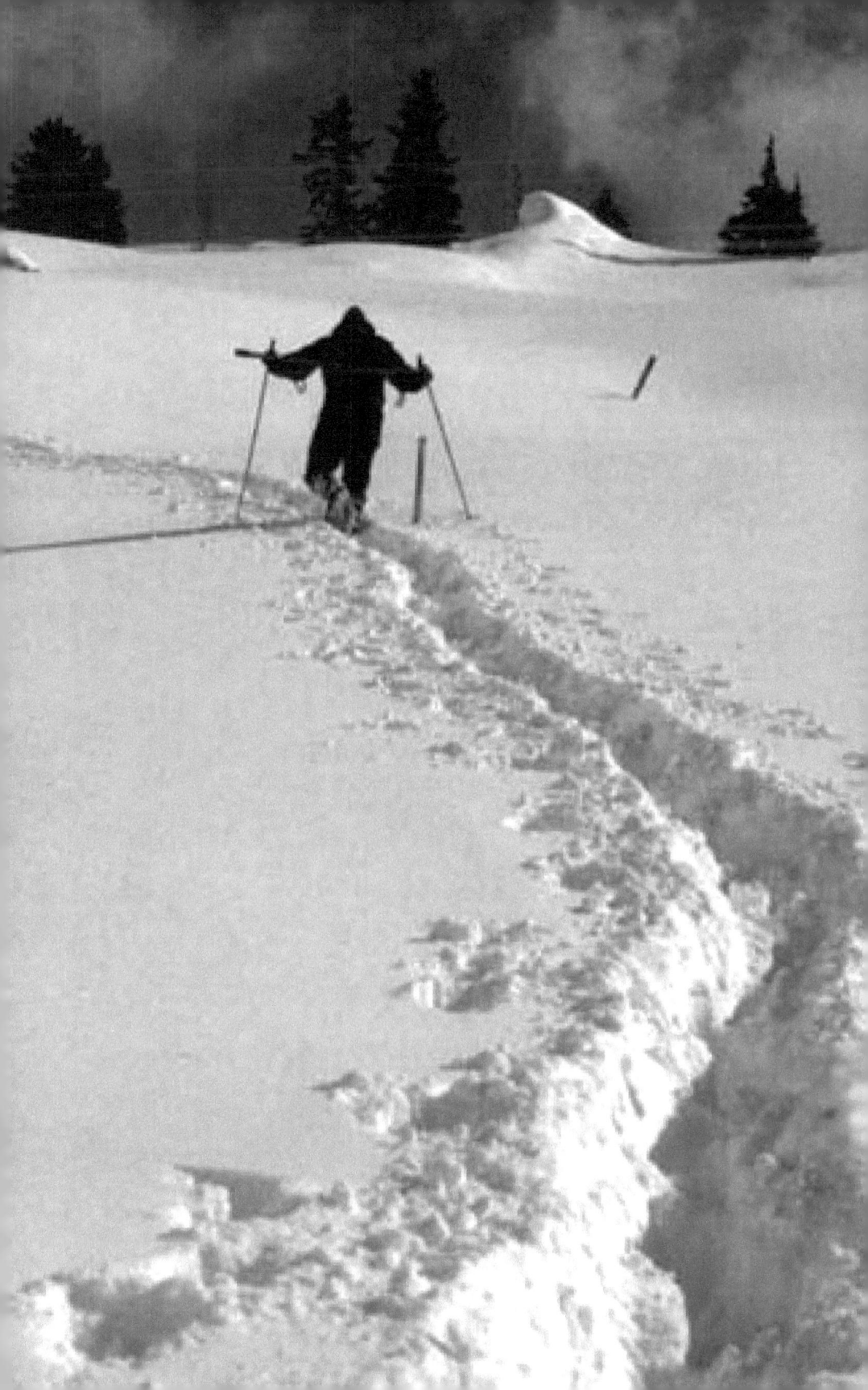

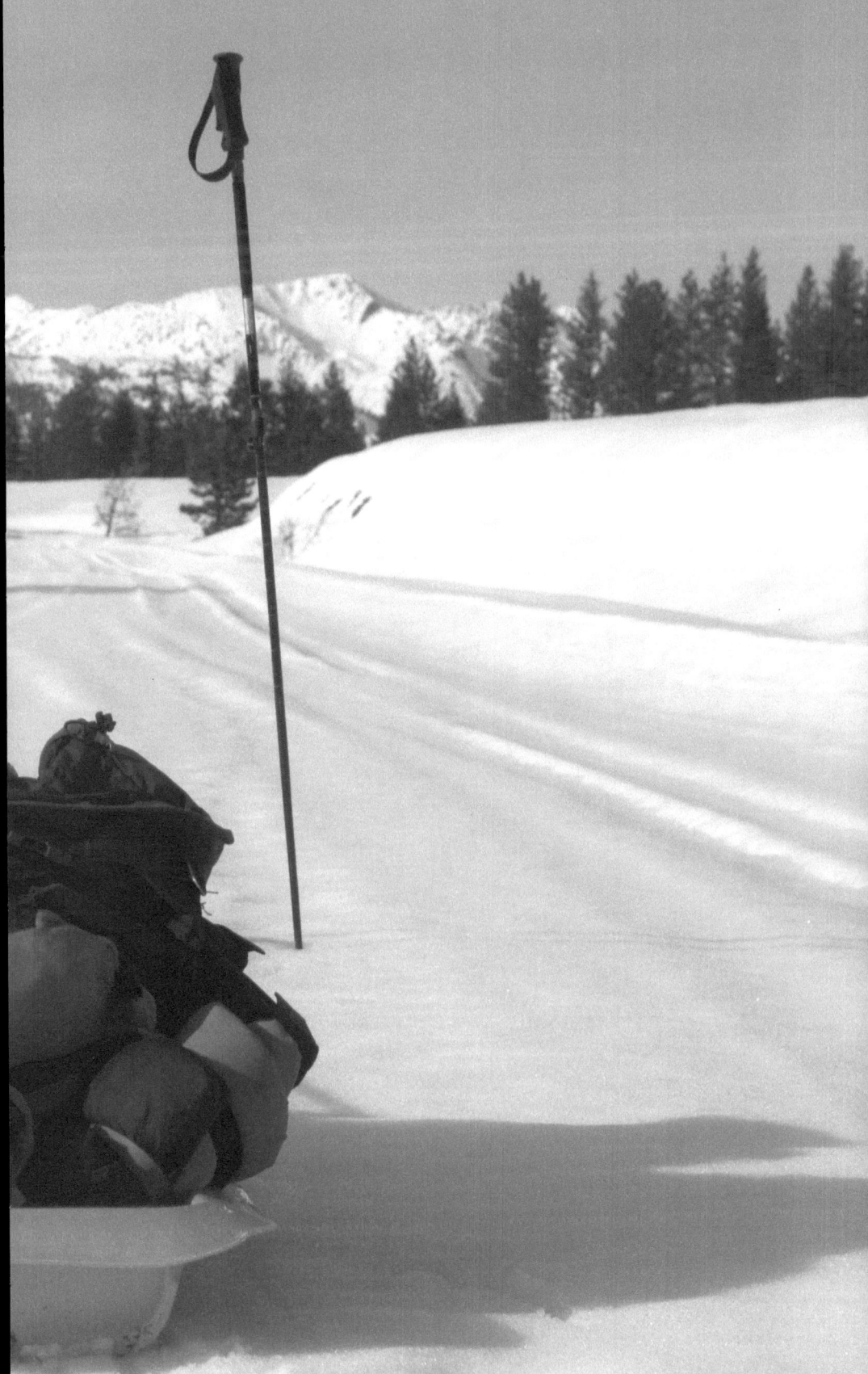

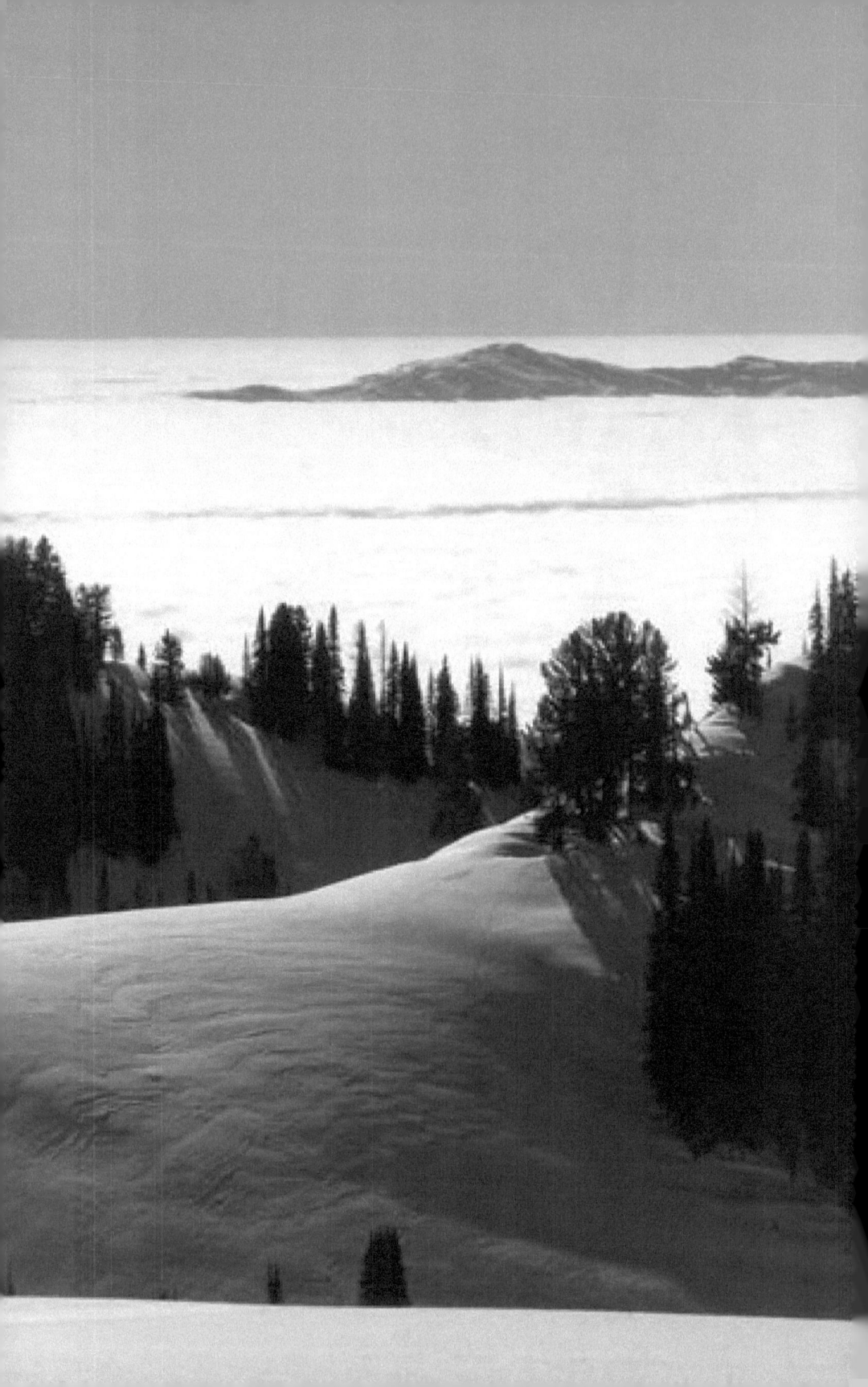

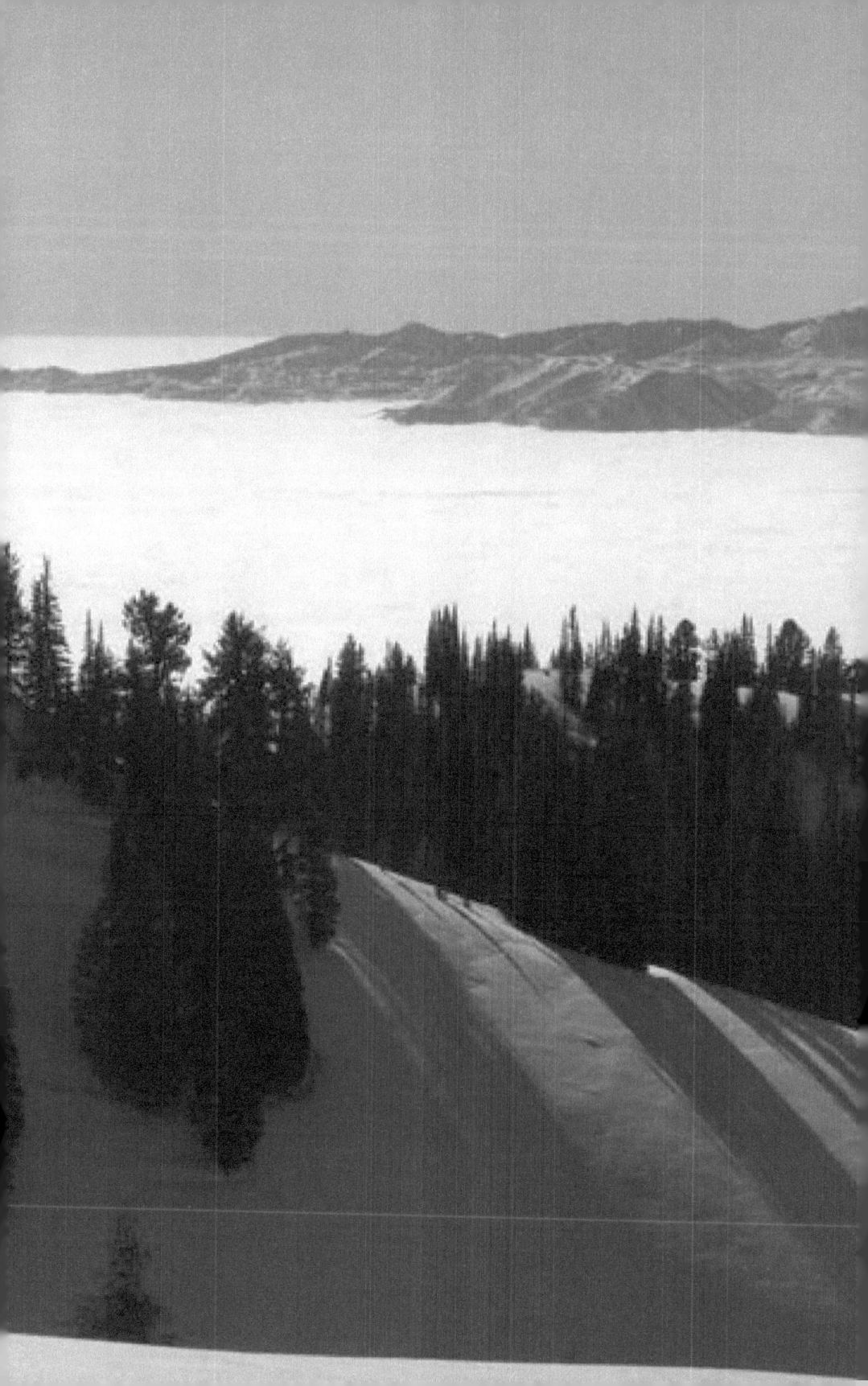

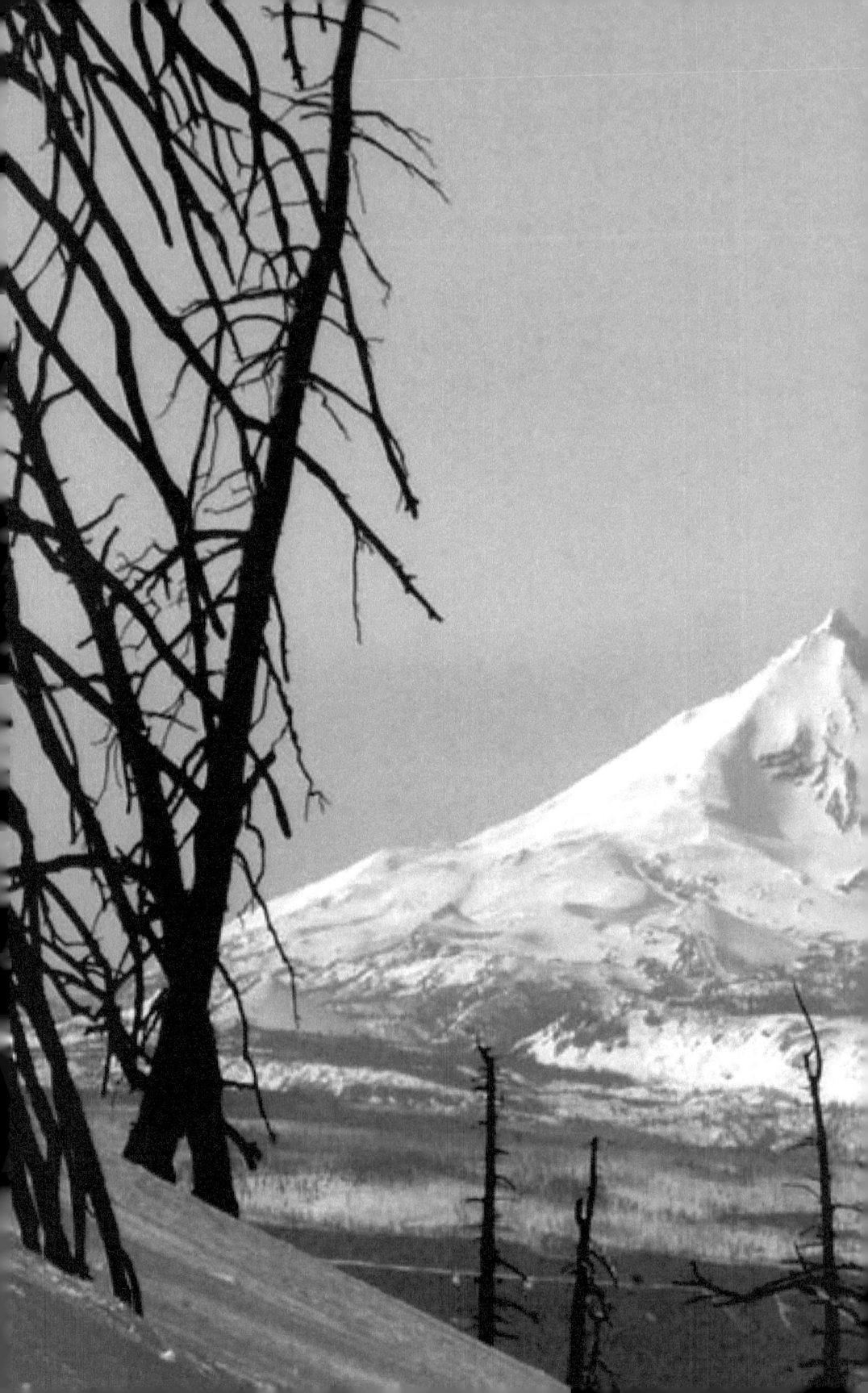

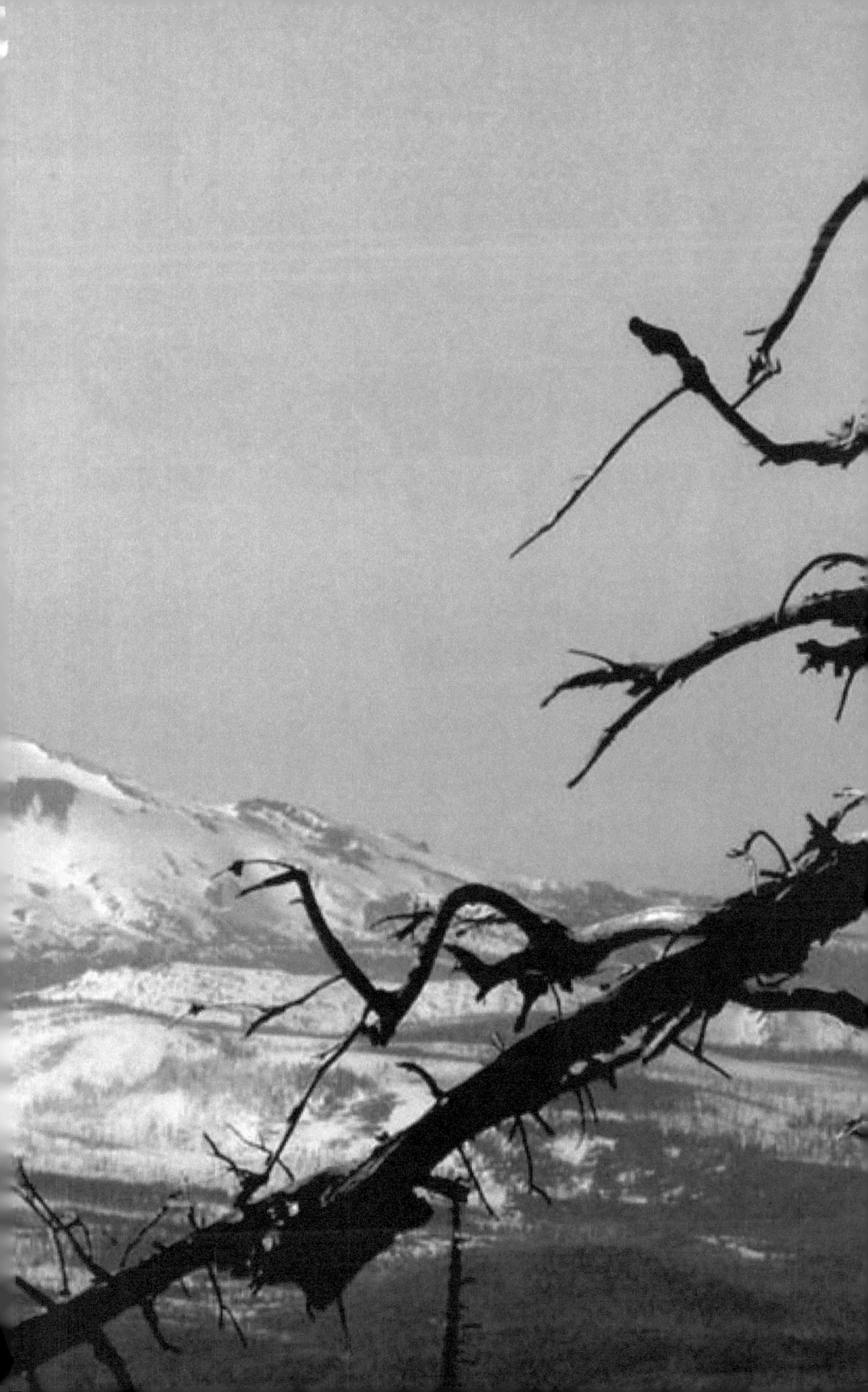

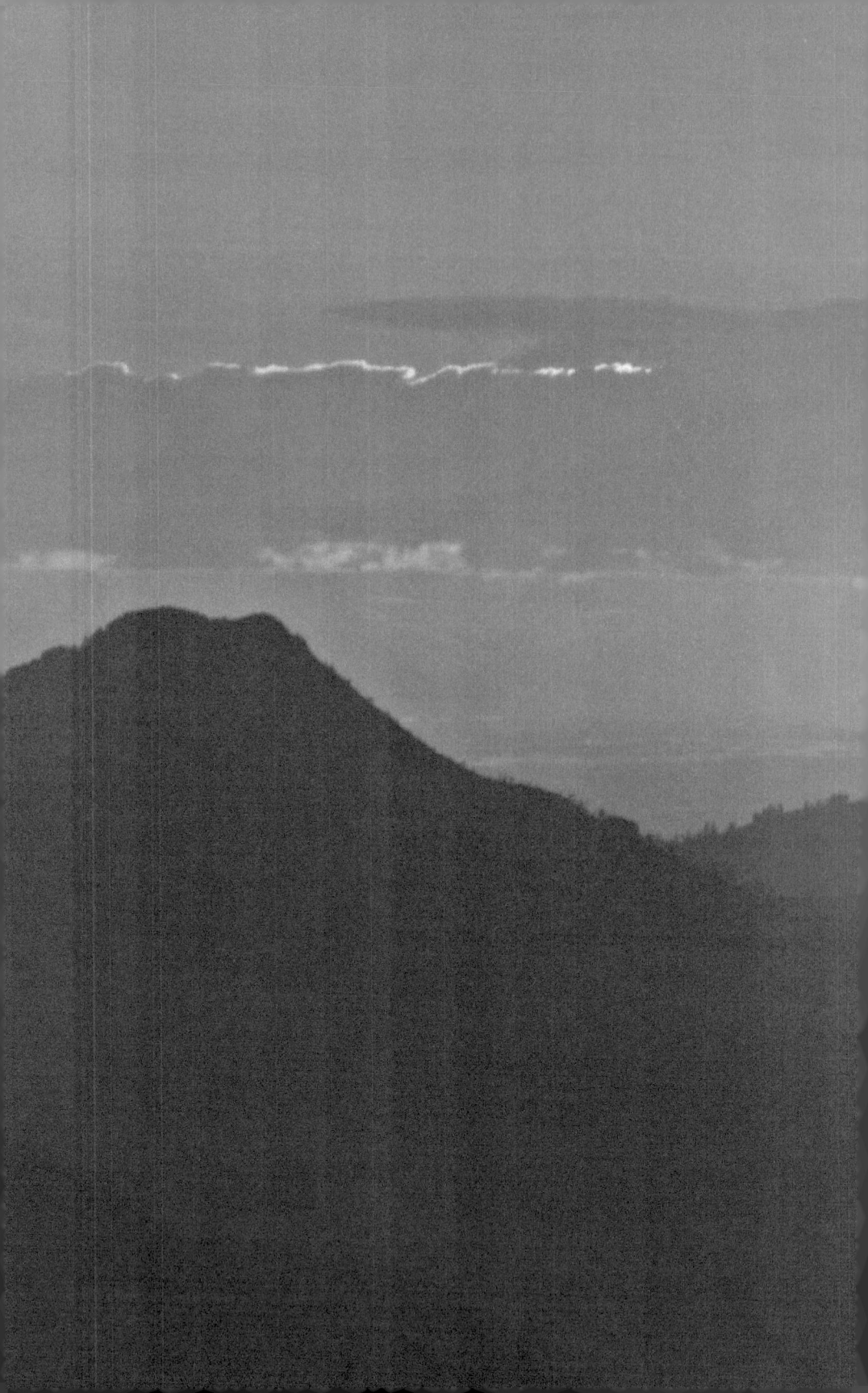

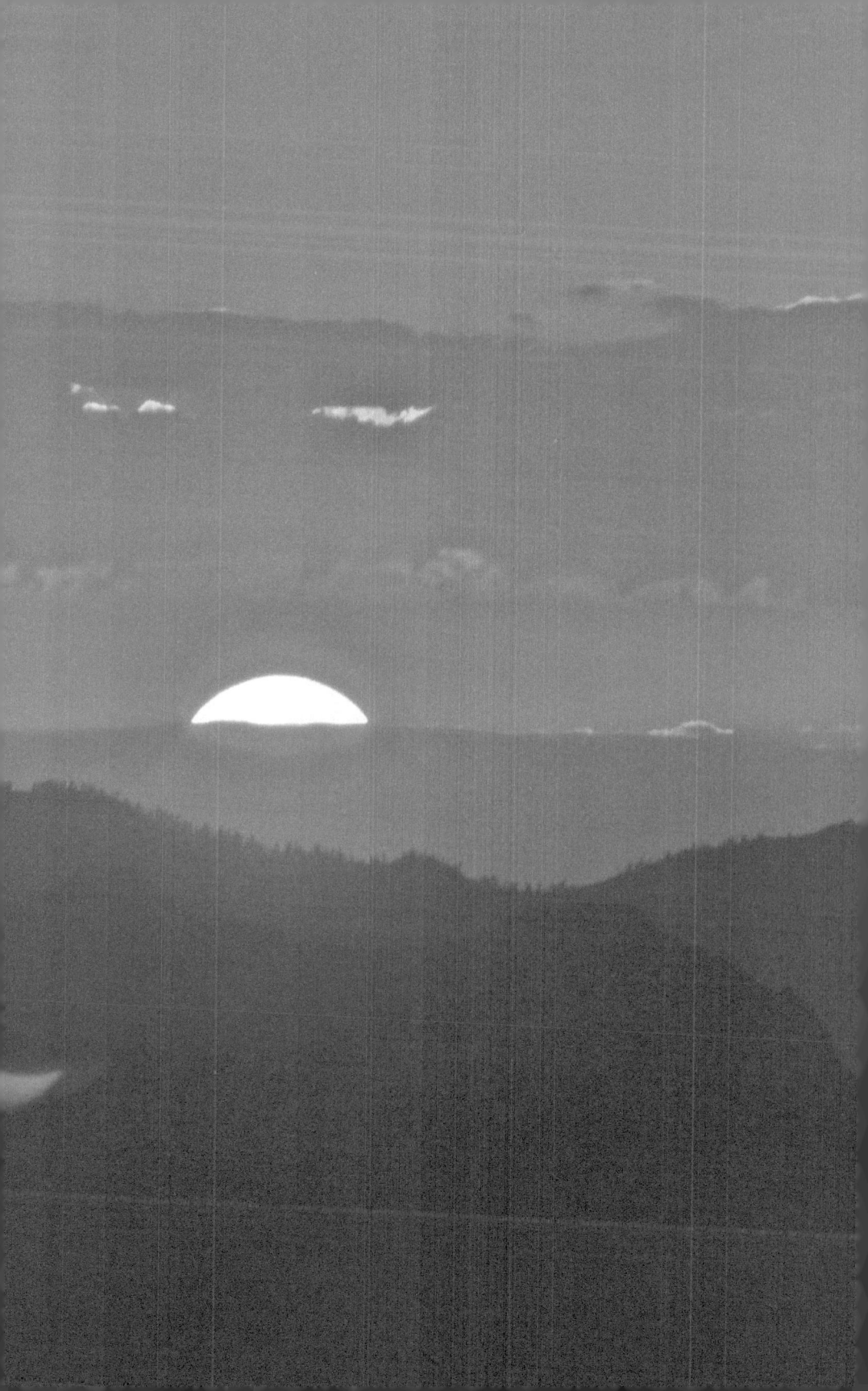

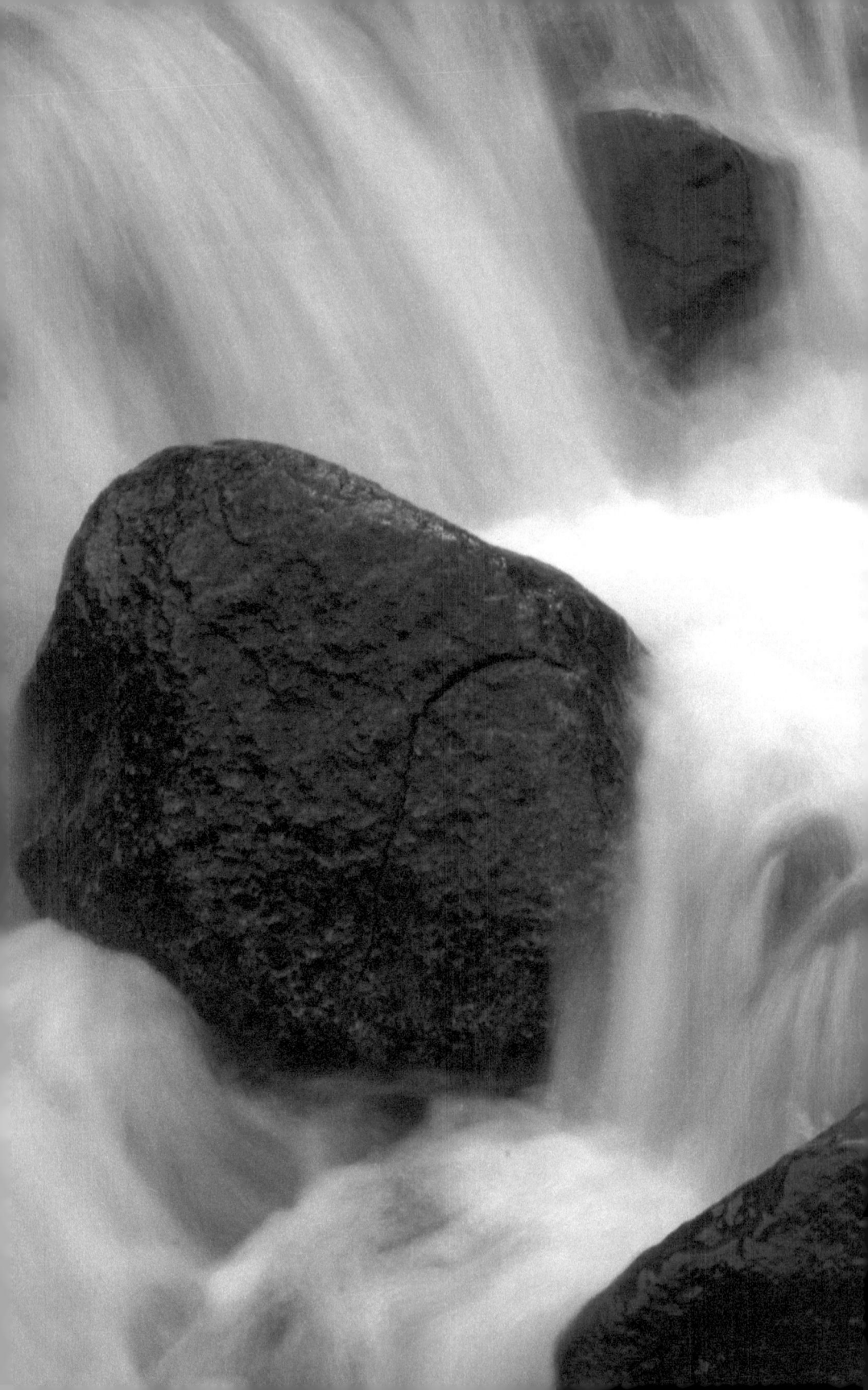

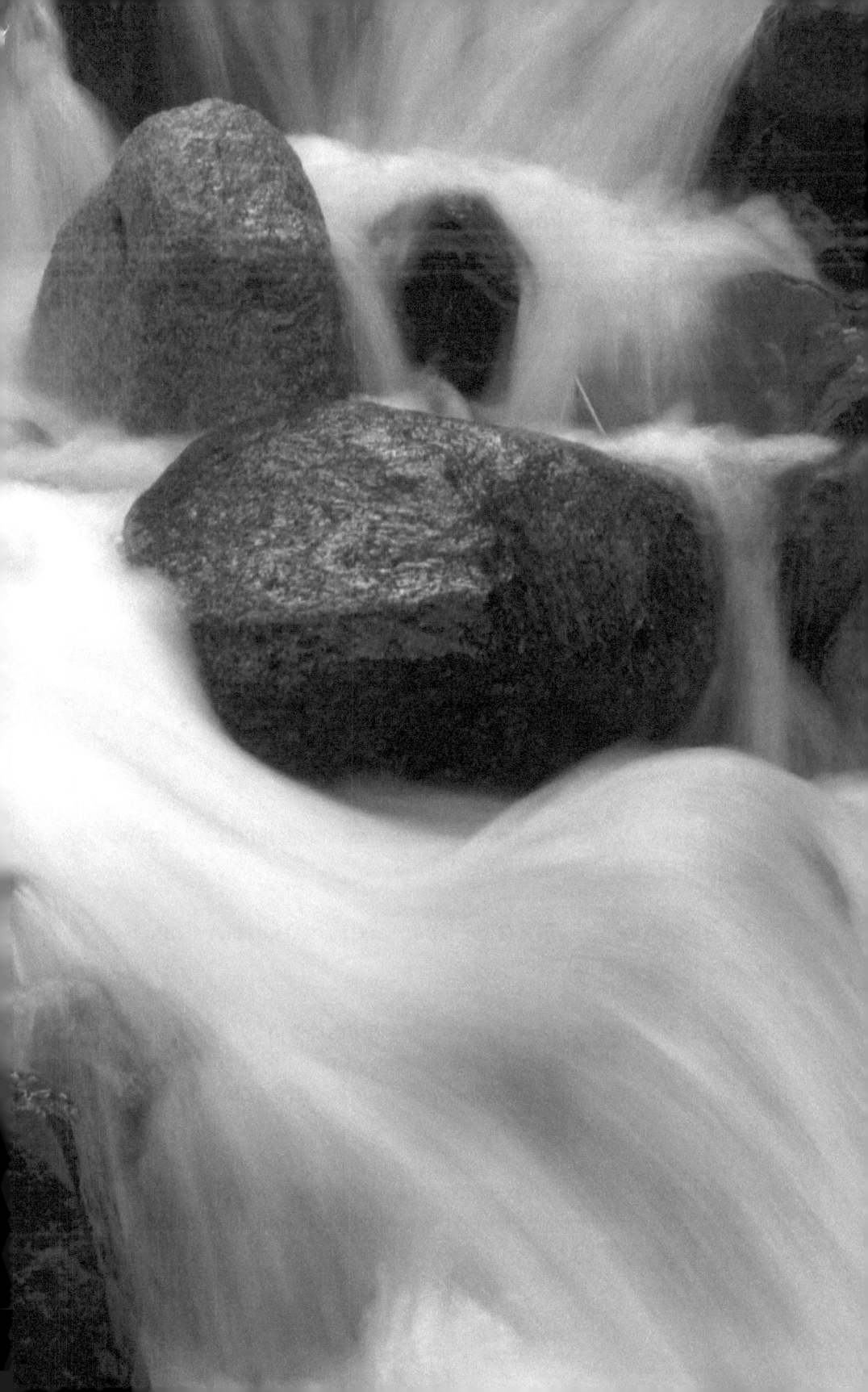

INDEX OF PHOTOGRAPHS

0 Cover photograph: ***Snake River Country, winter window*** I.18.2009 (Northeast Oregon, North America)

7 ***Muted Deschutes River*** (Billy Chinook Reservoir), above Round Butte Dam, east of Oregon Cascades

8 ***Beautiful Spring Snow***, above Hurricane Valley and Falls Creek, just southeast of Twin Peaks V.2009

10 ***Imnaha Canyon Country***, view west, not far from the famous Imnaha Store and Post Office, clearing after two days of strong chinook winds XI.13.2007

12 ***Above Eagle Valley High***, view west towards Baker City and the Blue Mountains, XII.26.2009

14 ***Hidden Lake***, view east, Eagle Cap Wilderness VIII.1.2008

16 ***Twin Peaks***, Hurricane Divide, the Wallowas, V.28.2009

18 ***Pine Bark Beetle Traceries or Galleries***, on standing Stonepine snag, Little Eagle Meadows II.12.2008

32 ***Center of the Summer High Wallowas***, (Lost) Glacier Peak, looking Southeast VIII.20.2009

34 ***"Thunder Rolling Down from Mountain,"*** or *Rolling Thunder Falls,* a place in the Eagle Cap Wilderness I pass frequently, that I like to call by this name for *Hinmaton-Yalaktit* (the young Chief Joseph). July snowmelt run-off.

36 ***Amusement Joy,*** a roller-coaster ride I passed biking down Idaho's notorious two-lane pipeline from North to South. South of

Bonners Ferry, Idaho IX.2007

38 ***Wheels!*** a mint-condition bike I picked up for friends in Eagle Valley at a garage sale. You could ride this machine cross-country, and that for $25!

74 ***Flatland!*** Highway 20, biking from Bend to Burns, West to East, with the wind at my back. Only someone on foot, or biking, or on horseback, would notice the barbed-wire running to near infinity on either side of the narrow road. These means you can't get off, so as night descends you naturally begin to wonder where you might camp. From here, I had to bike another 10 k to find a side-road and pitch my tent. It was already dark, windy and freezing cold. When I awoke just before first light, I found myself surrounded by a beautiful species of White Desert Lilies that I had never seen before.

90 ***Center of the Wallowas***, ridgeline cirque from *Glacier Peak* to *Eagle Cap.* From Glacier Lake VIII.2009. This is one of the primary areas where I do fieldwork. Glacier Peak's northeast side was the former home of the Benson Glacier, which lost as it retreated its status as an active glacier with crevasses in 1937. Ice fields are rapidly disappearing in the Wallowas with climate change. Hot summers and dry winters, a 50% decline in snowpack generally in the Northwest since 1950, and an increase of average temperature of 1.c do not bode well for the long-term health of the watershed. One should always realize that the effects of climate change are *amplified by a factor of two* or even three with both higher latitude and altitude. A dominant factor here is reflectivity, or snow albedo: how much incoming solar radiation is reflected back out to space. White new snow reflects 60% or more of this energy. In contrast, bare soil, which is much darker, absorbs about 80%.

108 ***Three Step***s, northwest corner of W. Central Avenue and Talmadge Road, on the border between present Sylvania and Toledo Ohio, close to where I rode my bike and grew up as a kid, and close to the location of my only Toledo joke: The Devil said to God, *"Well, now that Heaven*

is finished, where on Earth are we going to put Hell?" And God said, "What do you mean! We already have Monroe Street!" A good site for anyone interested to study closely just about everything that's wrong with urban design in North America, and that increasingly the rest of the world imitates so slavishly.

116 **Hyper-protection!** Scotch Thistle flower head, fall aspect *(Onopordum acanthium) Scotch Thistle* is native of the Mediterranean region that has become a weed of the Northwest, even-though it cannot compete with native perennial grasses. After overgrazing and the concomitant colonization by non-native annuals like *Cheatgrass*—a phenomenon I have witnessed mile after mile as far as the eye can see in North Dakota, Montana, Alberta Canada, Idaho and Oregon—a window of opportunity opens for non-native species like Scotch Thistle.

118 **Fuller's Teasel**, close-up, about to flower *(Dipsica fullonum)* Eurasian native, invasive in especially the West of North America. Teasel is an interesting plant in many respects. First, let me say that it is native to the southern part of the Alps, where it has become rare. (I've only seen it in ornamental gardens, where Teasel is planted for its beauty, and have never actually encountered a specimen in the wild.) Its common name refers to an archaic sense of *tease,* that of combing the surface of woolen cloth to raise a nap. In past times when wool was still harvested and processed on the farmstead, dried teasel heads were gathered in the fall evidently for this purpose. Teasel is a low-density weed of rural ditches in Ohio. But I was surprised to see how explosive it can be in the West, forming unnaturally high-density clusters. I noticed these clusters for the first time in Northeast Oregon in riparian areas, especially ones grazed by equally high densities of cattle. At a distance, Teasel looks like a thistle—which are all members of the Aster family—but it isn't. It's a member of its own group, the *Dipsacaceae family.* The v-cup shape of the leaves traps water, which then traps and digests insects.

120 **Composition in Barbed-wire** (Devil's rope), Eagle Valley, North-

east Oregon

137 *January Fieldwork,* new snow above Eagle Valley. I like to set up my camp at unique and special places like this, and then wait for the conditions to be just right.

140 *Muted Snake*, the Snake River under the swollen Brownlee Reservoir, border of present-day Oregon and Idaho.

142 *Three Crows on New Year's Ice*

144 *Cafe Windows*, winter in the rural Northwest

160 *Scarf and Beads, Tiwi-tekis Cemetery*, north shore of Wallowa Lake, with in the background, Signal Peak (Mt. Howard)

165 *Spring Wet Snow / Slab Avalanche*, the Alps

169 *Cornucopia Peak*, above the Pine Valley Inversion I.7.2010

172 *Going up Logan Pass*, Glacier National Park, newly rebuilt "Going to the Sun" road

174 *Cairn / Stoneman*, Rocky Mountains, Glacier National Park

176 *Two Waterfalls*, above Two Medicine Lake, Glacier National Park

184 *Fieldwork on the Benson Icefield* VIII.2009

203 *Snow Flowforms*, after January storm, South Wallowas I.2008

213 *The Columbia River Gorge*, above below The Dalles V.2009

221 *After Fall Storm*, West Fork of Wallowa River XI.22.2007

227 *Spotted Knapweed with Butterfly (Centaurea maculosa),* one of the most notorious weeds anywhere in the world, East Eagle Valley, the Wallowas VII.2009

234 *Weed Sign, Union County*, Northeast Oregon, USA

238 *Stop Weeds!* On the Minam River, as one enters Wallowa county from the west

252 *Drying lengths* of native Blue Elderberry wood *(Sambucus nigra spp. cerulea),* used for different sizes of Native American Flutes. Workshop of my Eagle Valley friend, weed expert, mountain skier (skied across the Wallowas, south to north, seven times!) and flute-maker, Dave Clemens. *Sambuca* species have also been used in the European Alps for flute-making.

253 *Finished Double-flute.* Noticed the miniature sopranino!

254 *New Horseshoe with 8 Nails,* in the hand of master farrier, Tommy McClure—Eagle Valley craftsman, friend and mentor on the trek for my WALLOWAS ON HORSEBACK photobook.

256 *Composition—Timberline Lodge*, Mt. Hood Oregon. Finished in 1937 as a Works Progress Administration (WPA) project, I find the Lodge one of the most beautiful structures anywhere situated in an alpine environment. It is unique, I think, for its combination of subtle geometry and rough-hewn materials. The extraordinary craftsmanship makes it well worth a pilgrimage, especially during the winter months.

258 *Fieldwork at Camp Lost & Found,* the Wallowas VIII.2008

266 *Fire Trajectories* X.25.2007

288 *Wire Snowman*, Eagle Valley I.2008

310 *(Lost) Glacier Peak*, from Eagle Cap, view of upper Benson Ice-

field. VIII.22.2009 This is the north-facing cirque that is the source of the glacier ice that helped carve the magnificent Wallowa Lake 17,000 years ago. Named in 1914 after a mountaineering expedition in the High Wallowas for governor Frank W. Benson, and losing its status as an active glacier—moving ice with crevasses, etc.—in 1937.

337 *Fieldwork,* divide between East Eagle & Main Eagle Valley IX.28.2009

356 *Leaf Venation Pattern*—I'm a student of leaves. I've always felt that the pattern of veins in their leaves makes excellent meditations on structure, or how the parts of a whole work together. Just imagine a village or small town laid out in such a pattern, instead of the standard *N / S // E / W* rectilinear Jeffersonian grids which tragically dominate most of North America.

362 *Primrose Monkeyflower (Mimulus primuloides),* a member of the Figwort family, bearing a resemblance to the garden Snapdragon, at 2,200 m. Notice the three lower flower lobes (bright yellow), each with distinctive red dots, and the opposite, oval (variable), shiny leaves covered with slimy white hairs. Water-loving; Grows along stream edges and seeps; Forms spreading mats with both rhizomes and stolons. VIII.22.2009

364 *String Trio, Dress Rehearsal,* XII.2006

368 *Modern Grand Piano, inner structure.* The piano is essentially a percussion instrument. Pressing a key on the keyboard (clavier) causes a felt-covered hammer to strike a set of three steel strings, which continue to resonate until the key is released. The name *piano* is a condensed version of the original Italian, *piano-forte,* which means *soft-loud,* a reference to the then unique capability of the instrument to produce sharp dynamic contrasts. The iron frame—introduced only around the time of Richard Wagner—allowed for greater volume and string tension (20 tons in a modern instrument). Of the three pedals found on a contemporary concert instrument, the right-most, or *sustaining pedal,* moves

all the dampers away from the strings which are thereby allowed to *vibrate freely*. This greatly increases the resonance and fullness of sonority, and underlies the central image of THE LITTLE CLAVIER. If you have never had an opportunity to explore the Grand Piano's unique structure and sound, try to find an instrument with which to experiment a bit. Even if you have no musical training, simply sit down at the clavier or keyboard, and one by one slowly depress keys. First, *without* sustaining pedal. Then, *with* sustaining pedal. And finally: depress the pedal without playing any keys, and now sing into the instrument. You will hear the strings give back your voice via the principle of *sympathetic resonance*, *"A mirror made not of light, but of sound."* I can guarantee that you will never forget the experience!

378 *January Rime-frost Crystals on Barbed Wire*

380 *Winter Snake River Country* (Brownlee Reservoir)

382 *Fieldwork,* end of February, South Wallowas

384 *Fieldwork,* summit of *Red Mountain,* South Wallowas VII.2.2009

386 *Krag Peak Twin Towers, Northeast Cirque,* early July aspect, South Wallowas

388 *Bringing Down the Cows,* the Alps. The tradition throughout the European Alps practiced by mountain farming communities known as *transhumance* involves, instead of *bringing the hay to the animals, bringing the animals to the hay.* Generally, the hay is stored in small barns at the place and altitude where it is cut. So one starts haying season in June at around 1100 meters or so, and gradually, week by week, works up higher and higher on the mountain to about 1800 meters, or right about treeline, by the beginning of September. At this time, one goes back down to the lower elevations on a good year for a second cut. Although too steep and rocky to till, the wildland hay is of superb quality, and is to this day for about 60 to 70% cut by hand with a scythe. I've done botanical inventories of lower meadows with

more than 120 different species—a fine mixture of native forbes and grasses—and the species composition of course changes dramatically with altitude. The soil is rich and deep, and the meadows mown for hay a generally small, but not when measured by what one can cut by hand in a day or two, or more especially, how large a steep, forest-free pasture can be and not be prone to avalanche in winter and mountain spring. If one's goal is health-giving quality, the mountain farmers of the Alps win the prize, producing world-class dairy and meat products with their Swiss Browns, goats and sheep. As stewards of the land, the mountain farming tradition has much to teach us I think. Over the centuries, they have produced a land of a thousand enchantments. I would echo here the Buddhist scholar Robert Thurman's wonderful insight about Tibetan culture, that people naturally migrated to the higher altitudes to live for spiritual reasons. This is true of the Alps I feel as well. And remarkably, if the tradition is lost, if young people move off the farms and out of farming villages to take jobs as ski instructors or in the tourist industry, the deeply rooted character of the landscape is quickly lost, with the charming diversity of meadow and forest reverting to closed stands of conifers. It is ironic in a way. In retrospect, all the years I spent building orchestras and performing my own music taught me a lot of what I know about how Culture and Nature are at present in *disharmony* with one another; whereas the years I've spent working shoulder to shoulder with mountain farmers of the Alps have taught me a very great deal about the *harmony*, both potential and realized, between Culture and and the natural world.

390 *Mt. Contradiction*, the Swiss Alps, above Andermatt

391 *Bringing ewes and lambs down to a lower barn,* March, the Alps. One always wants to have at least a few "black sheep," because, as you can see, they are much easier to find in the snow!

392 *High Mountain Village, January Chinook Storm*, the Alps

422 *North-facing Cirque above Hidden Lake, 4th of July* VII.4.2008

433 ***Bringing Down a Band of Sheep from the Alp***, end of September. A family in the Alps generally will have either sheep or goats, in addition to six or seven milk cows with associated calves. A band is about 30 ewes with lambs. The families of a village in turn band together with all their ewes and lambs and take them to the alp—*alp* means the place where the animals are taken in summer—around the end of June, depending on how much snow there is above 1800 meters or so. It is a journey round trip on foot of two or three days into spectacular roadless areas, far above treeline, surrounded by alpine glaciers. The sheep stay there with minimal shepherding until the first hard snow, usually around the end of September.

444 ***Glacier Landscape, early Autumn***—I've been watching, not always understanding exactly what I was seeing, climate change and glacier retreat for more than 30 years. It started while climbing lower peaks in Ticino, in the Italian-speaking region of the Swiss Alps. Below 3000 m. it seemed that signs of very recent—say, less than 100 years—disappearance of ice are everywhere. In this photo, the two glaciers on the left and right were in very recent times joined as one massive body of ice. In just the last 50 years, they have broken apart and in an accelerating way, pulled back. On the right-hand side, notice the pile of rocks left behind, what is known as the *terminal moraine*. The photo was made about 700 meters above the valley floor, the beginning of October. Notice that the ice surface is rock-strewn, and entirely free of snow. When I first came into Glacier National Park, and then the Wallowas, the similarities were very striking. Especially in the Wallowas, the ice is now nearly entirely gone. It should be remembered that the melt of large bodies of ice is a "wet," essentially non-linear process. (A light switch is a non-linear process, with no linear shift from *off* to *on*, but rather a sudden change of state.) For example, once warmer water starts to really flow under the glacier, huge blocks of ice can in an unpredictable way fragment and suddenly let go, greatly accelerating the glacier's decline into oblivion. In my darker moments, I meditate on this loss of what the Byrd Polar Research Center glaciologist, *Dr. Lonnie Thompson,* warns could be the irreversible loss of the Earth paleoclimatic archive, written in the ice of the Poles,

and in the high mountain glaciers. This record has now been cored in the Antarctic to a depth going back in time almost 1,000,000 years. At no period in this record of climate history—depending on your point of view, covering a span of time 100 times longer than recorded human history, and probably 10 times longer than the entire history of our species—have the levels of CO_2 in the atmosphere been as high. Unlike the Alps were climate change is seen as a tragically real crisis, in North America, people seem mesmerized by what I've come to see as *Attack Radio* and *Propaganda TV.* It is ironic that so many have lost all interest and respect for science, while at the same time becoming so dependent on its benefits, calling everything that doesn't accord with their worldview or that they don't like "just a theory," while avoiding the hard work of understanding content, argument and logic by sticking their heads in the sands of non-stop *ad hominem* attacks. The only thing more appalling is the complete lack of a deep, sustained, cultural relationship with the land being affected. But then, the two *do* go together.

446 *Ski Mountaineering, the Alps,* perfect January snow conditions in an uninhabited alpine valley. The concept of having snow machines in a valley like this in the Alps does not exist. One can ask: *What are mountains for? Why would one go there? What are the values, and therefore, what would you protect, and why?* Personally, I think it's simple. *Pure* sound. *Pure* air. *Pure*, trackless snow, and the challenge of getting there on one's own by the simplest possible means, without doing harm to the very values which attract one in the first place. What values would you add? Snow machines, in my view, contradict every single one. I do not mean this as an attack on those who enjoy riding them, among whom I count many of my friends, but rather simply to question what has become an overwhelming dominant cultural norm. As always, it is a question of balance, and the civil debate needed to find, in my opinion, a new ethical awareness.

453 *Mountain Monkeyflower* *(Mimulus tilingii)*

454 *Neon Graffiti Composite,* improvised photo composite

470 ***Rose-colored Glasses,*** found lost on a sandy beach in Ohio, USA

472 ***Dwarf Mountain Ragwort, skyview*** *(Senecio fremontii)* 2800 m., named for pioneer botanist, John Charles Frémont who came to the Oregon Country just 40 years after Lewis and Clark. VIII.25.2009

474 ***Alpine Aster*** *(Aster alpigenus var. alpigenus),* 2700 m., purple ray florets around a yellow disk, bracts lance shaped, sometimes tinted purple, from a single taproot, leaves in a tight basal rosette VIII.26.2009

510 ***Grouse Whortleberry*** *(Vaccinium scoparium).* A subalpine relative of the much more well-known Big Mountain Huckleberry. Bright red, highly edible, and very, very small. Like its bigger cousin, it is also deciduous, turning briefly a wonderful hue of yellow with the first snows of autumn, and a bright and happy green with mountain spring and snowmelt, which, depending on altitude, might not fully arrive until well into June or July.

540 ***North / South Ridgeline, Cornucopia Peak,*** view southeast into the small community of Halfway and Pine Valley. For those interested in snowpack depth and what is called snow-water equivalent, this photo was made in a good snow year, my first winter in the Wallowas —2008—around *the 27th of June.* When you fill a pan of with snow and melt it down for drinking water, like I do all winter long while out doing fieldwork, you're dealing with the ratio of *snow* to *water* after the snow is melted, varying with new snow and anywhere from 10 *(extremely light and fluffy)* to 2 to 1 *(extremely wet).*

562 ***January High, above Eagle Valley,*** the South Wallowas I.15.2009

566 ***Twin Pine Notch,*** *Northside,* the South Wallowas III.2.2010

581 ***March, the South Wallowas,*** III.2.2010

582 *December Snake River Country, evening light* XII.26.2009

588 *Breaking Trail after New Snow,* the Alps

590 *Packing In, with ski sled,* the South Wallowas II.15.2010

592 *Inauguration Butte, above January Inversion,* the South Wallowas I.20.2009

592 *Mt. Jefferson, Central Cascades,* from Black Butte IV.25.2008
596 *ASKO Ensemble AMERICAN MUSIC PROJECT,* Concertgebauw, Amsterdam, the Netherlands. From left to right: *Lien van der Vliet* (harpsichord), *Elliott Carter, Cliff Crego* and *René Eckhardt* (piano) after a performance of Carter's *A Mirror on which to Dwell* (a song cycle on Elizabeth Bishop poems), and the Double Concerto (q.v. **STRANGE LOOPS:** WHERE LINEAR & CYCLICAL MOVEMENT MEET IN ONE COMPOSITE 218) Photo: Vincent Rombouts (VI.1982). I started the professional *ASKO Ensemble* with a small group of close Dutch friends—academics, composers, conservatory students, professional musicians—in the spring of 1975 after conducting the amateur ASKO Orchestra for two years. We're happily divorced, now, but the *ASKO Ensemble* continues to be one of the most progressive and innovative small orchestras for New Music in the world, something of which I'm very proud. It could of only happened in the high-energy and supportive Arts environment of Amsterdam at the time.

598 *Sunclipse at Pop Creek Pass,* Eagle Cap Wilderness VIII.20.2009

600 *Night Stream, Little Granite Creek,* *Hurricane Valley,* the North Wallowas VI.1.2009

624 *Fieldwork at Horton Pass,* Eagle Cap Wilderness XI.2.2007

626 *Fieldwork on Highway 2, Montana,* east of the Glacier National Park and the Sweet Grass Hills VIII.22.2007

INDEX OF TITLES

A

ABSOLUTE *128*
ACRONYMSPEAK *462*
A DIFFERENT WAY OF SEEING *107*
ADVENTURE *354*
AFTER FALL STORM IN HIGH MOUNTAIN SUMMER *88*
AGAINST STURM & DRANG *500*
AGAINST THE SCOURGE OF RUNAWAY ABSENTEE OWNERSHIP *330*
ALPINE GEOMETRY *55*
ALPINE SIMPLICITY / COMPLEXITY *115*
A NECESSARY UNITY *127*
THE ASPEN OF FORGETFULNESS—*a prose poem* *72*
AN EYE TO THE SKY *306*
AN EXTINCTION OF A DIFFERENT KIND *73*
A NEW TENEBRISM *68*
ART & NATURE *101*
ART OF ARTS *101*
AT THE KEYBOARD *466*
A TOSS OF THE COIN *95*

B

THE BAG OF GAMING CHIPS *294*
BALANCE OF PERCEPTION *107*
BAPTISM *554*
BARBED-WIRE, WEEDS & OVERGRAZING *124*
BASIC BALLOT *465*
BEAUTY AS BALANCE *128*
THE BEAUTY OF THE SUNFLOWER WAY *47*
BEAVERS & THE ECOLOGY OF NATIONS *132*
BEER CAN *207*
BETWEEN THE WORLDS *87*
BEWARE! *135*
BEYOND ALL COMPARE *102*
BOOTMAKER *50*

C

CASSANDRA FALLS—*a children's poem* *51*

CATHEDRAL ROCKS *180*
CELESTIAL LEXICON & THE EPHEMERAL SHIMMER OF MEANING *359*
CENTER OF LEARNING *559*
CENTERS OF LEARNING *343*
CHILL MOUNTAINS OF THE HEART *45*
CLIMATE CHAOS *183*
CLOACA MAXIMA *87*
COFFEE—*the Good from the Bad* *190*
COMMON NAMES *438*
COMPLICATION? *87*
COLOR IN WINTER *198*
CONSERVATION *187*
CONTRA NATURUM *231*
CREDO—*a confession* *224*
CONTROL NOXIOUS WEEDS! *236*
THE COWBOY GOES TO CHURCH *56*
CULTURE OF CHAIRS? *187*
CUTTING TIME *436*

D

d & d *459*
DAM *209*
DIABOLUS IN MUSICA? *171*
DECIBELS 501 DICTIONARY *170*
DEATH AT A DISTANCE *550*
DEEP WATER *559*
DIVERSITY? *61*
THE DIFFERENCE BETWEEN THEM *407*
THE DIFFERENCE OF BUT HALF A STEP *413*
DOUBLE BIND *495*
DRAWING CIRCLES . . . *60*

E

EIGHT MINIATURES ON LEARNING *488*
END OF MOUNTAIN SUMMER *410*
THE ENERGY OF CORRUPTION *188*
ENERGY iPOD *230*
EPIPHANIES *248*
EPITHETS OF A SPECIES *46*

EUROPEAN CULTURAL BIAS & THE RULE OF REASON *156*
ETHICAL DESIGN *301*
ETHICAL IMPERATIVES—*a meditation on Earthrise* *428*
THE EXPANDING CIRCLE OF ETHICAL AWARENESS *166*
EVERY VALLEY REMEMBERS *433*

F

FALL-BACK *282*
FASTING AS PRINCIPLE *276*
FASTNACHT—*The Night of Mountain Carnival* *80*
THE FARMER & THE ARTIST *127*
THE FARMING LIFE—*six longer narrative poems from the Alps* *432*
FEAR AT NIGHT *67*
FIRST / LAST *448*
FIRE RING *308*
THE FITTING TOGETHER OF THE WORLD . . . *340*
FIVE LONG-LINE SONNETS *78*
THE FLAT-TIRE MODEL OF REALITY *69*
FOOL'S PROSPECT *292*
FOR A FRIEND & A CROW *61*
FOR THE YOUNG—*a few necessities of the artistic life* *558*
FORCING—*an improvized listing poem of indeterminate length* *349*
FOUR MINIATURES ON ART *430*
FOUR MINIATURES ON FORM *492*
FOUR MINIATURES ON SALT & SUGAR MAN AND EVOLUTION *304*
FOUR EASY STEPS . . . *46*
FRACTALS AS PATTERNS OF RHYTHMIC MOVEMENT *296*
FREEDOM & LIMITS *98*

G

GARDEN VARIETY VERSE *126*
GO BIKES! *66*
GRACE *191*
GRAND PARTITA *83*

H

HABIT & TRUTH *69*

HABIT OF PHOTOGRAPHY *63*
HABITUAL MODES OF PERCEPTION *240*
HERE *283*
HIDDEN LAKE *307*
HIGH-TECH / NO-TECH *314*
HITTING THE MARK *318*
HOPE IS . . . *411*
HORSE THIEF! *342*
HOW THE WORLD CHANGES *344*
HOW TO PROTECT AN ALPINE MEADOW *345*
THE HOUSE OF CULTURE *59*
HYPERLINK *329*
HYMN *552*

I

IDEAS & WRITING AS PERFORMANCE *352*
THE IDEAL OF CRYSTALLINE PROSE *360*
I'M TOO POOR IN THIS WORLD, AND YET NOT POOR ENOUGH *556*
IMAGES ARE CHEAP *56*
IN A WORLD AT WAR WITH SILENCE *84*
IN A WORLD OVER-POPULATED WITH PETROCHEMICAL ARTIFACTS *197*
INAUGURATION *412*
IN PRAISE OF NATURAL COMPLEXITY *67*
IN PRAISE OF COMPLEMENTARY WORLDS, LARGE & SMALL *358*
IN PRAISE OF ZIPPERS *499*
INTERCONNECTIONS . - _ / *104*
INTERNET ABC? *267*
INVERSIONS OF MEANING *64*

K

KNOWING *440*

L

LAND ABOVE THE TREES *399*
LANGUAGE OF WAR *64*
LAST MAN ON EARTH *408*
LEARNING MAKES THE CIRCLE ROUND *126*
LEAVES *355*

LET'S GO CAMPING! 52
LET ME REMIND MYSELF HERE 419
THE LIBERATION TRIANGLE 426
LICHENS AS SILENT WITNESSES OF TIMES GONE BY . . . 54
LIFE WITHOUT POETRY . . . 331
LIMITS 354
THE LITTLE CLAVIER 369
THE LITTLE CLAVIER & THE IDEA OF SYMPATHETIC RESONANCE 371
THE LITTLE CLAVIER—Coda 586
LOGISTICS 357
LOSS OF WHOLENESS 223
LOVE IS THE LITERAL MAN 332
LOVE RESONANCE 62
LOVE IS ROUND 63
LOVE & WATER 62
THE LUTE 81

M

MACHINE INTELLIGENCE 500
MAKING HAY 434
MAN OF ONE CUP 420
THE MAN AT THE DOOR 109
THE MASTER & THE APPRENTICE 129
MATTER & SPIRIT 404
A MEDITATION ON BATTERIES—a quartet 484
MEDITATION 403
MEMORY IS SPATIAL 499
METAPHOR 86
MIND / BODY SPLIT 189
MIRACLE 559
MIRRORS OF LIGHT & SOUND 508
MIRROR OF RELATIONSHIP 580
MISCONCEPTIONS & CORRUPTION 102
MONEY? 329
MONEY AS NOTHING 293
THE MOONS OF GALILEO 82
MORAL COMPASS? 191
MOUNTAIN RHYMES 345

MUSIC? *187*

N

NAMES AS THE FIRST POETRY OF PLACE *158*
NATURE'S CIRCLE? *301*
A NEW WORD FOR SOUND *181*
NIGHT ODE *44*
NIGHT THOUGHTS ON A FUTURE ENERGY HOUSEHOLD *246*
NO GLACIERS IN GLACIER NATIONAL PARK BY 2020? *182*
NO SUGAR ADDED *58*
NOISE & THE MIND *196*
NOTE TO MYSELF . . . *343*
NOTHING AS RESOURCE . . . *138*
NOTATION & THE KNOWN *99*

O

OLD & NEW ECONOMIES *197*
ON CHANCE *94*
ON COMPLEMENTARITY *127*
ON FREEDOM'S NECESSARY BALANCE *298*
ON FUNDAMENTALISM & ABSOLUTE BELIEF *299*
ON THE NECESSITY OF POETRY *48*
ON THE LITERAL MAN & THE IMPOSSIBILITY OF METAPHOR *86*
ON THE LOSS OF RHYTHM *96*
ON NECESSITY *104*
ON THE DIFFERENCE BETWEEN LIMIT & CONTROL *105*
ON THE TEMPO OF PERCEPTION (I) *106*
ON THE NECESSITY OF ROADLESS AREAS (I) *130*
ON THE DIFFERENCE BETWEEN THE BRUTISH
BRAIN & THE COMPASSIONATE MIND *148*
ON THE ILLUSION OF INDEPENDENCE *350*
ON THE DIFFERENCE BETWEEN INFORMATION & MEANING *170*
ON THE NECESSITY OF CULTURE NESTED WITHIN WILD NATURE *192*
ON CARS & CAR CULTURE *194*
ON JUSTICE & TIME *302*
ON RELEVANCE *319*
ON NORMS *303*
ON THE DYNAMIC BALANCE OF PRIMARY CONTRASTS *222*

ON THE DIFFERENCE BETWEEN METAPHORICAL & LITERAL MIND *242*
ON THE CULT OF COMPLICATION *242*
ON THE SOUND OF RUSHING MOUNTAIN WATER *243*
ON THE NECESSARY SEPARATION OF ETHICS & RELIGION *244*
ON THE FRAGMENTATION OF RELIGION, SCIENCE & ART *243*
ON THE NECESSITY OF ONE FREE WORLD-WIDE WEB *262*
ON TWO IMPORTANT EXCEPTIONS TO NATURAL MOVEMENT *284*
OUT OF CONTROL—*the runaway economies of systemic imbalance* *272*
ON THE TRIANGLE OF RELATIONSHIP *324*
ON THE NECESSARY UNITY OF FREEDOM DEMOCRACY
 IN THE WORKPLACE *328*
ON THE TEMPO OF PERCEPTION (II) *346*
ON THE MEANING OF NATURAL LIMITS *402*
ON MUSIC AS COMMODITY *414*
ON THE PROTECTION OF TREES *520*
ON THE FRAGMENTATION OF NATURAL WATER CYCLES *478*
ON THE NECESSITY OF ROADLESS AREAS (II) *482*
ON HOLOGARCHY—*the order of the whole* *504*
ON THE MASCULINE ENERGY OF CONTROL *506*
ON THE SOUND OF WHITE-WATER RUSHING *525*
ON THE WAYSIDE *206*
ON THE NECESSARY WISDOM OF ELDERS *507*
OPERA BUFFA *501*
ON THE TWIN GUIDEPOSTS OF YOGA &
 THE ALEXANDER TECHNIQUE *518*
OUT OF TUNE *516*

P

THE PASS *361*
PARTING WAYS *301*
PATH OF VIOLENCE / PATH OF PATH OF DIALOGUE *405*
PATH OF CONFLICT *405*
PEACE *100*
PEACE MAKER *405*
PILGRIM *396*
PILGRIM'S PATH *397*
PLACE FIRST! *61*
PIANOFORTE—a fractured mirror poem *416*

PHOTOGRAPHY AS MANDALA *408*
POOL OF LIFE—*a meditation* *400*
THE POET'S LYRE *415*
POLLUTION, WHOLENESS & THE PLASTIC BAG *514*
POOL OF MIND—*a meditation* *401*
THE PRESENCE OF THE PAST . . . *162*
PROTECTING THE COMMON GROUND OF LANGUAGE *105*
PROOF WITHOUT WORDS *197*
PINECONES & FORM AS MOVEMENT . . . *216*
POPLAR OF FORGIVENESS *406*

Q

QUIET WATER *398*
A QUINTET OF NEON GRAFFITI *458*

R

THE REAL THING *516*
RETRONYMS? *99*
RIDGE CROSSING *526*
ROAD OF CHANGE *69*
ROUGH ROAD AHEAD? *68*
RESONANCE *129*
RIGHT MEASURE / RIGHT ACTION *114*
RUNAWAY DECEPTIONS . . . *497*

S

SCIENCE. ART. RELIGION. *496*
SEARCH GOOGLE *208*
SIMPLE DESIRES *65*
SEEING *344*
SIGNS OF EMPIRE *64*
SIMPLICITY *501*
SECURITY & WHOLENESS *223*
SLAM *210*
SEPTEMBER STREAM *334*
SOCIAL ECONOMY *328*
SIMPLICITY / COMPLEXITY CYCLE *561*
SITTING *442*

SOLITARY STARS *189*
THE SQUARE OF FALSE RATIONALITY *186*

STRANGE LOOPS: WHERE LINEAR & CYCLICAL
 MOVEMENT MEET IN ONE COMPOSITE *218*
SNOW COCKTAIL *232*
SNOW DEVILS *502*
SNOW MACHINE *502*
SORRY, THIS SPACE IS TAKEN *232*
THE SOUND OF DISAPPEARING GLACIERS *323*
SUNSIGHT! *341*
. . . SUNSIGHT / SUNCLIPSE . . . *342*

T

TECHNIQUE *503*
TEMPO OF CHANGE *134*
THOUGHT EXPERIMENTS OF THE COMPASSIONATE MIND *97*
TERRA MADRE — THE LIFEBODY OF THE EARTH &
 THE SYNERGY OF THREE *152*
THE THREE MISTAKES OF EDUCATION *519*
THREE MINIATURES ON SOUND *431*
THIS MORNING *503*
THREE MINIATURES ON SEEING *490*
THERE'S A CERTAIN SOUND THE WIND MAKES — *a prose poem* *482*
THREE MINIATURES ON WAR & THE CHANGE OF MEANING *548*
TOWN *409*
THE TWELVE PRIMARY CONFUSIONS *418*
TREE OF WISDOM *498*
A TRIO OF MINIATURES *450*
TOO MANY VARIABLES *483*
TWO MINIATURES ON PLANTS & NOISE *491*
TWO MINIATURES ON RELATIONSHIP *493*
A TWO-PART MEDITATION ON BOTH THE BRIGHT AND
 THE DARK SIDES OF COMPUTERS & COMPUTER NETWORKS *320*
THE TWO FACES OF EMPIRE *522*
TWO PATHS *524*

U

UNDERSTANDING THE SHAPE OF CHANGE *419*

V

THE VAGABOND OF THE GRANDE DIXENCE *79*
VETERAN *547*

W

WALKING THE WORLD: *Stonepine Mountain!* *110*
WALKING THE WORLD: *Look at the Mountain!* *340*
WAR DEAD—*a prose poem* *546*
WAR GAMES *107*
THE WATER IN US . . . *549*
WATERCOURSE WAY—*a prologue* *42*
WASTE OF TALENT *415*
WAY OF COLLAPSE *168*
THE WAY OF NON-VIOLENCE *54*
WATERCOURSE WAY *498*
WEATHER IN THE WEST *55*
WEALTH & POWER *136*
WEALTH *136*
THE WONDER OF WALKING *98*
WEST WIND AT POP CREEK PASS—*a prose poem* *560*
WILDERNESS IN NORTH AMERICA *402*
WHEN GROWTH IS 'FALSE COMPARE' *268*
WINTER STORM *502*
THE WORLD'S WORST BAD IDEAS *70*
WINTER LINES *567*
WINTER PATHS—*The Alps* *568*
WINTER PATHS—*two sets of seventeen 17-step poems* *570*
WINTER PATHS—*deep snow . . .* *571*
WINTER PATHS—*refuge . . .* *576*
WORLD MIRROR *303*
WOODEN FLUTES, AND THE DIFFERENCE
 BETWEEN THEORIES IN NATURE & THEORIES IN CULTURE *103*
WHOLE & PART *223*
WOMEN IN THE WEST *344*
WITHOUT *292*

Z

ZERO DOLLAR DAYS *71*

Cliff Crego is a composer, conductor, teacher, poet and art photographer.

He is currently on an extended bike / ski / mountaineering trek of the Pacific Northwest.

Weekly updates of his photos, poems & metaphysical journals for this trip can be viewed at: picture-poems.com

You can contact Cliff directly at: crego@picture-poems.com

www.ingramcontent.com/pod-product-compliance
Lightning Source LLC
Chambersburg PA
CBHW031809170526
45157CB00001B/15